CULTURE
WARRIORS

CULTURE
WARRIORS

NATIONAL INDIGENOUS
ART TRIENNIAL

■ national gallery of **australia**

It is customary for some Indigenous communities not to mention the names or reproduce images of, or associated with, the recently deceased. All such mentions and images in this book have been reproduced with the express permission of the appropriate authorities and family members, wherever it has been possible to locate them. Nonetheless, care and discretion should be exercised in using this book and the regions highlighted on the map on page 203.

Where there are several variations of spellings for Indigenous words, the most commonly used versions have been included or, where supplied, the preferred spelling of individual artists or communities.

Produced by the Publications Department of the National Gallery of Australia
nga.gov.au
The National Gallery of Australia is an Australian Government Agency.

EDIT: Deborah Clark and Susan Jenkins
DESIGN: Brett Wiencke, Art Direction Creative
RIGHTS AND PERMISSIONS: Nick Nicholson
INDEX: Puddingburn Publishing
PRINT: Blue Star Print, Australia

FRONT COVER: Destiny Deacon
Man and doll (c) from the series *Colour blinded* 2005
lightjet print from orthochromatic film negative
81.0 x 111.2 cm
Courtesy of the artist and Roslyn Oxley9 Gallery

Cataloguing-in-Publication data
National Indigenous Art Triennial
(1st : 2007 : Canberra, ACT).
Culture Warriors : National Indigenous Art Triennial 2007.
1st ed.
Bibliography.
Includes index.
ISBN 9780642541338 (pbk.).
1 Indigenous art - Australia - Congress. 2 Artists, Aboriginal Australian - Congress. 3 Art, Australian - Congress. I. Croft, Brenda. II. National Gallery of Australia. III. Title.
704.039915

Published on the occasion of the exhibition: *Culture Warriors: National Indigenous Art Triennial 2007*

This publication accompanies the National Gallery of Australia's traveling exhibition *Culture Warriors: National Indigenous Art Triennial 2007*
Art Gallery of South Australia, Adelaide
20 June – 31 August 2008
Art Gallery of Western Australia, Perth
20 September – 23 November 2008
Queensland Art Gallery/ Gallery of Modern Art, Brisbane, March–May 2009

The exhibition was organised by the National Gallery of Australia, Canberra

The exhibition was curated in Canberra by: Brenda L. Croft, Senior Curator, Aboriginal and Torres Strait Islander Art
Exhibition administration: Tina Baum, Acting Senior Curator; Chantelle Woods, Acting Curator; Simona Barkus, Acting Assistant Curator; and Kelli Cole, Curatorial Assistant

The inaugural National Indigenous Art Triennial, *Culture Warriors* has been generously supported by Principal Sponsor BHP Billiton.

Culture Warriors has also been supported by Visions of Australia through its Contemporary Touring Initiative, an Australian Government program supporting touring exhibitions by providing funding assistance for the development and touring of Australian cultural material across Australia, and the Visual Arts and Craft Strategy, an initiative of the Australian Government, state and territory governments.

The Australia Council for the Arts has supported *Culture Warriors* through its Aboriginal and Torres Strait Islander Art Board, Visual Arts Board and Community Partnerships and Market Development (International) Board.

The Queensland Government, Australia through the Queensland Indigenous Arts Marketing and Export Agency (QIAMEA), has supported the exhibition, the accompanying catalogue and the ten Indigenous artists and five writers with cultural links to Queensland. QIAMEA promotes Queensland's Indigenous arts industry through marketing and export activity throughout Australia and internationally.

Arts NT, through the Northern Territory Government's Department of Natural Resources, Environment and the Arts, has provided support to artists and writers with cultural and community links to the Northern Territory to travel to Canberra for the opening of the exhibition and to participate in associated education and public programs.

The Victorian Government (Australia), through Arts Victoria, has supported the artists based in Victoria to travel to Canberra for the opening of the exhibition, and to participate in assorted education and public programs.

CONTENTS

DIRECTOR'S FOREWORD

Ron Radford AM

DIRECTOR,
NATIONAL GALLERY OF AUSTRALIA

The opening of this, the first National Indigenous Art Triennial, *Culture Warriors*, marks the National Gallery of Australia's 25th anniversary on, 13 October 2007. The exhibition also coincides with the 40th anniversary of the 1967 Referendum (Aboriginals), when non-Indigenous Australians voted overwhelmingly to include Indigenous Australians in the census. This year too, is the 50th anniversary of NAIDOC (National Aboriginal and Islander Day Observance Committee) which, each July, focuses Australians' attention on Aboriginal communities in their midst. This year also sees the commencement of stage one of our building redevelopment, which includes a major wing especially for Aboriginal and Torres Strait Islander art; the first increase in permanent display space the Gallery has had since the building was largely conceived in 1969. All these anniversaries have provided major inspiration for the inaugural exhibition and its theme, which pertinently addresses the challenges and accomplishments of Australia's Indigenous people – the culture warriors – from 1788 to the present day.

Of the thirty Indigenous artists represented in the Triennial, twenty-one were not formally considered citizens of Australia, nor counted in the national census until 1967. Neither was the exhibition curator, Brenda L. Croft. While *Culture Warriors* ambitiously offers up a comprehensive exhibition of the creative wellspring from across the country, it is not the full, final or only story of current Indigenous art practice. Neither is it a beginning – even though it is the first National Indigenous Art Triennial – as all of these artists have been inspired by their ancestors and the Indigenous artists who came before. Rather, it offers the exciting opportunity to contribute to an exciting chapter in the history of Indigenous visual art in this country. In three years the National Gallery of Australia will stage a different National Indigenous Art Triennial with a different curator and a different selection of artists.

In devising the curatorial context for this inaugural Triennial, the curator wanted to address several of the issues permeating contemporary Australian society. Implicit in the term culture is, of course, the rich ancestry of the artists represented, while also an acknowledgment that the National Gallery of Australia is a leading cultural institution in the region; one which has been innovative in its support of contemporary Indigenous art and culture as an integral component of Australian and international culture.

After conceiving of the exhibition's title, *Culture Warriors*, Croft discovered that the term is used in publications and websites promoting commentators in the United States known as 'culture warriors' who are conservative, right-leaning, anti-affirmative action and pro-war. The subversive thread discovered in hindsight suited Croft's intentions perfectly: to feistily give attention to a range of concerns while concurrently celebrating culture. The thirty Indigenous artists involved, through their art, reveal their individual and communal stories in an extraordinary range of voices – customary, venerable, spiritual, poignant, satirical, political, innovative and overt.

Indigenous artists have always used their visual language to ensure that personal and collective narratives are recorded and passed on to future generations. The earliest depictions by artists unknown – of ancestral beings, flora and fauna – were painted on rock and bark shelters and incised into tree trunks, weapons and personal effects. In the nineteenth century, drawings made by Indigenous artists with western materials recorded contemporary life and the irrevocable changes taking place for their people.

Contemporary Indigenous artists, including many participating in *Culture Warriors,* also draw upon a wealth of non-Indigenous references to create an explicit Indigenous identification reflecting their manifold experiences. Viewers of this exhibition might consider the parallel histories of this continent that have intersected, overridden and opposed each other for the past 219 years, to gain some insight into the inspiration for the works in *Culture Warriors.*

Indigenous people have proven themselves exceptionally resilient and adaptive, and that is clearly evident in the extraordinary diversity of media in *Culture Warriors.* The Triennial showcases paintings on canvas, bark and paper, carvings and sculptures, weaving, photo-media, video and

installations. They are remarkable, accomplished, majestic and innovative; some using traditional materials in highly original ways, some revitalising cultural practices, others tantalising us with the heady use of contemporary technologies and cross-cultural references. All, in combination, represent a breathtaking cross-section of contemporary cultural practice. Significantly, a great many of these works have been acquired for the national collection and will be enjoyed for generations to come – long after the touring exhibition finishes – by visitors to the National Gallery of Australia.

Culture Warriors pays tribute to a core group of dedicated and significant artists from the overall list of artists. Jean Baptiste Apuatimi, Philip Gudthaykudthay, John Mawurndjul, Lofty Bardayal Nadjamerrek AO and Arthur Koo'ekka Pambegan Jr are celebrated through major installations of their work in the exhibition, and important essay contributions in this accompanying publication. Although many senior artists are included in *Culture Warriors*, the curator considered that these five artists deserved particular focus. Colloquially referred to by Croft as 'The Big Guns', their respective careers span the four decades since the 1967 Referendum. *Culture Warriors* ensures their work is seen and appreciated during their lifetime.

Despite the anniversaries which celebrate milestones in Indigenous history, like NAIDOC and the Referendum, it is the here and now that Indigenous people must deal with. The issues that Indigenous people currently face in this first decade of the twenty-first century continue to inform the visual language of all artists represented in this exhibition. Indigenous artists provide some of the strongest affirmations for respect and understanding of contemporary Indigenous culture. The Triennial is our opportunity to share in, engage with and celebrate the Indigenous visual culture of Australia today.

As acknowledged by our Chairman, Rupert Myer AM, the National Gallery of Australia is extremely proud of the partnership with corporate and government bodies, particularly the very extensive sponsorship provided by BHP Billiton – without their generosity the Triennial would not be realised nor its tour possible. Thanks also to the Aboriginal and Torres Strait Islander Arts Board, Australia Council for the Arts, Arts NT, Arts Queensland, the Queensland Indigenous Marketing and Export Agency (QIMEA), Arts Victoria and the Torres Strait Regional Authority, all of whom have contributed generously towards this exciting new cultural event.

I would especially like to thank and congratulate Brenda L. Croft for stepping up to the plate with such enthusiasm to curate this inaugural Triennial. She has worked hard to pull off this complex achievement with the support of the Aboriginal and Torres Strait Islander Art staff, Tina Baum, Chantelle Woods, Simona Barkus and Kelli Cole combined with the skills of dedicated staff of key departments throughout the National Gallery of Australia.

Most importantly, I extend my thanks to the artists in this exhibition and the many that come after them in future national Indigenous art triennials. *Culture Warriors* is truly a national collaboration and I extend my sincere gratitude to all involved.

CHAIRMAN'S FOREWORD

Rupert Myer AM

CHAIRMAN OF COUNCIL,
NATIONAL GALLERY OF AUSTRALIA

There could be no more appropriate way for the National Gallery of Australia to celebrate its 25th anniversary than to inaugurate a new major contemporary visual arts event, and for that event to honour Australia's Indigenous artists.

The National Indigenous Art Triennial is a new concept that will place Australian Indigenous art at the heart of the Australian art calendar. It is intended to sit right alongside, and complement, existing annual, biennial and triennial contemporary visual arts events in Australia, which include the Biennale of Sydney, Brisbane's Asia-Pacific Triennial of Contemporary Art, the Melbourne Art Fair, the Adelaide Biennial of Australian Art, and Darwin's Telstra National Aboriginal and Torres Strait Islander Art Award.

The inaugural National Indigenous Art Triennial, *Culture Warriors*, brings together thirty Indigenous contemporary artists in a thematic context, presenting a mini survey of their work. At each Triennial the works will be selected by the curator, by invitation, and will have been created in the three years leading up to the Triennial. Of particular significance, the works selected for each Triennial will represent the diversity of art from the far-flung regions of Australia, with every state and territory included, and will demonstrate the breadth of Indigenous art practice today.

Australian Indigenous art has long formed part of the culture of this continent, but its proper recognition is relatively recent. In 1929, Australia's first major exhibition of Aboriginal material was held at the National Museum of Victoria (now Museum Victoria), while the first exhibition to include Australian Indigenous art in a public art gallery opened less than seventy years ago at the National Gallery of Victoria in 1943. The first fully documented and comprehensive travelling exhibition was organised by Tony Tuckson of the Art Gallery of New South Wales and it toured Australian state art galleries during 1960 and 1961.

Fortunately, acknowledgment of the aesthetic qualities and cultural importance of Indigenous art has increased over time and this has now been reflected in many significant exhibitions in succeeding decades, both in Australia and internationally. That recognition was nurtured by the selection of Rover Thomas and Trevor Nickolls as Australia's representatives at the Venice Biennale in 1990 and then by the selection of Emily Kam Kngwarray, Judy Watson and Yvonne Koolmatrie in 1997. Further acknowledgment was given in 2006 when a permanent, site-specific commission showcasing the works of eight major Indigenous Australian artists opened at the Musée du quai Branly in Paris.

Much of Australia's acknowledgment of Indigenous artists has centred on art prizes, which provide valuable recognition and incentive. The National Gallery of Australia believes it is now timely to establish a national event encompassing scholarship, curatorial expertise, the development of new work, an outstanding exhibition display, and imaginative education and public programs.

A major component of the National Indigenous Art Triennial is this monograph. Such publications provide enduring records of documentation, discussion and criticism, and are an integral part of the contemporary visual arts sector. They promote and give international and national visibility to living Australian artists and their work. They are an education resource and contribute to the development of audience, to marketing the work and to advocacy for the whole arts sector.

I would like to acknowledge and warmly thank BHP Billiton for their enthusiastic and generous support for this initiative. Their support is an acknowledgment of the role corporations can so beneficially play in building community cultural capital. BHP Billiton's leadership will contribute significantly to the scholarship and research, public access, education programs, marketing and promotion of the Triennial and to this publication.

I warmly congratulate the Director, the Senior Curator of Aboriginal and Torres Strait Islander Art, Brenda L. Croft, and her curatorial colleagues and the staff of the National Gallery of Australia for this sparkling new initiative.

Marius Kloppers

CHIEF EXECUTIVE OFFICER,
BHP BILLITON

BHP Billiton has a long history of supporting Indigenous cross-cultural programs in Australia and we are proud of our involvement with the remarkable and culturally significant inaugural National Indigenous Art Triennial. In the year that marks the 25th anniversary of the National Gallery of Australia first opening its doors, it is fitting that it should host an exhibition that celebrates the powerful art and culture that emanates from Indigenous Australia.

As a country, what makes Australia truly great is its diversity, built on the legacy of the oldest and richest Indigenous cultures in the world. What is so compelling about *Culture Warriors* is that it is almost as diverse as the Indigenous culture it represents, showcasing the works of a range of artists from a number of regions with different styles and working in various media. As the exhibition travels across the country, it will also provide many people with a wonderful opportunity to see some truly inspired works and learn more about a unique, and beautiful art and culture.

BHP Billiton is very proud to be associated with this salute to contemporary Indigenous Australian art. We hope you enjoy it.

VOTE YES
FOR
ABORIGINAL
RIGHTS

AUTHORISED BY JOE McGINNESS 9 GOUGH ST CAIRNS
PRINTED BY RISING SUN PRESS 192 CANTERBURY RD.
CANTERBURY VIC.

'Vote yes for Aboriginal
rights' poster 1967
National Library of Australia,
Canberra, Manuscript
Collection, Gordon Bryant
Papers (MS 8256/Series 11/
Box 175)

**A wonderland of truly wondrous things
That nowhere else upon this Earth are found;
Of reptiles rare, and birds that have no wings,
And animals that live deep in the ground;
And those poor simple children of the Earth,
(A disappearing race you here may meet),
Whom whites have driven from their land of birth
To regions still untrod by booted feet.**

A. G. Bolam, *The trans-Australian wonderland* [1]

Brenda L. Croft

SENIOR CURATOR OF ABORIGINAL
& TORRES STRAIT ISLANDER ART,
NATIONAL GALLERY OF AUSTRALIA

The title of the inaugural National Indigenous Art Triennial, *Culture Warriors*, and its timing are prescient in regards to the current focus on issues of nationalism, culture, history and citizenship, and the debates that have surrounded such issues since the days of first contact in the late 1700s.

In devising the curatorial context for the inaugural National Indigenous Art Triennial, the curator invites discussion on a number of issues pertinent to contemporary Australian society, which many of the artists in *Culture Warriors* address in their work, whether subliminally or overtly. The ongoing debates, particularly over the past decade, surrounding the 'the Culture Wars' and/or 'the History Wars' has ebbed and flowed within the public arena, yet remains an often polarising topic. Differing historical remembrances and perspectives are often challenged as revisionist or untrue/ fabricated histories, thereby challenging the validity of oral (Indigenous) versus written (non-Indigenous) histories. Even when objective scholarly accounts of history have been presented these have often been derided as promoting a 'black armband view of history'.[2]

Culture Warriors also has an ambiguous, ironic context: *any*- and *every*-one can be a 'culture warrior'. The Triennial's title and the inception of the exhibition itself appear to be right on the money (pertinent when considering the prices of Indigenous art on the secondary market) and prophetic. Of the thirty Indigenous artists represented in *Culture Warriors*, twenty-one were not considered citizens of Australia, nor counted on the national census until 1967, when a federal referendum was held on 27 May.[3]

The artists for the Triennial have been selected from regions far and wide: the sparsely populated desert regions of the Anangu Pitjantjatjara Yankunytjatjara (APY) Lands in Central Australia; the tropical and marine climes of Far North Queensland and the Torres Strait Islands; the windswept isle of Tasmania; the rural areas of the south-eastern and south-western states; the ever-ingenious artistic communities of Arnhem Land; and urban areas in the all states and territories, where cultures converge, contrast, collaborate and sometimes collide.

All of these artists are contemporary, irrespective of their domicile, their experiences, their connections to country and cultural practices – they are creating work in and of the here and now. Demarcations defined by others come and go, resurfacing and fading away – primitive, ethnographic, traditional, urban naive, folk, authentic – all of these artists consider themselves Indigenous, first and foremost, their heritage being the framework and foundation, which underpins their creativity. In the case of one artist, long-term collaboration with a non-Indigenous colleague brings a convergence of ideas, drawing on shared experiences.

In the 179 years preceding the 1967 referendum, Indigenous Australians – the First Peoples of this continent – have endured the ongoing effects of colonisation: loss of access to traditional lands, dislocation from customary practices, including language, and forcible removal of children from families and communities.

With the advent of transportation for thousands of convicts from Britain, the Great Southern Land became the new outpost for England's unwanted – mainly convicts – whose ties were severed with their homelands once they were transported to the other side of the world. The colonists had little capacity to imagine what awaited them as they travelled half a world away from their homelands to the 'upside-down' continent on the other side of the equator.

Danie Mellor's (re)creation of this gleefully contrived never-never land is realised in his phantasmagorical tableau *The contrivance of a vintage wonderland (A magnificent flight of curious fancy for science buffs … a china ark of seductive whimsy … a divinely ordered special attraction … upheld in multifariousness)* 2007 (see pp. 127, 128), which is the kind of diorama that should have been on display

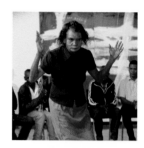

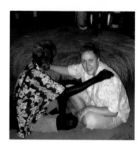

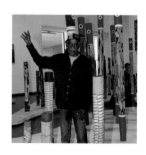

Culture Warriors also pays tribute to a key number of dedicated and significant artists from the overall group. Jean Baptiste Apuatimi, Philip Gudthaykudthay, John Mawurndjul, Lofty Bardayal Nadjamerrek AO and Arthur Koo'ekka Pambegan Jr will be venerated through a special focus on their substantial contribution over many decades to Indigenous art and cultural life in their communities, which continues to influence and inspire younger artists.

For *Culture Warriors*, Apuatimi – a Tiwi elder whose traditional name is Pulukatu (Female Buffalo) and dance Jarrangini (Buffalo) – has created an arresting series of large canvases, ranging from figurative representations of ceremonial objects: *tutini* (funerary posts) and *pukumani* (mortuary rituals) objects and, as always, body designs (see pp. 3, 5, 7). A tiny figure, she has a powerful presence, accompanied by a wicked sense of humour, declaring herself 'a famous artist now' because of her inclusion in *Culture Warriors*. The image of her standing *solid*[6] on her land on Bathurst Island, bracing herself against an incoming storm, is evocative of the manner in which she creates her art – firm and strong.

Philip Gudthaykudthay, one of the last conversant Liyagalawumirr speakers, was born around 1925 in Central Arnhem Land, and is a senior custodian of the Wagilag creation narrative. Gudthaykudthay's totem is Burruwara, the native cat, which has seen him endowed with the nickname of 'Pussycat', and he is known for his elegant, loping gait, almost gliding along as he walks.

Tutored by great artists of the mid twentieth century classical Arnhem Land style – including his classificatory father, Dawidi (1921–1970), and uncle Djawa (1905–1980) – Gudthaykudthay is the last active artist from the seminal Milingimbi School of painting. His peers from this movement included contemporaries such as David Daymirringu Malangi (1927–1999), and both artists were contributors to the *Aboriginal memorial*, an icon in the national collection since it was acquired in 1987.

In 1983 Gudthaykudthay was the first Central Arnhem Land artist to have a solo show at a contemporary gallery[7], making him possibly the first Aboriginal artist in Australia to hold a solo exhibition in a contemporary artspace. Gudthaykudthay has created a magnificent series of *badurru* or *dupun* (hollow logs) (see pp. 13, 15) for *Culture Warriors* in

LEFT: Danie Mellor
The contrivance of a vintage wonderland (A magnificent flight of curious fancy for science buffs ... a china ark of seductive whimsy ... a divinely ordered special attraction ... upheld in multifariousness) 2007 detail installation mixed media, kangaroo skin, ceramic, synthetic eyeballs, wood and birds photograph by Stuart Hay
TOP TO BOTTOM: Jean Baptiste Apuatimi dancing at the launch of the National Indigenous Art Triennial, April 2007; Philip Gudthaykudthay and Brenda L. Croft at Bula'bula Arts, Ramingining, Northern Territory, December 2006, photo by Belinda Scott; Philip Gudthaykudthay with his works in the *Aboriginal memorial* at the National Gallery of Australia, Canberra, April 2007

in the social-history museums of the past. Mellor's magical installation conjures up flights of fancy that might have been the imaginations of those terrified and ignorant initial 'boat people'.

Mellor (Mamu/Ngagen/Ngajan peoples) creates creatures that are manufactured from an amalgam of the man-made and the natural. Real macropod paws and ears adorn fibreglass life-size models, encrusted with a mosaic of shattered blue-and-white willow pattern Spode crockery.[4]

Indigenous artists have always used their visual language to ensure personal and collective narratives have been recorded, from the earliest depictions on rock and bark shelters in the north; dendroglyphs and petroglyphs carved into tree trunks and rock elsewhere; or etched onto personal effects such as weapons, customary and utilitarian adornments. Later the drawings by nineteenth-century artists on both sides of the continent[5] recorded contemporary life and unknowingly recorded the irretrievable changes being wrought on Indigenous communities.

Contemporary Indigenous artists draw upon an array of non-Indigenous sources to create unequivocal Indigenous identities, irrespective of domicile and experience, or heritage. The parallel and intersecting histories of this continent have often been subdued or opposed for over two centuries. The artists in *Culture Warriors* bring these comparable histories to the fore.

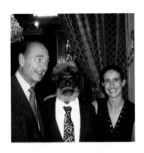

TOP TO BOTTOM: President Jacques Chirac, John Mawurndjul and Apolline Kohen at the Presidential Palace, Paris, France, June 2006, photograph by Michel Kohen; Andrew Blake, Peter Cooke, Lofty Bardayal Nadjamerrek, Lofty's grandson Kabulwarnamyo, Arnhem Land, Northern Territory, December 2006, photograph by Brenda L. Croft; Arthur Koo'ekka Pambegan Jr and John Street, Aurukun, Queensland, March 2007, photograph by Brenda L Croft

his characteristically elegant and spare *miny'tji* (clan body design and *rarrk* (crosshatching), quite distinct from the clan designs painted on the *larrakitj* and *lorrkon* from Yirrkala and Maningrida, respectively.

John Mawurndjul, from the Kurulk clan of Kuninjku people of Western Arnhem Land, is the most renowned Kuninjku artist working today. He has an acclaimed international reputation, and was lauded as a 'maestro' by former French president Jacques Chirac, at the opening of the Australian Indigenous Art Commission for the newest Parisian museum, Musée du quai Branly, in June 2006.

Mawurndjul's representations of *Mardayin* and sites associated with his traditional country of Milmilngkan – on bark and hollow logs (see pp. 19, 21, 23) – have become increasingly refined in his expert use of *rarrk*. Mawurndjul's artistic and cultural mastery was acknowledged when he was awarded the Clemenger Contemporary Art Award in 2003, and honoured in the solo exhibition *Rarrk: John Mawurndjul journey through time in northern Australia* at the Museum Tinguely, Basel in Switzerland, in 2005.

Lofty Bardayal Nadjamerrek AO is rightly acknowledged as one of the most learned elders of the Arnhem Land escarpment known as 'Stone Country', and is the last of the painters of the magnificent rock art galleries of the region. From the Kundedjnjenghmi people, Mok clan, Nadjamerrek was born around 1926, at Kukkulumurr, Western Arnhem Land and, as his name suggests, his elevated, graceful physique was often seen traversing the length and breadth of Arnhem Land in his early adult years.

Now residing at his outstation at Kabulwarnamyo, Bardayal paints sparingly, passing on his traditions to his grandsons, who sit quietly watching him as he paints. Although his hand is now somewhat unsteady, his great skill as an 'old-style' rock art painter is evident in the stunning barks and works on paper that have been secured for *Culture Warriors* (see pp. 27, 29).

Bardayal may scrape back some of the ochre pigments on the bark canvases or paper sheets when dissatisfied with a particular line, but the stature of his figures – creation beings and totemic animals – remains unchallenged. Whereas Mawurndjul continually works on refining his sublime *rarrk*, filling the entire surface of his canvas, Bardayal's painting reflects a fidelity to his cultural traditions, with the figurative elements reigning supreme.

Arthur Koo'ekka Pambegan Jr is one of the most respected Winchanam ceremonial elders in Aurukun, a community based on the western side of Cape York Peninsula in Far North Queensland. Pambegan Jr comes from a family of great standing in the community, learning his cultural traditions through his father, Arthur Koo'ekka Pambegan Sr, who was also an artist and cultural activist of great renown, and was among the first of the Wik-speaking people to live at Aurukun, a mission established by the Moravians at Archer River in 1904.

Pambegan Jnr is known for his wonderful sculptural installations of ancestral stories, Bonefish Story Place and Flying Fox Story Place. The distinctive art of Aurukun has also enjoyed a gradual move into the art market in the past twenty-five years, with younger artists encouraged by elders such as Pambegan Jr. *Culture Warriors* will present the first works on canvas by Pambegan Jr alongside his installations (see p. 37).

Kala Lagaw Ya artist Dennis Nona's bronze sculptures greet visitors to the exhibition, one of which – the impressive *Ubirikubiri* 2007 (see p. 139) – became the first work by a Torres Strait Islander artist to win the overall 24th Telstra National Aboriginal and Torres Strait Islander Art Award in August 2007.[8]

Ubirikubiri relates to an ancestral story, originally from the closest Melanesian neighbours of Torres Strait Islanders, Papua New Guinea, involving the Mai Kusi (River) on the west coast, and *Ubirikubiri*, the crocodile. The warrior figure lying prone on Ubirikubiri's reptilian back was killed in retribution for maltreating the crocodile. The intricate carving on the sculpture relates various aspects of the story and is a masterly development of Nona's skill as a print-maker, evident in the near-biblical creation narrative represented in another of his works in *Culture Warriors, Yarwarr* 2007 (see p. 141).

As previously mentioned, 1770 and 1788 are obvious reference dates when a way of life for 500–600 Indigenous nations, which had been secure for thousands of generations, collided cataclysmically with the encroachment of colonisation upon customary beliefs and practices. The monarch who reigned in England during this period of political and cultural turmoil was King George III (1738–1820), who appears as a character in emerging artist

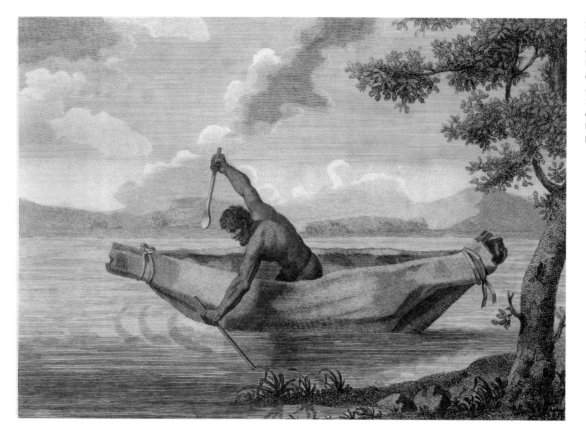

Samuel John Neele *Pimbloy:
native of New Holland in a
canoe of that country* 1804
From *The narrative of a voyage
of discovery performed in
H. M. vessel* Lady Nelson,
1803–1804, by James Grant
engraving from a copy in the
Dixson Library, State Library of
New South Wales

Daniel Boyd's reworked vision of leadership of
the earliest days of colonisation.

From the Kudjla/Gangalu people, Boyd is one of
the nine artists born after 1967 and has therefore
always been classed as a citizen of this country.
He is a young, politically aware, internet-savvy artist,
whose lush oil paintings reflect a satirical admiration
of the classical portraiture of the eighteenth
century.

Boyd's gloriously tongue-in-cheek appropriation
of the AIATSIS[9] Aboriginal languages map in *Treasure
Island* 2005 (see p. 73) seems particularly relevant
with the recent reprobation of Indigenous land in
the Northern Territory by the Federal Government
and the minerals boom that Australia is experiencing,
making a very few wealthy, as rarely do the newly
rich include Indigenous people.

His regal portrait of King George III in *King No
Beard* 2007 (see p. 74), portrayed in all his frills and
finery, is brought undone by closer observation
of the stately necklace, with the expected gold
orbs replaced by skulls. The portrait also contains
the artist's self-portrait, mockingly included as a

decapitated specimen in a jar, gazing mournfully
heaven-ward, like a latter-day Saint Sebastian,
martyred like so many of the first Indigenous
resistance fighters of Australia.

A direct appropriation of a portrait of King
George III, painted in London in 1773 by Nathaniel
Dance[10] and now held in the Hermitage collection
in St Petersburg, this and other portraits by Boyd
directly reference eighteenth-century portraits of
figures associated with the earliest days of Australia's
colonisation. Within these portraits are other
references, as is the case with the macabre self-
portrait. The fate of eighteenth-century Dharug/
Dharuk resistance leader, Pemulwuy (c. 1750–1802),
who led uprisings against the colonisers for twelve
years, before finally being captured and executed –
having escaped from captivity at least once – had
the indignity of his severed head being bottled and
sent back to the Home Country, as a trophy of
empire, long since lost.

Christopher Pease, Minang/Wardandi/Balardung/
Nyoongar people, employs a similar approach in his
work. Pease's work is concerned with Indigenous

Louis de Sainson *Taking on water – the Astrolabe – St George's Sound* 1826 lithograph on wove paper National Gallery of Australia, Canberra

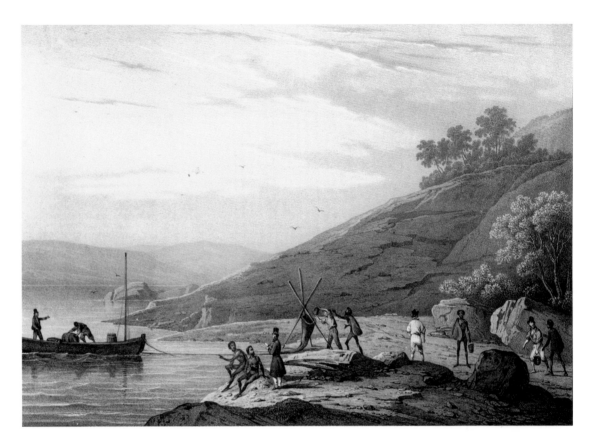

heritage and identity, particularly in relation to Nyoongar culture. He also focuses on contemporary Nyoongar and broader Indigenous identity, and the ongoing impact of non-Indigenous culture on Nyoongar culture from the earliest days of contact in the early 1800s until the present day. This is evident in *New Water Dreaming* 2005 (see p. 145), a direct reference from the hand-coloured lithograph produced by Louis Auguste de Sainson in 1826.

Julie Dowling, a Badimaya/ Yamatji/Widi artist also brings Indigenous history forward in her portraiture. Dowling's portraits of her ancestors and inspirational Indigenous people are a poignant and powerful means to invest dignity in those who were stripped of it during their lifetimes. Her portrayal of *Walyer* 2006 (see p. 97), a Tasmanian Aboriginal woman resistance fighter is a rallying cry of opposition. Dowling's protagonist, standing like an Antipodean Bodicea, is a culture warrior, overturning the myth of passive submission.

George Augustus Robinson – a former missionary and Chief Protector of the Aborigines, Port Phillip, Victoria (1839–1949) – referred to Walyer as 'an

Amazon'. She died shortly after her capture in 1830, on 5 June 1831, from another insidious 'gift' from the colonists, influenza. She had fought on behalf of her people with bravery and tenacity in a war for which there are no memorials.[11]

Another of Dowling's works, *Burrup* 2007 (see p. 99), powerfully depicts the degradation of traditional sites pertinent to her people, portraying the possible large-scale destruction of irreplaceable petroglyphs on the Dampier Archipelago. Murujuga/ Murijuga, as 'the Burrup' is known by local Aboriginal people, is twenty-eight kilometres north-west of Karratha, in one of the most isolated places in Australia. Its Indigenous petroglyphs, numbering between 500 000 and 1 000 000, are distributed over an area of eighty-eight square kilometres.

Murujuga has been nominated for the National Heritage List but is in imminent danger of being destroyed through mining for natural gas. Compounding the complexity of the issue, a number of local Aboriginal groups have recently signed a native title agreement with the state government. Dowling's painting conveys the paradoxical situation

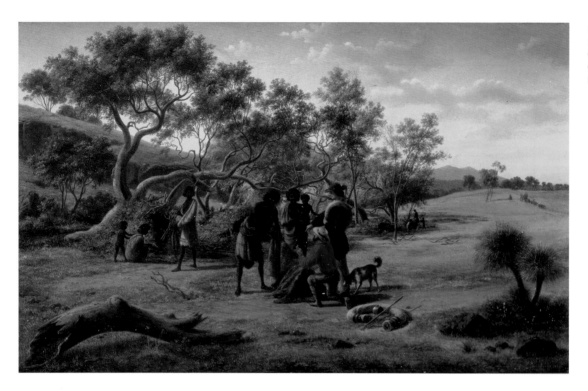

Eugène von Guérard *The barter* 1854 oil on canvas
Geelong Gallery
Gift of W. Max Bell and
Norman Belcher, 1923

Indigenous people face, having to make decisions on providing for their communities by exchanging access to traditional lands.

Dowling's portraits masterfully depict the emotional turmoil of the subject, whatever the context, whether it involves the ongoing pain – personal and communal – of the Stolen Generations, or the reverse role of enforced servitude upon Indigenous women, as in *The nurse maid (Biddy)* 2005 (see p. 98).

Yorta Yorta print-maker and cultural revivalist Treahna Hamm is another artist who gains strength and inspiration from historical customary objects. Like Dennis Nona, she consults extensively with elders from her community before making works that draw on collective memories and practices.

The possum-skin cloaks that Hamm makes are a regeneration of cultural practices that have been dormant for over a century. The skill of making possum-skin cloaks disappeared from Hamm's home state of Victoria nearly a century-and-a-half ago, leaving behind only six known specimens in museums around the globe, two being in the Melbourne Museum, Victoria.[12] *Barmah nurrtja biganga (Barmah Forest possum-skin cloak)* 2005 (see p. 103), was created as a direct response after

Hamm, with her fellow Koori artists Vicki Couzens and Lee Darroch, viewed these wondrous objects in 1999 and were spurred to recreate the work, and teach themselves the processes that had been 'resting'[13], undisturbed behind museum walls for so long.

Ironically, Hamm has also been inspired by one of colonial Australia's most prominent artists' illustration of the trade of one such cloak. Eugène von Guérard documented an inter-cultural transaction in his early *Aborigines on the road to diggings* or *The barter* 1854, an oil painting now in the Geelong Gallery, which depicts Wathawurrung people offering possum rugs for sale to white miners on their way to the goldfields. *Yakapna yenbena dungudja nyinidhan biganga (Family ancestor strong fight possum cloak)* 2007 (see p. 104), has been created especially for *Culture Warriors* as the artist's tribute to the exhibition's theme.

The first draft of the constitution that eventually led to Federation in 1901 was put to an earlier referendum in 1889. In 1890, speaking at the Australasian Federation Conference, Alfred Deakin – one of the founding fathers of Federation, who went on to become Australia's second prime minister, a position he held over three terms

Australasian federal referendum
certificate, 17 July 1899
National Library of Australia,
Canberra, Manuscript
Collection (MS1605)

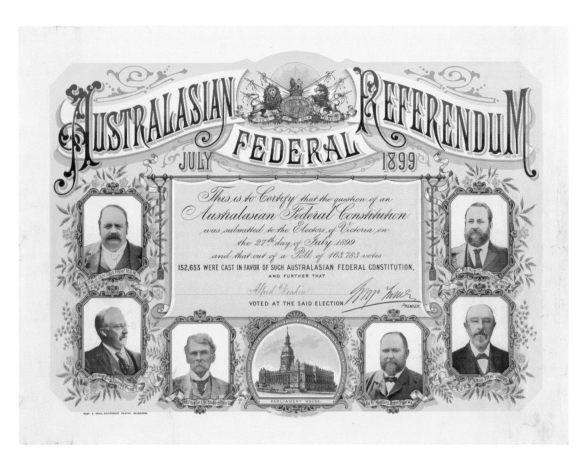

(1903–04, 1905–08 and 1909–10) – proclaimed that 'in this country, we are separated only by imaginary lines ... we are a people one in blood, race, religion and aspiration'.

The same year, 1901, was also the year that the 'White Australia' policy first came to prominence, although it was not an actual legislation but a generic term referring to a collection of historical laws and policies that were not abolished until 1973, under the Whitlam Labor Government. The topic of acceptable immigration has remained an incendiary political issue ever since, placed firmly back in the public arena in recent times by various public figures.

However, there have also been those who have challenged themselves and Australian society for its capacity to turn a collective blind eye to the injustice and inequality that the First Peoples of this land, the majority of whom live in Third World conditions despite living in a highly developed country that is currently experiencing one of its most prosperous economic periods in decades.

In arguably his most potent speech as Labor

prime minister, Paul Keating took Australian society to task for its complicity in doing little to change the status quo for Indigenous Australians. The speech – delivered on 10 December 1992 in Redfern Park, Sydney, at the Australian Launch of the International Year for the World's Indigenous People – included references to 'morally indefensible ... bad history' and was reported around the globe.

We non-Aboriginal Australians should perhaps remind ourselves that Australia once reached out for us. Didn't Australia provide opportunity and care for the dispossessed Irish? The poor of Britain? The refugees from war and famine and persecution in the countries of Europe and Asia? Isn't it reasonable to say that if we can build a prosperous and remarkably harmonious multicultural society in Australia, surely we can find just solutions to the problems which beset the first Australians – the people to whom the most injustice has been done.

It begins, I think, with the act of recognition. Recognition that it was we who ... practised

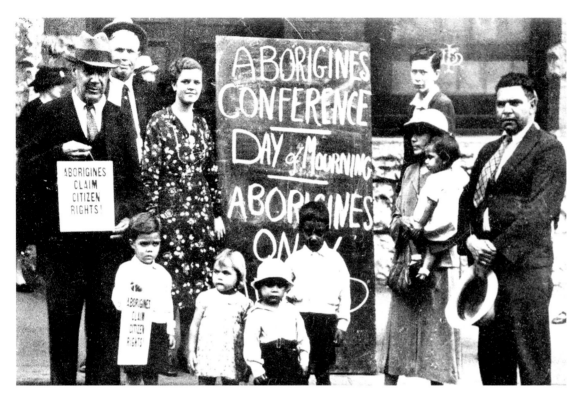

National Day of Mourning
1938 photograph Jack Horner
Collection Image courtesy of the
Australian Institute of Aboriginal
and Torres Strait Islander Studies

discrimination and exclusion. It was our
ignorance and our prejudice. And our failure
to imagine these things being done to us.
With some noble exceptions, we failed to
make the most basic human response and enter
into their hearts and minds. We failed to ask –
how would I feel if this were done to me?[14]
President Chirac's official speech in June 2006 at
the opening of the Musée du quai Branly, the newest
international museum dedicated to the art and
culture of the world's First Peoples, announced to
guests from around the world (including Kofi Annan,
then Secretary-General of the United Nations),
echoed the tone expressed in former Labor prime
minister Paul Keating's speech:

> Moved by that sense of respect and
> acknowledgment, in 1998 I decided to create
> this museum, in full agreement with the Prime
> Minister Lionel Jospin. France wished to
> pay a rightful homage to peoples to whom,
> throughout the ages, history has all too often
> done violence. Peoples injured and exterminated
> by the greed and brutality of conquerors.
> Peoples humiliated and scorned, denied
> their own history. Peoples still now often
> marginalized, weakened, endangered,
> by the inexorable advance of modernity.
> Peoples who nevertheless want their
> dignity restored and acknowledged.[15]

However, as the Tasmanian Aboriginal woman
resistance fighter Walyer indicates, Indigenous
people did not simply abdicate their rights, their
lands, their customs and their lives to the colonisers.
In 1938, after a decade's planning and the year
before a public gallery acquired the first Aboriginal
work of art[16], the first National Aborigines Day of
Mourning was held in Sydney.

Too often, however, Indigenous people are taken
out of their cultural context and placed in a colonial
curiosities cabinet, viewed as separate from their
communities and the events that shaped their lives.
Truganinni (1812–1876), a Tasmanian Aboriginal
woman from the Bruny Island people was a noted
celebrity in her day, best known for being incorrectly
identified as 'the last Tasmanian Aboriginal', who had
seen great tragedy during her life. She is portrayed in
Benjamin Duterrau's painting *The conciliation* 1840,
held in the collection of the Tasmanian Museum
and Art Gallery. Truganinni is also represented in the
national collection in another painting by Duterrau,

LEFT: Benjamin Duterrau
*Mr Robinson's first interview
with Timmy* 1840 oil on canvas
National Gallery of Australia,
Canberra Purchased 1979
RIGHT: H. H. Baily Queen
Trucanini, last Aborigine of
Tasmania c. 1866 photograph
National Library of Australia,
Canberra

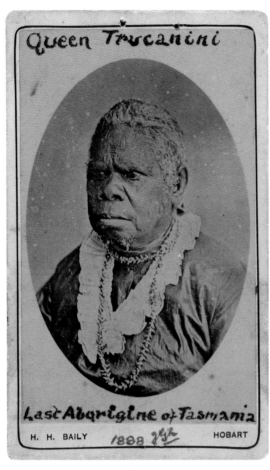

Mr Robinson's first interview with Timmy 1840,
acquired in 1979.

Brought to Melbourne as a young woman, with
two of her countrymen, Truganinni watched as they
suffered the ignominious distinction of being the
first men publicly executed in Victoria. When one
thinks of Truganinni, one recalls the photographic
image of an elderly woman, staring forlornly ahead,
her maireener shell necklace wound round her
neck – an object now held in the collection of the
South Australian Museum. Her remains were not
correctly laid to rest in a dignified manner until a
century after her death, having been stored in a
cardboard box in a museum basement in Tasmania
for many decades.

The work of Ricky Maynard (Ben Lomond/Big
River people), one of Australia's leading documentary
photographers and a master printer, is an elegy to
his Tasmanian Aboriginal ancestors and those who
have suffered, such as Truganinni. His exquisitely
printed, contemplative series *Portrait of a distant land*
2005–07 (see pp. 118, 121, 122, 123) – comprising
ten silver gelatin images of Tasmanian Aboriginal
sites – holds the viewer transfixed by that which
cannot be seen, but only imagined. The sweep of sky
conjures up the windswept landscape of the main
island and its surrounds. The lone figure represents
the continuity of cultural affirmation, in a quietly
dignified and profound stance.

Central Australian artists Jimmy Baker
(Pitjantjatjara) and Maringka Baker (Pitjantjatjara),
from the ground-breaking artistic community
established at Irrunytju (Wingellina) in Western
Australia (near the tri-border conjunction of

South Australia and the Northern Territory) in 2001,
have been working at Tjungu Palya Arts, Nyapari,
in the most westerly communities in Anangu
Pitjantjatjara Yankunytjatjara (APY) Lands since
2004.

This is a region that resonates with *tjukurpa*, with
creation stories: the same stories that underpin
the world's oldest surviving culture and the art
and culture of Australia's oldest contemporary
Indigenous art movement ... over 400 artists
work in one of the seven art centres, in local
craft-rooms, at home or in the bush across
the communities. Casual access to the Lands
without a permit is not allowed.

The canvases of both artists, such as *Katatjita* 2006
(see p. 49) and *Kuru Ala* 2007 (see p. 55), contain
an explosion of brilliant colour, much like the
shimmering hues resplendent in the wildflowers, red
desert sands, and the reds, yellows, greens and blues
of the expansive desert skies of their country.

Frank H. Johnston
Portrait of Albert Namatjira
1958 photograph
National Library of Australia,
Canberra

Sydney-born school teacher Geoffrey Bardon. Bardon was enthusiastic, yet culturally naive in relation to Aboriginal people, and willing to wholeheartedly embrace two-way learning. His encouragement and respect of the community's elders prompted one of the world's greatest art movements.[18]

Reid Nakamarra is part of the next generation of PTA artists, and is gaining increasing respect for her large-scale canvases. Her minimalist ground-scapes hypnotise with their apparently shifting perspective, using the most sparing of colours, as in *Untitled* 2007 (see p.113). Although seemingly far-removed in style, all of these Central Australian artists trace direct artistic and cultural links to the earlier innovative practitioners of Hermannsburg, such as Western Arrernte artist Albert Namatjira (1902–1959) and the earliest artists of Papunya, through their willingness to use unexpected colour and energetic brushstrokes to present their distinctive styles.

South-eastern artists H. J. Wedge (Wiradjuri), Elaine Russell (Kamilaroi) and Trevor 'Turbo' Brown (Latje Latje) are all largely self-taught, with Wedge and Russell sharing the experience of adult education through the Eora Centre for Aboriginal Studies, Redfern, Sydney. Wedge and Russell's early lives on Aboriginal Reserves – Erambie at Cowra, and La Perouse, Sydney, then Murrin Bridge, Tingha – are reflected in their paintings.

Wedge's works often deal with more complex issues facing disaffected communities: alcohol abuse in *No more drinking* 2006 (see p.176), degradation and dispossession of land in *Taking the land away* 2006 (see p.117), and colonialism in *Can't stop thinkin' about it I, II, III* 2007 (see p.175). Russell's works are generally more gentle in their reflections of mission life, as seen in *Bagging potatoes* 2004 and *Catching yabbies* 2006 (see p.157), although she addresses the authoritarianism of Aboriginal lives not being truly their own to run, as when the mission managers checked on the 'welfare' of children, depicted in *Inspecting our houses* 2004 (see p.159).

Brown, from rural Victoria, began painting native animals when he was a teenager living rough and homeless, and depicts his beloved animals in idyllic bush settings. His idiosyncratic style developed from having been encouraged to develop his art through adult art classes at RMIT University, Melbourne. His paintings of native fauna can be considered as

Their panoptical canvases enable the viewer to sense the intricacies of their traditional homelands, and spar playfully with the wonderful canvases of Jan Billycan (Djan Nanundie). Billycan is an elderly Yulparija woman whose painting has forged ahead since 2003, when her community was able to return to their traditional lands at Bidyadanga, a coastal town situated approximately 250 kilometres south of Broome in the Kimberley region of Western Australia.

Following the Bidyadanga community's return in 2003 many of the elders commenced painting later that year, which makes them fledgling artists. However, their art represents cultural reaffirmation portraying the collective knowledge of the Yulparija people since time immemorial.[17]

Billycan's work encompasses incredible knowledge of her country, as represented *All the jila* 2006 (see p.68), which depicts an important site on the Canning Stock Route, *Kunawarritji* (Well 33), in the Great Sandy Desert.

Pintupi/Ngaatjatjarra artist Doreen Reid Nakamarra is one of the most exciting of the next generation of artists associated with Papunya Tula Artists Pty Ltd (PTA), one of the longest running Aboriginal-owned companies in Australia. PTA has been at the forefront of the contemporary Indigenous art movement since the early 1970s, following the arrival at the government settlement Papunya of

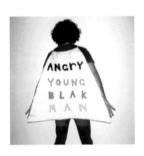

TOP TO BOTTOM:
Christine Christophersen
video image from *Blue print*
2006; Christian Bumbarra
Thompson *Untitled II*
from the series *Angry young
Blak man I, II* 2004
Image courtesy of the artist

metaphors for his people, as in *Sugar gliders* 2006 (see p. 80).

Christine Christophersen (Iwatja/Iwaidja) has spent the past decade-and-a-half refining and developing her artistic language, driven by a desire to represent her people's cultural belief system in all its complexities – kinship, family, clan relationships (see p. 85) – to as broad an audience as possible, whilst ensuring that her elders and community support her portrayal of their shared culture.

Christophersen's country is in one of the world's most pristine sites (and is rightly listed on the World Heritage Register), Kakadu National Park. She is equally at home out bush, or in one of the world's most metropolitan cities, Paris, where she undertook an artist's residency in 2006.

Christophersen is a cultural activist in every sense, having done time in gaol for refusing to pay fines imposed on her because she 'trespassed' on her traditional lands while protesting against the Ranger Uranium Mine at Jabiluka. A decade later and the minerals boom is again placing pressure on Indigenous communities as the Federal Government, having agreed to sell uranium to India, also has to placate concerns about the decision.[19]

Shane Pickett (Balardung/Nyoongar) is one of the foremost Nyoongar artists from the south-west, working as an artist since the early 1980s. However, since 2004 his practice has generated increasing acclaim and he has been the recipient of a number of major national art awards, the most recent being the inaugural major Drawing Together Art Award in May 2007.[20]

Like Christophersen, Pickett has worked for an extended period on developing a visual framework to encompass the distinctive belief system and customary structures of his people. His paintings refer to the complex seasonal changes in his country, as in *On the Horizon of the Dreaming Boodja* 2005 (see p. 151), with its luminous surface depicting where the light of the south-west, which plays such an essential role in viewing the country.

Christian Bumbarra Thompson (Bidjara), and Destiny Deacon (Kugu/Kuku people, Cape York, and Erub/Mer people, Torres Strait) in collaboration with non-Indigenous artist Virginia Fraser, all live and work in Melbourne, with Thompson and Deacon sharing cultural ties with Queensland. Some artists

work in collectives, secure in the flux of members, while others choose long-term, close collaborations that create an intimacy in the creative process, as with Deacon and Fraser. Deacon's cultural ties may be with tropical Far North Queensland, but it is the inner-city experience that informs her photography and her partnership with Fraser.

All of these artists are cultural bowerbirds, conversant in international art trends and influences; seasoned overseas travellers, undertaking countless residencies and participating in highly significant global cultural events annually; and always on the move, yet always returning home – an amorphous place, particularly for Thompson.

All co-opt new technologies, such as video, digital photo-media, and older art forms like film and performance, and incorporate the most basic of discarded/found materials: styrofoam packing balls, golliwogs and dolls rescued from second-hand shops, plastic, nylon and old music videos. All of this is placed, dare one say *forced*, into a *multi*-cultural (as opposed to integrated) blender – one big melting pot – and what comes of all this cookin' up is whatever the viewer wants it to be: entertaining, hilarious, haunting, unsettling, ambiguous, sinister, confronting, challenging and sublime.

The customary greeting between male relations and family members in Thompson's *The Sixth Mile* and *Desert Slippers* both created 2006 (see p. 165) are profoundly moving in the intensely personal rituals revealed to an unaware public audience. Thompson inhabits many bodies – young, male, urban, *Blak*[21], androgynous, playful, mimic, and performative – always Bidjara. As with Deacon, there is an underlying gravitas to his amusing imitations of the fetishised Indigenous art star: a male artist from the Kimberley; an internationally renowned, glamorous photographer; an elderly woman from the Northern Territory; a possibly mocking self-portrait; and the piece de resistance, the artist hawking up and spitting out the biggest bowerbird of all, Andy Warhol, in *The Gates of Tambo* 2005 (see p. 163).

The graphically enhanced photographic images, distorted, silent video and encased gollies and dollies of Deacon and Fraser's installation *Colour blinded* 2005[22] (see p. 92) suggest a myriad of burdens, as the viewer is literally colour blinded by the oppressive yellow sodium lighting. The removal of children –

LEFT: Destiny Deacon and Virginia Fraser *Colour blinded* installation image Courtesy of the artists and Roslyn Oxley9 Gallery
RIGHT: Yirrkala Bark Petition, 1963, Parliamentary Library, Parliament House

Blak, brindle and/or white – shadowed by the sad and angry echoes of the Stolen Generations, coupled with the more recent government-sanctioned threat of 'saving the little children' from Indigenous communities, whatever the cost – financial, political, physiological, physical and cultural is a bitter pill to swallow. It is one that Deacon and Fraser ensure is coated with a sugary layer of humour, but the acidic aftertaste remains, for these are bleak times if you happen to be Indigenous, or support Indigenous people.

Kuninjku artists Owen Yalandja and Anniebell Marrngamarrnga have created three-dimensional representations of the same ancestral being, the *yawkyawk* (a Kuninjku word meaning 'young woman' and 'young woman spirit being'), though their representations are complementary of each other.

Yalandja's majestic, elegant carvings of *yawkyawk*, as in *Yawkyawk* 2007 (see pp. 181, 182, 183), are hewn from kurrajong trunk, denoting strength and power. The chevron design, his signature, indicates the shimmering scales on the fish-like body of the creatures, designed to catch the light and suggest the inherent power within the billabong where

they reside. The son of renowned carver and senior Mumeka custodian Crusoe Kuningbal (1922–1984), was taught to carve by his father.

Marrngamarrnga's *yawkyawk* woven figures require hours and hours of construction. A tiny woman herself, Marrngamarrnga is dwarfed by the stunning scale of *Yawkyawk mother and babies* 2006 (see p. 115). The work is mind-boggling in its creation, the detail of the intricate weaving draws the viewer in, while the creature towers overhead.

Gulumbu Yunupingu is a Gumatj/Rrakpala elder in her community at Yirrkala, in North-East Arnhem Land. A member of an important artistic and cultural dynasty, her family has a long record of political and cultural activism. Her father, Mungurruwuy Yunupingu, was a contributor to one of the most potent cultural documents of the 1960s: the Yirrkala Bark Petition 1963.[23] The petition was presented to the Commonwealth Government, detailing the sovereign rights of the Yolgnu to their traditional lands, which were threatened with being excised by the Menzies Liberal Government for to access the mineral wealth in the region.

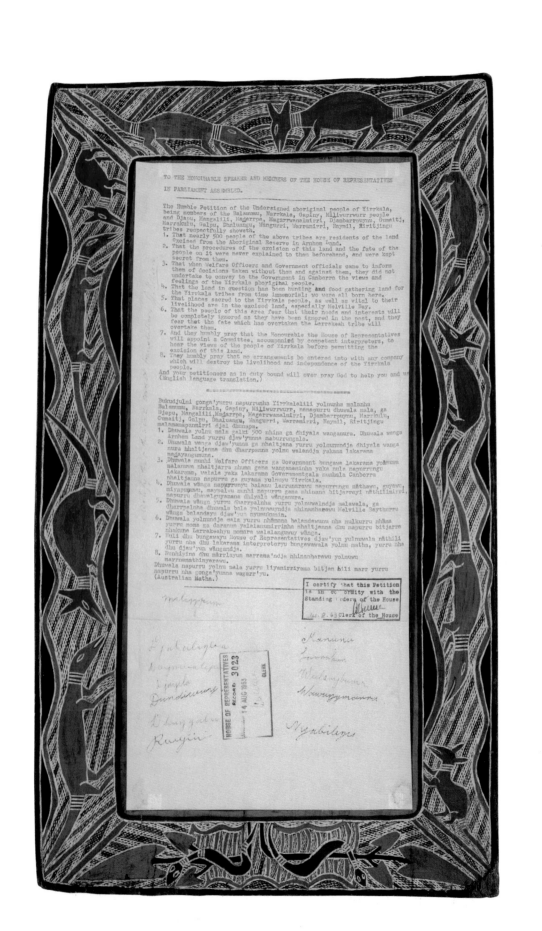

TO THE HONOURABLE SPEAKER AND MEMBERS OF THE HOUSE OF REPRESENTATIVES
IN PARLIAMENT ASSEMBLED.

The Humble Petition of the Undersigned aboriginal people of Yirrkala,
being members of the Balamumu, Narrkala, Gapiny, Miliwurrwurr people
and Djapu, Mangalili, Madarrpa, Magarrwanalmirri, Djambarrpuynu, Gumaitj,
Marrakulu, Galpu, Dhaluangu, Wangurri, Warramirri, Maymil, Riritjingu
tribes respectfully showeth.

1. That nearly 500 people of the above tribes are residents of the land
 excised from the Aboriginal Reserve in Arnhem Land.
2. That the procedures of the excision of this land and the fate of the
 people on it were never explained to them beforehand, and were kept
 secret from them.
3. That when Welfare Officers and Government officials came to inform
 them of decisions taken without them and against them, they did not
 undertake to convey to the Government in Canberra the views and
 feelings of the Yirrkala aboriginal people.
4. That the land in question has been hunting and food gathering land for
 the Yirrkala tribes from time immemorial: we were all born here.
5. That places sacred to the Yirrkala people, as well as vital to their
 livelihood are in the excised land, especially Melville Bay.
6. That the people of this area fear that their needs and interests will
 be completely ignored as they have been ignored in the past, and they
 fear that the fate which has overtaken the Larrakeah tribe will
 overtake them.
7. And they humbly pray that the Honourable the House of Representatives
 will appoint a Committee, accompanied by competent interpreters, to
 hear the views of the people of Yirrkala before permitting the
 excision of this land.
8. They humbly pray that no arrangements be entered into with any company
 which will destroy the livelihood and independence of the Yirrkala
 people.

And your petitioners as in duty bound will ever pray God to help you and us.
(English language translation.)

═══════════════════════════════════════

Bukudjulni gonga'yurru napurruwha Yirrkalalili yolnunha malanha
Balamumu, Narrkala, Gapiny, Miliwurrwurr, nanapurru dhuwala mala, ga
Djapu, Mangalili,Madarrpa, Magarrwanalmirri, Djambarrpuynu, Marrkulu,
Gumaitj, Galpu, Dhaluangu, Wangurri, Warramirri, Maymil, Riritjingu
malamanaparmirri djal dhunapa.

1. Dhuwala yolnu mala galki 500 nhina ga dhiyala wangunura. Dhuwala wangu
 Arnhem Land yurru djaw'yunna naburrungala.
2. Dhuwala wanga djaw'yunna ga nhaltjana yurru yolunundja dhiyala wanga
 nura nhaltjenne dhu dharrpanna yolnu walandja yakana lakarama
 magayangumuna.
3. Dhuwala munhi Welfare Officers ga Government bungawa lakarama yolnuna
 malanuwa nhaltjarra nhuma gana wanganaainuha yake nula napurrungu
 lakarama, walala yaka lakarama Governmentgala munhula Canberra
 nhaltjanna napurru ga guyana yolnuyu Yirrkala.
4. Dhuwala wanga napurrunyu baianu larrunaravu napurrungu nathawu, guyawu,
 miyapunuwu, maynalwu munhi napurru gana nhinana bitjarrayi nathilimirri,
 napurru dhuwalguyanana dhiyala wanganura.
5. Dhuwala wanga yurru dharrpalnha yurru yolnuwalndja malawala, ga
 dharrpalnha dhuwala bala yolnununundja nhinanharawu Melville Baythurru
 wanga balandayu djaw'yun nyumulumin.
6. Dhuwala yolnundja mala yurru nhinana balandawunu nha malkurru nhina
 yurru moma ga daranun yalalanumirrinha nhaltjanna dhu napurru bitjarra
 nhakuna Larrakeahyu momara walalangunuy wanga.
7. Buli dhu bungawayu House of Representatives djaw'yun yolnuwala nathili
 yurru nha dhu lakarama interpreteryu bungawawala yolnu matha, yurru nha
 dhu djaw'yun whangandja.
8. Nunhiyina dhu marrlayun marrama'ndja nhinanharavu yolnunu
 marromamathinyarawu.

Dhuwala napurru yolnu mala yurru liyamirriyama bitjan bili marr yurru
napurru nha gonga'yunna wagarr'yu.
(Australian Matha.)

I certify that this Petition
is in conformity with the
Standing Orders of the House
14.9.63 Clerk of the House

HOUSE OF REPRESENTATIVES
RECORD 3023
14 AUG 1963 CLERK

Senior custodians also created the Yirrkala Church panels, with clan groups depicting their ancestral stories, obligations and rights through *Dhuwa* and *Yirritja* moiety paintings in two massive panels, which are now permanently housed at Buku-Larrnggay Mulka Centre in Yirrkala. This is Gulumbu's heritage, and she depicts the ancestral stories in her statuesque *larrakitj* (hollow funerary logs), on bark paintings and recently on the ceiling of part of the Musée du quai Branly, in Paris, France.

The artistic styles of Western and North-East Arnhem Land are quite distinct, with the incredibly fine linear *rarrk* (crosshatching) of Maningrida artists complemented by the equally innovative figurative elements that appear in many Yirrkala artists works. Gulumbu's signature *Gan'yu (Stars)* and *Garak (the Universe)* designs are carefully built one layer upon another, giving a wonderful textural quality to the surface of her works, with the white and yellow pigments applied to suggest the twinkling of the infinite celestial heavens above.

Four of the ten artists of Murri[24] heritage in *Culture Warriors* have drawn on the case surrounding Mulrundji Doomadgee, who died while in police custody on 19 November 2004, twenty minutes after being picked up for being drunk and disorderly, and placed in the police cells on Palm Island, a notorious Aboriginal settlement.[25]

Palm Island (also known as Great Palm Island, or by its Aboriginal name, Bukaman) is sixty-five kilometres north-west of Townsville, on the east coast of Queensland, Australia. Despite its idyllic setting, Palm Island was a state Aboriginal reserve between 1918 and 1985, with a reputation as being the most repressive of the Queensland reserves. State-designated 'trouble makers' from other reserves throughout Queensland were sent there, with 'trouble' being a euphemism for those who challenged authorities and fought for their rights. It was also a place where many children who were removed from their families were sent and raised in dormitories.

On 28 September 2006, Coroner Christine Clements brought down a finding against Palm Island Police Station Senior Sergeant Chris Hurley, who was declared guilty of Doomadgee's manslaughter. Hurley became the first police officer in the history of Australia's settlement to

be found guilty of such an act, two centuries after colonisation commenced and twelve years after the Final Report into the Royal Commission into Black Deaths in Custody was tabled.[26]

Despite millions of dollars in public funding being dedicated to the Royal Commission, very few of its recommendations to address and overturn the high rates of incarceration of Indigenous Australians from juveniles through to adults have ever been implemented, and fifteen years after being tabled incarceration rates continue to rise, along with every other negative rate in relation to Indigenous communities.

Thus, when Clements' finding was overturned on 19 June 2007, following an appeal by Hurley, Indigenous people across Australia felt that justice would always be denied in their communities, and demonstrated their concern and disgust with public protests in many state and territory capitals. For many people from Queensland it served as a sorry indication that nothing had changed for Murri people.

Vernon Ah Kee (Kuku Yalanji/Waanyi/Yidinji/Gugu Yimithirr peoples) has family links with Palm Island: his grandfather, a Waanyi man from Lawn Hill, was taken there when he was young, and met and married Ah Kee's grandmother on the island.

Ah Kee is known for his text works on panels and walls, which play with visual language. The power of words, text as art and global genericism is represented by a number of powerful text works by Ah Kee. *hang ten* and *strange fruit*, both 2006 (see p. 45), have obvious connotations to deaths in custody, where deaths were often noted as an inmate having hung him or herself. *stolen/removed* 2006, refers to the Stolen Generations, of which Ah Kee's grandfather was a member. *not an animal or a plant* 2006 has a direct link with the 40th anniversary of the 1967 Referendum (as related in the artist's statement on p. 41).

Ah Kee's imposing triptych *mythread* 2007 (see p. 43) contains a tribute to one of his heroes, his grandfather Mick Miller, whose life was 'one of rigid control as government property' through his placement on Palm Island. The work also contains the first self-portrait of the artist, and the thread of reclamation of ancestry and pride resonates throughout all Ah Kee's work, text or drawing.

Gulumbu Yunupingu ceiling, Australian Indigenous Art Commission, Musée du quai Branly, Paris, France, 2006, Image courtesy of Cracknell Lonergan Architects

Island home … Friends and family walk ahead of the hearse carrying the body of Cameron [Mulrundji] Doomadgee, 11 December 2004, *Sydney Morning Herald*, photograph by Andy Zakeli

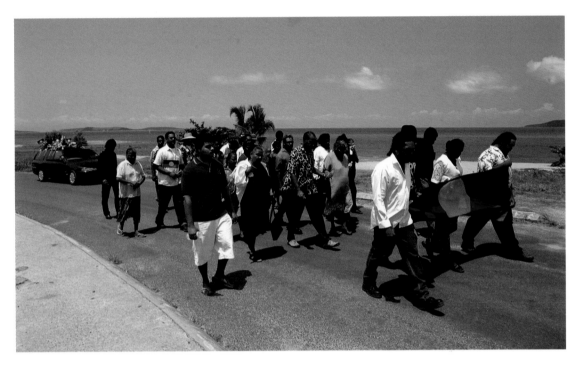

Although the scale of the drawings are gargantuan, they are incredibly intimate, allowing the viewer to share in a personal moment which is usually reserved for the family album, but in the public arena takes on the added meaning of *Here I am/I am Here* – you cannot avoid or ignore me.

Richard Bell (Kamilaroi/Kooma/Jiman/Gurang Gurang peoples), Gordon Hookey (Waanyi/Waanjiminjin peoples) and Judy Watson (Waanyi people) have traversed state and cultural borders, travelling extensively overseas. These four artists, all now based in Brisbane, grew up during the rule of Premier Joh Bjelke-Petersen (1911–2005, Premier of Queensland from 1968 to 1987), during which massive corruption in the police force was revealed. A Royal Commission, known as The Fitzgerald Inquiry (1987–1989) was established, followed by hundreds of prosecutions and many gaolings, including that of the disgraced former Police Commissioner Sir Terence Lewis, ultimately bringing about Bjelke-Petersen's loss of office, after being the longest-serving Queensland Premier.[27]

Bell and Hookey, like Ah Kee, are members of proppaNOW, an artists' collective based in Brisbane. Artists' collectives have long been important for the support and development of artists, and with the establishment of Boomalli Aboriginal Artists Co-operative Pty Ltd in Sydney in 1987 – where Bell, Hookey and Watson have also been members – create the a space for *Blak* people, as opposed to pushing Indigenous artists to the margins. As with many collectives, there is a continual ebb and flow, as artists juggle their art-making with earning an income in order to continue developing their creativity.

Bell, a self-styled propagandist, who shoots from the mouth, machine-gun staccato, in accompaniment to his painting and video-work, won more notoriety for the slogan on his T-shirt – White Girls Can't Hump – when awarded the 2003 Telstra National Aboriginal and Torres Strait Islander Art Award, than for the intent and complexity of his winning painting – a pity, as he was only the second urban-based artist to win at the time.[28]

His work is a re-reappropriation, a reworking, a reaffirmation of any number of artists from close to home, across the seas and throughout the decades: Jackson Pollock, Jasper Johns (in *Australian Art: it's an Aboriginal Thing* 2006, see p.63), Roy Lichtenstein (in *Big brush stroke* 2005, see p.62), Colin McCahon, Gordon Bennett, Michael Nelson Jagamarra, Imants Tillers and female artist Emily Kam Kngwarray. He is an Every*Blak*Man, vastly different from the *everyman* mould in which many of the country's leading politicians of all persuasions cast themselves.

The majority of Indigenous people live in the south-east states in urban areas, with the largest population residing in Western Sydney, not far from the site of first contact two centuries gone. And, although it is stated time and again, Indigenous people living in urban regions retain very strong connections with their cultural ties, their traditional lands, and through their travels connect and reconnect with other Indigenous individuals and communities, who all share one thing: a pride in culture and a willingness to share that with non-Indigenous people.

Culture Warriors is not a competition of 'us versus them', although Bell addresses this very issue with his usual caustic, hard-hitting humour (can't keep a good man down) in *Uz vs Them* 2006 (see p. 60). However, it is the tragedies of Doomadgee's 'accidental death', the destructive influence of Christianity upon many Indigenous communities, and the sorrow of a limited future once again being imposed upon Indigenous people that resonate in *Psalm singing* 2007 (see p. 61).

Hookey takes up the cultural baton, as opposed to police baton, for the loss of his "brother" Doomadgee – for all Indigenous people consider themselves brothers/sisters under the skin/in arms – with his elegiac masterwork *FIGHT: To Survive; To Live; To Die!* 2007 (see p. 109). At over ten metres in length, it contains a multitude of references: the enduring capacity of Indigenous people to stand firm, resist, regenerate, reject the oppression that continues to be heaped upon, the stripping of existing rights and the wish for peace. Like Wedge, Hookey is not troubled by confronting issues within Indigenous communities, such as the impact of alcohol abuse as in *Grog Gott'im* 2005 (see p. 111).

Some artists remain, return or chose to move on. Watson is the most peripatetic of herself, Ah Kee, Bell and Hookey, having lived in rural Queensland, Tasmania, Sydney, Darwin and now back in Brisbane with her family, when international residencies do not lure her overseas again. Watson's response to the Palm Island finding is revealed in *palm cluster* 2007 (see p. 169), from the series *a complicated fall*.[29] It is layered with direct and indirect references to the 'accident' which caused Doomadgee's painful death from 'four broken ribs, a ruptured spleen and a liver almost split in half'[30], and 'could also refer to a fall from grace, a fall of government' and the 'internal grieving that [the artist] was aware of when [she] was pushing and scrubbing the raw pigments into the canvas'.[31]

Like Dowling, Watson has experienced the after-effects of forced removal, through her grandmother being taken from her mother as a baby. The poignant memorial to her grandmother, who passed away recently, is revealed in *under the act* 2007 (see p. 171), an artist's book inspired by the official documents held in the Queensland State Archives relating specifically to the artist's family. Hidden histories revealed, laid bare, like an open wound that needs the air to heal.

Culture Warriors is not the full story – how can it be when there is so much more to learn? Neither is it a beginning, although it is the first National Indigenous Art Triennial. The issues that Indigenous people are currently facing in this first decade of the twenty-first century continue to inform the visual language of all the artists represented in this exhibition.

Despite the obstacles inflicted upon them, or perhaps *because* of all these things, these artists and the many who come after them in future Triennials will continue to inspire, shock, seduce, confront, challenge and encourage us to stand up for what is fair and just. It is time to stop desiring the creations as ownership of the artists themselves, and supporting the creators of these works, their communities and future generations of artists. You can buy their work, respect their visionary declarations and innovatory contribution to contemporary Indigenous *and* Australian art and culture, but you cannot buy their souls. Indigenous artists give voice to the resilience of their communities through their art, echoed in the words of contemporary Indigenous songman, poet and cultural activist, Kev Carmody:

> For 200 years us blacks are beaten down here
> too long on the dole
> My dignity I'm losing here and mentally I'm old
> There's a system here that nails us ain't we left
> out in the cold
> They took our life and liberty friend but they
> couldn't buy our soul[32].

Brian Kennedy, Franchesca Cubillo, Richard Bell and Cissy Bell in front of *Scientia E Metaphysica* 2003, the overall winning work at the 20th Telstra National Aboriginal and Torres Strait Islander Art Award, Museum and Art Gallery of the Northern Territory, Darwin, August 2003, photograph by Brenda L. Croft

1 A. G. Bolam, *The trans-Australian wonderland*, Melbourne: The McCubbin-James Press Pty Ltd, 1927.

2 Professor Geoffrey Blainey AC, born in Melbourne in 1930 is one of Australia's most significant historians, and coined the phrase 'black armband view of history' in 1993, while delivering the annual Sir John Latham Memorial Lecture, on 3 September at a *Quadrant* magazine dinner held at the American Club, Sydney.

3 'Fact sheet 150 – the 1967 referendum', National Archives of Australia, Canberra, viewed September 2007, naa.gov.au/about-us/publications/fact-sheets/fs150.aspx

4 Spode is an English manufacturer of pottery and porcelain, based in Stoke-on-Trent, United Kingdom, c. 1770.

5 William Barak (c. 1824–1903), Tommy McRae (c. 1835–1901) in Victoria, Mickey of Ulladulla (c. 1820–1891) in the south-east, and Gyallipurt, George Coolbul (b.d. unknown – 1871) and Johnny Cudgel from the south-west.

6 Solid, meaning 'firm', is also used as a colloquial term by Indigenous people to suggest 'good', 'fantastic', 'great'.

7 Garry Anderson Gallery, Paddington, Sydney.

8 The National Aboriginal and Torres Strait Islander Art Award, colloquially known as 'the Telstra' in recognition of its major sponsor, has been staged at the Museum and Art Gallery of the Northern Territory since 1983.

10 D. R. Horton, *Aboriginal Australia wall map*, Canberra: Aboriginal Studies Press, Australian Institute of Aboriginal and Torres Strait Islander Studies, 1996.

11 Nathaniel Dance (1735–1811) was a notable English portrait painter and later a politician, and one of the founder members of the Royal Academy, London, in 1768. He was commissioned to paint King George III and his queen, plus Captain James Cook.

12 Further reading, see Vicki Maikutena Matson-Green, 'Tarenorerer [Walyer] (c. 1800–1831)', in *The Australian dictionary of biography*, supplementary volume, Melbourne: Melbourne University Press, 2005, p. 376.

13 From an interview with Robin Usher, 'Arts review', in *The Age*, 13 March 2006.

14 'Arts review', in *The Age*, 13 March 2006.

15 'Australian launch of the International Year for the World's Indigenous People', speech given by then prime minister Paul Keating at Redfern Park, Sydney, 10 December 1992, a viewed September 2007, apology.west.net.au/redfern.html

16 Speech by M. Jacques Chirac, President of the Republic, at the opening of the Quai Branly Museum, Paris, 20 June, 2006.

17 *Ilum-baura – Haasts Bluff* 1939, by Albert Namatjira, was acquired by the Art Gallery of South Australia that same year.

18 Ashley Crawford, 'Yulparija show their colours', *The Age*, 19 April 2004.

19 Further reading, see H. Perkins and H. Fink, *Genesis and genius: Papunya Tula*, Sydney: Art Gallery of NSW, 2000.

20 'PM plays down India uranium concerns', 17 August 2004, ABC News, viewed September 2007, abc.net.au/news/stories/2007/08/17/2007586.htm

21 Organised jointly by the Australian Public Service Commission, Department of Families, Community Services and Indigenous Affairs, the National Museum of Australia and the National Archives of Australia as 'an art event exploring reconciliation and promoting the employment of Aboriginal and Torres Strait Islander people in the Australian Public Service', Pickett's winning painting was *Travel lines crossing the Bunurroo Waterway*.

22 The term *Blak* was first used by Destiny Deacon in the exhibition *Kudjeris*, at Boomalli Aboriginal Artists Co-operative Ltd, in 1991, with one of her works titled *Blak lik mi*.

23 Further reading, see Geraldine Barlow, *Destiny Deacon: talking back*, exhibition catalogue, Melbourne: Australian Centre for Contemporary Art, 2005.

24 Further reading, see 'Community action for rights', Treaty, 1.aiatsis.gov.au/exhibitions/treaty/rights.htm

25 Gulumbu Yunupingu was one of eight Indigenous artists selected to participate in the Australian Indigenous Art Commission at the Musée du quai Branly, which opened in Paris in June 2006, a decade after its initial planning. The other artists were Paddy Nyunkuny Bedford, John Mawurndjul, Ningura Napurrula, Lena Nyadbi, Michael Riley, Judy Watson and Tommy Watson.

26 Murri is a term used by the Indigenous people of Queensland to generically refer to themselves, meaning 'people'.

27 Between October 1987 and November 1990, the Royal Commission into Aboriginal Deaths in Custody investigated the deaths of ninety-nine Aboriginal persons in police and prison custody, which occurred during the nine years and five months period covered by the Letters Patent of the Royal Commission. Further reading, see summary of the final report into the Royal Commission into Aboriginal Deaths in Custody at austlii.edu.au/au/special/rsjproject/rsjlibrary/rciadic/rciadic_summary/rcsumk01.html

28 Further information, see 'The moonlight state' by Chris Masters, aired on *Four Corners*, ABC Television, 11 May 1987, and *Courier Mail* reporter Chris Dickie's investigative journalism during this period.

29 Jodie Broun won the overall Telstra NATSIAA in 1998 with *Whitefellas come to talk 'bout land*.

30 A solo exhibition held at Bellas Milani Gallery, Brisbane, from 17–26 May 2007.

31 Kenneth Nguyen, 'Palm Island man "bashed to death by policeman"', *The Age*, 28 September 2006.

32 Artist's statement, 2007.

33 Kev Carmody, *Song cycles*, 1991.

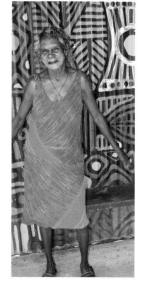
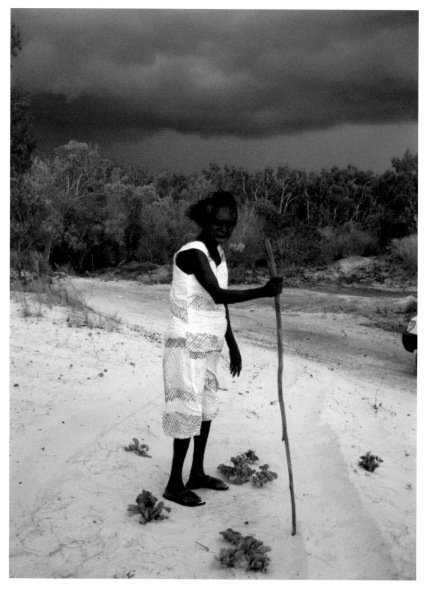

JEAN BAPTISTE APUATIMI

I am a painter. My husband Declan Karrilikiya Apuatimi taught me how
to paint. I love my painting, I love doing it. The designs are the ones he
taught me. He said, 'One day you will be an artist. You will take my place.
You do this painting when I die, to support the kids that I gave you.'
He gave me this work to do to support my family. Now I am doing that.
Painting makes me alive.[1]

I work with my friends at Tiwi Design. That's where we paint, men
and women, those who I love. We are all artists, me and my friends.
We all work the same. We share food. I love them and they love me.
We paint *jilamara* (body painting designs) ... I also paint ceremony ...
tutini (cemetery pole), old *tunga* (bark basket), *pamijini* (arm band),
japarrunga (double-forked digging stick for *kulama* yam) and that's
what my husband taught me to paint.

Angela Hill

Jean Baptiste Apuatimi was born at Pirlangimpi (Garden Point) on Melville Island. Her country is Imalu, from her father's country, which is her husband's country too. Her skin group is Tapatapunga (March Fly), from her mother. When she was a young girl the family moved to Nguiu on Bathurst Island, where she lived at the convent and was educated and cared for by the nuns from the Catholic mission. She was happy at the convent: 'My mother and father used to come and visit me. I was a dormitory girl.' When Jean reached the age of fourteen her parents chose Declan to be her husband:

> My mother and father gave me to marry Declan Apuatimi. He was the same skin group as my father, Karntukini (Ironwood), from the same country. They chose him, they loved him.[2]

Jean and Declan were one of the first Tiwi couples to be married in a Catholic ceremony. Her eyes sparkle and she buries her face in her hands with laughter as she recalls her wedding day: 'I said I'll take you as my awful husband. He left out the back door and I left out the front door.'

> When we got married and we had children I was happy. He gave me eleven children that old man. Declan was doing all the painting and all the carving then. He used to tell me to stay at home and look after the children. He would go out and get ironwood, *tunga*, pandanus, to make *pamijini*, spear, pole, all them things for ceremony. I sat with him. I watched him what he was doing. I used to help him. Josette and Carmelina used to help him too. He showed them how to carve. He told them stories.[3]

After Declan passed away in 1985 Jean moved to Milikapiti, back to Melville Island. At that time she painted alongside Kitty Kantilla.

> Same painting like this *parlini jilamara*. This is olden days painting. Long time ago in the early days we put *yalinga* (red), *arrikininga* (yellow) and *tutyangini* (white) ochre on our face and body for *pukumani* and *kulama* ceremonies. We call this *minga*. I used to do that at Snake Bay.

In 1991 Jean participated in her first exhibition *Jilamara Milikapiti* at Alcaston Gallery in Fitzroy, Melbourne. She moved back to Nguiu three years later and worked at the hospital – cleaning and making damper – for half the day and painted in the afternoon. Jean began painting full time in 1997, encouraged by Gillian Dallwitz, the then new art centre manager at Tiwi Design.

Jean is one of the most senior artists on the Tiwi Islands, with a career now spanning twenty-one years. Every day she walks around the corner from her home to Tiwi Design to paint. She shares a cup of tea, a piece of damper, a cigarette and a laugh with her Tiwi Design family before settling down to work. She paints alongside her daughter Marie Josette Orsto, as well as Margaret Renee Kerinauia, Ita Tipungwuti, Roslyn Orsto and Alan Kerinauia. They all call her aunty. This group of painters have worked together since the late 1990s, and together they have created the special atmosphere and community spirit that is Tiwi Design.

In 2006, soon after Jean's eldest daughter Carmelina Puantulura passed away, she began working on a series of *pukumani* and *kulama* ceremony paintings. Although the current ceremonies no longer include many of the ceremonial objects and body decorations of the past, in her work the artist likes to recall the ritual practices that Declan participated in when he was alive, and her paintings play an important role in passing on Tiwi traditions to younger generations. She has moved beyond using only red, white and yellow for these works, adopting the practice of mixing ochres to create greens, blues, pinks and purples, initiated by Marie Evelyn Puautjimi in the 1990s.

Jean Baptiste Apuatimi paints with conviction, certain of her role as an artist who has carried on the tradition of *jilamara* and the responsibility of caring for her family, as well as establishing herself as a significant Australian artist in her own right.

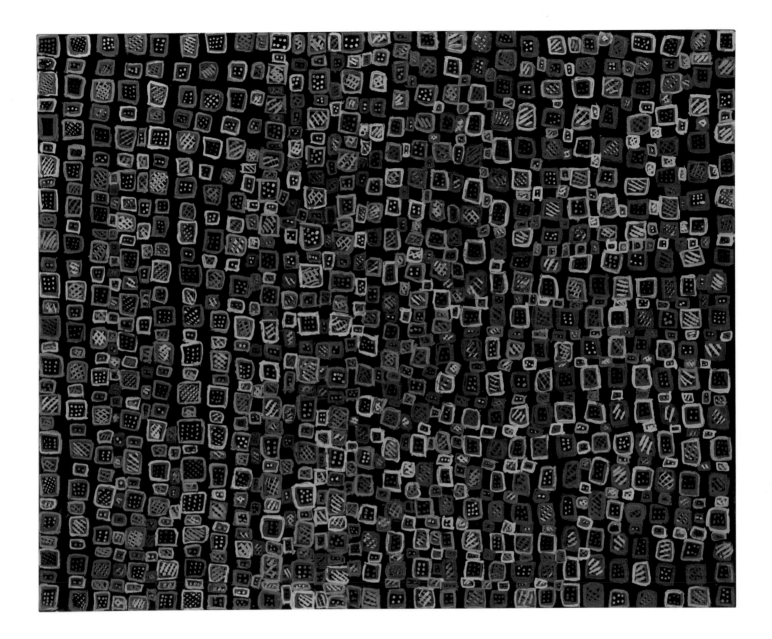

Jikapayinga 2007

Judith Ryan

For Jean Baptiste Apuatimi, painting is a way of remembering her late husband and mentor Declan Karrilikiya Apuatimi who, in teaching her to carve and paint, passed on his personal *jilamara* (design), which survives but is dramatically re-interpreted in her work. The source of the artist's vigorous carving style, figurative iconography, spontaneously painted designs of *pwanga amintiya marlipinyini* (dots and lines)[4] and bright ochre palette undoubtedly lies in Declan's inspirational oeuvre, much of which was produced collaboratively with her, if largely unacknowledged. But once she focused on painting in her own name, Jean Baptiste immersed herself in making art and gradually forged a radical individual style recognisable for its gestural verve, audacious *jilamara* and oscillation between figuration and conceptual abstraction. The potency of her innovative aesthetic derives from both its compositional expansiveness and close connection with customary ritual.

After Declan's passing and Jean's move to Milikapiti on Melville Island, she dispensed with her chisel and established herself as a painter. Her work first came to my attention in 1992, when eight bark paintings of hers were exhibited and subsequently acquired by the National Gallery of Victoria.[5] The barks served to establish her signature style: compositions of dotted or hatched squares, circles and rectangles in which she structured schematic *tutini* (*pukumani* poles), *japalingini* (headbands), *pamijini* (armbands) and Tiwi ancestors conceived in the form of sculptural objects. Declan's sombre red ochre and black palette, and heavier mark-making is set aside and reinterpreted in a delicacy of line and a penchant for white and yellow ochre detailing, which is visually accentuated by the negative space of sections left black.

Back in Nguiu on Bathurst Island, Jean painted very little from 1993 until 1997 when she began to work full time at Tiwi Design. She renewed her acquaintance with Declan's work and made a *tunga* (bark basket) painted with a grid of parallel lines and squares. A large canvas ensued, which expanded small sections of this linear design to create her first large-scale

composition of *pukumani* poles: a sequence of vertical dotted, crosshatched and solid bands of colour creating a riot of pattern that masks the background. The massed bold abstracted poles and other geometric crocodile compositions in her inaugural solo exhibition of 1999[6] revealed her daring conceptual vision and signalled a new direction in her practice. The artist's dynamic gestural painting, raw and idiosyncratic, exploits the physicality of the painted surface, what she terms 'crooked' painting.

Jikapayinga 2007 and *Yirrikapayi* 2007 are both inspired by ochre designs on objects and transformed into modern conceptions. Jikapayinga, the cheeky female crocodile who lives in a waterlily place, is schematised by a plethora of freely painted, different sized squares floating on a black ground, whereas Yirrikapayi, a man who transformed into a crocodile after he had been speared, is represented by multiple conjoined crosshatched and dotted squares and triangles, a flattened version of the textured grid of squares used by Declan to indicate crocodile skin in his carvings.

These works – rich in the rhythmical patterning of Tiwi *jilamara*, which is used to disguise the bodies of *Pukumani* participants from *mapurtiti* (malevolent spirits of the dead) – are characterised by a reduction of the figure to the grid. Jean, however, expresses her cultural activism by depicting important ritual objects encoded with meaning on black, sepia or red ochre grounds.

Yirrikamini 2007 is a dramatic close-up view of the individual shapes and surface patterns of five *tutini*: 'that one *pukumani*: that means really sad ceremony … Those poles remind me of Snake Bay … [of] my husband. He carves that way.'[7] By including *tutini*, *japurraringa* and *pamijini* in her paintings, the artist refers to the story of Purrukuparli, which explains how death came to the Tiwi. This symbiosis of iconography and narrative imbues these works with an indelible and immutable Tiwiness which is intrinsically associated with the poetics of mourning.

Jean's paintings generally rely on strong Tiwi colours of red, yellow, black and white, a palette that references the work of Declan,

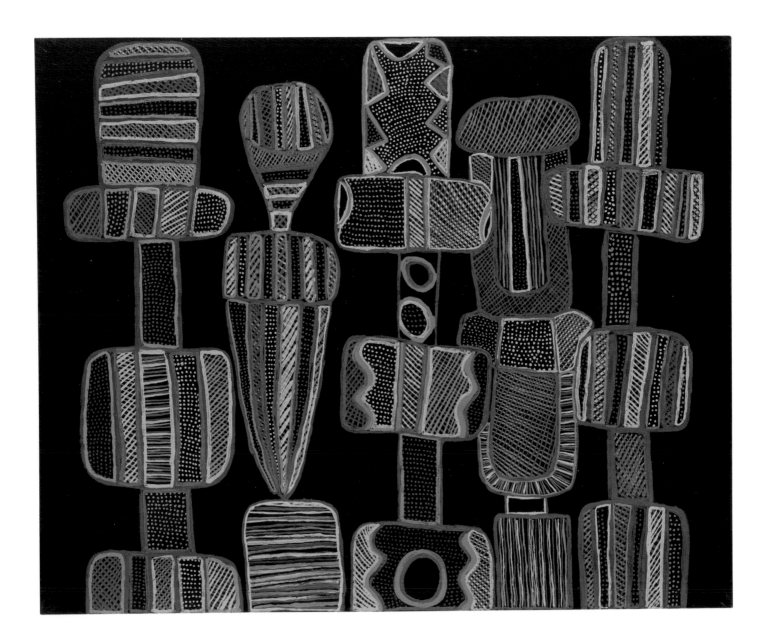

Yirrikamini 2007

with pigments pure and intense rather than subdued by intermixing. She has recently expanded her palette, mixing softer nuances of natural ochres, resulting in a quieter tonality, and has also ventured by painting her forthright *jilamara* onto a white ground, so that it stands up stark rather than emerging subtly from a black ground.

Although plagued by 'too much humbug' [8], Jean is a warrior for Tiwi culture: her zest for painting and for seeking out new compositions, colours and designs remains undiminished. Art is her authoritative form of activism. In her audacious canvases *parlini jilamara* (old designs) of Declan are celebrated and revitalised with a modernist awareness.

1 From Jean Baptiste Apuatimi, introduction in Tiwi, Nguiu, 3 February 2007, transcribed and translated by Margaret Renee Kerinauia.

2 All statements from Jean Baptiste Apuatimi quoted in this essay were recorded and transcribed by Angela Hill at Nguiu, 3 February 2007.

3 Sadly Jean's eldest daughter Carmelina Puantulura, a talented carver, painter and musician, as well as a highly respected teacher and culture woman, passed away in 2006. Jean's other daughter Marie Josette Orsto has painted and carved at Tiwi Design since 1991, and her son Declan Apuatimi is a carver and potter at Munupi Arts and Crafts.

4 The spelling of Tiwi words is based on the Tiwi-English dictionary compiled by Jennifer Lee, *Ngawurranungurumagi Nginingawila Ngapangiraga: Tiwi – English Dictionary*, Darwin: The Summer Institute of Linguistics, 1993, in consultation with artists at Tiwi Design.

5 *Ngingingawula jilamara kapi purunguparri: our designs on bark*, 12 September – 2 November 1992, an exhibition of fifty-five bark paintings and printed textiles organised by the National Gallery of Victoria in conjunction with Jilamara Arts & Craft Association, Milikapiti, Melville Island.

6 Sutton Gallery, Fitzroy, Melbourne, the first of ten solo exhibitions.

7 Jean Baptiste Apuatimi interview by Angela Hill, Tiwi Design, email to Judith Ryan, 5 March 2007.

8 These words were on the door of Jean Baptiste Apuatimi's house at Nguiu, photographed by Gillian Dallwitz in 1999.

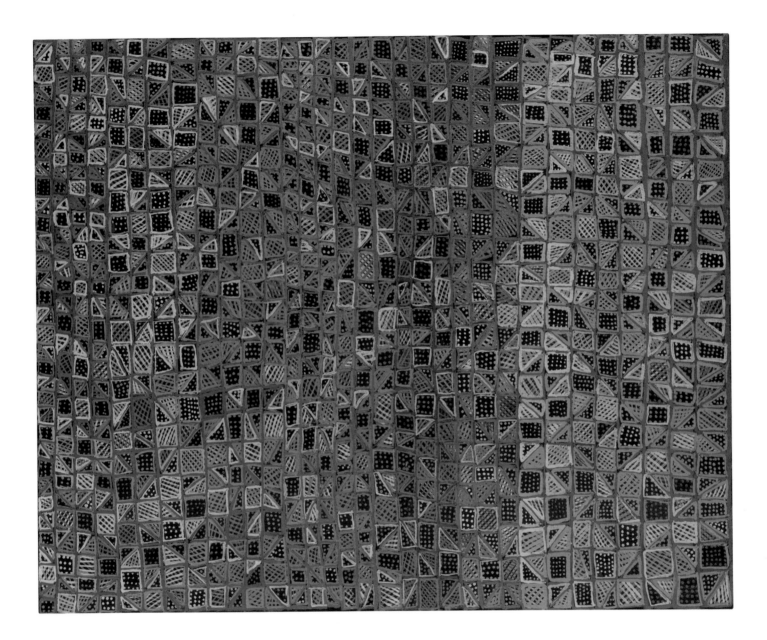

Yirrikapayi 2007

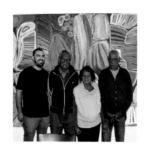

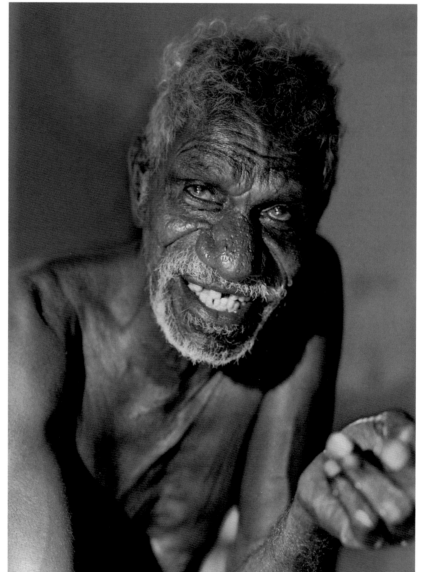
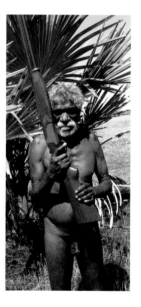

PHILIP GUDTHAYKUDTHAY

I'm botj (boss) here. Ramingining. My mother. Me *bungguwa* (leader), from my mother (for) *Marrawalwal* (Red Kangaroo tribe), *marrabal* (kangaroo), *gandayala* (kangaroo) [stories]. My mother here.

Me, number one painter … Right up from … Milingimbi, Ngangalala, Ramingining, Maningrida, now come here, Ramingining. Stop here. Number one painter here.

Bark, finish 'im up here; canvas, finish 'im up here. Hollow log. All painting here. Me, number one. *Maku* (maybe) Minygululu second [in line to take over responsibility] here.[1]

Susan Jenkins Philip Gudthaykudthay, I think, will not ever fit into a tidy summing up. He always seemed one on the fringe, a peripheral dweller. When I worked at Bula'bula Arts at Ramingining in the mid 1990s Pussycat – as Gudthaykudthay is known – was certainly one of the regulars, but I never got the impression he was one of the lauded ones, nor that he ever would be. He was often in at the art centre, bringing in paintings or just visiting, always by himself, loping around on those broad long feet. We had sort of abstract conversations where we would muddle through, using words foreign and frowning and laughing.

Pussycat was often alone, with no family or children around him, unlike other senior men. He had a succession of trucks that were so battered they barely stood a chance, but were used for hunting and being on country, allowing Pussycat to lead the solitary life that he had led thus far. As with other artists, he painted with the added incentive of saving up to buy a truck for hunting.

Pussycat is a Liyagalawumirr Wititj man and his paintings often feature, in figurative form, the key protagonists of the Wagilag narrative at Mirarrmina, where Wititj the Olive Python devoured the Wagilag Sisters.[2] Burruwara the native cat is also a principal totem in the story of 'Pussycat' and Crow, who created the Milky Way with the bones of the first hollow log coffin at Guyungmirringu.

Gudthaykudthay's somewhat ungainly figures have a wildness about them, their shapes blocked in to reveal watery stretches, where the pigment pools and dissipates across the surface. Often narratives are depicted less overtly, and Wititj appears in a shifting field of *miny'tji* (clan body design) and *rarrk* (crosshatching), or a patterned field may have no figurative clues at all.

The Milky Way narrative is represented by Gudthaykudthay as a distinctive grid design, in-filled with *rarrk*; a representation of Guyungmirringu. The hatching is the key to really engaging with the artist's character, his humanity: what elements are emphasised, what is left undone or to chance, and what is laden with knowledge to the initiated viewer. *Rarrk* is the sinuous, soupy travelling of pigment across the surface, thicker, then thinner, allowing translucency, ambiguity, frailty and, in Pussycat's case,

a certain edginess. The fine lines run meanderingly parallel, move precariously close, then move apart. There are moments where the end of long strokes are left to overlap beyond their outlines, not all tidied up, allowing us a glimpse of the interstices of process.

Some of Gudthaykudthay's paintings are almost entirely made up of high-key striations and laborious *rarrk*: expert, considered, full of energy, knowledge, power and playfulness. Looking at these the idea of *bir'yun* or brilliance in bark painting springs to mind. The more a bark 'sings' – to achieve a shimmer, an agitation, an energy to the surface – the closer the connection to an ancestral presence.[3]

In 1983 Pussycat had his first solo exhibition in Sydney, with great success. The National Gallery of Australia acquired some barks, and later Pussycat contributed five hollow log coffins, some bearing the same distinctive grid design as the paintings, to the National Gallery of Australia's *Aboriginal memorial* 1987–88, to stand with the *badurru* of fellow Liyagalawumirr artists.[4]

In 1995 I left Ramingining to work at the National Gallery of Australia, where I had contact again with Gudthaykudthay in the lead-up to the exhibition *The painters of the Wagilag Sisters story 1937–1997*, in which his work was included. A senior Wagilag custodian, Pussycat visited twice while the exhibition was on. On the first trip, he chose a big green overcoat from the pile of available winter woollies donated by the Gallery staff for the Arnhem Land guests.[5] At the opening, Pussycat, one of a significant contingent of visiting Ramingining and Yirrkala artists, was quietly but powerfully on the edge of events, in the background, in the coat, but very much present.

Pussycat and his art seem unshackled by influence. While the glorious *rarrk* and *miny'tji* are the cornerstone of any such work by a senior artist, in Pussycat's work the figure shifts in emphasis, but endures. In the 1980s Gudthaykudthay's minimal, apparently abstract, grid bark paintings became his signature pieces. The *miny'tji* was a key concern with his work in *The Aboriginal memorial*, where entire logs were enveloped in the Liyagalawumirr Guyungmirringu and Wititj *miny'tji*, without concern for the need of corresponding figurative clues. The early 1990s saw another shift, where the *miny'tji* remained foregrounded while players in the ancestral narratives had an increased presence.

PHOTOGRAPHS ON PAGE 8

MAIN IMAGE:
Philip Gudthaykudthay, 2002, © MJN Bowles
CLOCKWISE FROM TOP RIGHT:
Central Arnhem Land river system, December 2006, photograph by Brenda L. Croft; Gudthaykudthay with *Wagilag Sisters, with child*, Ramingining, 2007, photograph by Belinda Scott; Portrait of Gudthaykudthay, © Steven Wilanydjangu, 2005; *Ten canoes* film still, provided by Rolf de Heer and Belinda Scott, 2006; Gudthaykudthay working on *badurru*, Ramingining, December 2006, photograph by Brenda L. Croft; Gudthaykudthay's studio, Ramingining, 2007, photograph by Belinda Scott; Gudthaykudthay outside Bula'bula Arts office, Ramingining, December 2006, photograph by Brenda L. Croft; Daniel Boyd, Arthur Koo'ekka Pambegan Jr, Jean Baptiste Apuatimi and Gudthaykudthay in front of Jan Billycan's *All that jila*, National Gallery of Australia, Canberra, April 2007, photograph by Steven Nebauer

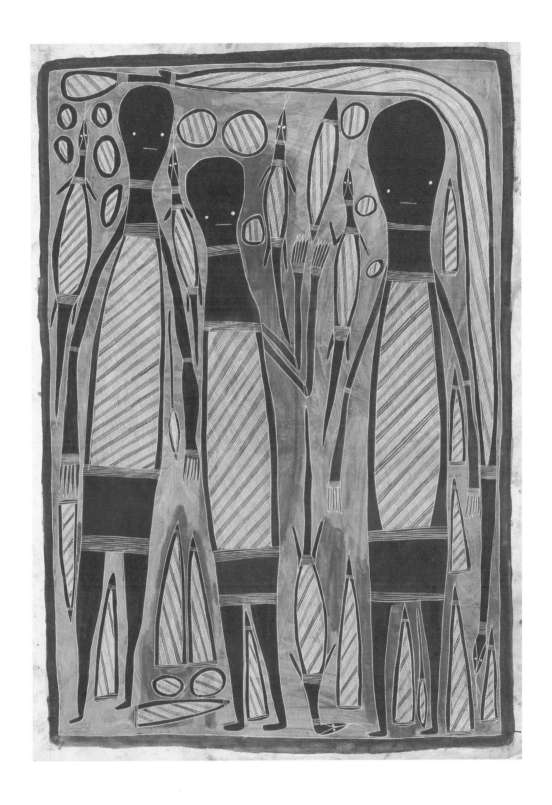

Wagilag Sisters, with child 2007

His works in *Culture Warriors* seem a true reflection of the Pussycat that is so hard to encapsulate. He plays with us and our expectations; certainly the exquisite *miny'tji* and *rarrk* are present on the hollow logs but not without a deliberate inclusion of bold figurative depictions of Wititj and Djarrka. This new group provides a fine balance to the hollow logs in the *Aboriginal memorial*. In recent painting the figures do more than re-emerge with greater frequency; they are literally embedded in the painting. This action perhaps goes against the contemporary market penchant for big minimal *rarrk*-filled Arnhem Land works. Pussycat is like one of those artists who continue to paint highly rendered portraits when they are clearly out of fashion.

Pussycat's works are magnificent and unpretentious at the same time. In painting his ancestral inheritance with enduring figurative elements alongside knowledge-laden *miny'tji*, he says 'this is my place. This is what I do and always will'. Gudthaykudthay, the enduring figure.

Rolf de Heer

From the very start Pussycat was an enigma to me. I met him mid 2003, when I went to Ramingining to talk with David Gulpilil and others about what sort of film they wanted to make up there. Pussycat was often on the peripheries of the discussions but he was a mumbler: I could never understand a word of what he was saying; I could not even distinguish between his speaking English and his speaking his own language.

His eyes, though, had a sparkle, very alive, even wicked at times, as if there was a streak of naughtiness inside this old man, a streak that had been with him for life. On my subsequent visits I began to connect with him, despite the verbal communication barrier being almost complete. He would seem genuinely pleased to see me again and I was consequently genuinely pleased to see him.

He took great interest in the project that became the film *Ten canoes*. He would pore for hours over the folder of a hundred or so 1937 Thomson photos I had, pointing out things to me or anyone else who happened to be around. As the script developed I began to think of what might be a good role in the film for Pussycat but there was

nothing obvious, apart from perhaps an old man in the background. Then one day I discovered him with a stick through his nose, through the septum hole I didn't know he had. He looked like one of his own ancestors, like a Thomson portrait, a man from ages past, with wisdom and more than a little mystery. And I suddenly thought, 'the sorcerer!'.

Pussycat was proud of my interest in his septum hole, and pleased to have a role with so much prestige attached to it. He began to talk up his qualifications for the part, spreading the word that he had been a real sorcerer in the old times and since he was one again, people had better watch out.

His enthusiasm for the film now knew no bounds and he had to be part of everything. This was mostly very fortunate because he knew more than almost anyone except Minygululu about making bark canoes, and Minygululu was away when we first started to make one. I remember that day well, the day that the first canoe was completed. Old Pussycat was in the thick of things, cutting, sewing, shaping, showing the younger men how to do it. Then he had a moment of inspiration. He walked out of the mud we were working in and took all his clothes off. He turned and glared at the other men, daring them to laugh: this is how it should be done, this is how we used to do it. And then he walked naked back into the mud and continued working, as if nothing at all had changed.

Coming as it did only a week before shooting started, it was an important moment. The gesture was an indication of the depth of understanding Pussycat had about what we were about to do, and laid the ground for a much easier transition to nakedness for the actors when the shoot commenced.

Despite being a respected elder, Pussycat was often the butt of jokes and even derision. He would sometimes struggle with something he had to do in the film, making mistakes in blocking or saying something quite wrong. Each time there would be laughter and jeering from the others, to such a degree that sometimes I had to clear the set of non-essential personnel so that Pussycat could continue without this intense pressure. And for reasons I never understood, at rushes in the evening when everyone got the chance to see the raw footage, the loudest laughter was always reserved for a Pussycat stuff-up.

Even when he was not required for shooting, Pussycat used to come out to set, keeping an

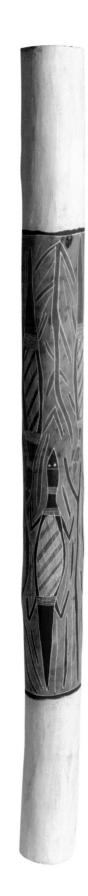

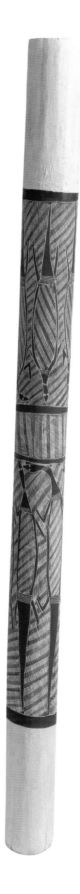

LEFT: *Goannas* 2007 RIGHT: *Goanna and rarrk* 2006

elder's eye out on the proceedings, joining in the shenanigans and skylarking, watching, sometimes sleepily, for crocodiles. Eventually though, the call of the canvas proved too strong. Pussycat tired of the filming and life on set, he'd had enough of the high life. He went happily back to his painting, something he never seemed to tire of.

Belinda Scott I first met Philip Gudthaykudthay in 1989 at Ramingining, when for a time he lived in a blue nylon tent outside the old craft shop *donga* (a rudimentary movable steel structure often used for 'temporary' housing in mining camps and remote communities). The guy ropes were always taut, his bare camp tidy, and the front flap zipped when he wasn't at home, which was hardly ever during daylight hours. What particularly struck me about his camp was the kink in the top of the tent. A deep kink would tell me that he had not been home for some time. Tall and lanky, Pussycat skulked about the place, barely spoke and mostly wore a wicked grin during our infrequent interactions. I had been told he was a 'clever [man]'[6] and he was scary.

At that time Ramingining had only about thirty houses, dirt roads only, and communications were by VJY radio telephone and short-wave radio. There were hardly any vehicles. Ramingining is Gudthaykudthay's mother's country and he takes his role as *djunggayi* (the boss or manager of the ceremonies of the land of his mother's clan) very seriously. In part, this was why he camped outside the craft shop. There had been a spate of petrol sniffing in the community and buildings had been broken into and ransacked. Gudthaykudthay was determined that this would not be the fate of Ramingining Arts and Crafts and his night-time vigil prevented that. (Subsequently a new art centre was built.)

One day, in the dry season of 1991, an older *balanda* (white man) turned up at the art centre. His eyes kept darting to a pair of paintings leaning untidily against a wall, which had been put aside for a Gudthaykudthay exhibition at Roslyn Oxley9 Gallery in Sydney. It didn't matter that I insisted they were reserved, the *balanda* kept badgering me to sell them to him, for a paltry price. He argued that they were not 'true' bark paintings, as they had been executed

on plywood. What had struck *me* about these works was Gudthaykudthay's message about culture: I felt he was saying 'fuck you *balanda* mob, you can build your houses all over my mother's country, but you can't destroy my ceremonies'. The plywood had been discarded after a major building project in the community that brought telephones and television with it. Tarred roads soon followed, and Ramingining doubled in size in a matter of years. The paintings, both titled *Wurrdjara (Sand palm)*, are now in the collection of the National Gallery of Australia.

I left Ramingining in May 1993 and came back in May 2002. A glance through the work at Bula'bula Arts immediately revealed the capacity for a Gudthaykudthay solo show. Two months later *Wititj & Wagilag man* went on display at Karen Brown Gallery in Darwin, and with the success of that show Gudthaykudthay was offered financial assistance to prepare a show for Aboriginal and Pacific Art, Sydney. With recent income from exhibitions and the film *Ten canoes*, Gudthaykudthay was once more able to buy trucks to go hunting, painting and travelling for ceremony; his current vehicle is a troop carrier.

Over these recent times of significant creative productivity, needing assistance, Pussycat set up his 'studio' on my veranda. He worked daily and we spent hours together in the evenings and at weekends, him painting, me sitting, watching or reading, fetching him endless mugs of tea and clean water, and making us meals. It was often the company of shared silence. I broached the subject of making a short film of him at work, and the resulting piece, *Paintings in process: Garrtjambal and Wagilag Sisters*[7], captures the creation of the painting of the same name.

In 2006, the third application for a two-year Fellowship for Gudthaykudthay was submitted to the Aboriginal and Torres Strait Islander Arts Board of the Australia Council, and this time it was successful. Pussycat is thus now able to fully support himself (and his recently acquired extended family) without the need to make work simply for sale. Eschewing the blocks of *rarrk* for which he is renowned, Gudthaykudthay is audaciously revealing spirit figures and animal totems, adding a new dynamism to his art. This year the National Gallery of Australia acquired *Wagilag Sisters, with child* from this period for *Culture Warriors*. Truly living as an artist, Pussycat is now at his most untainted and creative.

1 Statement taken from Philip Gudthaykudthay, interview with Belinda Scott, March 2007.

2 Wally Caruana and Nigel Lendon (eds), *The painters of the Wagilag Sisters story 1937–1997*, exhibition catalogue, Canberra: National Gallery of Australia, 1997.

3 Howard Morphy, *Ancestral connections: art and an Aboriginal system of knowledge*, Chicago and London: University of Chicago Press, 1991, p. 194.

4 Neville Nanytjawuy and Paddy Dhathangu, now both deceased, and Yambal Durrurrnga. *Badurru* is the name for hollow-log coffin for the Liyagalawumirr people. See Susan Jenkins, *It's a power: an interpretation of the Aboriginal memorial in its ethnographic, museological, art historical and political contexts*, thesis, Canberra: National Institute of the Arts, Australian National University, pp. 139–45.

5 This stockpiling of clothing for visitors, especially from the warmer north, is now a well-established tradition, and in recent times has extended to staff donating clothes to be sent up to art centres in remote communities for distribution among artists and their families.

6 'Clever' meaning knowledgable man with spiritual prowess.

7 Edited by Tania Nehme. See bulabula-arts.com for availability. Proceeds from the sale of this DVD are paid to Gudthaykudthay.

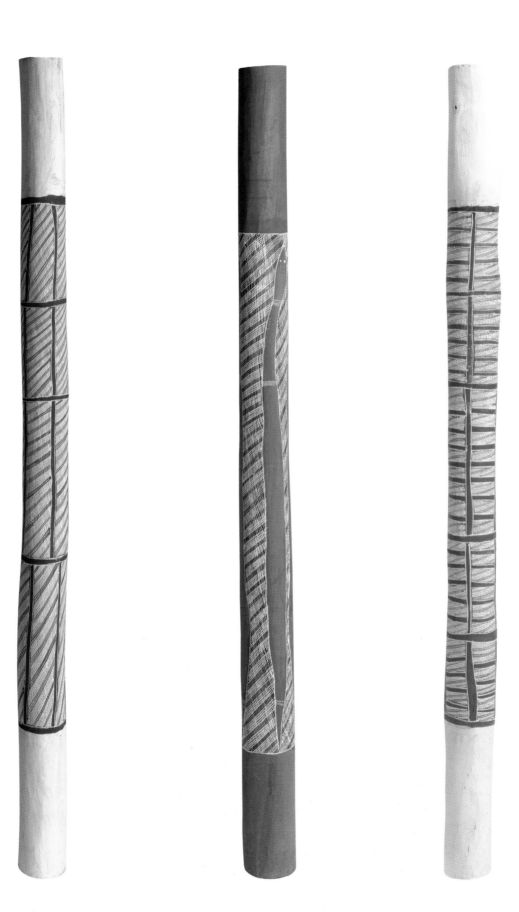

LEFT: *Wititj (olive python)* 2007 CENTRE: *Gunyunmirringu* 2007 RIGHT: *Gunyunmirringa (landscape)* 2007

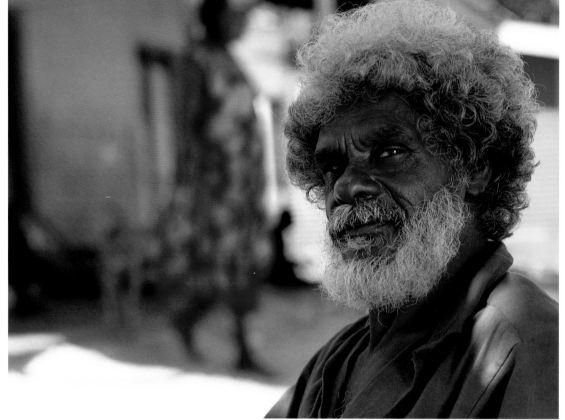

JOHN MAWURNDJUL

My work and my *rarrk* (crosshatching) have changed a lot since
I started painting a long time ago [late 1970s]. That was with my
brother [Jimmy Njiminjuma], and together we have changed the
rarrk and started to paint in a new style. We are new people ...

Now, I concentrate on painting important places, my land,
my *djang* (sacred places). I paint the power of that land. I mainly
paint Milmilngkan, Kakodbebuldi, Mukkamukka, Dilebang, Mumeka,
Kurrurldul, Mirelk and Kudjarnngal. They are very important places
for us, they have meanings.

I keep thinking, I keep finding new ways, new styles for my
paintings. I just can't stop thinking about my paintings. I also
teach other people, I help them, I give them advice and I tell them
to make strong paintings. My children, they are now painting:
Anna [Wurrkidj], Josephine [Wurrkidj] and Semeria [Wurrkidj].[1]

Apolline Kohen John Mawurndjul's contribution to the arts goes well beyond his own work. He inspires and mentors other artists and plays an influential role within Maningrida Arts and Culture (MAC), the art centre that represents his work.

When I first met Mawurndjul in 1998, he was a star in the making, on a trajectory that made him a few years later an artist of international reputation, travelling to Europe on a regular basis to present his striking bark paintings and *lorrkons* (hollow logs). The impact of his success on other artists from the Maningrida region is evident, and at MAC not one day goes by without an artist enquiring about Mawurndjul and his work. He has introduced new standards of quality and professionalism to art in the region and inspired artists to find their own individual styles. Mawurndjul has also been instrumental in raising the profile of other artists at a national and international level by exhibiting his work with theirs. There is a strong feeling of community pride in Mawurndjul, who is an ambassador for all artists – and people – from the Maningrida region.

He is a great teacher and mentor within his family. I have seen him instructing others in the many and various skills needed for art: selecting trees suitable for barks or *lorrkons*, curing and preparing barks for painting, gathering and mixing ochres, making brushes, and the finer points of crosshatching. In the late 1990s he taught his wife, Kay Lindjuwanga, and eldest daughter, Anna Wurrkidj, to paint. He was one of the first Kuninjku artists to support the idea of women making art independently, and was instrumental in the quiet revolution that led more conservative Kuninjku men to accept Kuninjku women as painters in their own right. He is now closely monitoring the career of his niece Irenie Naglinba, daughter of his late brother Jimmy Njiminjuma, and teaching another two of his daughters: Semeria Wurrkidj and Josephine Wurrkidj. He is generous and unselfish in his promotion and support of MAC and its projects, including the funding and building of a new arts centre. Through his knowledge and leadership a new generation of artists is at work, ensuring the future of the Maningrida art movement.

Mawurndjul still has the desire and energy to remain what he calls 'the number one artist' of MAC. There is no doubt that he will keep finding new ways to give expression to his subjects and thus continue to lead and inspire this vibrant contemporary art movement for a long time to come.

Luke Taylor John Mawurndjul grew up in country that is alive with the art of previous generations and was surrounded by relatives who were expert painters. Changes to the Western Arnhem Land lifestyle, including the support of Maningrida Arts and Culture, have enabled Mawurndjul to perform on a world stage like no other Kuninjku artist before him.

Mawurndjul is a member of the Kurulk clan of Kuninjku speaking people. There are about ten identified Kuninjku clans whose lands form a mosaic between the vast floodplains of the Liverpool and Tomkinson rivers in the north, to the freshwater escarpment country of the upper reaches of the Liverpool, Mann, and Tomkinson rivers. Mawurndjul was born in the bush in 1952 as his family moved between favourite camping sites. Some of these places are rock shelters, painted by hundreds of generations of Mawurndjul's ancestors.

Maningrida was established at the mouth of the Liverpool River as a permanent settlement in 1957 and, as the closest town to their country, is now a focus in the lives of Kuninjku. Mawurndjul went to live there as a young man in 1963. His early interest in painting was encouraged by his father, who taught him the Kuninjku techniques of *rarrk* designs for the *Mardayin* ceremony around 1968. In 1973 an insightful change in government policy saw Mawurndjul and his family return to their lands at Mumeka on the Mann River. At Mumeka outstation he was encouraged to paint on bark for the market, and his elder brother Jimmy Njiminjuma was particularly influential in training him in the iconography of representing ancestral subjects. Mawurndjul married Kay Lindjuwanga at this time and his father-in-law, Peter Marralwanga, also became influential in his ceremonial and artistic tuition.

Mawurndjul travelled to the National Gallery of Australia for the first time in 1983 and to galleries in

PHOTOGRAPHS ON PAGE 16

MAIN IMAGE: John Mawurndjul courtesy of Sonia Payes and Charles Nodrum Gallery CLOCKWISE FROM TOP RIGHT: Kay Lindjuwanga and Mawurndjul courtesy of Sonia Payes and Charles Nodrum Gallery; Detail of Mawurndjul ceiling, Australian Indigenous Art Commission, Musée du quai Branly, Paris, 2005–06, image courtesy of Cracknell Lonergan Architects, Sydney; Gulumbu Yunupingu, Mawurndjul, Judy Watson, Linda Burney and Kunmunara Dawson, Musée du quai Branly official opening, Paris, June 2006, photograph by Brenda L. Croft; Mawurndjul painting AIAC *lorrkon*, Musée du quai Branly, Paris, December 2006, image courtesy of Cracknell Lonergan Architects, Sydney; Mawurndjul and Gulumbu Yunupingu, Musée du quai Branly, Paris, June 2006, photograph by Brenda L. Croft; Apolline Kohen, Art Co-ordinator, and Mawurndjul, Maningrida Arts and Culture, Maningrida, December 2006, photograph by Brenda L. Croft; President Jacques Chirac, Mawurndjul and Apolline Kohen, Presidential Palace, Paris, June 2006, photograph by Marc Kohen

Mardayin design at Dilebang 2006

other cities, and became familiar with the scale of works on display. As a result, he increased the size of his paintings and experimented with more complex figure compositions. The first key phase was his labyrinthine paintings of the Rainbow Serpent Ngalyod. For Kuninjku, important features of their lands were created through the transformational powers of Ngalyod, who dwells in life-giving waters and brings the monsoon rains that transform the landscape in the wet season. Mawurndjul captures the vast energies of this being in tumultuous overlapping figures, and is a master at working the *rarrk* patterns to echo the body shapes, to delineate form, to create rhythm, or to create disjunction and points of surprise across the painting.

A later phase of Mawurndjul's art has seen experimentation with wholly geometric compositions of *rarrk*, such as *Billabong at Milmilngkan* 2006, a large picture that hums with patterns of multicoloured banding. Kuninjku may use the term *kuk-mak* (good body, shape, form) to describe the best works, and the best effects of the paint may be described as *kabimbedme* (shining paint), the effect of the bright paint jumping out at the viewer. For Mawurndjul, these vibrating fields of ancestral light and energy suggest the power invested in landscape.

Hetti Perkins

At the opening of the Musée du quai Branly in Paris in 2006, in the presence of Kofi Annan, Nobel Peace Prize Laureate and Secretary-General of the United Nations, the President of the French Republic Jacques Chirac introduced John Mawurndjul to his wife, Madame Bernadette Chirac, as a 'maestro'. This acknowledgment by the head of state of one of the world's eminent cultural powerhouses was a critical moment in the engagement of the western world with Aboriginal art from Australia. It occurred beneath Mawurndjul's installation *Mardayin at Milmilngkan* 2006, occupying over 100 m² ceiling space on the ground floor of the museum building on rue de l'Université. This work is one of ten by eight artists, including a monumental *lorrkon* sculpture by Mawurndjul, that together comprise the Australian Indigenous Art Commission, a project initiated by architect Jean Nouvel and facilitated by the Australia Council for the Arts at the invitation of the French Government.

Mawurndjul's commitment to Kuninjku culture and his unwavering pursuit of excellence in its contemporary expression was clearly demonstrated during the process of realising his installations. The execution in-situ of his towering five-metre-tall *lorrkon, Mardayin* 2005, required incredible physical stamina and powers of concentration. The Commission is intended to be viewed from the street twenty-four hours a day, and in so doing visitors can now see Mawurndjul's work set against the backdrop of the Eiffel Tower.

Mawurndjul grew up in the (literally) painted landscape of Western Arnhem Land, the latest in a lineage of visionary artists. More than any other he has successfully brokered acceptance and respect for bark painting as a contemporary medium. The art of this small and disproportionately gifted group was the inspiration for the major exhibition *Crossing country: the alchemy of Western Arnhem Land art*, presented at the Art Gallery of New South Wales in 2004 in partnership with Maningrida Arts and Culture. From playing a starring role in this event, Mawurndjul subsequently exhibited in *Rarrk*, a retrospective hosted by the Musée Jean Tinguely in Basel, Switzerland.

A self-professed member of the 'new generation', Mawurndjul continually stresses the inventiveness of his work and takes great satisfaction in his skill in preserving the 'inside' meaning of his *Mardayin* paintings, yet allowing its powerful essence to infuse the works with a sparkling brilliance.

Mawurndjul's home at Milmilngkan on the Tomkinson River is an infinite source of inspiration, while his art is a key element in the renewal of Kuninjku culture. His pulsating surfaces contain multitudes: waterholes, *Mardayin* lights, body designs, all the hallmarks of the Kuninjku cultural realm embedded within a meticulously rendered field of *rarrk* that infers the corporeality of the omnipresent Ancestral Being, Ngalyod. Equipped with a mind 'full of ideas' and armed with skinned tree bark, reed brushes and locally mined ochres, Mawurndjul is at the avant-garde of asserting Kuninjku and more generally Indigenous culture's status as a powerful force in international contemporary art.

LEFT: *Lorrkon (Mardayin design)* 2004 RIGHT: *Lorrkon* 2004

Ian Munro

My first clear recollection of John Mawurndjul is from 1992, when I was organising the construction of outstation housing for the Bawinanga Aboriginal Corporation (BAC). John was in line for a new house, and the two of us travelled to the place where it was to be built. This was Milmilngkan, later to become ground zero for a series of extraordinarily powerful paintings, and central to John's connection with his Kurulk estate. At the nearby creek a slab of rock caught my eye. In passing, on some former visit, John had painted a simple but beautiful image of a long-necked turtle, using a finger dipped in red ochre. It had remained there, an ephemeral work of art, testimony of his irresistable urge to paint. Fifteen years later there is no sign of it.

John was already a star of Maningrida Arts and Culture, but few realised how successful and famous he was later to become. His work was produced in basic conditions, generally sitting cross-legged on the ground under a bough shelter. With the exception of PVA glue, he sourced all of his materials from the bush. He now spends most of his time at Milmilngkan, and hunting remains part of John's daily routine. He is an exceptional bushman, and is noticeably happier when he is on his country. John is a small wiry man, fit and in good health. His commercial success means that he is rarely without a vehicle, the white troop carrier being the truck of choice. He is generally in the company of his wife, Kay Lindjuwanga, and a varying number of his children. He has a keen, if unconventional, sense of humour, and a distinctive laugh.

John's older brother, the late Jimmy Njiminjuma taught him to paint. John's composure and air of command at Jimmy's funeral was a powerful reminder of his traditional authority. He was magnificently decorated from head to toe in white ochre, wearing a red loincloth, and clutching a shovel-nose spear. His appearance was imposing, and his management of the occasion was both dignified and inspiring. His ceremonial authority allows him to assert his right to paint the powerful and secret *Mardayin* images which have dominated his production recently.

Milmilngkan is one of thirty-two outstation communities established by the BAC, which provides services such as the repair and maintenance of buildings; the installation of solar power for lights and refrigeration; the construction of bores and water reticulation systems; a mobile shop; road maintenance; and support facilities, such as mechanical repairs, personal finance and banking. BAC also assists the Maningrida clinic to extend services to bush people. Conventional job opportunities are few, but BAC is actively developing opportunities for its members to participate in the economy. John sometimes takes a break from painting to work as a land management ranger for BAC and his bush skills and knowledge are a welcome inspiration to younger rangers. Bawinanga's art centre, Maningrida Arts and Culture (MAC), provides services to bush artists. MAC purchases, promotes and markets the work of local artists and artisans. John's career is managed by MAC, and his considerable success is the product of his prodigious talent and the efforts of MAC over many years.

While John enjoys a secure life at Milmilngkan, there are fears that it will not be so for future generations. Shifting government policy on outstations threatens their existence. Governments need to be periodically reminded that the nation has an obligation to accept the right of our Indigenous people to reside on their country. The inspiration for much of the art produced by Kuninjku people comes from the extensive rock art galleries of the sandstone country. John and his countrymen are the descendants of the artists who painted these images, and their connection with the 'old people' is tangible and robust. However, this connection relies on occupancy of the country. Strong organisations like BAC, backed by understanding and supportive governments, are a means to ensuring continued occupancy of this distinctive landscape.

1 From a conversation between John Mawurndjul and Apolline Kohen, 19 March 2007.

Mardayin at Milmilngkan 2006

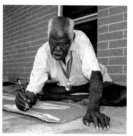

LOFTY BARDAYAL NADJAMERREK

Barrk, the black wallaroo, is endemic to the sandstone country of the great Arnhem Land Plateau. Shy and nocturnal by nature, it is not often seen. Bardayal's country of Kabulwarnamyo has the rocky upper reaches of the Liverpool River valley running through it, just the habitat for *barrk*.

On Bardayal's country, extensive 'caring for country' programs are being conducted using Bardayal's treasured wealth of traditional knowledge in conjunction with western science.

The great Arnhem Land Plateau no longer has the traditional populace that traversed country, who managed estates, in part, with controlled burning. Not only did these burns suppress fuel quantities building up to dangerous levels ecologically, but they cleared bush, allowing the hunter to see further into it.

The work *Barrk – black wallaroo after fire* was produced when large-scale burning programs were being undertaken across the Plateau from Kabulwarnamyo. It depicts the burnt landscape; the hunter, now able to see his mark, has speared his prize: a large male *barrk*.[1]

George Chaloupka

I first met Lofty Bardayal Nadjamerrek through Nipper Kapirigi and George Namingum, my early mentors and friends, and members of the Badmardi clan whose Balawurru estate, an escarpment valley in the Arnhem Land Plateau's western region, lies within the World Heritage Kakadu National Park. Kapirigi and Namingum were senior men of great knowledge who encouraged me to pursue a study of rock art and introduced me to some of the last practitioners of this art form. Before then, I only knew of Bardayal as a gifted bark painter. At Gunbalanya (Oenpelli) in the late 1960s, Bardayal produced a series of paintings. They were small and intimate barks, executed in fine detail and hatching, and their subjects glowed out of their black background.

After my Badmardi friends passed away, Bardayal was called upon as the ceremonial master to officiate at their *Lorrkon*: secondary burial ritual. Before the rite could commence, it was necessary to locate the source of *yamitj*, the lustrous pink ochre used in this region to decorate skeletal remains. When Bardayal learnt the local people were unsuccessful in locating the source of this ochre, he told them that he knew where it was quarried and led them there. Bardayal had visited the site with his father long ago, before his own facial hair had begun to grow. He remembered his father had carried a paperbark parcel containing *yamitj* back to their country for use in rock painting. Impressed by Bardayal's recollections and knowledge of a place far removed from his own country, everyone wondered how much greater and more intimate his knowledge of his own region and traditions would be.

I began to appreciate the depth of Bardayal's knowledge in the 1980s when we commenced a survey of rock art and other sites of significance in the Liverpool River region. One of the first sites Bardayal took me to was the Kawayam rock shelter where there is a large dark red painting of *kandagidj*, the male antilopine wallaroo. Bardayal told me that the painting of *kandagidj* actually represents Nadjamulu, a protean creator being who brought *djungunj* (kinship system and totems) to his people and placed his own image onto the rock. While non-

Indigenous observers would interpret this painting as being a macropod, Bardayal identified its species and from his storehouse of oral traditions revealed that the painting commemorates one of the places Nadjamulu visited within this mythically inscribed landscape.

Since then, we have visited hundreds of rock art galleries with layers of brilliant images of ever-changing stylistic forms and subjects that open a window into the past. Walking along the decorated walls Bardayal kept up a constant commentary, identifying the majority of represented subjects and their place in his universe. Within some well-protected shelters we found early representations of animals depicted in a naturalistic mode, some larger than life. Over these paintings were compositions of fine, lightly sketched images of elaborately decorated groups of people running across the sandstone walls' notional landscape. At times Bardayal would look long and hard and shake his head in wonderment at the artist's skill or inventiveness. He has said the *mimih* and other ancestors made these early paintings, some from a time when there was little water in the country, a very long time ago (such an arid period occurred during the last Ice Age some 20 000 years ago).

Bardayal has most interest in rock art galleries with more recent colourful x-ray art, each subject depicted with internal detail and infilled with all manner of decorative hatching. He would often smile, turn to me and gesture at a painted image with the thumbs-up to indicate that we were looking at exceptional work, some made by his immediate ancestors. Bardayal was present when the more recent paintings were executed and has added his own paintings to this remarkable rock art heritage: the longest and most detailed record of human endeavour.

Bardayal's earliest rock art images are at Karrmadjabdi, a shelter in his Mok clan estate on the Liverpool River. Here he painted a number of fish species, a yam and a rock possum, and also made two representations of Namorrddo spirit beings by shaping pieces of beeswax and pressing them onto the rock. In 1950, when his first son was born, Bardayal painted *djugerre*, the female black wallaroo, at the Dumebeh rock shelter where he then camped with his relatives and friends.

PHOTOGRAPHS ON PAGE 24

MAIN IMAGE: Lofty Bardayal Nadjamerrek on Sydney Harbour, 2005, photograph by Andrew Blake

CLOCKWISE FROM TOP RIGHT: Nadjamerrek's birth tree, bush apple, Kabulwarnamyo, December 2006, photograph by Brenda L. Croft; Nadjamerrek painting, wearing his AO medal, Marrawuddi Gallery, Jabiru, 2005, photograph by Andrew Blake; Andrew Blake viewing Nadjamerrek's last rock art painting of Kangaroo and hunter, Mok clan estate, Arnhem Land Plateau, December 2006, photograph by Brenda L. Croft; Anthony Murphy, Art Centre Co-ordinator, Injalak Arts, with Nadjamerrek and his family, solo exhibition opening, Indigenart, The Mossenson Galleries, Carlton, Victoria, March 2006, photograph by Brenda L. Croft; Nadjamerrek and grandson, Gavin Namarnyilk, Kabulwarnamyo, December 2006, photograph by Brenda L. Croft; Arnhem Land riverscape, December 2006, photograph by Brenda L. Croft; Nadjamerrek singing to his country, Mok clan estate, Arnhem Land Plateau, 2004–05, photograph by Andrew Blake

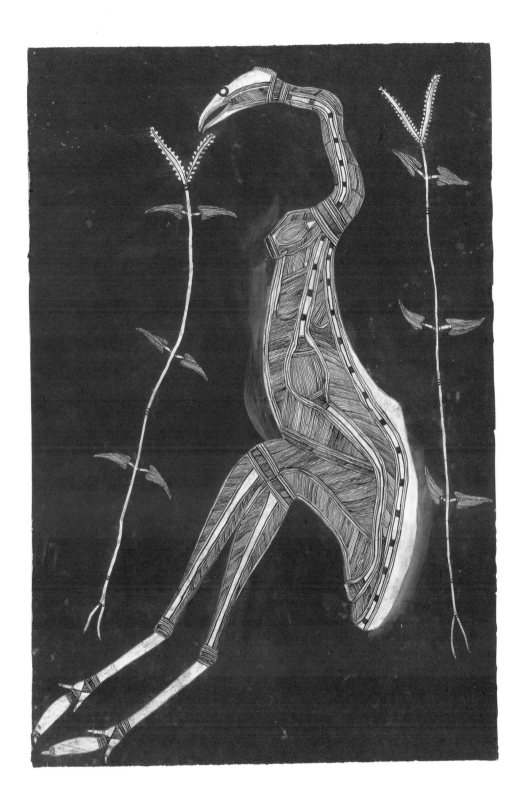

Kurdukadj (Emu) 2004

More than fifty years later, while reminiscing about all the *nawarrdegen*, the Stone Country people he has known to have painted on rock, Bardayal decided to paint perhaps his last rock painting. In January 2005, after a long and distinguished career with his bark paintings and works on paper in national and state art galleries, Bardayal selected a suitable rock shelter and on its ochre-stained wall painted a large *djugerre*, one of his favourite subjects. Pausing occasionally, he recalled the creature's nature and sang its hunting song. Bardayal said that he made this painting for his family and the other members of the Kabulwarnamyo community where he now resides, admired and honoured by his people, friends and the nation.

Murray Garde My entry into the world of Lofty Bardayal Nadjamerrek was in 1993 when archaeologist Paul Taçon and I were undertaking a survey of rock art in the Mann River region. Bardayal took us to a site called Djokay near Kamarrkawarn outstation where there is an image of Nakorrkko, the father and son cultural heroes of Western Arnhem Land. As we sat in that shelter, which was completely covered in x-ray rock art, Bardayal recounted to us the odyssey of the Nakorrkko across Western Arnhem Land, listing site after site through which these creation figures travelled, from Croker Island and east along the coast to Maningrida and then south through Mankorlod and across the Arnhem Land Plateau to places south of Katherine, instituting ceremonies and switching languages as they journeyed into new territory. He told the intricate story with extraordinary fluency and brought the significance of the rock art of the area directly into the present. It was a gallery tour like none other I had experienced.

Bardayal's knowledge of the art of Western Arnhem Land is rare and without it we would be left guessing as to the significance of many of the thousands of art sites on the Plateau. He is a link with a way of life that has all but disappeared.

Since the late 1990s we have criss-crossed Western Arnhem Land by helicopter numerous times together, recording hundreds of named sites in the labyrinthine and awe-inspiring stone country of the Plateau. Given a departure point and a destination, Bardayal can list placenames one after the other, mentally mapping the scores of traditional walking routes across the Arnhem Land Plateau. This mental encyclopaedia of place is also the storehouse of inspiration for his art.

If you arrive at Bardayal's camp at Kabulwarnamyo on the upper Liverpool River in the dry season, expect to see a range of people who go there to learn from him. Over the years he has worked with biologists, botanists, fire ecologists, zoologists, entomologists, linguists, anthropologists, historians, filmmakers, musicologists and museum curators. Bardayal's knowledge is profound, and across many fields, yet it is fragile, and with some urgency he and his associates have worked in recent years to ensure that this knowledge is recorded and archived for the people and management of the Arnhem Land Plateau.

Each dry season Bardayal and a small group of elders lead young Aboriginal people in a walk along one of the traditional *Bininj man-bolh* (Aboriginal walking routes) across the Plateau. In the evenings Bardayal and other senior family are flown in by helicopter to join the younger walkers, and the stories of these places allow young people to connect with the country of their ancestors.

I am sometimes amused by the notes on the reverse of Arnhem Land bark paintings or work on papers: 'x-ray fish', 'kangaroo', '*mimih* spirit', 'shooting star spirit being' and so on. Such brief descriptions are like condensing an encyclopaedia down to a phrase. Much of the Aboriginal art produced in Arnhem Land is strikingly beautiful to non-Aboriginal audiences, but inaccessible. Lofty Bardayal Nadjamerrek has always been concerned to share his knowledge with those who are interested, without compromising the integrity of the division between public and restricted domains. Realising that the Arnhem Land Plateau culture is moving into an era of loss, Bardayal is spending his last years teaching about the relationship that people once had with a particular environment. The knowledge being transferred will allow people on the Plateau to continue to care for this special place.

Bardayal's legacy will be more than his priceless works of art. Once, Bardayal told me about a Honey

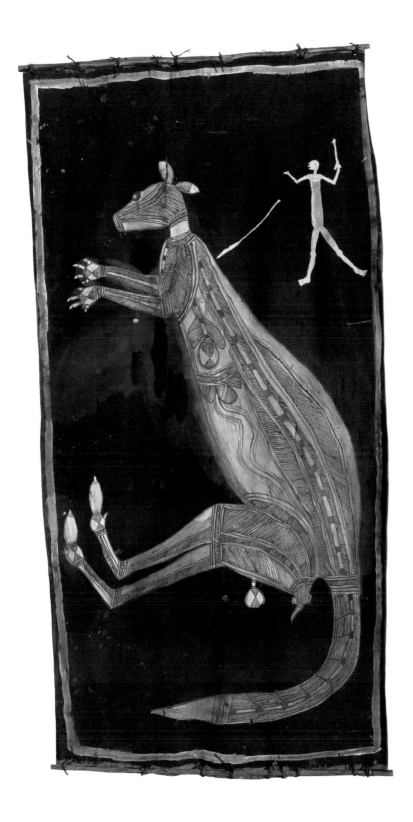

Barrk – black wallaroo after fire 2005

Dreaming site of great spiritual significance in his country. He sang a sacred song about a particular type of native honey bee from that place and on completing the song, he said softly *Ngan-kangemang ngarduk kun-red*: 'This country of mine gets to the foundation of my emotions'. At a time when we are faced with the grave damage industrial societies have wrought on the global environment, it is a great lesson for us to learn to know the places where we live with intimacy, and to be concerned for the health, wellbeing and spiritual significance of the land we all share.

Andrew Blake

Lofty Bardayal Nadjamerrek was born in the Stone Country of the great Arnhem Land Plateau, on his mother's country, neighbouring his father's Mok clan land. To live the way he did with his family, traversing these headwater regions along timeless tracks from estate to estate, must have been an art form in itself.

My career in the arts started more than sixty years later when I arrived in Darwin at the beginning of the 1990s and found focus through deeply impressive introductions to the county of Kakadu and Western Arnhem Land. From the countrymen of the Top End I began to understand the Indigenous relationship to land and its traditional art. The country provided the exhilaration; the paintings, the intrigue and the spirit. I saw beautiful paintings on bark by a number of artists, including Lofty Bardayal Nadjamerrek, some of which went to the National Gallery of Victoria and became part of Judith Ryan's pivotal *Spirit in land* exhibition. Bardayal's work seemed most revered in the region and fascinated me most. His painting was particular and something of a paradox; his figurative work on stark backgrounds are at once static and incredibly alive, beautifully animate human figures in dance or conversation snap-frozen to float in time. His work and palette is simple, yet his lines contain dazzling nuances in tone, and his imagery is swollen with profound knowledge of his land and traditions.

I met Lofty Bardayal Nadjamerrek for the first time more than ten years later when I was managing the Marrawuddi Gallery in Kakadu National Park, and I eagerly took up his invitation to visit him and country. He greeted me at the Marlgawo airstrip presenting a beautiful painting of an elegant brolga. Bardayal's Mok estate was twenty kilometers down the track from Marlgawo, on top and in the middle of the great Arnhem Land Plateau. I was in another world, ancient, with an old and gentle guide welcoming me to country. His driver that day was Peter Cooke, and he and Bardayal had set up a bush camp at None, which is today a high seat of learning. It remains quite the most magical outstation I've experienced.

The old man exudes genuine happiness sitting on the sandy soil of his country. There are paintings so special in this glorious backyard of his that they herald the very place where the spiritual identity of all generations of the ancient Mok clan takes its focus. It is a humbling experience to be awed by such a place in the presence of its final authority. Bardayal represents perhaps the last of this rock-painting tradition. His paintings chosen to be part of this exhibition are late works but have direct descent from this continuous tradition; it is a living essence of country from which he draws. Grandchildren are now painting with him, on some of what could well be his last works. There is now a real chance that his style of painting, which is so outstandingly identifiable as *his*, continues with young hands under the idyllic shelters of the land of sacred honey: Kabulwarnamyo.

1 Story of *Barrk – black wallaroo after fire* 2005, courtesy of Marrawuddi Gallery, Bowali Visitor Centre, Kakadu National Park, 2007.

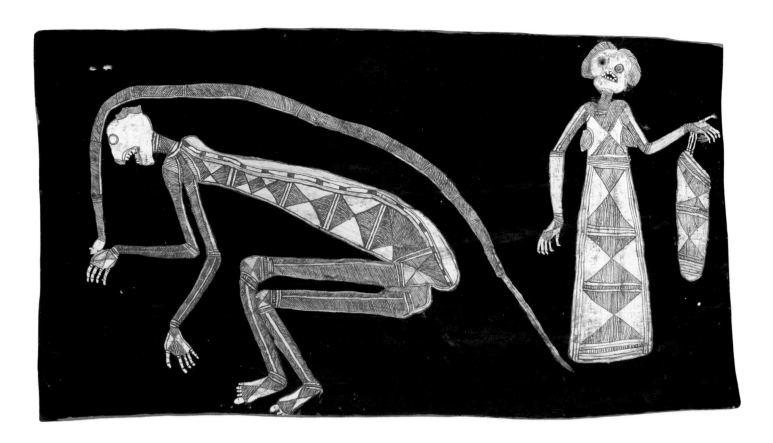

Dulklorrkelorrkeng and Wakkewakken 2005

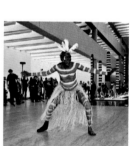
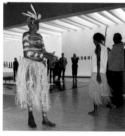

ARTHUR KOO'EKKA PAMBEGAN JR

I'd just say ... I won't stop doing it. This belong to all of us. We share it together ... we share our culture and you sharing your culture.

The culture, what you see in the carvings, in the body painting, what you see in the canvas, they more important, because this is the way we are – not going to lose it.

If we don't keep our laws ... our culture ... then we fade away. We lose our culture ... we lose our language. Then we be talking something else, maybe in English. So we have to take care. This is our background. From the beginning to the end. From generation to generation. Just passing it on.

Peter Sutton

Arthur Koo'ekka Pambegan Jr, the only son among seven siblings, was born into a family with a long history of prominence in the affairs of the Aurukun community. His father Arthur Koo'ekka Pambegan Sr, born in 1895, was among the earlier Wik-speaking people to live at Aurukun, a Mission established by German-speaking Moravians at Archer River, Cape York Peninsula, in 1904. Baptised a Christian in 1926, Pambegan Sr was clearly his clan's head by 1962, when he acted as chief informant on Bonefish and Flying Fox stories, sculptures and performances for Frederick McCarthy.[1] Pambegan Sr's brother, Billy Mammus, was among those who left the bush to work in boats and returned to Aurukun where, after 1927, he became the principal informant for anthropologist Ursula McConnel. Pambegan Jr's eldest sister, the late Geraldine Kawangka, was the first woman Chair of Aurukun Community Council and a prominent community spokesperson from the 1970s to 1990s. Pambegan Jr is now a leader of his clan and a highly regarded artist.

The designs and colours of Pambegan Jr's sculptures and paintings come from traditions of his ceremonial group, Winchanam. This is the ceremony owned and principally performed by Wik people with countries in the timbered inland of the region. Winchanam, formerly the second-stage initiation ritual of all the Wik groups, has in recent decades become distinctively an inlanders' ceremony. Its trademark body-paint design worn by performers is a set of horizontal stripes, alternating red, white and black. This distinctive banding is the one in Pambegan Jr's untitled paintings. In a modified form it appears on the bonefish in his representations of Bonefish Story Place.[2] It is the design on the bullroarers Pambegan Jr hangs in his Flying Fox Story Place installations.

Traditional identification with the flying fox and bonefish sculptural designs and their associated legends lie not with Winchanam people as a whole, but principally with those whose country lies in the Tompaten Creek area (locally, Small Archer River). Here in Pambegan Jr's country lie two sites of great importance to his work: *Walkaln-aw*, a Bonefish Story Place, and *Kalben*, a sacred site in the Flying Fox Story. Pambegan Jr's uncle Billy Mammus told

this bonefish legend to McConnel and his version, under his clan name of 'Bambegan', was published by her in 1957.[3]

Briefly, the story tells of an argument that erupted when a sister of Bonefish refused his demand that she cook his meat. He threatened to hit her. In turn she hit him below the shoulder with her yamstick, an artefact laden with feminine symbolism. In retaliation Bonefish speared his sister in the head, the spear likewise being an artefact laden with masculine meanings. They then both lay badly wounded. Later they parted forever, entering the earth at separate places. It is a legend that evokes the deeply ambivalent emotions of siblinghood. It also visits a recurrent Wik mythic theme of anger between men and women.

The Flying Fox Story, another legend of Pambegan Jr's country, is also a classic Wik tale of inter-gender tension, sexual symbolism, and broken taboos, wherein a group of youths undergoing *Uchanam* (the first stage of initiation), illicitly hunted and ate flying foxes and broke the law by speaking with two young women. The story involves the women finding a bullroarer (sacred object) and deciding that henceforth it would be for men only to use. Pambegan Jr's distinctive installations of carvings hung on a cross-string represent these traditional forms, which are particular to this region.

Wik culture has been more secular (and marketable) in recent times. As late as 1976 Wik men maintained that the sacred sculptures revealed at community ceremonies were not carved by human hand, but were transformations of mythic beings; by the 1980s they were carved openly in Aurukun township. And until the 1970s only unpainted carvings were sold on the Aurukun craft market, painted works being considered too sacred or dangerous to be in the hands of those who lacked the right songs. This attitude has given way to the selling of fully painted works, though they can still have sacral qualities.[4] The rich repertoire of pre-mission ceremonial forms has also declined dramatically and, by 2006, only five remained in regular use.[5] These were augmented by Island dance and Hula at mortuary rituals, but all were under testing competition from hip hop.

Arthur Pambegan Jr has lived through these momentous social and political changes.

Face painting 2006

Engaged from an early age in the ceremonial life of Aurukun, learning from his father and later performing, carving and painting with authority, Pambegan Jr has nonetheless only recently emerged as an artist in the wider world. His success is grounded in the brilliance of his form and colour integrations, and in his finesse as a carver, and, essentially, in combination with the authentic mythological roots of his subjects.

Bruce McLean

In 2003 Arthur Koo'ekka Pambegan Jr travelled from Aurukun to the Queensland Art Gallery to finish a set of large sculptures for the exhibition *Story place: Indigenous art of Cape York and the rainforest*.[6] He was with other senior men Ron Yungkaporta and the late Joe Ngallametta, who were also completing commissioned works. Pambegan Jr and Joe's sons, Alair and Joel, accompanied the old men and assisted in making the sculptures. This was the first time that the sons were allowed to do this and had been given access to associated privileged cultural knowledge. At the time it was seen as a significant episode in the passing on of traditional Wik and Kuku knowledge.

This took place in my very first weeks at the Gallery, where I had just been employed as a trainee on the exhibition. I was lucky enough to be allowed to assist and to observe the masters at work, carving and painting their art.

The completed works are exceptional in size and presence. They have great visual appeal, but more importantly they are the embodiment of thousands of years of history, of creation story. They hold lessons of the law, the creation of our galaxy and tangible connection to land. In a sense they are tantamount to a Black Bible, or at least the Wik Old Testament, with law poles from surrounding clans combining to fill the other chapters.

Pambegan Jr has placed impressive monuments to his Wik-Mungkan culture in major art galleries thousands of kilometres away, yet within his community he is the last senior master artist, and still the only noted carver of his Winchanam clan sculptures. He has been working with members of his family to pass on his knowledge and train another major Wik-Mungkan sculptor of these

stories and it is hoped that another will take on responsibility for *Kalben* and *Walkaln-aw* in the near future.

During the opening weekend celebration of *Story place* Aurukun dancers performed in front of Pambegan Jr's works, which were installed at the end of the Queensland Art Gallery water mall, floating delicately above the pool. It was an amazingly powerful performance. I have travelled many places as a dancer and have seen many performances, but none I recall as vividly as this. That day Pambegan Jr was foremost among the dancers. Posed whilst dancing in the 'shake-a-leg' stance, in front of his poles, his body painted in the same red and white stripes on his black skin, the same design featured on and dictated by the poles and their story, the moment declared: this is his dance, these are his poles, this is his story, his spirit, his land, his life. This is *him*.

Each time I see Pambegan Jr he appears fitter and healthier, and I tell him this. His response is 'no, I won't be around for much longer ...' Though the thought of losing such an important artist, leader and man is incredibly sad and near incomprehensible, Pambegan Jr is right, he can't live forever. But as long as he breathes the clean hot air of Aurukun he will stop at nothing to ensure that he and his living culture are survived, not only by his monumental works of art in public collections but also by further generations of great carvers in the tradition of his country.

Chantelle Woods

Arthur Koo'ekka Pambegan Jr's carving and sculptures are an expression of his ancestors, his country and his culture; with every chisel mark he makes he is teaching his people and the rest of the world where he comes from. Central to his practice is the responsibility of making sure his stories of his country and his people don't fade out and die. He has said, 'If you don't do anything, you lose everything'.[7] Many of us have experienced losing culture.

Pambegan Jr was born in 1936 in Aurukun and has lived in the community all his life. He is a senior member of the Wik-Mungkan people and an elder

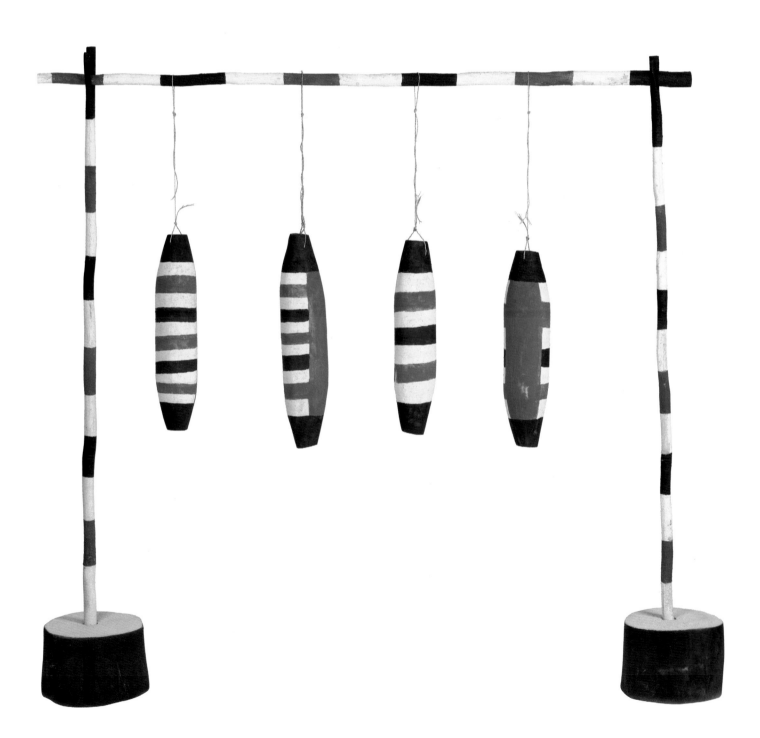

Flying fox (red back) 2007

of the Winchanam ceremonial group. His ancestral country lies between Small Archer River (Tompaten Creek) and the Watson River in West Cape York, and he is responsible for these areas, meaning that he is a ceremonial leader for the stories associated with these places as well as being accountable for the upkeep of the country, making sure it is all being respected. Pambegan Jr is the custodian of the two main ancestral stories: *Walkaln-aw* (Bonefish Story Place) and *Kalben* (Flying Fox Story Place), traditionally located on the two aforementioned rivers. The creation of these sacred totemic sites is told through these two stories, which also describe customary law and beliefs.

Aurukun is one of the larger communities of Cape York, with a population of just over 1200 people. During Pambegan Jr's childhood he was separated from his family and grew up in the boys' dormitory on the Presbyterian mission established in Aurukun in 1904. Due to the seniority of his father, Arthur Koo'ekka Pambegan Sr, who was a well-respected artist and important figure in the community, he was allowed to spend some time with his family. Certain 'acceptable' forms of traditional life were encouraged by the Aurukun Mission, and from his father Pambegan Jr learnt, sometimes secretly, about his culture. In the 1960s his father taught him to carve.

> Before my father died he teach me everything, you know … the stories, the carving … what I make now. I'm carrying it on … to pass it on to my son and my grandchildren … for their future … to pass it on. You can never just show it and just leave it and forget it.

Pambegan Jr has been making art for the commercial market for many years, reaffirming his identity out of the soft milkwood trees (*Alstonia muellerana*) that are abundant in the area and perfect for carving. Included in this exhibition are the first canvases that he has ever painted. These diptychs are the body paint designs of the *Walkaln-aw* and *Kalben* used by the Winchanam people. They symbolise the skin of their painted bodies before they go into ceremony.

As well as inspiring the next generation of artists in Aurukun, Pambegan Jr has also generated artistic dialogue with Indigenous artists around Australia. Fiona Foley's *Annihilation of the blacks*

responds to Pambegan Jr's *Walkaln-aw* installation. From a distance, Foley's work looks like a fish-drying rack, but on closer inspection it is a row of Aboriginal figures, displayed hanging from the neck. Pambegan Jr and Foley's works would startle if hung together: although visually similar they are loaded with very different messages.[8]

With important Indigenous artists in Australia today telling their stories through their art, it is imperative that the general public takes the time to understand what they are inviting us to see, and why they make their art. Arthur Koo'ekka Pambegan Jr's way of keeping culture strong is by teaching and expressing his ancestry through carvings and sculptures based on his places and stories. The fact that these works exist makes a political statement, as well as affirming that Indigenous culture is alive and strong.

1 Frederick McCarthy, 'Aurukun dances' Part II, Sydney, 1978, pp. 34, 58. Unpublished typescript, Australian Institute of Aboriginal and Torres Strait Islander Studies Library. The sculptures collected by McCarthy are in the National Museum of Australia.

2 In 2006 Pambegan Jr told me that although in earlier generations there had been other stories and other designs belonging to his clan group, his father had taught him only these two, Bonefish and Flying Fox.

3 Ursula McConnel, *Myths of the Mungkan*, Melbourne: Melbourne University Press, 1957, pp. 39–41. Both stories also appeared elsewhere in paraphrase.

4 Art making is one of the few professions at Aurukun that could be said to belong squarely to the 'real economy', as opposed to the world of government transfer payments. It is noteworthy that in 2006 the Wik sculptors, including Pambegan Jr, were being paid handsomely for their sculptures but also very modestly for their attendance at the Aurukun Craft Centre under the CDEP make-work scheme.

5 Shivirri, Winchanam, Apelech, Puch, Wanam.

6 The finished pieces, sculptures *Flying Fox Story Place* and *Bone Fish Story Place* must be considered true masterpieces of Queensland art.

7 Arthur Koo'ekka Pambegan Jr, interview with Brenda L. Croft, Aurukun, 1 March 2007.

8 Fiona Foley's *Annihilation of the blacks* 1986 was one of the National Museum of Australia's first major acquisitions of a work by a city-based Aboriginal artist.

Red-backed flying fox 2006

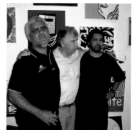
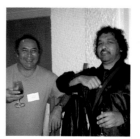

VERNON
AH KEE

not an animal or a plant is a declaration. I am declaring on my own behalf and that of my family and my people that 'I am not an animal or a plant'.

In 1901 when Australia ceased being a collection of British colonies simply sharing a land mass and became a federated country, the Aborigine – the native people of the land – was excluded from the new nation's constitution and the many arbitrary rights of citizenship that accompanied all its new citizens. Which is not to say that the Aborigine had escaped consideration altogether, rather, the Aborigine, ever the least considered was, as a people, relegated to a status less than human, ergo, an 'animal' or a 'plant'. Subsequently, the Aborigine's life became government property and one of rigid control. This truly degrading and derogatory action is not surprising given the prevailing beliefs and attitudes towards the Aborigine at the time.

What is surprising, or shocking, is that it wasn't until May 1967, facing substantial international attention and mounting criticism that Australia, by virtue of a national referendum, removed the Aborigine from under the heel of quasi-slavery and possession and placed this 'othered thing' within the constitution proper, albeit as a confined ward of the state. Nevertheless, the Aborigine was transformed from an Aboriginal thing of scientific curiosity and public derision, into an Aboriginal people of romanticised curiosity and political derision.

Russell Storer

Vernon Ah Kee's work oscillates between beautifully rendered realist drawings and stark, post-conceptual text pieces. Although visually far apart, there are clear correspondences between the two bodies of work. As writer Timothy Morrell has noted, 'Both mediums are handled with a degree of precision and a restraint that appeals to an old-fashioned love of the perfect line, whether drawn or written'.[1] The artist has made both forms his own, developing in each a distinctive aesthetic that at the same time appears to retreat from individual authorship. The drawings are the epitome of meticulous technique, cool and detached, while the text pieces use clean, sans-serif fonts in plain compositions that are produced with a professional sign-writer. It is of course the content of Ah Kee's works that gives them their specific charge: pushing against the form, it bubbles beneath his serene surfaces in a complex mixture of fury, poignancy and bleak, black humour.

Ah Kee has only been exhibiting his drawings since 2004, beginning with *fantasies of the good*, a series of portraits of male family members. The drawings arose from the artist's research into the Tindale Collection at the South Australian Museum, which contains hundreds of photographs of Aboriginal people taken by anthropologist Norman Tindale between 1930 and the mid 1960s. Individuals are identified by number, not name, and on requesting images of his own family from the collection, Ah Kee received them as cropped portraits that to him resembled mug shots. The layers of institutional violence that this well-meaning act implies inspired Ah Kee to render the images as off-centre drawings, with a focus on the piercing, direct gaze of his subjects. The series has been expanded into portraits of living relatives, each drawn from photographs to maintain the restrained, slightly distant style.

For this exhibition, Ah Kee presents a major new drawing, a triptych featuring an image of his grandfather and two of himself. The artist's seductive, sensitive draughtsmanship, an index of cultural refinement and aesthetic sophistication, appeals to our desire for beauty and technical prowess, yet he and his grandfather are positioned front- and side-on, their expressions blank, in poses common to images of anthropological subjects and of criminals. Implicit here are both sides of European culture's coin. As in Ah Kee's other portraits, the eyes address us directly, forcing us to meet their gaze, and communicating 'an immeasurable amount of sadness, weariness and suppressed anger'.[2]

Ah Kee's text works also arrest our vision, using bold arrangements and sardonic wordplay to activate and address the violence embedded in language. The artist refers to his text pieces as 'signs', drawing on our natural reading instincts by employing stark black-on-white designs with the strident sloganeering of advertising. Employing puns, in-jokes, and double-entendres, Ah Kee turns the English language, as well as its Australian vernacular, upon itself, isolating words and phrases from their contexts and excavating a racist subtext from the most seemingly innocuous of phrases. He takes palpable delight in words, pulling them apart and playing with their sounds, meanings and associations, encouraging a slipperiness to occur beneath the seemingly didactic nature of the works.

The words in Ah Kee's signs therefore resist linear readings, ranging from direct references, as in *strange fruit* (recalling the famous blues song about lynching in the American South), to invented slogans such as *i used to go to church like it was religion* and strange conjunctions such as *paradigmme* and *privilegeme*. Works such as *hang ten* and *race ya* strike deep into the heart of Aussie ocker culture, casting a dark shadow over the phraseology of our laid-back, beachside way of life. The artist views the text works as portraits in a sense, drawing on his own experiences and interests to build a kind of fragmented personal narrative. Viewed together with the drawn portraits, which could be seen to address the treatment of bodies as symbols or texts, the signs provide a compelling argument for the place of reflexivity, ambiguity and memory within the rigid regimes of Australia's race debate.

PHOTOGRAPHS ON PAGE 40

MAIN IMAGE: Vernon Ah Kee reading *The Koori Mail* at proppaNOW studio, Brisbane, February 2007, photograph by Brenda L. Croft

CLOCKWISE FROM TOP RIGHT: Richard Bell, Peter Bellas and Ah Kee at proppaNOW studio, Brisbane, February, 2007, photograph by Brenda L. Croft; Gordon Hookey and Ah Kee at Old Canberra House, Australian National University, August 2007, photograph by Brenda L. Croft; Ah Kee, Bruce McLean and Moses Gibson at the opening of the 4th Asia-Pacific Triennial, GOMA at the Queensland Art Gallery, Brisbane, December 2006, photograph by Brenda L. Croft; Vernon and Lisa Ah Kee, APT/GOMA/Queensland Art Gallery opening, December 2006, photograph by Brenda L. Croft

1 Timothy Morrell, *Vernon Ah Kee: mythunderstanding*, exhibition catalogue, Adelaide: Contemporary Art Centre of South Australia, 2005, unpaginated.

2 Morrell.

not an
animal
or a
plant

not an animal or a plant 2006

strange fruit

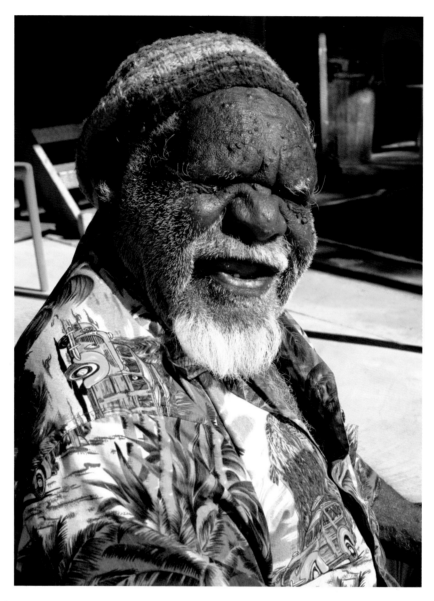

JIMMY BAKER

This is Piltati, the place of *Wanampi Kutjara Tjukurrpa* (Two Serpent Men's Creation Story). The men travelled from Walkatja to Tjitipiti. After that they went on [to] Piltati. The two women were sitting down sharpening their digging sticks. They lay them in a line. Then they began to dig. The circles in the painting are where the women were sitting and digging. This area is their hunting ground. They are digging for snakes, for food.

Graeme Marshall

Jimmy Baker was born over ninety years ago, along the *Kalaya Tjukurrpa* (Emu Dreaming) track in the Western Desert at a rockhole called Malumpa, a location close to the present-day community of Kanpi in north-west South Australia. He is one of the most senior and highly respected men in the Anangu Pitjantjatjara Yankunytjatjara Lands.

His father, Tjuwintjara, was also an important cultural figure renowned for his survival skills and profound knowledge. Tjuwintjara acted as a guide for T.G.H Strehlow and Charles Duguid on their expedition to the Petermann Ranges in the far south-western corner of the Northern Territory, after encountering them at Piltati Rockhole in 1939, as Duguid described in his autobiography, *Doctor and the Aborigines* (published in 1972).

Jimmy Baker married Nyinmungka during the late 1930s and they had three daughters and a son. He has a younger brother, Toby Ginger Baker, as well as a sister, Tjuwilya, and his nephew Douglas married Maringka, who is also an artist.

Baker worked as a shearer on the mission at Ernabella in the Musgrave Ranges, also repairing fences, sinking bores and mustering livestock. Bob Capp, a teacher in the Lands in the 1960s, remembers him as a great storyteller who 'would have people in peals of laughter as he embellished stories'. He was subsequently instrumental in encouraging key family members to return to their home country at Kanpi.

From an early age Baker was aware that he had special powers. As a highly respected *ngangkari* (healer), he has travelled extensively throughout South Australia, Western Australia and the Northern Territory, applying his traditional knowledge and skills. He is also an exceptional craftsman who is able to create traditional implements of the highest standard. Baker began painting in 2004 and has since produced a relatively small body of work. He is one of a handful of artists attached to Tjungu Palya, a community-based art centre at Nyapari.

Baker is a strong law man who is custodian of many stories befitting his seniority, including *Kipara* (Bush Turkey), *Kalaya* (Emu), *Piltati* (Sacred Rockhole Site) and *Wanampi Kutjara* (Two Serpent Men's Creation Story). His intimate cultural knowledge is inextricably linked to his *ngangkari* status. His work depicts the cultural landscape, his *Tjukurrpa*, with authority and integrity, acting as a bridge toward mutual respect and understanding. Like other senior men he paints stories in a way that clearly defines significant sites or paths etched in the landscape by ancestral beings. These sites are multi-layered, with physical, geographical, spiritual and ceremonial connotations.

Jimmy Baker's work encapsulates the essence of culture, country and Indigenous pride. He has a rare artistic gift and is one of the most important artists from the central and Western Desert region. His paintings are now represented in major public and private collections in Australia.

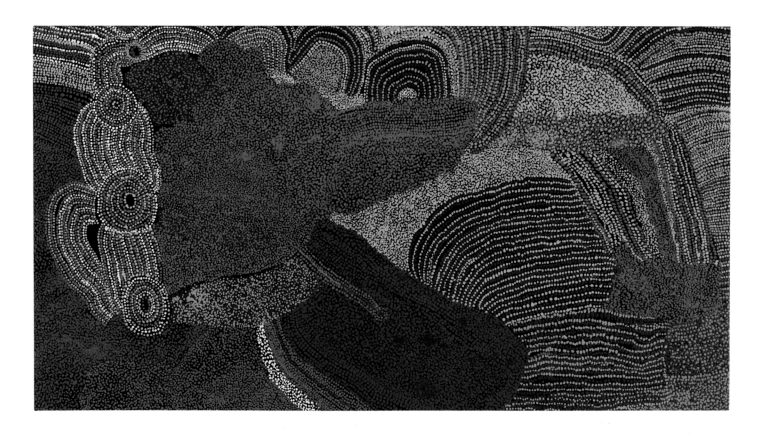

Piltati 2007

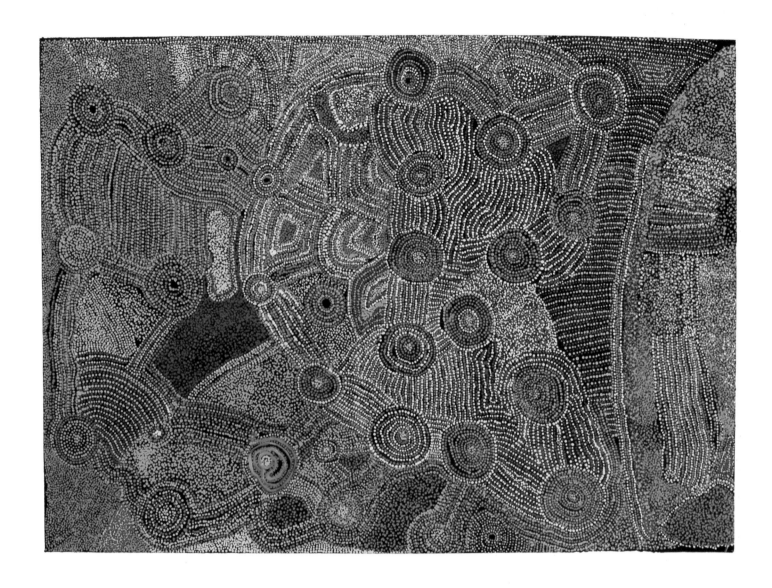

Wanampi Kutjara (Two Serpent Men's Creation Story) 2006

MARINGKA BAKER

This is Kuru Ala. These are creeks and rock holes everywhere, and many trees. There is *puli* (rocks) and *apu* (rocky hills). This is *Minyma Tjuta Tjukurrpa* (Seven Sisters Creation Story). This area is close to Tjuntjuntjarra.

Graeme Marshall

Maringka Baker is a senior Pitjantjatjara artist who lives in the small community of Kanpi, in the north-west corner of South Australia. She was born in the bush around 1952 at an important ceremonial site, Kaliumpil. After losing both parents as a child, she was raised by her extended family. During adolescence and adulthood Baker continued to observe and participate in traditional cultural practices.

The 1950s and 1960s was a period of displacement for many Indigenous people over a broad area of the north-western desert region of South Australia. Rocket and atomic tests were carried out at Woomera, Emu Plains and Maralinga, and many Indigenous desert families were relocated. Family groups established new camps close to water, and later some of these camps became outstations, which now function as small communities.

Maringka Baker was sent to primary school at Warburton, across the border into Western Australia, from where she ran away to join relatives who had moved to Ernabella in the north of the Anangu Pitjantjatjara Yankunytjatjara Lands. She later shifted to Fregon, where she completed her education and began employment as a teacher. She married Douglas Baker and had a daughter, Claire. The Baker family name extends throughout the Ngaanyatjara and Pitjantjatjara lands.

Due to the remoteness of these small communities, many of the senior members have continued to observe traditional practices and ceremonial rituals, which enrich and reinforce the importance of country and its relevance to individual *Tjukurrpa*. Maringka Baker is custodian of many important stories, including Anmangunga, her mother's country (a camping site near Watarru, where she played as a small child); Kaliumpil (the place of her birth); Kuru Ala (a sacred place for the Seven Sisters Creation Story); and Kungkarrakalpa (the Seven Sisters Creation Story).

Baker began painting for the arts centre Ninuku Artists in 2004, and now paints for Tjungu Palya, an art centre which grew out of Ninuku and represents the communities of Nyapari, Kanpi and Watarru, and the small homeland of Angatja. Tjungu Palya is an Aboriginal community-based collective consisting of a small group of senior men and women, as well as a number of younger artists. Loosely translated, Tjungu Palya means 'being together is good'.

Maringka Baker's paintings are rich in colour and cultural significance, and grounded in country and ceremony. As she has grown in confidence, so has the work, which is now large in scale, blending landscape with a fusion of passion, individual expression and cultural integrity. Where some see the desert as barren, Baker paints it green: testament to her perspective of seeing life and soul beyond the merely obvious.

PHOTOGRAPHS ON PAGE 52
MAIN IMAGE: Maringka Baker, 2006–07, photograph by Amanda Dent
OTHER IMAGES: Baker painting at Tjungu Palya Arts, South Australia, 2007, photograph by Amanda Dent

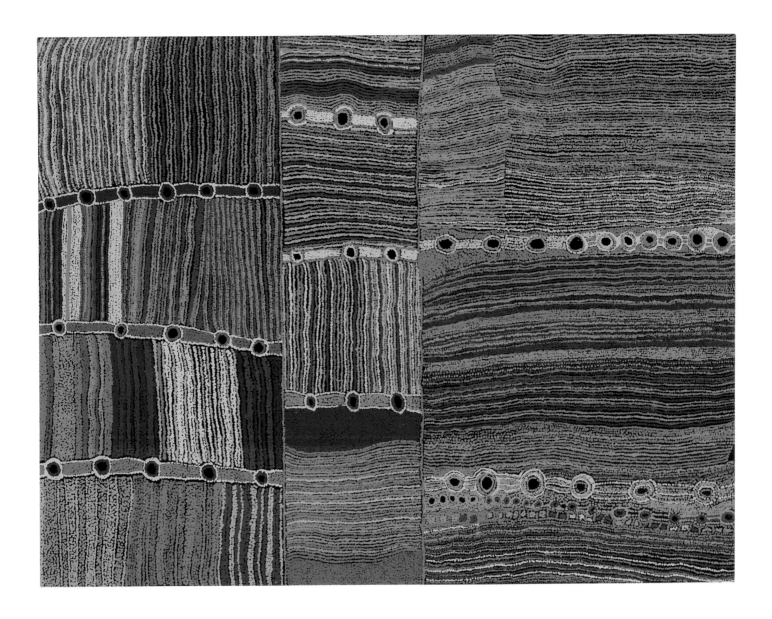

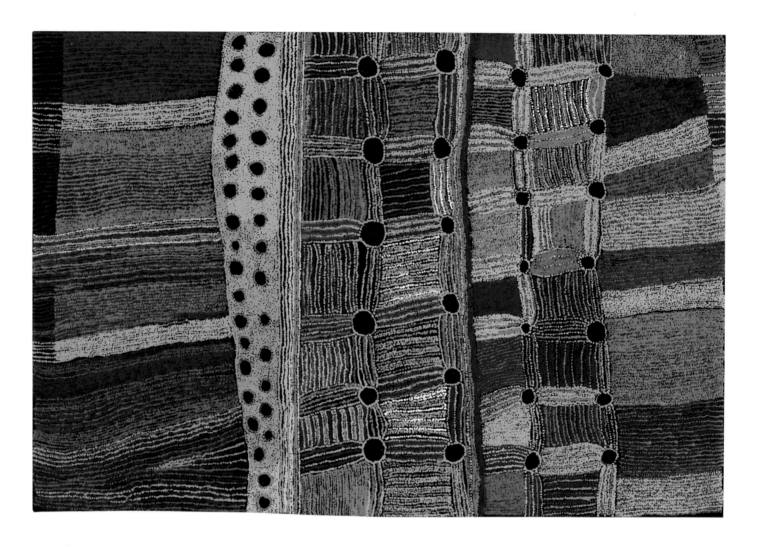

Anmangunga 2006

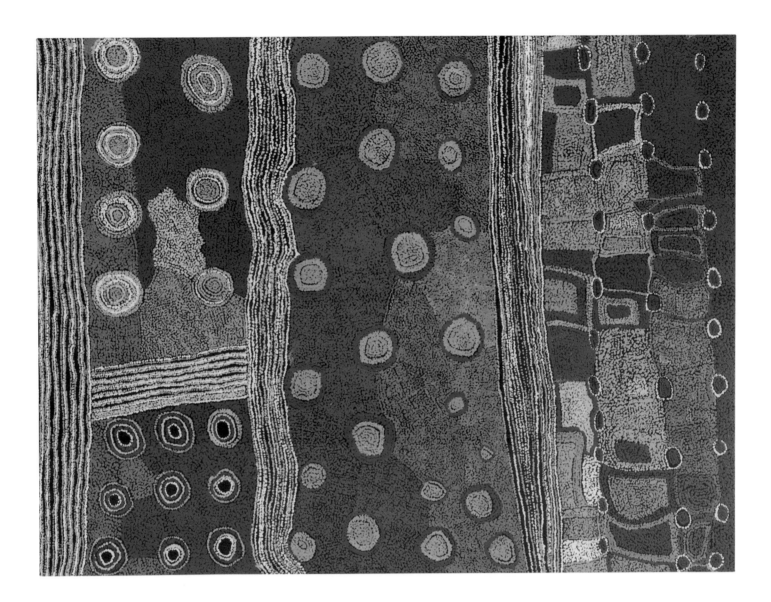

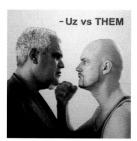

– Uz vs THEM

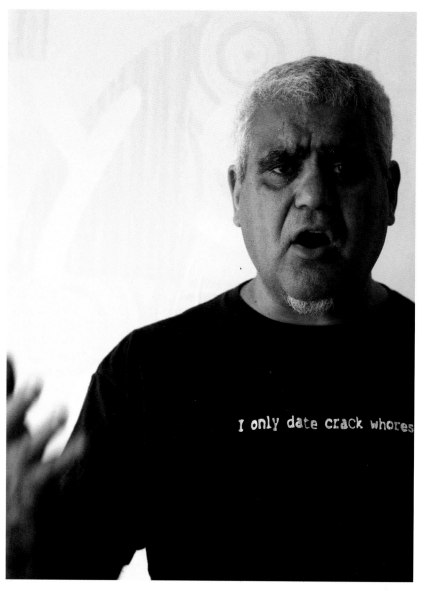

I only date crack whores

RICHARD BELL

My name is Richard Bell. I am an Aboriginal man living and working in Brisbane, Queensland, Australia. I make a living from painting pictures. Because I am from the closely settled east coast of Australia I am not allowed to paint what is popularly called 'Aboriginal art'. Nor can I use the symbols and styles of Aboriginal people from the remote, sparsely settled areas of northern Australia. Apparently, this would make my work derivative and hence diminished in importance, relevance and quality. However, in western art, which appears to be almost entirely and increasingly derivative, no such restrictions apply. Quoting, citing, sampling or appropriating pre-existing works even has its own movement: appropriationism. There is even a belief that 'everything has been done before'. (Which makes it cool to appropriate.)

Consequently, I have chosen to quote, cite and sample the works of many artists from around the world, for example, Jasper Johns, Roy Lichtenstein and Colin McCahon; just like most artists today. But I don't believe that every painting has been painted, just as I don't believe that every song has been written.

I have also been privileged to watch closely how many of the great desert artists paint and have learned plenty. In Australia there are many Aboriginal artists from urban areas who are producing art with similar subject matter to mine.
Our art has been, incorrectly I believe, called 'urban Aboriginal art'. It is work that that often speaks of contemporary injustices against our people. Liberation art is a far more accurate term that may also help to discourage the perpetual attempts to ghettoise us.

Hetti Perkins

Self-styled cultural maverick and art world renegade Richard Bell well disguises the tender experiences of his youth and adult life that fuel the furnace of his art. The combination of verbal and visual onslaughts that comprise his *raison d'être* are a calculated but simultaneously honest ploy, realised in the seemingly dichotomous and idiosyncratic nature of the work of this formidable artist. In a tactical 'shoot first, ask questions later' approach, his art takes the offensive and opens the door to dialogue in the true tradition of radical politics. Armed with the courage and conviction born of a life marked by discrimination, Bell images himself splayed crucifix-like, or snarling, or as the heartless heartbreaker, and revels in slaughtering lambs and sacred cows with fierce abandon.

While Bell has consistently come out of his corner swinging in the arena of Australian politics, there is more to his work than the technical know-how and political nous that meet the eye. A judicious reading of his work reveals an arguably feminist agenda that critics of his controversial act in accepting a major art award wearing a T-shirt stating 'white girls can't hump' would adamantly refute.[1] Bell employs the crudest forms of male egotism and voyeurism in lampooning the vulture-like consumption of women, in particular Aboriginal women. The infamous T-shirt, for instance, had its origins in a 2001 work entitled *For the gin jockeys*. Does the T-shirt slogan discriminate against white women, or does its play on 'white men can't jump' subtly suggest the racism that decrees black men as only capable of sporting prowess and black women as objects of sexual colonisation? Is Bell ultimately attacking the Darwinism of stereotypes that reduce blacks to empty-headed physical automatons? In his 2007 series of Roy Lichtenstein-inspired narrative paintings the women fight back, blasting the 'pricks' with sub-machine guns and guerrilla girl rhetoric. In his persona of the 'super-nigger' matinée idol Richie, Bell continues to play up to male fantasies of unremitting female lust and desire and strides into the dangerous waters of sexual politics. Other images in the *Psalm singing* suite offer the viewer a peepshow perspective of a naked white woman erotically posed in various settings, including as a foreground to a flagpole bearing the Aboriginal flag. These cartoons operate as a barometer of unspoken unrest in black gender dynamics.

Bell was wearing his 'white girls' T-shirt when he accepted the NATSIAA in 2003 for *Scientia e metaphysica (Bell's theorem)*, a painting which has the statement 'Aboriginal Art it's a White Thing' emblazoned across it[1]. His accompanying unpublished 'Bell's theorem' dwells on academic enterprises and parasitic commercial industries that have developed around contemporary Aboriginal art. Bell argues that Aboriginal art has become a commodity, being voraciously assimilated by western society. In keeping with the discredited government social policy in operation from the mid twentieth century, this system categorises Aboriginal artists as either tribal people living in the outback or cultureless urban blacks. For Bell, cross-cultural appropriation becomes a shrewd strategy for Indigenous artists whose cultural authenticity has been disenfranchised by the ravages of colonisation. As he states: 'Our culture was ripped from us and not much remains. Most of our languages have disappeared. We don't have black or even dark skin. We don't take shit from you.' Increasingly Bell's work has relied on the dynamic play of image and text, and along the way he has coopted some of the most distinctive symbolism of contemporary art practice, from the dotted matrix of Western Desert art to the whiplashes of Jackson Pollock and the patchworked assemblages of Imants Tillers. The debate around this 'curatorial' process of artistic appropriation was galvanised by the engagement between Tillers and Bell's fellow Murri artist Gordon Bennett in the late 1980s and early 1990s.[2]

Richard Bell's *Australian Art it's an Aboriginal Thing* 2006 inverts the message of its 2003 counterpoint. Like the recurring target symbol in his paintings that plays on Western Desert art motifs, Bell positions himself as a moving target, inviting his audience to take a shot – and usually sending a volley of ammunition in return.[3] The title of his *Psalm singing* series makes pointed reference to the murder of Mulrundji Doomadgee at Palm Island police station in late 2004. With its biblical references *Psalm singing* 2007 chillingly evokes the climate of fear engendered by the frightening prevalence of institutionally sanctioned acts of violence against Aboriginal people. These works declaim the ungodly hypocrisy of a nation that professes Christian values yet will not allow the 'meek' basic human rights, much less to inherit the earth.

PHOTOGRAPHS ON PAGE 58

MAIN IMAGE: Richard Bell, courtesy of Sonia Payes and Charles Nodrum Gallery CLOCKWISE FROM BOTTOM RIGHT: Peter Bellas and Bell at proppaNOW, Brisbane, February 2006, photograph by Brenda L. Croft; Bell with *Scientia E Metaphysica*, 20th Telstra National Aboriginal and Torres Strait Islander Art Award, Museum and Art Gallery of the Northern Territory, Darwin, August 2003, photograph by Brenda L. Croft; Bell, courtesy of Sonia Payes and Charles Nodrum Gallery; Bell, courtesy of Sonia Payes and Charles Nodrum Gallery; DVD still *Uz vs Them*; proppaNOW studio, Brisbane, February 2006, photograph by Brenda L. Croft

1 Bell's painting *Scientia e metaphysica (Bell's theorem)* 2003 won the major 20th Telstra National Aboriginal and Torres Strait Islander Art Award (NATSIAA) at the Museum and Art Gallery of the Northern Territory, Darwin, in 2003.

2 The idea of a curatorial process in an artist's work is raised in Holly Arden and Kris Carlon, 'Interview with Imants Tillers', in *Machine: Visual Arts Bi-monthly*, no. 2.3, December 2006, pp. 3–7.

3 With his colleagues Vernon Ah Kee, Tony Albert, Bianca Beetson, Andrea Fisher, Fiona Foley, Jenny Fraser, Gordon Hookey, Jenny Herd and Laurie Nilsen, Bell formed the Brisbane-based artists cooperative ProppaNOW, which continues to lay bare the injustices of contemporary Australian society.

Big brush stroke 2005

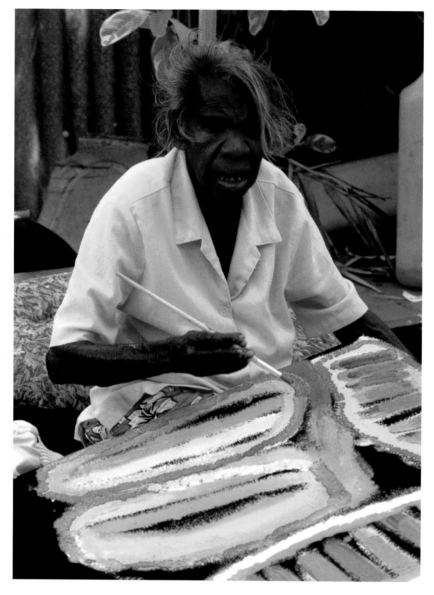

JAN BILLYCAN
(DJAN NANUNDIE)

All a long the *jila* (waterhole) this side, my country, we been walk, *wanga* (my people) belong to him ... We get him cold water and carry him on our head in round one (like *coolamon*). This is all the *jila* in my country including Karrparti, Kawarr, Jurntiwa and Wirrguja *jila*. It also shows Dodo, Kartal and Kiriwirri and Yukarri and others. When I was young I walked all around these places, with my mummy and daddy. In living water there is a quiet snake. Sometimes he rises up, but we sing him down, sometimes he can travel and bring rain ... Ilyarra is my country, Ilyarra, where I grew up. Lots of *tali* (sand dunes) and *jila* in this country. This is big dog country.

Patrick Hutchings

Jan Billycan (Djan Nanundie) was born around 1930 and grew up in Ilyarra country in the Great Sandy Desert in the north of Western Australia, and this is the country depicted in her large eight panel painting *All the jila* 2006. It can be read as a choreographic or musical suite, taking the line for a dance, along with colours, shapes and forms. Of the extraordinary mixed hues of Bidyadanga art Emily Rohr said, '... [these are] discordant colours, which don't belong together. For [the artists'] colours are vibrations ... songs in vibrating, pulsating paint, with themes in colour counterbalanced by other answering colours.'[1] The panels of the big composite work may be read separately, but the conjunctions will not break up visually. It is a harmonised set of moments of *élan*.

Water, until the recent ominous drought, was something quite commonplace for city dwellers in Australia; now they feel acutely how its presence can bring joy to erstwhile desert dwellers. Billycan's work, says Rohr, 'is a story of survival in a harsh landscape; it is also the story of time and creation'.[2] Bidyadanga, where Billycan paints, is a small place of some 800 persons, 250 kilometres south of Broome. It is inhabited by five language groups who came out of the desert to estuarine land when their *jila* (waterholes) failed due to the disruption of the water table caused by whitefella mining operations. Many of the paintings are memory-maps made to show the younger generation their elders' origins. Often works combine sea and desert on the one canvas. An important youngster Daniel Walbidi has said, 'They old ones are desert mob, but now they live at Bidyadanga, saltwater country'. The paintings are the cartography of memory and of migration.

Most of Billycan's works refer to *jila*. They are images of fecundity, with lush, highly coloured waterholes. A traditional healer, Billycan paints life, and her x-ray vision penetrates the forms that represent both the land and the human body, itself an extension of the land. All are one. Without immersion in the ancient culture from which the story derives, it can be no more than an emotional pointer to the picture. The picture may do the trick by itself, though: let us *see* beyond understanding.

The eye that collectors of Indigenous art bring to the pictures they buy is one which knows the work of Hans Arp, Paul Klee, Joan Miró, Jackson Pollock or any one of a number of abstract artists. Bidyadanga painters paint for themselves, to fix their own group stories, a local one, for future generations. Whitefellas are privileged onlookers who take as aesthetic what for Aboriginal people are real memories and real history. Aesthetic distance is fine, but one must remember that Bidyadanga life-work is our work of art only by the accident of Imperial history.

PHOTOGRAPHS ON PAGE 64
Jan Billycan (Djan Nanundie) painting at Bidyadanga, Western Australia, 2006, photographs by Michael Hutchinson

1 Quoted in Nicolas Rothwell, *Another country*, Melbourne: Black Inc., 2007, p. 246.

2 Emily Rohr, interview with Patrick Hutchings.

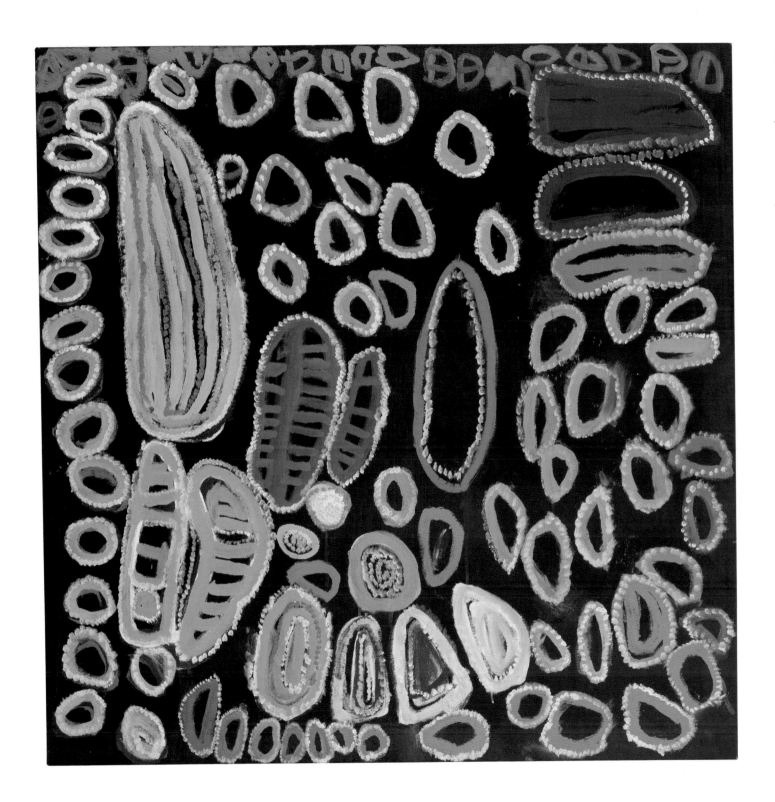

All that Jila 2005

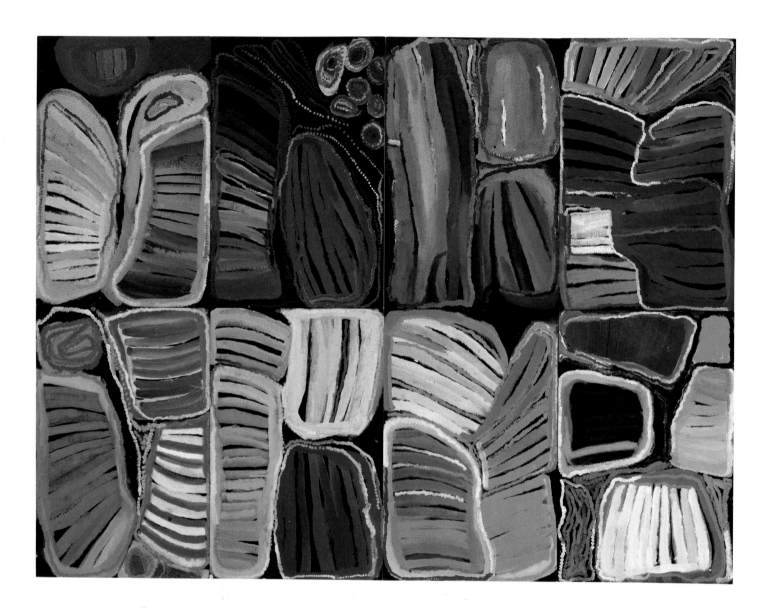

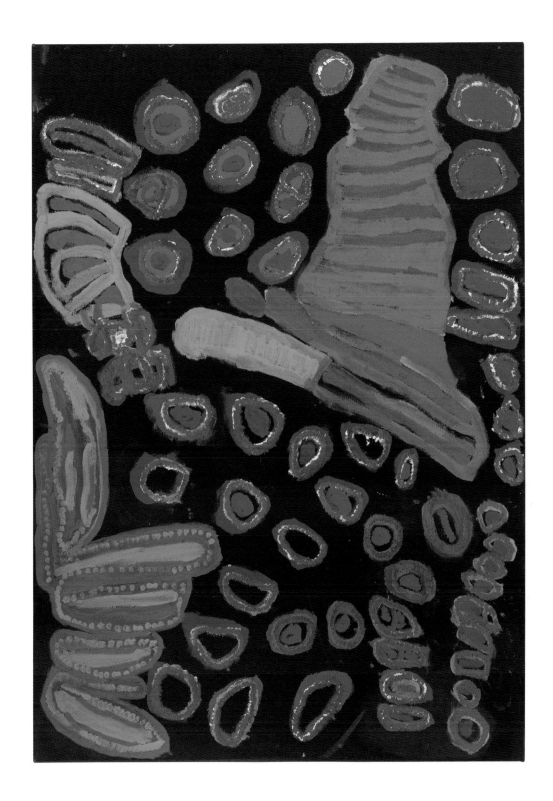

DANIEL BOYD

Questioning the romantic notions that surround the birth of Australia is primarily what influenced me to create this body of work. With our history being dominated by Eurocentric views it's very important that Aboriginal and Torres Strait Islander people continue to create dialogue from their own perspective to challenge the subjective history that has been created.

Tina Baum

The quietly spoken young Kudjla/Gangalu man from Cairns in Far North Queensland stands tall, weaving a story of his life and vision into the fabric of his paintings. Daniel Boyd's perspective on Australia's colonial history and its impact on its Aboriginal people are not new but his artistic portrayal of it is. Hearing him speak freely and honestly about his work one gains an understanding of the intelligence and considered thought behind it.

I first met Daniel Boyd in Canberra in 2006, at the National Gallery of Australia. His work is humorous and exciting. His paintings for this exhibition read like pages in a book. Each is part of a story which, chapter by chapter and page by page, chronicle the 'discovery' of Australia by Europeans and their subsequent colonisation of the continent.

Chapter one, the story's just begun ... Boyd introduces themes of piracy to his painted replicas of eighteenth-century portraits of King George III[1], called *King No Beard* 2007, and Governor Arthur Phillip[2], called *Governor No Beard* 2007; as well as the dramatic *Apotheosis of Captain James Cook*[3], called *Fall and expulsion* 2006, in a 'spot the difference' kind of series. Key figures in Australia's discovery and growth into nationhood are altered with here an eye patch, there a macaw parrot, and now and then a Jolly Jack.[4] The historical figures of King George III, Cook and Phillip have been extensively discussed and portrayed in terms of their impact on Indigenous peoples throughout the new worlds. Today, hundreds of years later and several continents apart, Boyd's work encourages the idea of parallel dialogues between different cultures through a kind of visual mimicry.

Captain No Beard 2005 was the first work Boyd painted in this series:

> ... in response to the posthumous portrait of *Captain James Cook* by John Webber at the National Portrait Gallery ... Prior to seeing Webber's portrait I'd come across documents such as the Secret Instructions Cook had in his possession during the three voyages from 1768 to 1779. They stated that Cook was 'with the Consent of the Natives to take possession of Convenient Situations in the Country in the Name of the King of Great Britain (King George III).' I immediately drew parallels between a common practice of the time, the act [of] Piracy. Nationalistic rivalry with Spain and others drove the practice of employing privateers to engage in combat with other countries, resulting in the British indirectly participating in piracy.[5]

The expression 'no beard' refers to an account of Cook's first landing in Australia, when, it is said, Aboriginal people thought he and his men were women, due to their lack of facial hair. While this is funny enough, as a *name* No Beard is also a reference to the well-known pirate Black Beard, with whom the clean-shaven King George III, Cook and Phillip have much in common, as in Boyd's terms they all performed acts of piracy.

Treasure Island 2005, at first glance, seems unconnected to the other works and quite innocuous. It's a map (of Australia) with a random pattern of coloured segments and the name – and work's title – 'Treasure Island' in cursive script across the centre. The map is a replica of one drawn up in 1994 for the Australian Institute of Aboriginal and Torres Strait Islander Studies, showing the 300-plus Aboriginal and Torres Strait Islander language groups in the country.[6] Before European settlement these clans lived harmoniously with their environment; their culture a rich and intricate heritage grounded in profound knowledge. For an Indigenous person, this map represents sadness and loss as well as strength of culture. It reminds us of just how many of our people since 1788 have been dispossessed and denied access to our language, lands and basic human rights; yet it's also a beacon of hope as Australia's Indigenous people have shown great resilience and strength in surviving as the world's oldest living cultures.

Boyd's talent for historical extraction and contemporary remodelling that plays off Australia's collective historical consciousness, reminds us that history is not one-sided but multi-faceted, and that Australia's Indigenous narratives are as real and as valid as those written in the accepted history books.

PHOTOGRAPHS ON PAGE 70

MAIN IMAGE: Daniel Boyd, courtesy of the artist
CLOCKWISE FROM TOP RIGHT: Boyd with *King No Beard* in studio, 2007, photograph by Belle Charter; Jean Baptiste Apuatimi and Boyd at National Gallery of Australia, Canberra, April 2007, photograph by Steven Nebauer; Belle Charter, Boyd and Arthur Pambegan Jr, National Gallery of Australia, Canberra, April 2007, photograph by Tina Baum; Boyd, Balloon trip, Canberra, April 2007, photograph by Brenda L. Croft; Boyd artist talk, National Gallery of Australia, Canberra, 2006

1 Nathaniel Dance, *King George III* 1773.

2 Francis Wheatley *Arthur Phillip* 1786.

3 After Philippe Jacques de Loutherbourge and John Webber, London: J. Thane, 1794.

4 This flag is a combination of the British Union Jack and the Jolly Roger (a pirate flag), created by Boyd, which features in his works. The image is also the focus of a singular work in the collection of the National Gallery of Australia, called *Jolly Jack* 2005.

5 Artist's statement, 2005.

6 The map was created by David Horton from research conducted for the *Encyclopaedia of Aboriginal Australia*, which Horton edited for AIATSIS (Canberra: AIATSIS, 1994).

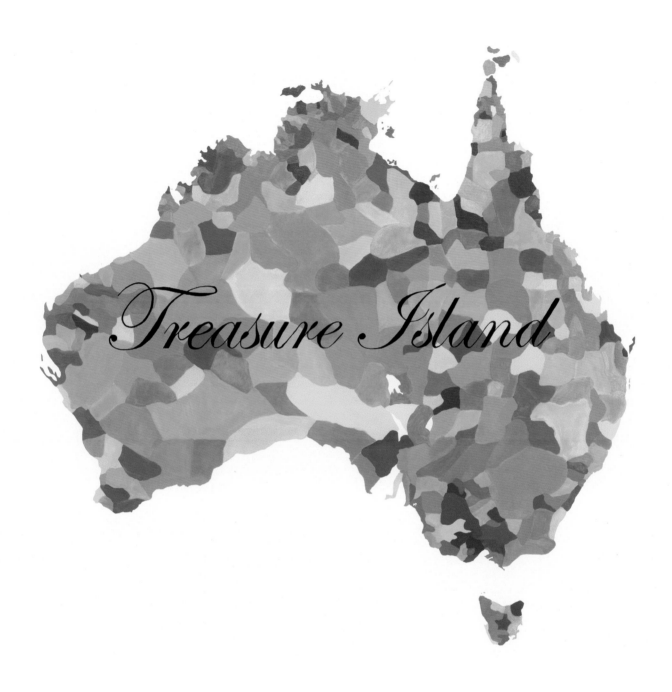

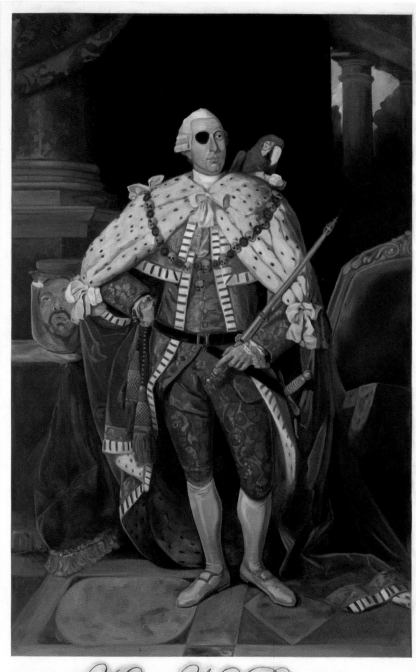

King No Beard

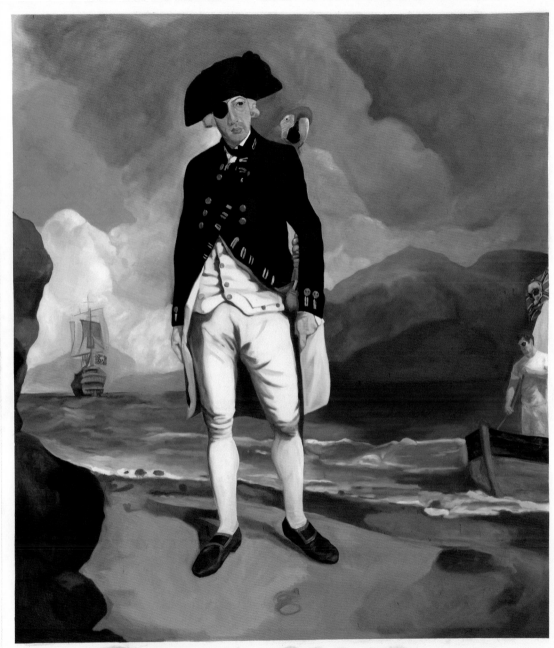

Governor No Beard 2007

TREVOR 'TURBO' BROWN

When I paint I feel like I'm in the Dreamtime and can
see all the animals and birds that live there.

Trevor 'Turbo' Brown, it is said, would only paint
animals, because when he was fifteen years old and
homeless, living on the streets of Mildura and on the
banks of the River Murray, they were his only friends.[1]

Stephen Gilchrist

Trevor 'Turbo' Brown, born in 1967, is a Latje Latje man from Mildura, Victoria. His nickname Turbo is derived from one of the central characters of the 1984 film *Breakdance*. Brown's breakdancing ability was renowned in the 1980s and 1990s, and it could be said that his idiosyncratic painting style shares much with breakdancing's immediate and highly kinetic properties. The fast-paced, fluid brushstrokes speedily block in the form and colour of his subjects, followed by a subsequent layer of studied detail. The combination of his spontaneous application of thick, unmixed acrylic paints in vibrant colours and his engaging pictorial style make his work pulse with an irresistible and syncopated beat.

Brown's use of pictorial narrative reflects what he refers to as his 'Latje Latje Dreaming'. He says, In *Dreamtime kangaroo and bird* 2006 Brown seems to conjure up an Aboriginal arcadia, a time before night and day, when all animals lived in unspoiled harmony. Within this stylised representation of refreshing simplicity and co-existence is an unexpected statement of cultural defiance and presence. The intense repetition of line and expressionistic dotting in the recognisable colours of the Aboriginal flag immediately politicise the painting, giving it a contemporary edginess. The message is matter-of-fact. The land that nurtures these animals is and has always been Aboriginal.

Nestled beneath a canopy of interlocking branches with emerald green leaves are the silvery-grey coats and the intense red-eyed gaze of two inquisitive sugar gliders. In *Sugar gliders* 2006 Brown captures the greedy nocturnal feedings of the tiny marsupials as they gorge themselves on the sweet sap of the eucalyptus trees – they look not unlike mischievous children being caught with their hands in the lolly jar. The features of the sugar gliders are flourished to reveal the keenly observed details of their soft, plump underbellies, their big rounded eyes for night time foraging, and their specialised wing-like flaps that extend down either side of their bodies. Their razor-sharp claws grip the tree boughs intuitively, poised at any moment to fly away from predators or fly towards prey.

Unlike koalas, sugar gliders from Victoria are not currently endangered, but their habitats are nevertheless continually under threat from human activities. Broad scale clearing of the land not only increases soil erosion rates in forests, but displaces the animals it shelters and devastates their natural habitat. This threat of dispossession is particularly painful for Brown, who has experienced first-hand the sting of homelessness. Despite these hazards, sugar glider populations continue to thrive and Brown celebrates the remarkable resilience of these small, vulnerable animals.

Although Brown is only in the formative stage of his career, he has already received much acclaim for his innovative and bold style, and has carved out a significant exhibition history. Training his perceptive eye on the animals of the Australian bush, Brown images and celebrates a world of unabashed loveliness. Demonstrating his illustrative flair for striking compositions, split colour harmonies and abbreviated symbols of line and texture, Brown's studies of lifelike animals in their environment evoke the distinct fauna of north-west Victoria. The oblique environmental and political dimensions add substance to his disarming oeuvre, painted fluently from the heart.

PHOTOGRAPHS ON PAGE 76
MAIN IMAGE: Trevor 'Turbo' Brown, courtesy of the Koorie Heritage Trust, Melbourne, 2007
CLOCKWISE FROM TOP RIGHT: Brown, 2007, courtesy of Dixon Patten; Brown, 2007, courtesy of Dixon Patten; Brown painting *Koala and babies*, Koorie Heritage Trust, 2005, image courtesy of Koorie Heritage Trust; Sharon West and Brown, 2007, courtesy of the Koorie Heritage Trust, Melbourne; Brown in studio, 2007, photograph courtesy of the Koorie Heritage Trust; Brown and Kutcha Edwards, Koorie Heritage Trust, 2006, photograph courtesy of the Koorie Heritage Trust

1 Statement courtesy of Koorie Heritage Trust Inc., Melbourne, Victoria, 2007.

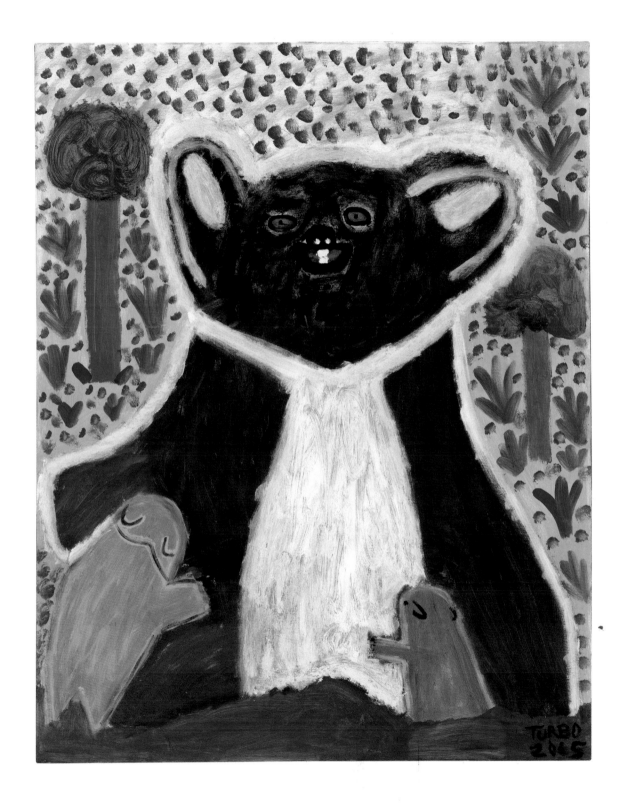

Koala and babies 2005

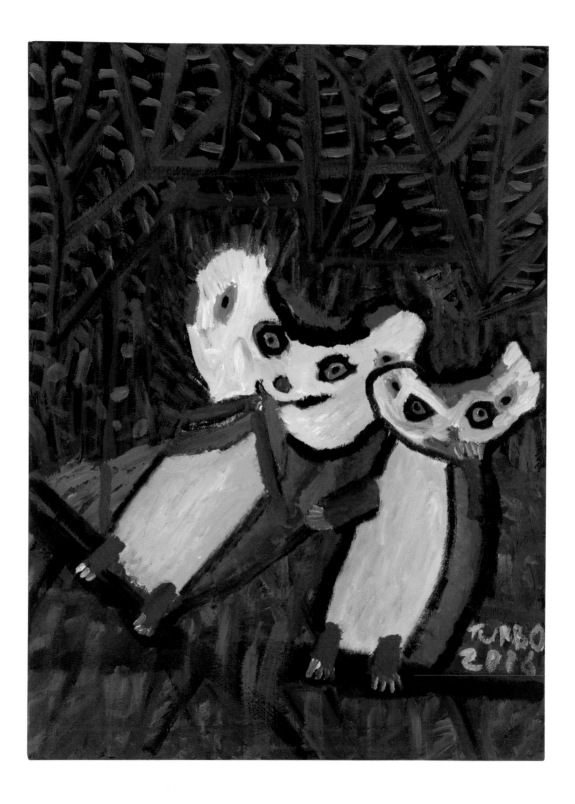

Sugar gliders 2006

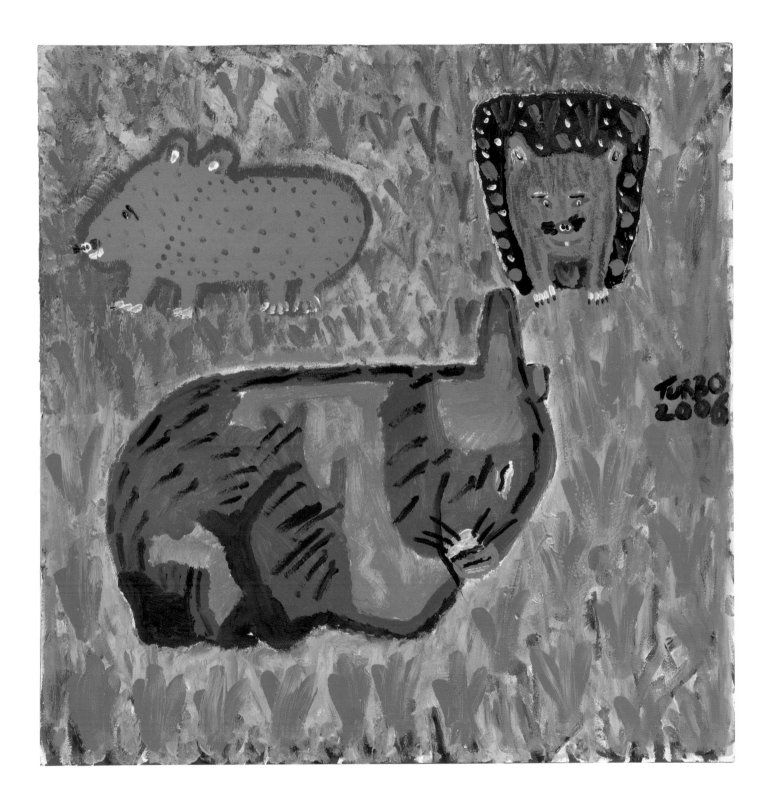

Three wombats 2006

CHRISTINE CHRISTOPHERSEN

What is it that you value most?

This is the question that Bill Neidjie (senior elder of Kakadu National Park) asked of Federal Parliament when opposing the Ranger Uranium Mine and the Northern Territory Government as they attempted to further contaminate his lands, located within the World Heritage–listed Kakadu National Park in 1994.

This single question affected me profoundly. For me, it has become the measure to strive for in my art, my life. For me, the question has become: 'what is our capacity as human beings?' and then: 'how do we seek our saving grace?'.

Is our shared humanity at question?

This is who we are, this is where we come from and where we are going, and we are holding the stories!

Christine Christophersen, *Blue print* 2006

Franchesca Cubillo

Why is it that as Indigenous people in Australia we are always justifying ourselves, having to assert our legitimacy and affirm our human right to live within this society? A battle has been raging in this country for over 200 years; this is not only a battle, however, but also a generational war fought within us and outside of us. It is both personal and political. The war rages as we re-claim our land, reclaim our language and reclaim our identity. We are coerced into believing that all has been lost, all has been destroyed, and that our culture was static. But has it? Were they? Is it? Or have we been acculturated to such an extent that we put on our battle fatigues and step into the battleground to engage in a war that should not be fought? We should be jealously celebrating and defending the beauty of all that has endured: the continuity, ingenuity and strength of our culture and heritage, just as our ancestors have done for thousands of years. Christine Christophersen's works challenge us to consider these questions.

In this exhibition are paintings by Christophersen that I refer to as her kinship series: a collection of paintings that speak to us of identity, belonging, and relationship to country and to each other. The nature of this relationship is based on respect, obligations, responsibilities and maintenance of cultural protocols. These cultural imperatives are important to Christophersen, as it defines who she is and her place within her community. As a mother and grandmother it is these principles that she passes on to the next generation, mindful that they will provide guidelines for the future. These principles are epitomised in her painting *The past, the present, the future* 2006.

Christine Christophersen first began to paint in 2000 after an intensive five-year period of political campaigning against Energy Resources of Australia's Ranger uranium mine in Kakadu National Park. She worked within the Gundjehmi Aboriginal Corporation, defending her mother's country along with many other Mirrar/Murran clan members from the Western Arnhem Land region. Christophersen was imprisoned in Darwin's Berrimah Gaol for twelve days for refusing to pay a fine for trespass on the Ranger lease, which ironically is on Aboriginal land, her mother's country.

Painting gave Christophersen time and space to reassess who she was and where her place was, in the world and in her country; it allowed her to communicate with herself. Her art in this period was private; she never saw herself as an artist so she didn't use a paint brush. Paint was applied with her hands; expressive and intimate. For Christophersen painting became her saving grace, as she discovered a new language with which to engage. Her commentary remains one of political protest, of contestation and reinforcement/reinstatement of culture, identity and connection to country.

For Christophersen, defending country is both a personal and professional responsibility. She is one of a handful of women painters making art in a male-dominated art-producing region and recognises that men and women have complementary roles to play in defending, communicating and maintaining cultural practice, through ceremony, social obligations and artistic expression.

Christine Christophersen displays her militant rank proudly as her art traverses the battleground; her defiance is legitimate: it is her birthright, handed down to her, her family and her clan over thousands of years – this is her *Blue print*.

PHOTOGRAPHS ON PAGE 82
MAIN IMAGE: Christine Christophersen at solo exhibition, Darwin Entertainment Centre, 2007, photograph by Bruce McLean
CLOCKWISE FROM RIGHT: Studio image of grandmother, photograph by Brenda L. Croft, 2006; Christophersen's hand, December 2006, photograph by Brenda L. Croft; Christophersen and Shane Pickett, Darwin, 2005, photograph by Brenda L. Croft; Christophersen at Thunder Rock Primary School, Coburg Peninsula, 2006, photograph by Carol Christophersen; Christophersen's studio, December 2006, photograph by Brenda L. Croft

The past, the present, the future 2006

Blue print (film still) 2006

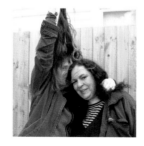

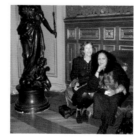

DESTINY DEACON
& VIRGINIA FRASER

Colour blinded exemplifies the way we work together, when we work together. Destiny thinks her thoughts and Virginia thinks hers. Neither of us recalls a time we've talked much about making work together, or discussed ideas or methods except while doing it and even then only briefly.

In this case Destiny proposed doing something with sodium lights that Virginia had used before, though not in joint works. Destiny wanted to take black-and-white photos and Virginia suggested using orthochromatic film because of the way it reads and reduces colour. Destiny dreamt up and took the photos and proposed and directed most of the scenarios for the video, which Virginia shot and edited. Destiny had the idea for the snow dome and Virginia made it work. That's the mechanics of it.

But the other things that go into it result from what we've each been separately thinking, doing and reading; our awareness of current events and our personal histories in contact with each other and anyone else we're working with; materials, media and the occasion or opportunity for making and showing work.

The empty space in the installation is as important to us as the objects in it. When anyone walks into the space they're absorbed into it and, visually at least, become part of the work, instead of getting in the way of it. It was exciting when a serious and respectable-looking older woman standing with her friend in *Colour blinded* in Paris clapped her hands and laughed and asked in French, 'Are we alive or dead?' Part of the point of the lights is always the same: the somewhat sinister thrill of the change they make to whatever and whoever is in their range, and the way they illustrate that how you look at things – literally the light you see them in – affects what you see.

Kelly Gellatly

On entering Destiny Deacon and Virginia Fraser's installation *Colour blinded* 2005, the eyes of the viewer are literally assaulted by the acidic yellow hue that bathes the exhibition space in a sickly, perception-altering glow. Calling to mind the heightened visibility and slightly surreal ambience of the roadside construction areas that employ this type of industrial lighting (experienced as bright, confronting blips as one speeds by on a freeway), or art world parallels in the work of Dan Flavin or Bruce Nauman, this created environment is at once unsettling and strangely revealing. For the intensity of the light in *Colour blinded* transforms the gallery into a space of surveillance, one in which it seems that our movements and actions are monitored and assessed, and in which the act of looking – and being looked at – is central. Similarly, as the space fills with the accusatory tone of the dialogue that emanates from the DVD *Good golly miss dolly* – 'What are you looking at?', 'What are you doing here?' – we also realise, as audience, that we have been cast in the role of both interloper and conspirator.

Since the beginning of her career Deacon's photographs have been peopled by a ragtag assortment of dollies and gollies that obediently perform for her camera, bringing in turn pathos, tragedy, violence and, importantly, humour to their roles within her improvised and deliberately low-tech images. In *Good golly miss dolly*, Deacon's niece Sofii, who is at once animated, disaffected and bored, unpacks a collection of golliwogs from a cardboard cylinder, laying them out for inspection before her on the floor. As the jolting camera surveys the golliwogs' faces, panning in and out on their wide, constantly surprised expressions, it creates a disorienting sense of disconnect, which is further reinforced by another sequence in which two dolls hurtle down a slide, their little bodies making a dreadful 'thwacking' sound as they fall to the ground. Just what is going on here?

As photographs such as *Baby boomer* 2005 and objects like *Snow storm* 2005 attest, Deacon's work ambiguously plays out the complex history and present realities of Australia's race relations; a reality (as the high-keyed context of *Colour blinded* makes

patently clear) in which we, as either individual or nation, are totally implicated. In *Snow storm*, Deacon and Fraser have stuffed a display case with golliwogs and filled it to capacity with white beanbag balls. While this work can be interpreted, at the outset, as a light-hearted swipe at museological practice, these innocent toys are trapped and suffocated by the polystyrene balls that are supposed to protect them. This very public display of knitted folk – the case exhibited on a plinth like a classical sculpture – reinforces the conflicting feelings of vulnerability and resilience that pervade the work. As Geraldine Barlow has noted, the emphasis on looking and display in *Colour blinded* reflects the unrealistic and highly public expectations that are placed upon contemporary Indigenous artists, particularly the assumption that they will automatically (and willingly) act as cultural ambassadors:

> Indigenous artists are at the coalface in the much contested national struggle for healing and understanding, as a vanguard they carry the hopes and aspirations of their own people, and the nation as a whole. We look to indigenous artists for national self-knowledge and the opportunity to make amends for past oversights. We also look to indigenous artists to display what it is that makes us uniquely Australian on an international stage.[1]

Deacon's practice steadfastly refuses to take on this position and responsibility but she nevertheless continues to confront her audience with works that initially disguise their hard-hitting and at times confounding content in a cloak of 'blak' humour. However, while photographs such as *Pacified* and *Back up* engage the artist's characteristic team of kitschy Aboriginalia in scenarios that point to Australia's complacency, ignorance and denial of its Indigenous population, the narrative that unfolds across the suite of photographs of the artist's brother John Harding and his bedraggled doll companion is far more open-ended. For when seen against the various other components of the *Colour blinded* installation, the poignant and somehow tender relationship of this unlikely couple, together contemplating a horizon filled with Melbourne's skyline, seems to suggest (or perhaps hope for?) a space of different possibilities.

PHOTOGRAPHS ON PAGE 88

MAIN IMAGE: Virginia Fraser and Destiny Deacon, Melbourne, 2007, photograph by Sofii Belling CLOCKWISE FROM RIGHT: Fraser and Deacon, National Gallery of Australia, Canberra, 2007, photograph by Brenda L. Croft; Fraser and Deacon, Hotel de Ville, Paris, December 2005, photograph by Brenda L. Croft; Fraser and Deacon, Brunswick, Melbourne, 2006, photograph by Brenda L. Croft; Fraser viewing video installation, National Gallery of Australia, Canberra, 2007, photograph by Brenda L. Croft

1 Geraldine Barlow, 'Destiny Deacon', in *NEW05*, exhibition catalogue, Melbourne: Australian Centre for Contemporary Art, 2005, p. 44.

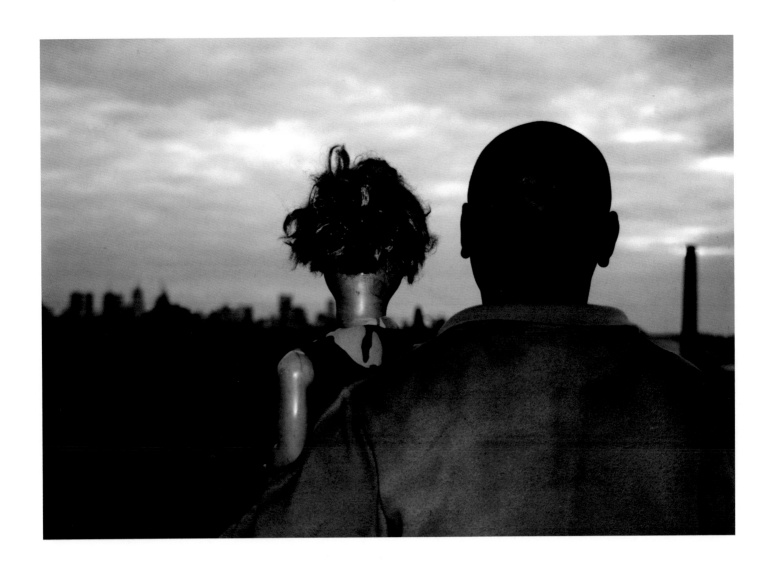

Destiny Deacon *Man and doll (c)* from the series *Colour blinded* 2005

Destiny Deacon and Virginia Fraser *Colour blinded* 2005

Destiny Deacon and Virginia Fraser *Good golly miss dolly* from the series *Colour blinded* (film still) 2005

JULIE
DOWLING

I painted Walyer gesturing towards a group of colonial houses
in the distant right. The moon shows light from behind the
clouds, outlining her cloaked body as she holds two guns.
She is gesturing to the viewer as if they were one of the fighters
she has assembled to battle the colonial encroachments upon
their land and hers.

There is a road carved into the trees under the distant
mountains leading to the houses, which have smoke coming out
of their chimneys, signifying their occupancy. Walyer stands in
action, holding a fowler's rifle with a small flintlock pistol held
in the belt around her skirt. She wears a *bookah* (kangaroo cloak),
a shell necklace and clay ornamentation covers her hair.[1]

Carol Dowling

People in my community believe artists are our diplomats to the wider world. My *nurrumba* (sister) Julie Dowling confronts complex issues about native title, internalised racism, social/spiritual/cultural degradation and the devastating destruction of our natural heritage. She also confronts the far-reaching legacy of the brutal oppression of Aboriginal people in Australia, which continues in the Stolen Generations who were wrenched from their families and society. Nothing speaks more about the moral nature of Australians than how they deal with this devastating holocaust.

Since 1996, the Howard Government remains the chief obstacle to the dream of Aboriginal self-determination. Our Indigenous artists, writers and performers formulate their work as dissertations about the struggle for the freedom to live out our destinies. Since being declared human beings in the 1967 referendum, we have just begun to speak of our experiences in this land.

I know my sister's work very intimately, having witnessed her struggles for acceptance and expression throughout her life. Julie has always been a culture warrior for us all. She lures onlookers, both Aboriginal and *Wudjula* (non-Aboriginal person), into her world. Any spectator becomes integral to the dramas she courageously depicts, and part of a complex web of intimate spaces and relationships. The glances depicted in her images in turn create a dynamic where the viewer becomes the subject of the gaze. The expressions of the people in her paintings have unflinching power, even in the smallest look or gesture. Julie implores her audience to see through Aboriginal eyes, as oppressed peoples, to have compassion and respond humanely, and to celebrate our survival.

In 2006 Julie's exhibition *Widi boornoo* (wild message) paid homage to our historic warriors and resistance fighters. Aboriginal people must have the freedom to navigate our history of resistance, because the stories of these warriors have shaped our contemporary Aboriginal consciousness. We reach across the generations, trying to understand what happened to our people, feeling what we have in common with them and where we differ, so that we can see who we are and see what we might become. Despite our efforts, we see the dominant

cultural majority in this country disregard our oral histories as 'anecdotal evidence' or 'unreliable'. This is the luxury of the coloniser.

What is at stake in this disputed history is who can belong in this land, and the insecurity that many non-Aboriginal people feel in their relationship with Indigenous people. This is evident today in the Western Australian state government appeal against the Federal Court decision to grant native title to the Widi people over Perth: the government claim seeks to deny that the Widi have maintained community and that they continue to acknowledge and observe laws and customs relating to land passed down through time. In effect, this appeal seeks to extinguish the cultural identity of Widi people.

Julie has painted about the destruction and removal of the Burrup Peninsula rock art in the Pilbara region of north Western Australia, an act that has had widespread international condemnation. Traditional custodians do not want the Burrup developed at the cost of their cultural heritage; this area contains thousands of petroglyphs (carved rock art) believed to be up to 40 000 years old. The Nickel Company Woodside, supported by the Western Australian state government, has pushed ahead for a mine and has already removed forty pieces of this precious art since January this year. It is only a matter of time before Australia will be viewed in the same light as the Taliban, who blew up the monumental Bamiyan Buddhas in Afghanistan.

Have the souls of our people been crushed? In Western Australia, Aboriginal people are 41.9 per cent of the prison population although we comprise only 2.5 per cent of the overall population. Aboriginal people are constantly targeted by the police for minor offences, are demonised by *Wudjula* society, disempowered and denied self-determination. Our babies continue to be taken from us and we are dying younger every year. With every breath, we wish to remain sovereign peoples. We struggle to maintain our languages, our customary law and our oral traditions. With the ratification of the Universal Declaration of the Rights of Indigenous peoples, we dream that the world will hear our call for justice and freedom as the oldest living culture on the planet.

PHOTOGRAPHS ON PAGE 94

MAIN IMAGE: Carol and Julie Dowling, Perth, December 2006, photograph by Brenda L. Croft CLOCKWISE FROM BOTTOM RIGHT: Julie and Carol Dowling, Perth, 2007, courtesy of Carol Dowling; Julie and Carol Dowling with Mollie and Rocky the dog, Perth, 1969, courtesy of Carol Dowling; Julie and Carol Dowling, and Brenda L. Croft, Perth, 2003, photograph by Stephen Gilchrist; Julie Dowling and her grandmother, Mollie Dowling (née Latham), 2007, courtesy of Carol Dowling

1 Story for *Walyer* 2006.

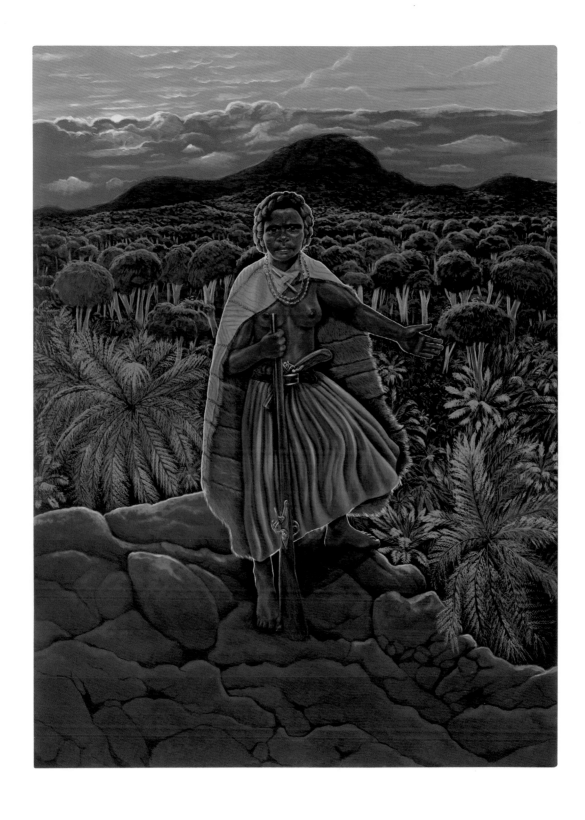

Walyer 2006

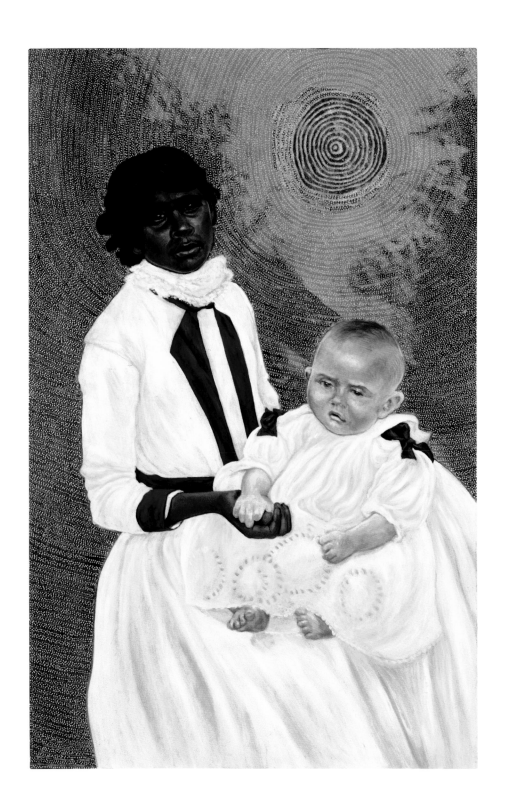

The nurse maid (Biddy) 2005

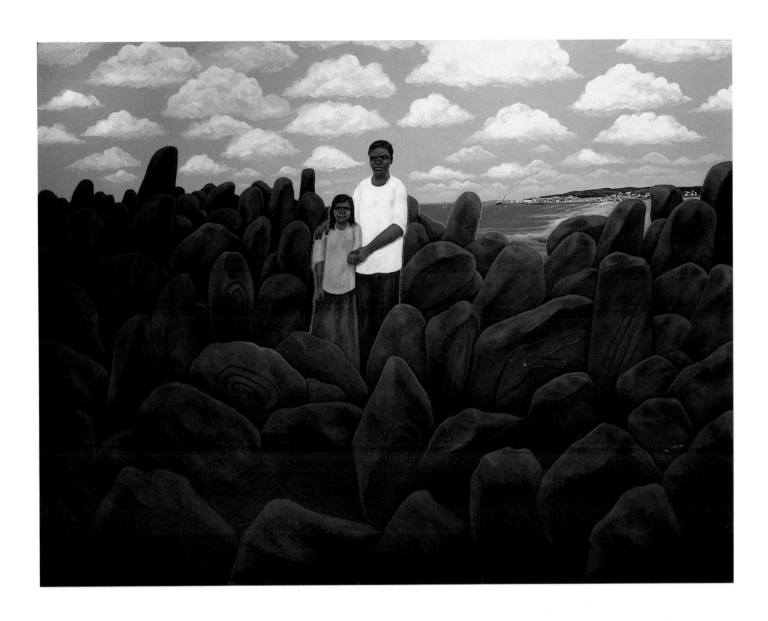

TREAHNA
HAMM

As an Indigenous artist, the sharing of stories and making of art promotes a growth of understanding and a continuation of our culture. Art also supports dialogue and helps people to heal, by creating bonds between individuals and communities, through the linking of identity, land, people and places. Telling our stories and making our art regenerates the past, the present and the future.

When I make art, I delve deeply into who I am. I get inside the questions which reflect individual narratives as well as total community experience. Whatever I learn through historical or cultural knowledge reveals something to me about myself. There is a drive in finding out and in creating. Where I create is a safe space. Going deep within me is a point of pure creation, where there are no words. There is no sound, no smell, and no touch – just the personal experience. Everything I produce is like little pieces of my soul entwined from different experiences I have had.

I commenced art school in 1982 when visual art content was based on mainstream artists and their experiences; I later discovered Boomalli Aboriginal Artists Co-operative Ltd in Sydney and that my art and its themes were reflected in the work of other Indigenous artists. In 1988 I began my journey back to my Indigenous family to reconnect with my cultural history. This was achieved in 1992. Creating art is important to me as it connects me, my art and my family together.

The work of Indigenous artists nation-wide, both traditional and urban, can fill a void that has existed for so long in Australian society; it can tell the 'collective' experience of our people. Indigenous history and culture has never been taught through Indigenous experiences, thoughts and stories. Indigenous art sustains and continues the very long history of this land. The storytelling of culture through art is a means to redress and balance the telling of Australian history.

Stephen Gilchrist Yorta Yorta artist Treahna Hamm was born in Melbourne in 1965. Her customary lands are along the Murray River around Echuca, in northern Victoria. From an early age Hamm has been inspired by the Murray: the stories it cleaves to, the ancestors residing there, the animals it harbours. A renowned printmaker for over fifteen years, Hamm has also been active in the resurgence of making *biganga* (possum-skin cloaks).

Nestled along the cool waters of the Murray River floodplain, Barmah Forest is a site of enormous cultural significance to the Yorta Yorta people. With evidence of ancient middens, canoe trees and burial sites, the forest is testament to thousands of years of Aboriginal tenure and custodianship.[1] Suffused with the intense spirituality of place, on the inside of the immaculately prepared possum-skin cloak, Hamm has depicted the Barmah Forest and the meandering path of the Murray River. Populating this landscape is the Yorta Yorta totem, the long-necked turtle, the broad clawed yabby and the Murray Cod. Materialising from the river are the slender forms of sentinel-like Spirit Beings reaching out tenderly in contrary motion, seemingly guiding and welcoming visitors home. Celebrating this powerful site and its spiritual custodians, Hamm avows her own connection to this country and explores its regenerative possibilities. She also invests the site with intense political significance, eloquently contesting Justice Olney's patently false comments in the Yorta Yorta Native Title Claim that the 'tide of history had washed away' Yorta Yorta people's connection to their land and that it was 'not capable of revival'.[2]

The revival of evanescing customary practices has been fundamental in Hamm's practice, and the art of making cloaks from possum-skin pelts sewn together with kangaroo sinew is rapidly being revitalised and renewed in Victoria and parts of New South Wales. Specific to south-eastern Australia, possum-skin cloaks were ubiquitous *quotidian* objects used for clan identification, as slings for cradling babies, blankets for warmth and bedding, burial shrouds for the deceased and even making music in ceremony.[3] In 1999, Hamm and fellow Yorta Yorta artist Lee Darroch, with Kirrae Wurrong/Gunditjamara artists Vicki and Debra Couzens, resolved to revive this tradition by reproducing the two nineteenth-century possum-skin cloaks still extant in Australia and held in the collection of Museum Victoria.

The first collaborative *biganga* that Hamm created was a faithful reproduction of a Yorta Yorta cloak collected from Maiden's Punt in 1853.[4] Liaising with community representatives, museum staff and Indigenous artists, and poring over historical records, Hamm learnt the arduous craft of cloak making. Synchronous with this technical expertise was the successful identification of the hitherto unknown meanings of many of the designs incised into the original cloak. Hamm's practice draws heavily not only on listening to the teachings of elders, but also listening to the voices in the land.

In 2001, Hamm and Indigenous elders from around Victoria participated in a weaving workshop facilitated by the celebrated weaver Yvonne Koolmatrie, at Gas Works in Melbourne. Recognising the importance of educating through the stories of the weavings, Hamm's aim was to create animals and objects evocative of the Murray, revealing the palimpsest of Yorta Yorta history. By giving life to these woven articulations, Hamm gives life to the 'myriad of stories not yet told in Australian history.'[5] Hamm's whimsical woven *Yabby* 2005 demonstrates her command of the coiled bundle technique of Indigenous weaving, and despite the exaggerated size of the crustacean, sensitive detailing is not sacrificed and the artist highlights its irresistible tactility.

Unerring in her commitment to reigniting customary practices, Treahna Hamm's work, irrespective of the media used, cherishes and replenishes cultural traditions. Yoking together her knowledge of Yorta Yorta history and her intuitive artistic verve, she produces work of aesthetic, cultural and political power. For Hamm, the creation of works of art resonant with cultural memory is a pressing imperative. It inscribes her indelibly in the physical and spiritual worlds of the Yorta Yorta, strengthens cultural associations, and ensures that which was nearly lost is never lost again.

PHOTOGRAPHS ON PAGE 100

MAIN IMAGE: Treahna Hamm wearing *Barmah nurrtja biganga (Barmah Forest possum-skin cloak)*, Melbourne Museum, 2006, photograph by Rodney Start CLOCKWISE FROM RIGHT: Hamm and friend at the opening of the Melbourne Commonwealth Games, 2006, photograph by Wayne Quilliam; Hamm at NAIDOC Week workshop, National Gallery of Australia, Canberra, 2006, photograph by Brenton McGeachie; Hamm in her studio, 2006, photograph by Wayne Quilliam; Hamm at NAIDOC Week workshop, National Gallery of Australia, Canberra, 2006, photograph by Brenton McGeachie

1 Parks Victoria, viewed 10 March 2007, parkweb.vic.gov.au.

2 Quoted in Amanda Jane Reynolds, *Wrapped in a possum skin cloak,* Canberra: National Museum of Australia, 2005, p. 51.

3 Reynolds, p. 14.

4 Reynolds, p. 1.

5 Interview with Stephen Gilchrist, by email, Saturday 10 March 2007.

Barmah nurrtja biganga (Barmah Forest possum-skin cloak) 2005

Yakapna yenbena dungudja nyinidhan biganga (Family ancestor strong fight possum cloak) 2007

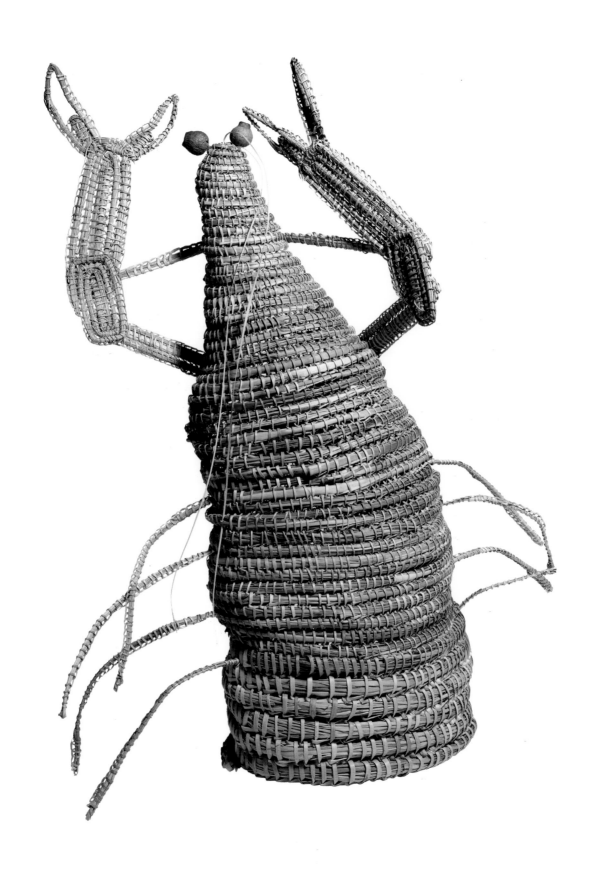

Yabby 2005

105

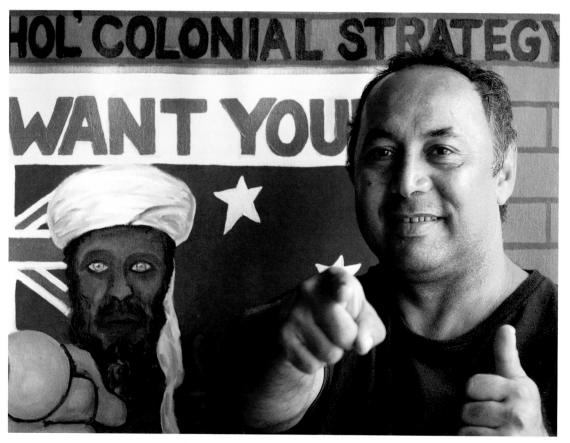

GORDON
HOOKEY

A while ago I was asked to do some work about the Chris Hurley[1] case. Because I wasn't directly involved I decided to do a more general painting on black deaths in custody. This is it: *FIGHT: To Survive; To Live; To Die!*

My first thought was to depict a subversion of events. Instead of a blackfella being beaten by the cops, here, you've got the cops being beaten by a blackfella. My central figure is the key to this painting: an image of resilience, of fighting back against the odds.

The boxing tent to the left refers to a history of blackfellas fighting in Australia. Here I use it as a sign of empowerment with the blackfellas as heroes and the redneck crowd as villains. The left panel shows the faces of the rednecks. Like criminals, their faces are obscured by stockings. This obscurement refers to how racism can be masked or institutionalised. It's a kind of crowd mentality.

The crow on the right of the central panel refers to the spirit of blackfellas who have died in custody, ascending from the jail cell. To its right, the dove symbolises the resting place of those spirits: a place of freedom and peace.

As for the global symbol, I've used this in the past. Global decisions impact on us locally, such as multinational companies drawing resources from Indigenous lands. It's a reminder that the fight is not just against crooked cops.

Timothy Morrell

In 2005 Gordon Hookey won the Deadly Award for Visual Artist of the Year. Serious artists are never overly concerned about trophy hunting, but this wasn't an ordinary art prize. The Deadlys are awarded by an Aboriginal media and management company to celebrate Indigenous achievements in popular culture and the community. Hookey's Deadly was an acknowledgment that his work is not only respected by institutional tastemakers but also appreciated and enjoyed by other Indigenous Australians.

Hookey sees himself as operating at the interface between black and white society in Australia, and by doing so he is implicitly stating that they are separate entities. The interface between them is not always a place of easy interaction.

Hookey's imagery is often extreme, sometimes violent or scatological, and nearly always monstrously funny. He depicts contemporary Australia in ways that are reminiscent of the way George Grosz used images of bloated capitalists and human mutilation to evoke Germany's Weimar Republic during the 1920s. Rather than borrowing from Grosz, however, Hookey shares a common source with that artist: the urgent and caricatured style of protest art. He doesn't see himself as an angry or bitter artist. He just wants to get a message across. His use of metaphor – emblematic native and introduced animal species and other symbolic and fictional figures – is a way of making strongly radical statements without cutting all the way to the bone.

Social and economic factors make it difficult for Indigenous artists everywhere to control the distribution and sale of their work, but artists who live within their traditional culture can at least have absolute control over their visual language. Non-Indigenous curators and collectors can never fully understand what all those dots and circles mean, we just like them. For city artists the situation is different. Organisations like Boomalli give them more direct control over marketing, but because they participate in the same intellectual milieu as every other urban Australian artist, ownership of their visual language is much harder to establish.

This is where Gordon Hookey has made such a valuable contribution to Australian art. His work speaks the same inventive, ribald, disorderly language

as thousands of Indigenous people in Australian cities and towns who would otherwise not have a voice in the hallowed halls of high culture.

Hookey received conventional training as an artist and graduated from the University of New South Wales College of Fine Arts in 1992. He draws carefully and well, so the underlying structure of his pictures is far more considered than the finished results might suggest. Conflict and chaos seem to be central to the meaning of everything he produces, and he specifically refuses to provide simple answers to complex problems. Nevertheless, the improvisational, ad hoc nature of his work develops within a planning process that allows things to look as though they're getting out of control. Trained as a sculptor rather than a painter, he produces three-dimensional works (such as his installation for the 2004 Biennale of Sydney) that add an intrusive physical presence to the startling effects of raucous colour and terse verbal commentary.

A conflict between two forms of expression, verbal and visual, is part of his working method. The text that is usually emblazoned across his paintings is always done freehand, but in the same soberly sans serif typeface as the stencil perforations on the clear plastic rulers used for drafting (he has a background in technical drawing). This gives the words a tone of authority, often contrasting ironically with the jokes and obscenities that the words convey.

Hookey's art means different things to different people. He is genially accepting of the widely varying interpretations that viewers from differing racial, social and cultural backgrounds give to his work, from ideological ferocity to slapstick humour. His impact is largely due to the fact that he never conveys a simple or obvious message. He is not involved in straightforward political sloganeering. He has the ability to capture the full-on intensity of a street chant while holding the viewer's attention with intriguingly complex details and multiple oblique references.

This is a painted equivalent of the joke-cracking, word-mangling narrative style shared by Kooris, Murris, Noongars and other Indigenous people all over Australia. Quite often a white audience just isn't going to get it. As with the traditional abstract symbolism of desert art that has captivated and mystified the rest of the world, Hookey's paintings are actually talking to somebody else.

PHOTOGRAPHS ON PAGE 106

MAIN IMAGE: Gordon Hookey, courtesy of Sonia Payes and Charles Nodrum Gallery
CLOCKWISE FROM RIGHT: Hookey, courtesy of Sonia Payes and Charles Nodrum Gallery; Gordon at proppaNOW studio working on *FIGHT: To Survive; To Live; To Die!*, Brisbane, 2007, photograph by Eric Meredith; Hookey, H. J. Wedge and Brenda L. Croft at Boomalli Aboriginal Artists Co-operative Pty Ltd, 1993, photograph by Jason Mumbulla; Hookey and Judy Watson, Brisbane, February 2007, photograph by Brenda L. Croft; Gordon at proppaNOW studio working on *FIGHT: To Survive; To Live; To Die!*, Brisbane, 2007, photograph by Eric Meredith

1 Senior Sergeant Chris Hurley was the arresting police officer of Mulrundji Doomadgee, who died in police custody on Palm Island, after being arrested for drunk and disorderly behaviour in November 2004.

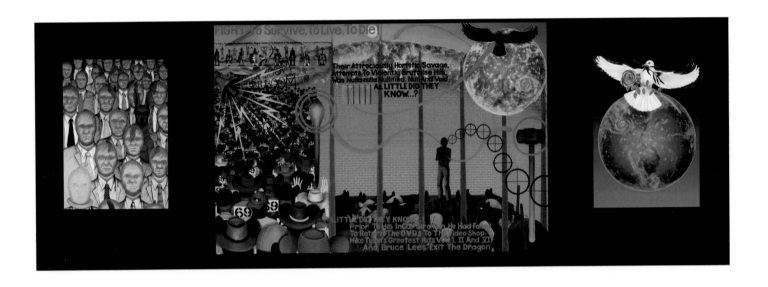

FIGHT: To Survive; To Live; To Die! 2007

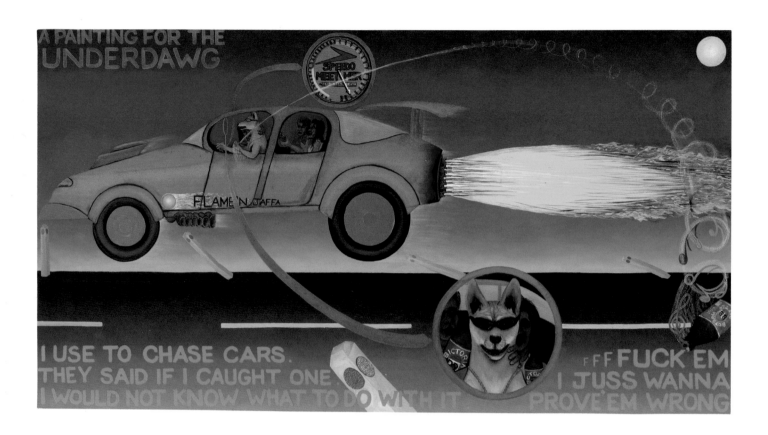

A painting for the underdawg 2005

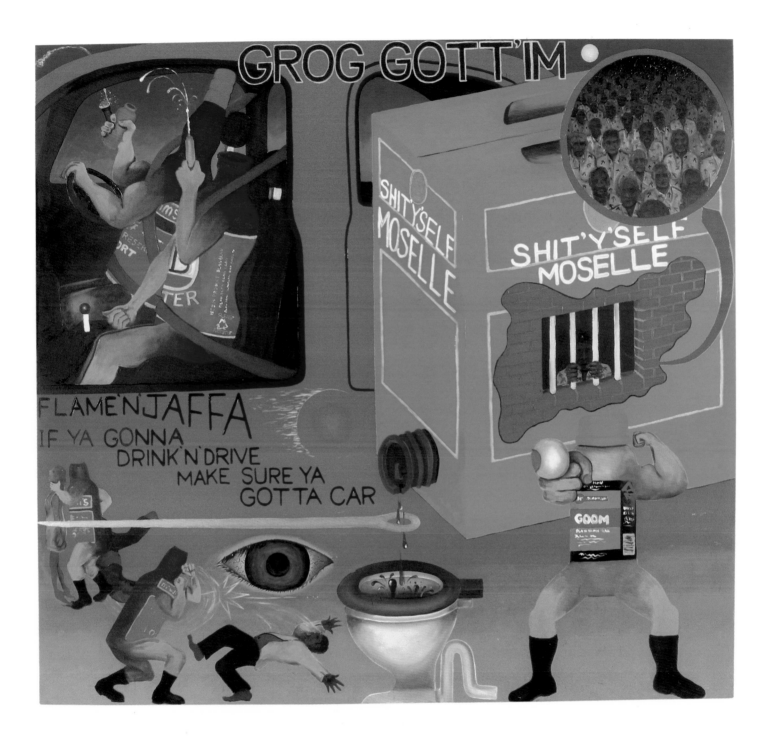

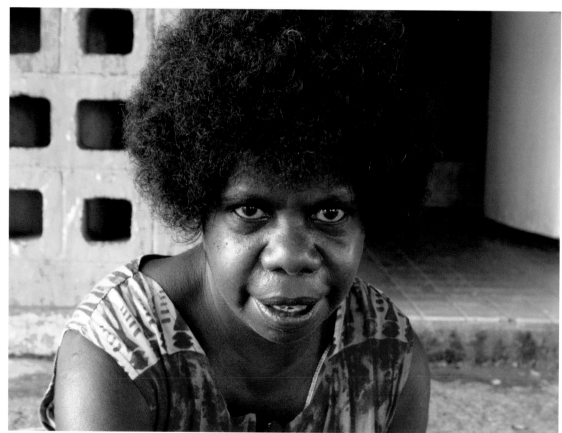

ANNIEBELL MARRNGAMARRNGA

I learnt how to weave from my mother, Nancy Djulumba, who passed away a long time ago [1995]. I first made coiled baskets, twined bags and string bags. I then learned how to paint from my husband [Dick Nadjolorro].

My favourite subject is to represent the *yawkyawk* spirit who lives in the water at Kubumi. It is my husband's Dreaming. I represent her in my bark paintings, in my timber carvings and also in my weaving.

I came with the idea to make flat *yawkyawks* from pandanus [*Pandanus spiralis*]. My husband helps me to build the bamboo frame and I then weave with colourful pandanus in the same technique I used when making twined bags. I use lots of different colours and I like it. Colours are important in my work.[1]

Simona Barkus

Anniebell Marrngamarrnga is a Kuninjku woman from Maningrida, in western Central Arnhem Land. Her moiety is Yirritja and subsection Bangardidjan. In her work Marrngamarrnga frequently depicts animals such as the crocodile that lives at Kubumi, and most often the *yawkyawk* spirit.

In the Kuninjku/Kunwok language of Western Arnhem Land *yawkyawk* means 'young woman' and 'young woman spirit being'. The Kuninjku people have various *yawkyawk* stories, which relate to specific locations in clan estates. *Yawkyawk* are female water spirits who live in freshwater streams and rock pools, and are usually described and depicted in bark painting, sculpture and some rock art, as having the tail of a fish and long hair (associated with trailing green algae, *man-bak* in Kuninjku). There are interesting parallels with the European (and other) mythology around mermaids.

In Kuninjku mythology the creation ancestor *yawkyawk* travelled the country in human form and changed into spirit form as a result of ancestral adventures. Certain features of country are equated by the Kuninjku with body parts of *yawkyawk*, for example, a bend in a river or creek may be said to be the tail of the *yawkyawk* or a billabong may be said to be its head. Like much ancestral and creation mythology the *yawkyawk* stories link clans and language groups across country.[2]

The people of Arnhem Land are well known for their beautiful fibre objects, which are an important part of everyday and ceremonies. The fibre art of Maningrida is some of the finest in Australia; its forms and techniques have been around for many thousand of years and that knowledge has been passed down through generations. Some of the distinctive fibre objects of the Arnhem Land region are coiled baskets, dilly and string bags, fish traps and mats, most of which are made by Aboriginal women.

The activity of making fibre objects is a very social one, involving women and children in the community. The most commonly used fibre is the pandanus (*Pandanus spiralis*). For weaving, the only part of the pandanus collected is the new leaf growth found at the top of the tree, which is only in season at certain times of the year, usually during and several months after the monsoon season. The natural dyes used are collected from the roots, leaves, berries and barks of local flora. The process of collecting fibres and native dyes, and then dyeing and drying the fibres takes days.

Marrngamarrnga uses a combination of colour and pattern in her work, often featuring reds, purples, oranges and white to create contrasting patterns and shapes that complement the woven form. The *yawkyawks* begin as a bamboo frame with strips of pandanus leaves finely woven from the outside in, until segment by segment the body and features are created. Many of Marrngamarrnga's forms are quite large, demanding much time and skill.

Marrngamarrnga's fibre art is innovative, playful and stunning. Her woven sculptures breathe new life into the rich traditions of her Kuninjku culture, bringing it to a world audience.

PHOTOGRAPHS ON PAGE 112
MAIN IMAGE: Anniebell Marrngamarrnga, Maningrida, 2007, photograph by Apolline Kohen
CLOCKWISE FROM BOTTOM RIGHT: Marrngamarrnga and Apolline Kohen, Maningrida, 2006, photograph by Brenda L. Croft; all other photographs Marrngamarrnga, Maningrida, 2007, by Apolline Kohen

1 Anniebell Marrngamarrnga, interview by Apolline Kohen at Maningrida Arts and Culture, 12 February 2007.

2 Information on *yawkyawk* stories from Murray Garde and Christine Kellor, provided by Apolline Kohen, Maningrida Arts and Culture, 2007.

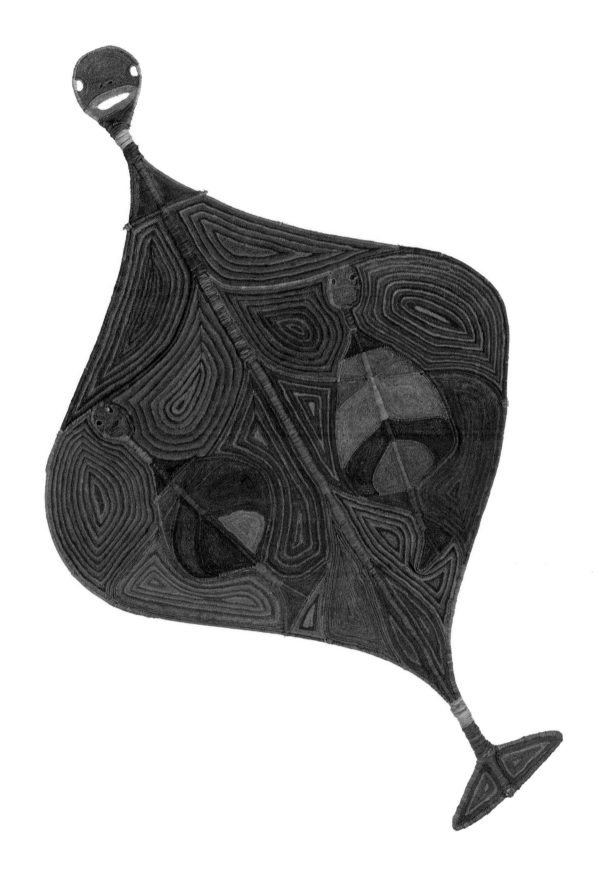

Yawkyawk mother and babies 2006

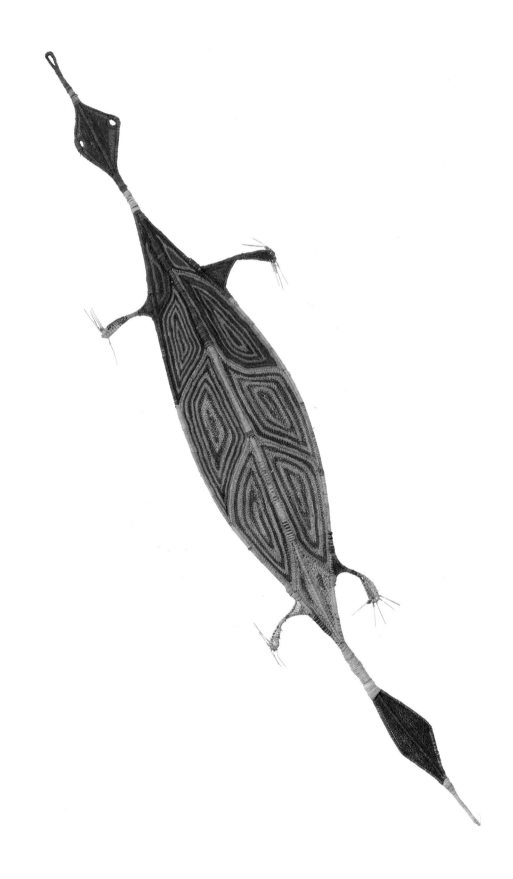

Crocodile 2007

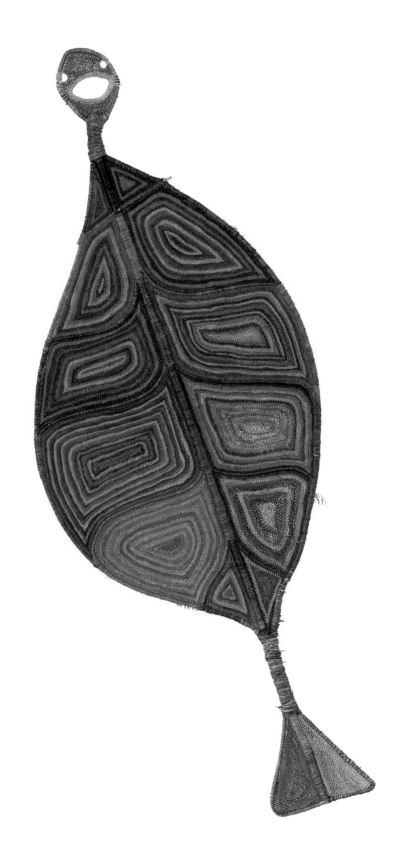

Yawkyawk 2007

RICKY MAYNARD

I am by nature a deep thinker, yet find it hard
to articulate my thoughts, although sometimes
I go overboard.

I know you should not tell people too much,
but this work has a very clear intent anyway –
of re-claiming our own.

The truth really is about an honest interpretation.[1]
Ricky Maynard, 2007[1]

Keith Munro

What do you see when you look into Ricky Maynard's photographs? Do you see the incredible attention to detail in the work of a tremendously gifted and dedicated picture-maker, or perhaps the technical mastery and passion of an artist who has remained loyal to the tradition of large-format photography? Maybe you see the unique cultural presence in Maynard's works that gives them a layered complexity and challenges the perspective of the viewer.

Maynard's practice is skilled, considered and culturally charged, and in *Portrait of a distant land* the work seems intensely personal and critical on a number of levels. This series of photographs traces the modern evolution and adaptation of the ancient living culture of Aboriginal people in Tasmania alongside recent European settlement, in the context of the frequently violent interaction between the two cultures.

Maynard is a member of the Big River and Ben Lomond tribes of Tasmania, and his work is about the history of his people. He tells their stories as a way of honouring them and affirming the maintenance of local Aboriginal cultural practices. His photographs are indeed *portraits*: of people, and of places; more than mere documentation they illuminate local Aboriginal history. In his first body of work, the *Moonbird people* 1985–88, Maynard depicted a Tasmanian Aboriginal community from the Bass Strait during the annual muttonbird season. In *Portrait of a distant land* Maynard shows the physical and social landscape of his people through songlines, corner stones, petroglyphs, massacre sites, middens, meeting places, sacred sites and cultural practices, in a combination of visual diary and oral history. The works question the ownership of land and history. Recognising that the history represented in Australian cultural institutions is largely written – and pictured – by the dominant colonising European culture, Maynard invites audiences to understand things from a different perspective, that of the first Tasmanians. He asserts:

> We now tell our own history. Picking that up and carrying forth.[2]

Each image in *Portrait of a distant land* is juxtaposed with personal, poignant and insightful words by revered members of the Tasmanian Aboriginal community, who have maintained and upheld local cultural heritage. Maynard believes strongly in maintaining cultural integrity in his practice, and he sees the process of picture-making as collaboration with his subjects.

In *The healing garden, Wybalenna, Flinders Island, Tasmania* and *Death in exile, Wybalenna, Flinders Island, Tasmania* both 2005, Maynard portrays two sides of the human condition by showing two important aspects of the same place: Wybalenna on Flinders Island. Here is both life and death. The pictures are about remembering both the bad and the good: Aboriginal people living in exile because of conflict and broken promises, yet, perhaps most importantly, revealing the ability to heal. *Vansittart Island* 2007 depicts another site of exile for mainland Tasmanian Aboriginal people, where there is evidence of their graves, subsequently raided by Europeans in the name of research. This culturally insensitive, indeed barbaric, practice is controversial yet sadly continues today.

The first four images in Maynard's *Portrait of a distant land* were completed in 2005 to wide acclaim, and were subsequently produced as billboards around Sydney train stations and freeways as part of an exhibition at the Museum of Contemporary Art, Sydney, *Interesting times: focus on contemporary Australian art* (22 September to 27 November 2005). This high-visibility project was later included in the Busan Biennale (Korea) in October 2006 and Ten Days on the Island (Tasmania) in March 2007. The title of the series highlights the artist's desire to create a body of work that is considered and true; a portrait, by definition, is an honest and genuine attempt to portray a person, place or subject matter. Maynard presents important aspects of Aboriginal history, of a people largely ignored or defined by romanticised stereotypes that persisted through to the late 1970s and early 1980s, when their continued existence was still in dispute.

Maynard's images do more than welcome us to aspects of his culture; they show the maintenance of Aboriginal cultural practice and challenge audiences to view our shared history and country with empathy and with greater understanding.

The works in *Portrait of a distant land* make a very powerful statement.

PHOTOGRAPH ON PAGE 118

MAIN IMAGE: Ricky Maynard, 2007, courtesy of the artist
BOTTOM RIGHT: Ricky Maynard *Broken Heart* 2007

1 Interview with Keith Munro, 2 March 2007.

2 Maynard, interview.

Coming Home 2005

The Spit 2007

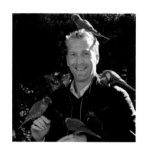
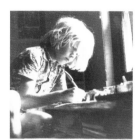
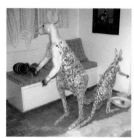

DANIE MELLOR

There are two bodies of work in this exhibition: a series of shields and an installation that recalls a 'naturalistic' diorama from a museum display.

Cut from travelling trunks, the shields in this series reference voyages, arrivals, departures, moving on, presence, displacement and adventure. Sculpted to the size and shape of rainforest shields from the Atherton Tablelands, their age and patina relate also to the incongruous buttoned-up Victorian identity that Indigenous women in our family projected in photographic portraits. The feminine identity of this western context dovetails with the matrilineal heritage of rainforest culture, where the shield is seen as a feminine object.

The diorama is representative of 'museum theatre' and the spectacle of the curious, the collected, the displayed. The simulation of reality, the re-telling of stories, the topographical (on the surface) representation of culture and landscape through objects, is exemplified through inert and lifeless, constructed, animals. Yet the animals do have life; they do convey a sense of reclamation, of reconstruction, of spirit in an Indigenous land.

The blue and white designs that comprise the china mosaic suggest both commodified stories retold through an art form – ceramics and transferware – that was industrialised in the eighteenth century, and fables that depict the exotic and fantastic, the Oriental and the Other in faraway places. This period of western intellectual thought and industrial expansion also brought forth theories of evolution that attempted to rationalise and 'scientificate' the natural order of nature and humanity.

Nature is intrinsically connected to the spiritual, and cannot simply be bound by a cool and detached framework of intellectual theory or observation. The imposition of purely scientific theory in natural history as the only explanation for the breadth of creation was (is) anathema to any living culture and humanity connected to the land, and anaesthetises our connection to that which lies beyond: the invisible.

Maurice O'Riordan

Arabunna elder Kevin Buzzacott's removal of the Australian coat of arms from Canberra's Old Parliament House site in 2002 was a brazen act of protest, one for which he was eventually found guilty of 'theft' in Australian whitefella law. As an act of protest and provocation, however, Buzzacott certainly made his point – that it was indeed he who was provoked by the denial of Aboriginal sovereignty and spirituality implicit in the misappropriation of the kangaroo and emu.

Danie Mellor may not be so bold as Buzzacott in his antics but both the artist and activist reveal a similar spirit of provocation and reclamation, in this case realised through their focus on native fauna, most notably the kangaroo. The kangaroo has been a central and familiar motif in Mellor's art, initially appearing in the meticulous drawings and prints through which he first came to critical attention over a decade ago. In these works the kangaroo is both a symbol of Indigeneity and Australiana: the former speaks of Mellor's own connection while the latter, according to Mellor, belongs to the story of 'how Indigenous people were co-opted into plans of settlement'. In this regard, the co-opting of the kangaroo as the icon of national identity aims to legitimise colonisation and its core mythologies: *terra nullius*, Darwinism, Enlightenment. The presence of the kangaroo bound to these narratives is also the political absence, the voicelessness of Aboriginal people.

Part of the appeal of Mellor's earlier prints and drawings lies in his deliberate evocation of a colonial-style aesthetic, not so much a reclamation as a subversion of the colonial tools of trade. The illustrative tools for botanical and ethnographic science are for Mellor a means of investigating the past and iconising certain representations of his North Queensland Rainforest heritage. As a printmaker, Mellor's preference for mezzotint is also politically inspired, as the discovery of this particular process coincided with colonial settlement in Australia.

In his research as a printmaker, Mellor came across the English company Spode, which revolutionised English ceramics with its use of hand-engraved copper plates to perfect blue underglaze printing and with its invention of fine bone china. The bone china became synonymous with the blue-and-white Willow pattern first adapted from Chinese patterns by Spode and other English firms in the late eighteenth century. Mellor recalls one early Willow design showing two kangaroos in an enclosure, apparently referencing an actual kangaroo breeding program in a Chinese zoo (that didn't get too far as the zoo had been sent two male kangaroos). It is just one piece in the curious mosaic-puzzle comprising Mellor's installation, which continues his critique of the ethnographic, museological and cultural construct. Signifying a moment of imperial reach (again contemporaneous with early colonial Australia), the Willow pattern appropriates Chinese mythology (a love story) for popular consumption. It is a visual trope of the 'Chinese whisper', the story and image so fragmented and bastardised through repetition and distortion that the original source no longer has currency.

Mellor's 'true blue'-and-white Willow wash shows just how enduring and embedded these whispers can become, perpetuated by the sheer force of numbers, status quo and blind, 'parroted' obedience. In his diorama-myth of national identity we are treated to new renditions of the kangaroo as it first appeared in his 2005 exhibition *Voyages of recovery or an ongoing catalogue with moments of reason from the cabinet.* They embody the process of cultural transplantation (and commodification), a travesty of nature or, at least, of totemic currency. Elements of the 'real' in the overall installation are the glimmer of authenticity needed to sustain such myths and processes, as well as Mellor's critical and often lyrical recasting of taxidermy to challenge notions of 'natural history' and museum display.

The groundbreaking exhibition *Story place: Indigenous art of Cape York and the rainforest* 2003 was a turning point for Mellor, coinciding with his own extensive cultural research and providing an important context where, for instance, his reclaimed metal shields could be appreciated alongside historical examples and other contemporary rainforest shields by Michael Boiyool Anning and Paul and Stewart Bong. Mellor's shields also provide an important context in this overall installation. Their origin in rusted travelling trunks may conjure an archaeology of dislocation, yet the shields also anchor Mellor's identity. They symbolise Mellor's Buzzacott-like resistance in this exhibition commemorating forty years since Aboriginal people first gained citizenship status, long after the official elevation of the emu and kangaroo.[1]

PHOTOGRAPHS ON PAGE 124

MAIN IMAGE: Danie Mellor, 2007, courtesy of the artist
CLOCKWISE FROM TOP RIGHT: Works in progress in Mellor's studio, 2007, photograph by Brenda L. Croft; Archival family portrait of Mellor's great-great grandmother Eleanor (Nellie) Kelly, unknown, and great grandmother May Kelly, Cairns, early twentieth century, courtesy of the artist; Mellor in his studio, Canberra, 2007, photograph by Ben Kopilow; Archival family portrait of Mellor's great-great grandmother Eleanor (Nellie) Kelly, Cairns, early twentieth century, courtesy of the artist; Mellor with birds, Canberra, 2007, photograph by Steven Murray; Mellor as a young child, Scotland, c.1979, photograph by Doreen Mellor

1 Kevin Buzzacott's removal of the coat of arms in 2002 was also a commemoration of thirty years of the Aboriginal Tent Embassy.

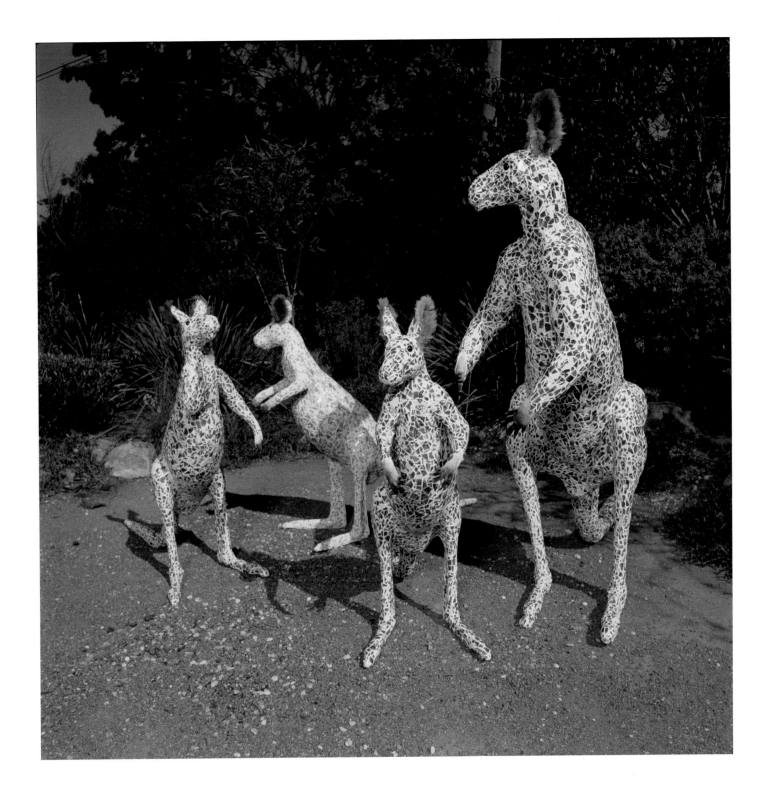

The contrivance of a vintage wonderland ... 2007

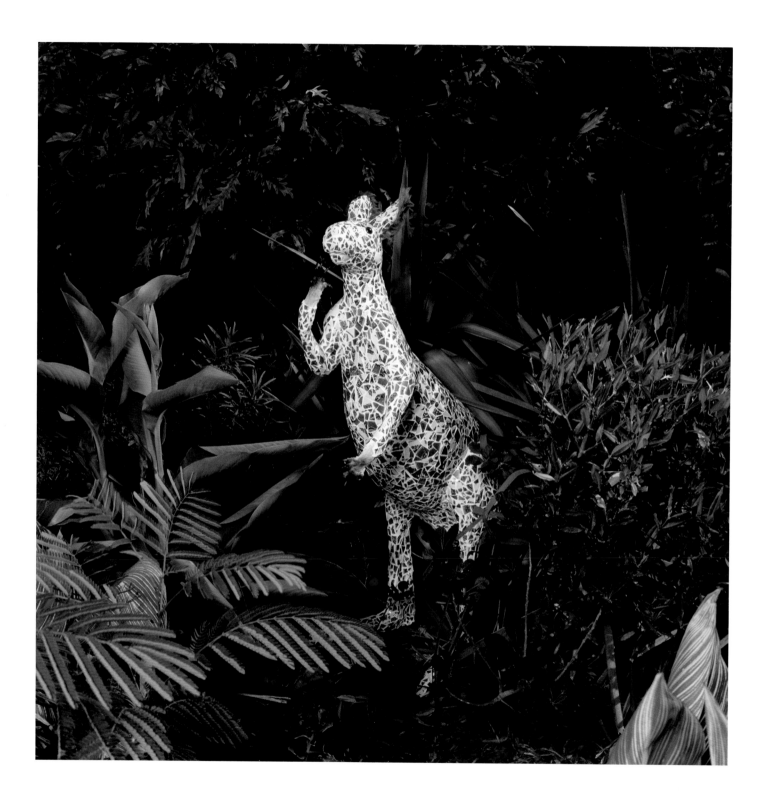

The contrivance of a vintage wonderland ... 2007

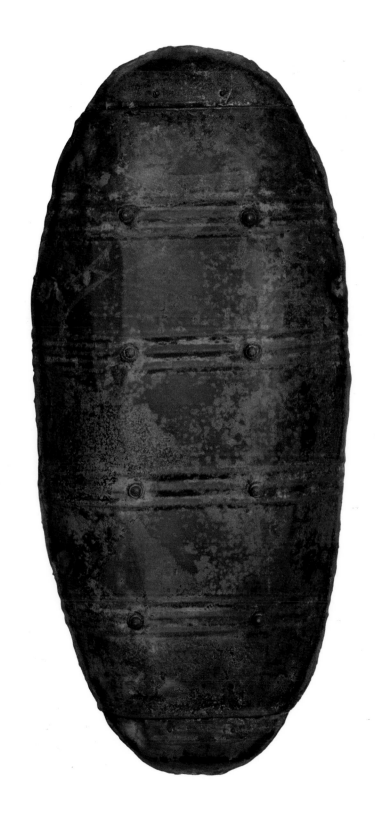

Of dreams the parting 2007

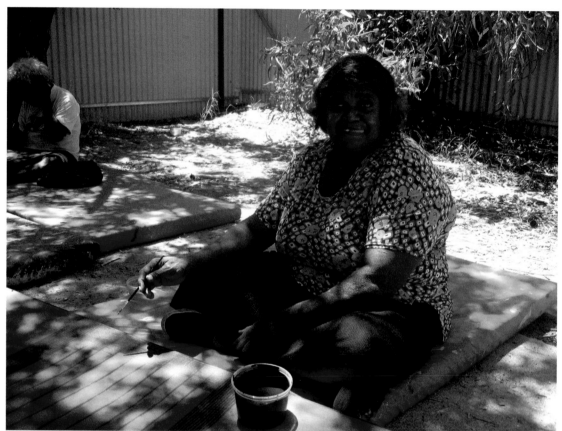

DOREEN REID NAKAMARRA

Marrapinti is the rock hole site west of the Pollock Hills in Western Australia.

Ancestral women of the Nangala and Napangati subsections camped at Marrapinti during their travels east. There, the women made nose bones, also known as *marrapinti*. During ceremonies relating to Marrapinti, the older women pierced the nasal septums of the younger women who were participating in the ceremony. Now, nose bones are only used by the older generation for ceremonies.

Upon completion of the ceremonies at Marrapinti, the women continued their travels east, passing through Wala Wala, Ngaminya and Wirrulnga, before heading north east to Wilkinkarra [Lake Mackay].[1]

Paul Sweeney

Doreen Reid Nakamarra was born near the Warburton Ranges in Western Australia in the mid 1950s. As a young girl she walked with her parents and other family members to the Lutheran settlement of Haasts Bluff, which had been serving as a ration depot since the early 1940s. Her family later spent time at the nearby community of Papunya, where she attended school. Following this they returned to the south-west to live at the Warburton community, enabling them to be closer to their traditional homelands. As a single woman, in the early 1980s Doreen travelled to Kintore, where she met her husband, George 'Tjampu' Tjapaltjarri, who later established himself as a painter with Papunya Tula Artists. They eventually settled further west at the small isolated community of Kiwirrkura in Western Australia, to be closer to George's country. George passed away early in 2005 but Doreen continues to live and paint in Kiwirrkura, occasionally travelling south to visit relatives in Warakurna and Warburton.

In 1996 Doreen was one of a small group of women in Kiwirrkura who painted their first works through Papunya Tula Artists. She was a very occasional artist from 1996 until 2000, producing only a handful of paintings during this time. In the following years, however, her artistic output increased as her confidence and desire to participate grew. Between 2001 and 2003 she completed more than sixty works. Today she approaches the largest canvases with no hesitation, and demonstrates a high level of expertise.

During the course of her developing career, Doreen's style and compositional range continued to change. In the early period, the iconography in her work was typical of her contemporaries in its representation of women's food-gathering stories. By 2003 she had developed a particular composition that satisfied both her cultural interpretation of the ancestral stories referred to in her paintings, and the audience's love for contemporary minimalism. This development marked a pivotal moment in the market's recognition and appreciation of her work. Her style was influenced by her late husband, who also painted in a dichromatic minimalist manner. His work was best known for its mesmerising optical effects, illustrated in the larger canvases executed towards the end of his career.

Nakamarra is a quiet achiever who has been gradually honing her skills over the last decade. Currently she is leading a group of relatively young women painters from Kiwirrkura who have continued to explore intricate line work and subtle colour shifts. Her combination of fine brushwork and precise technique has ensured that even her smallest works are highly detailed. On the larger formats, her current style of finely drawn zigzags combined with broken lines of alternate coloured dotting creates an optical effect in which the canvas appears to rise and fall like a series of meandering ridges and valleys. These are *tali*, or sandhills, which surround all the major women's sites at Kiwirrkura that Doreen refers to in her work. Doreen has expanded on the theme and recently has introduced an even more subtle use of colour, using two or sometimes three slight tonal variations, and combining them with the complex, wavering line work that has become synonymous with her signature pieces.

Nakamarra's exhibition history peaked last year when she was represented in twelve shows, including *Right here, right now* at the National Gallery of Australia, the Melbourne Art Fair and *Pintupi* at the Hamiltons Gallery in London. Her paintings have an appeal that attracts the viewer from a purely contemporary perspective, and have succeeded in introducing new audiences to Western Desert art.

PHOTOGRAPHS ON PAGE 130
MAIN IMAGE: Doreen Reid Nakamarra painting at Papunya Tula Artists studio, Alice Springs, 2007, photograph by Jodie Cunningham
CLOCKWISE FROM BOTTOM:
Papunya Tula Artists paints, Alice Springs, 2007, photograph by Brenda L. Croft; Children at Papunya Tula Artists studio, Alice Springs, 2007, photograph by Brenda L. Croft; Nakamarra and Daphne Williams, Papunya Tula Artists Pty Gallery, Alice Springs, 2007, photograph by Brenda L. Croft; Paul Sweeney and Luke Scholes, Papunya Tula Artists Gallery, Alice Springs, 2007, photograph by Brenda L. Croft; Jodie Cunningham and Chantelle Woods, filming the artist's canvases, Papunya Tula Artists Gallery, Alice Springs, 2007, photograph by Brenda L. Croft

1 Statement courtesy of Papunya Tula Artists Pty Ltd 2007.

Untitled 2007

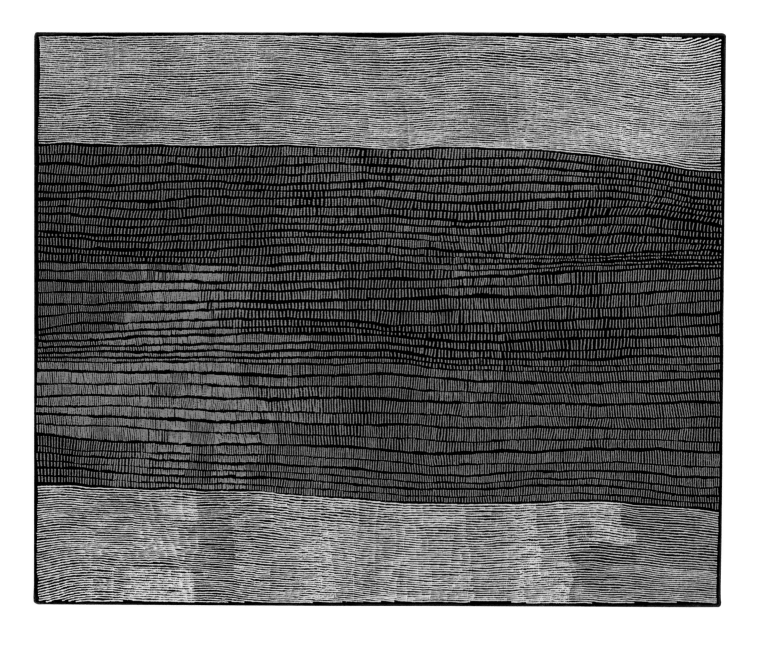

Untitled 2005

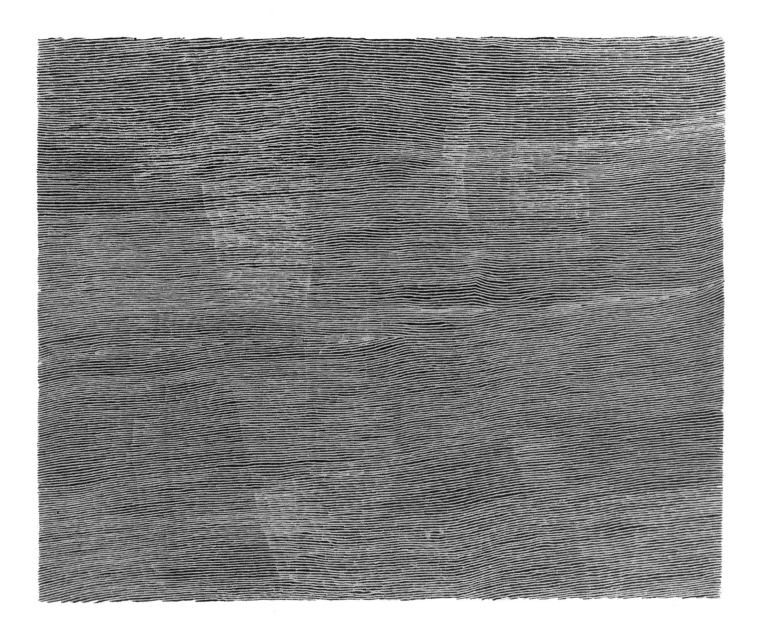

Untitled 2006 122.0 x 153.0 cm

DENNIS NONA

It was very, very important for me to see what Haddon [British anthropologist] took back overseas, because I knew that these were lives and that these were our ancestors and their spirits were now housed there. ... My body hairs stood up!

Even though ceremonies have disappeared today, to see these objects, all carved and handmade; it gave me inspiration and the questions to ask the older people back home.

People carve mainly for tourists today, but these objects were actually sung and worn and still contain these memories. I knew I could take the vision of these things and combine it with everything I was being taught back on Badu as a kid and now as an artist looking to keep telling the stories.[1]

Leilani Bin-Juda

This exhibition of contemporary Aboriginal and Torres Strait Islander work at the National Gallery of Australia, *Culture Warriors*, draws on the diversity of Indigenous art across Australia. The exposure of visual arts from the Torres Strait to national and international audiences has increased dramatically over the past few years. The expansion of the linocut medium has led to a wider appreciation and understanding of Torres Strait Islander culture and heritage, and leading the way is the well-respected Badu artist Dennis Nona. His sculptures and prints highlight his diverse skills, deep cultural knowledge and capacity to draw from contemporary practices to make his art.

Nona was born in 1973 on Badu (Mulgrave) Island, Western Torres Strait, Queensland. Primarily focusing on carving skills in his early days, the artist diversified into the linocut prints that set the tone for contemporary art and culture in the Torres Strait. Linocuts have become possibly the most popular and effective ways of communicating cultural stories to audiences today.

Nona's ability to use storytelling in an inclusive and engaging way has given audiences a greater understanding of Torres Strait Islander history and culture. Most recently, his work on a number of sculptural pieces has shown that as an artist, he is developing skills and knowledge in other areas of practice. Being awarded the 4th International Angel Orensanz Foundation Art Award in New York in 2004 gave Nona international recognition, of his art and its expression of traditional Torres Strait stories.

Ubirikubiri 2007, Nona's outstanding bronze sculpture of a crocodile with a man on his back, is a significant step forward in the production and recognition of contemporary Indigenous art practices. *Apu Kaz (mother and baby dugong)* 2007, another bronze sculpture, also brings together traditional storytelling with powerful and expressive realism and movement.

Nona's extraordinary linocut prints and etchings, which have featured in many significant exhibitions, including *Sesserae: the works of Dennis Nona* at the Dell Gallery, Queensland College of Art 2005, demonstrate his mastery of mediums. As with the detail in his prints, in *Ubirikubiri* the intricate sculptural designs on the bronze form relate and describe Torres Strait Islander history and mythology. Nona depicts these stories in a contemporary art context with ingenuity; his works are accessible because they are representational, engaging because of their vital evocation of narrative, and compelling in the way that they convey the deep cultural meanings of his people to a wider audience. His is an art practice of the future. He is a true culture warrior.

PHOTOGRAPHS ON PAGE 136

MAIN IMAGE: Dennis Nona, 2007, courtesy of Michael Kershaw, Australian Art Print Network CLOCKWISE FROM TOP RIGHT: *Ubirikubiri* in progress, Urban Art Projects, Brisbane, 2007, photograph by Eric Meredith; Nona printing *Yawarr*, KickArts, Cairns, 2007, photograph courtesy of Michael Kershaw; Alick Tipoti, Nona, David Bosun, Billy Missi and Theo Tremblay, printing *Yawarr* KickArts, Cairns, 2007, photograph courtesy Michael Kershaw, Australian Art Print Network; Urban Art Projects artisans with Nona, third from right, and *Apu Kaz (Mother dugong)*, Urban Art Projects, Brisbane, 2007, photograph courtesy Michael Kershaw, Australian Art Print Network; Mary-Lou Nugent, Tina Baum, Simona Barkus, Nona and Chantelle Woods discussing installation at National Gallery of Australia, Canberra, 2007, photograph by Brenda L. Croft; Nona and Theo Tremblay, Cairns TAFE, 2007, photograph by Brenda L. Croft

1 Dennis Nona, interview by Simon Wright, 11 February 2007.

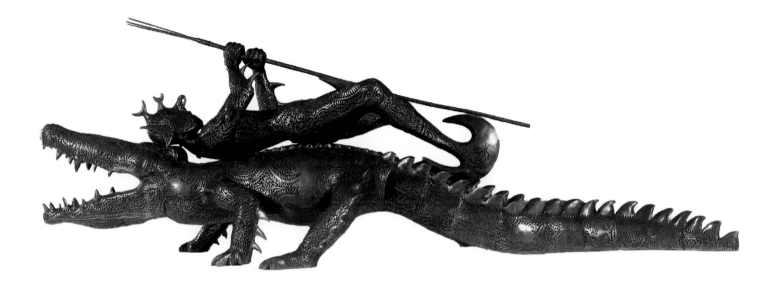

Apu Kaz (Mother and baby dugong) 2007

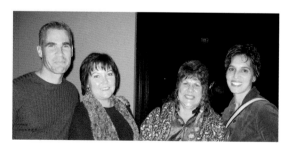

CHRISTOPHER PEASE

The Indigenous culture of this country has been depicted visually in many ways throughout postcolonial history, from the idea of the 'noble savage' to a drawcard for the tourist industry. Because of cultural stereotypes, images of Indigenous people living traditionally are seen as pure. Images of those living in an urban environment are seen as impure. These stereotypes can be traced back to the spread of the British Empire around the globe.

I vividly remember browsing for books in my high school library. My best friend at the time found a book by Spike Milligan. He showed me a picture of Milligan pointing a gun at some Indian people. The caption read 'Shooting a few coons before breakfast'. My friend laughed, but I didn't think it was funny. I was shocked by his response, and at the same time wondered how he learnt such an ideology.

My artistic training in high school as well as college focused largely on Impressionism, the Heidelberg School and modernism. Any lessons related to Aboriginal art were generic with no relationship to land/country. I associated concentric circles with Jasper Johns rather than Indigenous iconography. The rise of Boomalli and the so-called urban Indigenous artists of the 1980s was the point where Indigenous people who were not living 'traditionally' found a voice through non-traditional art.

Richard Bell once told me that we (Indigenous artists) are creating the new Dreaming. This was a concept I had not thought about before, but it made perfect sense. From Tjapaltjarri's dot paintings to Destiny Deacon's photographs, they all tell our stories – old and new.

Clotilde Bullen

When we were younger, the cousins would spend many of our days together – after school, on weekends – playing games that we made up. Chris's creative mind would always come up with the most ingenious diversions for kids with nothing else to do. There was always something quirky in the way that the game would unfold, some imaginative element introduced. The games never lacked structure; they may have been creative and fantastic, but they were organised in strangely logical ways that made sense to us all. As we grew older, sadly, we stopped playing as many games as we used to. Later though, when Chris was studying at Perth TAFE, he drew constantly, in charcoal or pencil, and he would draw incredible creatures, things from his imagination that were neither scary nor approachable but something in between. In the worlds in which these creatures existed there was, again, a strange logic.

To this day, Chris's artistic practice reflects his natural sensibilities. In his work he does not impose order, but seeks to extract the natural order of things, no matter how tangled or absurd. His creative eye sees logic in the most illogical of circumstances and situations. His elegant painting style makes sense of and contains the dream-like environments his subjects often inhabit. It is this self-contained world-within-worlds approach that makes Chris's work unique. Like him it seeks a balance between science, logic and the deep underlying mysticism that is part of his cultural heritage. The two are not in conflict but co-exist and feed each other.

In the case of *Wrong side of the Hay* 2005, the spiritual and the actual combine, with the ancestral story-lines of the land brought to life in a ghostly shimmer over the length of the painting. The two men depicted in the work are unaware of the framework of spiritual inheritance embodied within the land, which is the birthright of every Indigenous person, depicted by the artist as unbroken curves over the horizon. We are reminded of Indigenous reality as the orderliness of the European-style landscape is interrupted by this Dreaming motif.

The artist has conducted research on the iconography of the Nyoongar, the Indigenous people of south-west Western Australia, and it is versions of these motifs and signifiers that make their way into his work. In *Swan River 50 miles up* 2006 Chris references how colonisers see Indigenous people in the same way that they viewed the flora and fauna of the new country: able to be scientifically categorised and de-contextualised. They saw the land as there for their exclusive use, to be sectioned, partitioned and sold off in lots, irrespective of prior claim.

Target 2005 is more sinister – the symbol of the target is used to communicate the idea that not only Indigenous people but the land itself at the time of settlement in Australia was the target of greed, ignorance and, as represented by the single Indigenous female figure in the work, lust.

New Water Dreaming 2005 directly references a lithograph produced by Louis Auguste de Sainson (see p. XV), who was the appointed draughtsman on the *Astrolabe*, commanded by Dumont d'Urville. It depicts an area within King George Sound, in the south-west of Western Australia, with members of the d'Urville expedition loading water onto one of the ship's longboats.

Interaction between the crew and the Minang people[1] – Chris's people – is portrayed as positive, with several individuals helping to load the water. The diagram over the work points to the Europeans' ways of thinking about obtaining water, which were new and different for the Minang people. Scientific thinking began to create structure in an environment that, to the newcomers, had no structure. The depiction of colonisers attempting to impose order on an unruly environment reflects the artist's fascination with the struggle between science and logic and less structured systems, and it is the tension between the two that creates the distinctive dialogue in Pease's work.

PHOTOGRAPHS ON PAGE 142
MAIN IMAGE: Christopher Pease, courtesy of the artist
CLOCKWISE FROM BOTTOM RIGHT: Pease, Trish Barnard, Pamela Croft, Carly Lane at the Blak Insights symposium, Brisbane, 2004, photograph by Tina Baum; Pease surfing, Western Australia, courtesy of the artist; Pease in his studio, Perth, 2007, photograph by Molly Pease; Pease in his studio, Perth, 2007, photograph by Molly Pease

1 The Minang are members of the Nyoongar people from a particular part of the south-west of Western Australia.

Wrong side of the Hay 2005

SHANE PICKETT

I am Meeyakba Shane Pickett, a painter of the Nyoongar lands. I am privileged to have been taught the traditions and cultural values of my father's Jdewat people and also my mother's Balladong people. These include hunting skills, reading of weather patterns and signs that teach me to respect the seasons and understand their movements, changes and moods. I have learnt to read the songlines that journey through all living things across the entire landscape. I have sat down and watched the dusk infusion (the changing of day into night) and seen the colours of the sky and shadows move or merge into dreams of soft calming rhythms. I will always respect my cultural values, for the dreams do flow strongly through the views of my life.

Every river, every tree, every rock is important, as the Dreaming runs through them connecting all things, including mankind. These are the energy paths of the Dreaming and they are never meant to be broken, never meant to fail. When they are broken by mankind's negative effects on the land, the energy paths can never be repaired.

I am not yet a culture warrior. The real culture warriors are the elders – those gifted senior men and women fighting to keep the Dreaming alive. In my paintings, and in my own personal Dreaming journey, I try to honour their teachings, their knowledge and their law. Together we must work to heal and rebuild, to be stronger and stronger for the Dreamings of tomorrow – to keep our culture, so that the generations to come can live and sing of their identity.

Ian McLean

Dreaming is not just some ancient mysticism, but true, real and palpable. It is like DNA: the language of all life, the power in all things, animate and inanimate. It began when Ancestral Beings first roamed a featureless earth and sky. Changing shape at will, they travelled all over, their tracks making today's differences of geography, biology and culture. Thus their tracks are the key to understanding these things, how they relate and what they do.

Dreaming gave each country, species, group and gender its own autonomy, language, culture and authority, but more importantly, it established within this autonomy and difference a rhythm of relationships and obligations. It is a dynamic system in which things often appear other than what they are. As Darwin discovered, the seeming boundaries between things are not entirely immutable. 'Clever' people and 'clever' animals can, like the Ancestral Beings, actually inhabit Dreaming, cross these boundaries and assume the shapes of others and even converse with them in their language. To be alive is to be alive to this otherness and communicate across its differences.

While we cannot all be 'clever', there are, as Shane Pickett demonstrates in his art, other ways of feeling Dreaming. Dreaming has an aesthetic form: it relates differences without reducing their complexities. Pickett uses his hunting skills to feel it. He carefully scans ahead, not just with his eyes but all his senses, looking beyond the appearance of individual things to what is moving in and between them: alert to the shifting light, breeze, scents, sounds, to patterns and rhythms of shapes and colour tones, the passing clouds and the sun inching across the sky, even the pull of the moon. Likewise, to properly understand the content of his early landscape paintings, look past their figurative literalness to the patterns and rhythms that hold across the surface of the canvas. Notice how they take on a new intensity as they converge towards the horizon or another fold in country. Here one finds the origins of his later abstractions. They are the culmination of a project that had its genesis in his childhood, when he was taught the cultural values and skills of his Balladong and Jdewat traditions: how to read weather patterns and signs,

the seasons and movements of animals and stars; how to feel the Dreaming tracks.

Pickett was born in the wheat belt of south-west Australia in 1957, but has lived in Perth since the mid 1970s. He grew up at a pivotal time in Nyoongar and Aboriginal history, during the end of the assimilation period as Aboriginal people across Australia lurched towards self-determination in a series of radical events centred around land rights and cultural revival. Like most Aboriginal groups torn apart and displaced by colonialism, Nyoongar families treasured and re-told the stories and language of their ancestors. From this emerged a vibrant postcolonial Nyoongar school of landscape art, of which Pickett's painting is a legacy.[1]

Far from being a nostalgic yearning for something lost in the colonial holocaust, Pickett's paintings are proof of the continuing everyday power of Dreaming. Whatever might have been lost in the way of knowledge, language and ceremony, Dreaming continues, always waiting its discovery by those who will look with open hearts, with care and respect. To understand Pickett's paintings is to feel this revelation of Dreaming. They remind us that we are never without Dreaming, but without knowledge of it we are lost in an empty and indifferent space with no map to plot our course. This is why it is often said that Dreaming is a map. And this is why Pickett's paintings, especially his more recent abstract ones, are also like maps, not the static drawings of western cartography but more like weather charts, always changing as the complexity and subtleties of meteorological pressure systems ebb and flow.

The greatest joy Pickett gets is seeing the tears of the old men and women from remote Australia as they recognise in his paintings the traces of Dreaming. Then he knows his personal journey as an artist has become an integral part of his people's return from their exodus, for in these quiet moments in his studio with these old people from long away, he feels their respect for his Balladong and Jdewat ancestors and so for him.

PHOTOGRAPHS ON PAGE 148

MAIN IMAGE: Shane Pickett with *Guardians of the good energy spirit*, 2005–06, Perth, photograph © Nick Tapper

CLOCKWISE FROM TOP RIGHT: Clotilde Bullen and Pickett, Darwin 2005, photograph by Brenda L. Croft; Portrait of Pickett, 2007, courtesy of Indigenart, The Mossenson Galleries, Perth; Lynelle Briggs and Tom Calma with Pickett at the *Drawing together* 2007, Canberra, image courtesy of Indigenart, The Mossenson Galleries; Pickett in his studio, Perth, 2007, photograph by Naomi Mossenson; Dorcas May, Pickett and Fred Pickett at Indigenart, The Mossenson Galleries, Perth, 2007, photograph courtesy of Indigenart, The Mossenson Galleries

1 See John Stanton, *Nyungar Landscape: Aboriginal artists of the south-west: the heritage of Carrolup, Western Australia*, Perth: Berndt Museum of Anthropology, University of Western Australia, 1992; and Brenda L. Croft, *Southwest central: Indigenous art from south Western Australia 1833–2002*, Perth: Art Gallery of Western Australia, 2003.

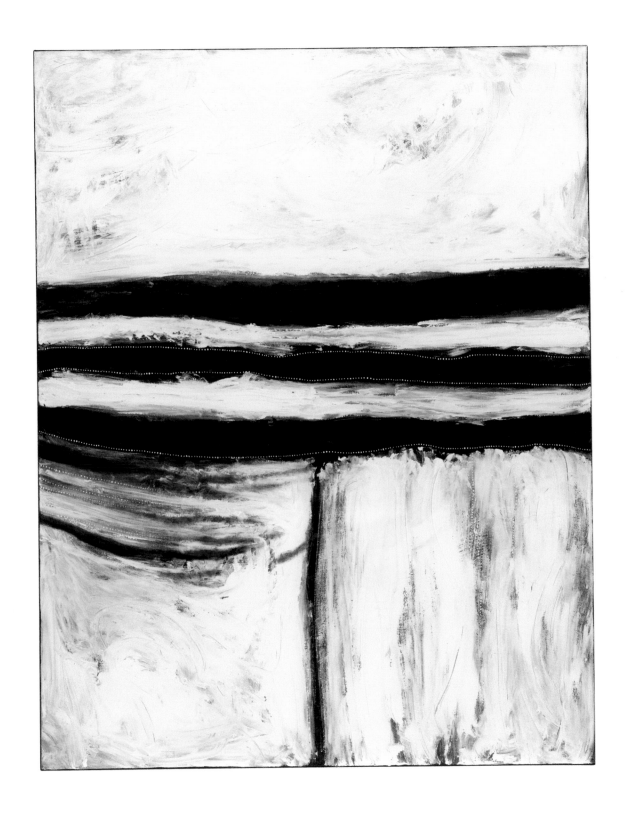

On the Horizon of the Dreaming Boodja 2005

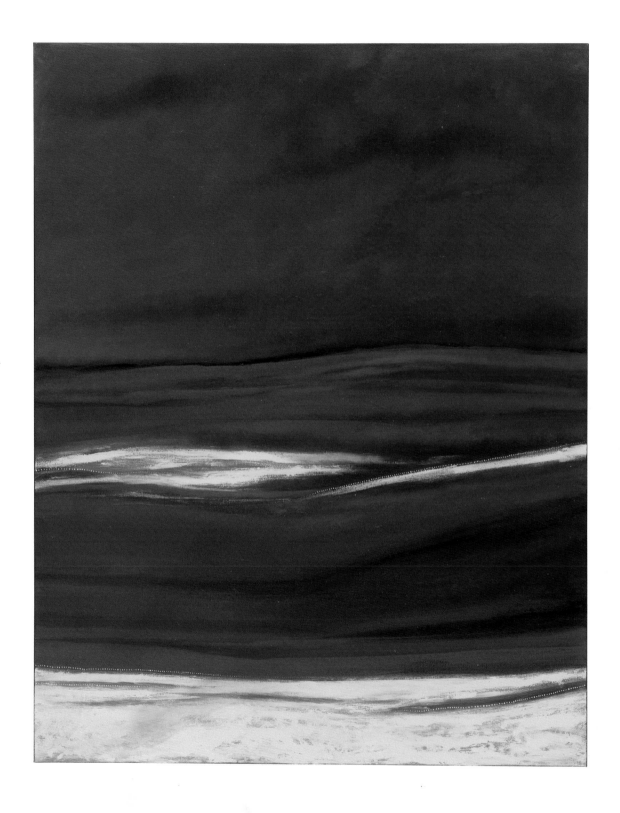

Bunuroo afternoon moods of a hot humid day 2006

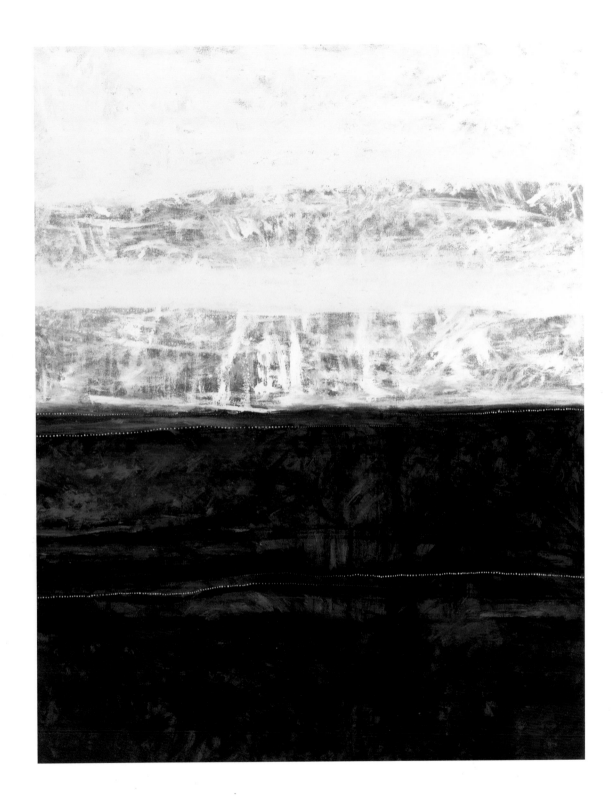

Landscape with a morning touch of Wanyarang 2006

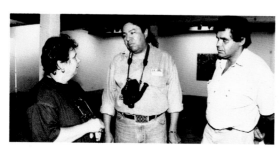

ELAINE RUSSELL

The manager's wife was a nursing sister and once a week she would inspect the houses on the mission to make sure that our homes were clean and tidy, which they were. She wanted to know how mum's floors were so white, seeing that we had no electricity to use an electric floor scrubber. That's when mum showed her a piece of sandstone, by which she was very surprised![1]

Cara Pinchbeck

Elaine Russell's paintings intimately recall her childhood memories and experiences: fond moments spent with family and friends, tinged with painful reminders of imposed restrictions and meagre living conditions. Her personal snapshots of Indigenous life in the 1940s and 1950s offer a narrative of shared experience and important evidence of the impact government policies had on the lives of so many Indigenous people.

Russell was born in Tingha in northern New South Wales and at about five years of age moved with her family to La Perouse in Sydney, where there was a large Aboriginal community on the shores of Botany Bay. She recounted her experiences at La Perouse in her 2004 book, *The shack that Dad built*. Her family subsequently moved to Murrin Bridge Mission on the Lachlan River in central New South Wales. Like the numerous missions across the state, Murrin Bridge was controlled by the ironically titled Aborigines Welfare Board. Residents of the mission were at the mercy of the mission manager who had absolute control over people's lives and was responsible for enforcing the paternalistic policy of the Board.

The majority of Russell's paintings refer to her time at Murrin Bridge and create a record of mission life that has been absent from Australian written and visual history until recently. From catching yabbies to bagging potatoes, Russell captures everyday experiences of her family that offer unique insights into their lives: the impact of mission policies, the difficulties they faced and their strength in extremely trying times.

Russell's use of bold, intense colour, flattened perspective and simple graphic elements offer a childlike perspective, seemingly naive and idyllic. Neat rows of quaint pastel houses with pitched roofs line perfectly ordered mission streets, complete with the obligatory church. Rolling hills stretch across the deep blue horizon dotted with fluffy white clouds, while isolated figures animate the landscape. The picturesque nature of the scenes created is compelling, and evokes sentimental memories of innocent, carefree days. Yet the controlled perfection is disturbing, as it is apparent this is a façade masking an imperfect reality.

In *Inspecting our houses* 2004 Russell provides an overview of Murrin Bridge Mission. Bordered on all sides by dirt roads the mission consists of a cluster of freestanding houses in fenced yards, shaded by large trees. Complete with their external outhouses, they are the very image of the suburban dream. The tight composition and defined barriers within the work reflect the regimented and regulated nature of mission life. The repetition is interrupted only by the different colours of the houses, an expression of individuality from inside a system that sought to enforce assimilation. Russell recalls her spotless family home being inspected on a weekly basis by the mission manager's wife to ensure it was kept to an acceptable standard. The floorboards would even be polished with a stone from the river so that they were immaculate. This unnecessary intrusion into family life is a bitter memory for Russell: the inference that such visits would even be required cut into the heart of the family's respectability.

Freedom from the mission routine offered happier times for Russell and her family. When seasonal work was available they would spend a month or so living and working on a nearby farm. Although this involved hard physical work and they had to sleep in a barn, these were good times as the family was together. Russell's family is seen working the field in *Bagging potatoes* 2004, collecting potatoes too small to be collected by machinery. Sheep graze in the distance. This work offered them a certain level of independence, practical and financial, which was otherwise unattainable.

The resourcefulness of Aboriginal families in times of adversity is also apparent in Russell's 2006 paintings, *Catching yabbies* and *Untitled* from the *Mission* series, which show how her family supplemented their scant rations by trapping possums and catching yabbies. Seeing the brighter side of such experiences is a current that runs through Russell's work, engaging the audience in a non-confrontational way with the oppressive reality of our shared past.

PHOTOGRAPHS ON PAGE 154

MAIN IMAGE: Elaine Russell in Alice Springs, 2007, photograph by Brenda L. Croft
CLOCKWISE FROM TOP RIGHT: Brenda L. Croft, Dillon Russell, Stephen Gilchrist, Russell and Tina Baum, National Gallery of Australia, Canberra, 2005, photograph courtesy of Brenda L. Croft; Russell at Boomalli, Sydney, c. 1995, photograph by Brenda L. Croft; Jason Mumbulla, Russell and Marlene Cummings, Boomalli Aboriginal Artists Co-operative, Sydney, 1994, photograph by Brenda L. Croft; Russell, Edgar Heap of Birds, H. J. Wedge, Boomalli Aboriginal Artists Co-operative, Sydney, 1994, photograph by Jason Mumbulla; Russell, Matilda House and Dillon Russell, NAIDOC Week 2005, National Gallery of Australia, photograph by Brenda L. Croft; Brook, Elaine and Shane Russell, Boomalli Aboriginal Artists Co-operative, Sydney, 1994, photograph by Jason Mumbulla

1 Story for *Inspecting our houses* 2004.

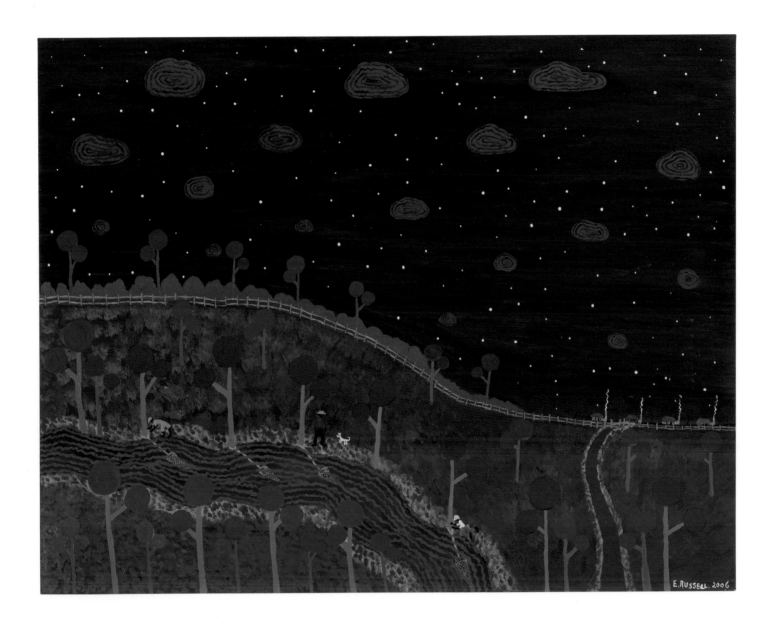

Catching yabbies 2006

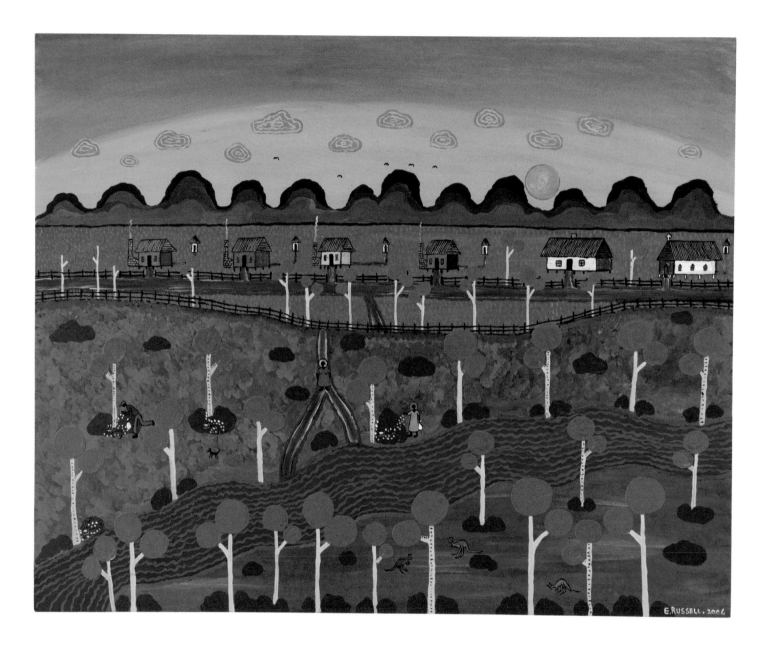

Untitled from the *Mission* series 2006

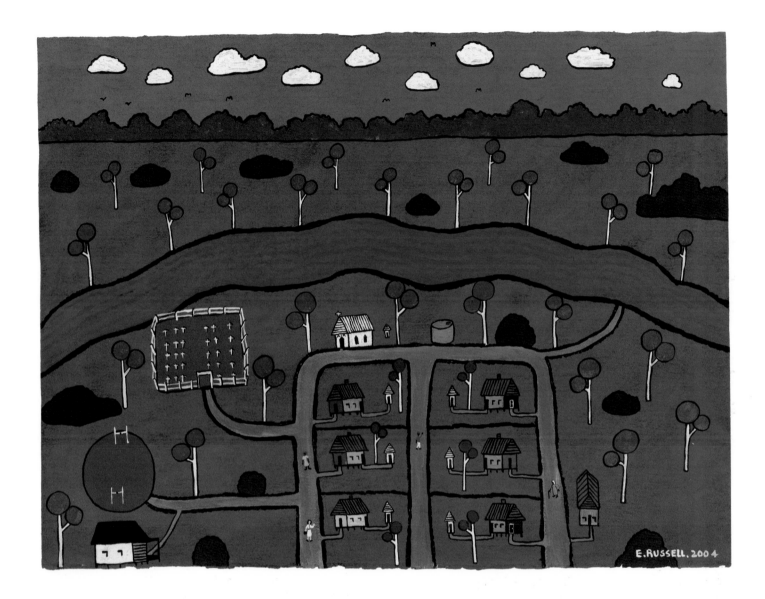

Inspecting our houses 2004

CHRISTIAN BUMBARRA THOMPSON

My artistic journey has been punctuated by investigations into my own identity: in my work, I articulate my experience as an artist of Aboriginal and European heritage, unpacking my individual history in order to unveil the transitory state of dispossessed peoples in the world.

Notions of cultural hybridity have been dominant in my practice, permeating my artistic trajectory and unifying Indigenous art practice with western art making and history.

I represent my community in various ways: as an artist, curator and writer, placing emphasis on process over product; this has allowed me to engage with my community, who participate in my work. I employ photography and video to capture the performance action of my textile-based sculptures. Through these mediums I illustrate the diversity of my community, working in contrast to stereotypical notions of Aboriginal culture seen through the canon of the dominant Anglo-Australian culture.

My journey has been concerned with the inaccurate representation of my people and our material culture in a historical, contemporary and international context.

My work is both political and contemporary; I seek to engage objects, ideas and practices that have disenfranchised my people from our land and art, then remix these themes to infer new meaning. My desire to unify my work with real time has brought me to performance and to use my body as a primary medium. The context of contemporary art has become the site for modern 'ceremonies' in keeping with Indigenous aural-based cultural traditions. I aim to forge a new visual language that reflects a true perspective of our culture as a dynamic contemporary entity.

Marianne Riphagen

Christian Bumbarra Thompson creates art expressive of a continuing relationship to his people, country and culture. Subtle and sometimes more explicit references to the land and heritage of his community, the Bidjara people of the Kunja Nation from south-west Queensland, present themselves in the artist's multidisciplinary practice.

His photographic series *Gates of Tambo* 2004 refers in its title to two bottle trees ('the gates of Tambo'), planted by Thompson's great-uncle outside the town of Tambo, north-west of Brisbane. Thompson's photographs afford viewers insight in ways that a young Indigenous Australian artist positions and defines himself within the world, and the various art worlds, in the early twenty-first century. Through impersonations of, variously, Indigenous artists Rusty Peters, Tracey Moffatt and the Woman from Peppimenarti, plus Andy Warhol, Thompson deconstructs the amalgam making up his identity.

In this work the artist underlines that he sees himself as both the young man behind a laptop in Melbourne, with a keen interest in 1980s fashion and pop culture, and the Aboriginal artist in remote Australia documenting his country and traditions.[1] The ease with which Thompson transforms into the other Indigenous practitioners challenges us to question the distinction made between Indigenous peoples living in different parts of Australia. The *Gates of Tambo* photographs also initiate an intergenerational dialogue between Thompson and the individuals whose characters he assumes. Exploring the ways in which his art relates to works made by well-established practitioners such as Peters and Moffatt, this younger artist pays homage to those who inspire him and also firmly situates his practice within recent Indigenous art histories. At the same time the image of Andy Warhol, celebrated international symbol of pop art, forms the key to Thompson's desire for himself and other Aboriginal artists to be part of global discourses on art making.

His digital video *Desert Slippers* 2006 continues Thompson's mapping of identities and relationships with Aboriginal and non-Aboriginal people – the things that shape him as an artist – but in a more intimate manner. The title comes from a cactus that has always played an important role in Bidjara society: the desert slipper. In the video the artist and his father, speaking Bidjara, perform a greeting ceremony with their bodies turned towards each other. The two men are engrossed in repetitively acting out the same gestures. This work describes a recent shift in Thompson's practice towards a more personal approach, using family members to document Bidjara ceremonies and rituals in a visual language accessible to large audiences.

The artist is acutely aware that in the past Indigenous peoples have been coerced into disclosing aspects of themselves and their culture for European scientific and ethnographic study, and in *Desert Slippers* he does not reveal the meaning of the words exchanged between him and his father. Thus our attention is drawn to what is unspoken: the intimacy and ritual nature of communication between a father and son, teacher and student, older and younger man. This video is part of a larger project to create a family archive, begun by Thompson after becoming an uncle to his brother's children, when he re-evaluated his responsibilities as a Bidjara man.

Whilst exploring his Indigenous heritage, Thompson's work engages with topics that affect and move both Indigenous and non-Indigenous Australians, transcending cultural boundaries. *Desert Slippers* not only invites us into a private space, allowing unique insights into the contemporary nature of Indigenous ceremonies and processes of enculturation, but also speaks about universal human experience. Irrespective of our cultural background, family rituals such as this Bidjara greeting have universal resonance. And the complexity of relationships and communication between fathers and sons, which is communicated in the work, is also fundamental to humankind. This merging of the culturally specific and universal leaves a lasting impression in Christian Thompson's art.

PHOTOGRAPHS ON PAGE 160

MAIN IMAGE: Christian Bumbarra Thompson, 2007, courtesy of the artist
CLOCKWISE FROM BOTTOM RIGHT: DVD still, *The Sixth Mile* 2006, photograph by Steven Nebauer; Thompson speaking at Garma Festival, Gulkala, 2004, photograph by Brenda L. Croft; Self-portrait of Thompson, Nhulunbuy, 2004, courtesy of Brenda L. Croft; Thompson, *Angry young Blak man* 2004, courtesy of the artist; *In search of the international look* 2005–06, courtesy of the artist; *Untitled (self portrait),* from the series *Emotional striptease* 2003, courtesy of the artist

1 Christian Bumbarra Thompson, interview by Marianne Riphagen, 23 May 2006.

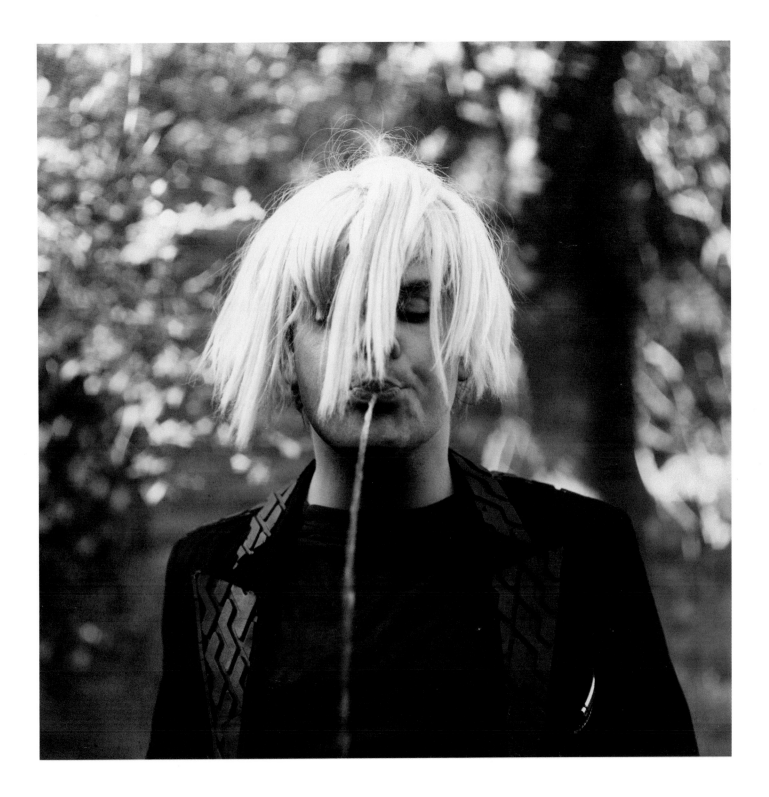

Andy Warhol from the series *Gates of Tambo* 2004

Tracey Moffatt from the series *Gates of Tambo* 2004

The Sixth Mile (film still) 2006

JUDY
WATSON

I made the work *palm cluster* for my exhibition *a complicated fall*
at Bellas Milani Gallery. The exhibition title related to a comment
by the Queensland Director of Public Prosecutions that Mulrundji
Doomadgee, a Waanyi man's death on Palm Island was caused by
'a complicated fall'. This was a surprising finding considering the
physical damage that the man had suffered during his ordeal in the
Palm Island Gaol. 'A complicated fall' can also refer to a fall from
grace, a fall of government and so on.

Other works in *a complicated fall* referred more specifically
to recent events on Palm Island, and/or used familiar recurring
motifs from my work such as shells, ribs, plants and maps.
While I was making the work for this exhibition I listened to
ABC Radio National. At this time there were many news updates
about events on Palm Island. Part of my response to this was
an internal grieving that I was aware of as I was pushing and
scrubbing the raw pigments into the canvas. The deep blues of
the background of the canvas are made by scrubbing the intense
dark Prussian blue and purplish ultramarine blue pigments onto
the material using a stiff brush.

Blue is the colour of memory and is associated with water; it
washes over me. Waanyi people are known as 'running water people'
because of the inherent quality of the water in their country.[1]

Avril Quaill

Just before the Easter break this year I visited Judy Watson's new temporary studio at the State Library of Queensland. One enters through a sliding door into a huge space. The view is magnificent: a two-storey glass wall overlooks the meandering Brisbane River, the rising city humming along its northern bank. Several large canvasses are already in varying stages of progress. They are spread out on top of black plastic laid down to protect the floor from powdered pigments. It is a vast room and at the other end of it I see four or five long benches, empty save for two with a few sketchbooks and pencils. In such a huge space the artist's materials look sparse. Hmm, no paint brushes.

In the lead-up to the opening of the new wing of the Library the artist was invited to create an artist's book for a project to commemorate both the 1967 national referendum, which determined that Aborigines would be counted in the census, and the centenary of women's suffrage in Queensland. Watson's work was *a preponderance of aboriginal blood* 2005. The artist subsequently found her Aboriginal grandmother's and great-grandmother's government files in the Queensland State Archives, which led her to make an illustrated book, *under the act* 2007: a series of works using print techniques and drawing based on personal family photographs and photocopied pages of letters and official documents found in the archives.

Watson's great grandmother's 'exemption card' is depicted in the work. These cards were official government papers that Aboriginal people were required to carry to prove they had the signed permission of the Protector of the Aborigines to be in a public place: boarding a train, walking to the shop, being off the government reserves. The papers could be asked for at any time by the police. Aboriginal people called these hated papers 'dog tags', as they felt they were being treated like animals in their own country. In official records Aboriginal people were frequently categorised as 'full blood', 'half-caste, 'quadroon' and 'octoroon'. In the Archive Watson found letters written by her grandmother to the government seeking permission to marry her grandfather who was white, with documents relating to the application for exemption of her grandmother from 'under the Act'.[2]

The artist remembers her mother speaking of her grandmother's stories of ancestral country around Riversleigh Station in north-east Queensland, as well as darker stories of the threats Aboriginal people lived with under the Act, including the fear of being sent to an island. Her grandmother used to say that she 'didn't know which island it was, but I was always told I'd be sent there'. In the Archives Judy Watson found a reference to her grandmother's aunt who had been sent to Palm Island and of another family member who was threatened with this punishment.

In much of Watson's art the techniques of drawing and printmaking both inform and are a foundation for realising paintings on canvas. In speaking about the painting process she speaks about being influenced in her work by the pooling of water, and this relates to how she prepares the surface of the canvas. Water plays a vital part in the print workshop, especially with lithography, where the pushing and pooling of liquid inks on the surface of the stone makes the image.

The artist describes the body of work shown in her exhibition *a complicated fall* (2007) as a lament for Palm Island. The title, *a complicated fall*, refers to the state Director of Public Prosecution's description of the cause of death of Mulrundji Doomadgee while in police custody on Palm Island. The exhibition consisted of a series of paintings on unstretched canvas, employing the artist's signature powdered pigment washes pushed into the surface, with some areas washed back and graphic elements overlaid. One painting is rendered in deep red ochre hues. The outline of a male torso in classical pose is visible; a shell form can be seen as a body organ, maybe a heart, and ribs or throwing sticks appear to float away at the bottom of the frame.

> ... a bailer shell is also a cultural vessel. It was used as a container to bail water out of canoes to stop them from sinking, and as a receptacle for red ochre used in healing, and for painting up and ceremony.[3]

PHOTOGRAPHS ON PAGE 166

MAIN IMAGE: Judy Watson in her studio, Brisbane, 2007, photograph by Megan Cullen CLOCKWISE FROM TOP RIGHT: Watson, Rani and Peter Carmichael, Australian Embassy, Paris, 2006, photograph by Brenda L. Croft; Watson with *wurreka* zinc wall at Bunjilaka, Melbourne Museum, 2000, courtesy of the artist and Melbourne Museum; Watson in her studio, Brisbane, 2007, photograph by Eric Meredith; Watson's studio, Brisbane, 2007, photograph by Brenda L. Croft; Watson with her mother, Joyce Watson, Brisbane, 2006, photograph by Brenda L. Croft; Watson's studio, Brisbane, 2007, photograph by Eric Meredith; John Mawurndjul, Gulumbu Yunupingu, Watson, Linda Burney and Kunmanara Dawson, Musée du quai Branly, Paris, 2006, photograph by Brenda L. Croft

1 Courtesy Judy Watson and Bellas Milani Gallery, Brisbane.

2 The Queensland Aboriginals Protection and Restriction of the Sale of Opium Act came into force in 1897 and controlled the fate of Indigenous people in Australia for much of the twentieth century; it was the model for other states. It severely restricted their movements and the basic civil rights.

3 Judy Watson, interview by Avril Quaill, 5 April 2006.

palm cluster 2007

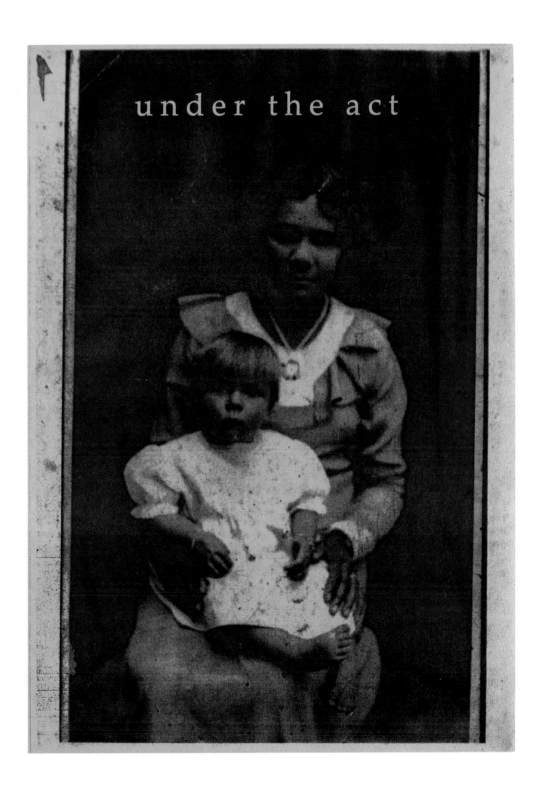

under the act (frontispiece) 2007

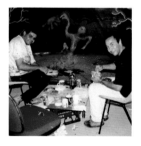
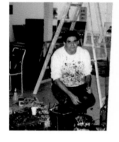

H.J. WEDGE

I know there are a lot of things go through my mind. Some of the things I really can't stop thinking about: when Captain Cook came and landed and called it a new country in British justice or whatever you want to call it. Captain Cook made a map of our coastline. They even buggered that up, they did. They thought Tasmania was joined up to Australia, but it wasn't. They came here with a lot of stuff and they went around to a lot of other countries and that, discovering new lands as well. But I can't help thinking about when they landed here: what it would be like if the native people did start to spear them, frighten them and kill them all.

I wonder how this country would look now. Would we still be living in the bush – no fences, no cities and no pollution – everything the way it was before they came here? The air sweet and beautiful. The animals now extinct, they'd be around as well. But you know we can't bring them back, and you can't change the past, as the saying goes. But they did land here and Captain Cook and his men done things I don't think they even put in their diaries or their catalogues ...

It's funny things never seem to work out. I mean, you look at the country now. It's a fair bit of a mess now already, with all these factories diggin' up the earth, people destroyin' a lot of things. If you know in your mind or heart, you know what I'm tryin' to get across. This is my opinion anyway.

It's really up to each of us to make up our own minds what is right and what is wrong. You know this land was ours, but it's yours now. But there's still a lot of people out there fightin' for us so that we can get it back one day, maybe in one lifetime.[1]

Matthew Poll

H.J. Wedge was born around 1958 on Erambie Mission, Cowra, in New South Wales. He proudly acknowledges his Wiradjuri heritage in many of his paintings. The experience of the colonisation of the Wiradjuri was different to other Indigenous experiences in Australia and is expressed in their own aesthetic forms; historically, painting was not as widely used in the Wiradjuri culture as it was in other regions of the country.

H.J. Wedge is an artist who has had the most unusual of careers. Although currently living on the borderline of poverty in the Cowra mission, where he has been for around thirty of his fifty years, his art has been seen by thousands of people and, for many, represents exemplary contemporary art.

What separates Wedge's work from that of other Aboriginal artists is his bold use of colour and contemporary subject matter, which deals with social and political issues more relevant to Aboriginal people living in an urban context than the traditional cultural information that defines many other styles of contemporary Indigenous art. He has produced hundreds of images documenting his experiences and memories as an Aboriginal man, observations that are sometimes quotidian and sometimes shockingly confrontational.

Being illiterate, H.J. Wedge uses his art as a way of communicating his stories and perceptions as an Indigenous person in contemporary Australia. Many non-Indigenous Australians appear interested only in the traditional and ancestral themes of Aboriginal culture. Aboriginal people from New South Wales in particular have faced community perceptions that they were assimilated long ago, and that the only Indigenous culture that survives is in remote areas.

Wedge bypassed the cultural baggage associated with many other Australian artists' art education by studying art history at Eora College, an Aboriginal institution. Traditional cultural information informs most Aboriginal art, but for a long time Aboriginal people lost or were denied access to, and expression of, their own culture; they lost a basic human right. Contemporary art allows them to speak to the wider Australian community. Contemporary art does not need the English language to explain itself, and perhaps this is another reason for the huge interest in Aboriginal art internationally.

It is a sad fact that for many Aboriginal artists lack of education is a serious barrier to the contemporary art world. For some, an even greater barrier is the fear of being perceived by other Aboriginal people as 'acting white'. To achieve equity and balance in the representation of Indigenous art as contemporary art is an ongoing issue; the inclusion of Aboriginal perspectives in Australian art displays following the major bicentenary survey exhibitions of 1988 is an unresolved aspect of the 'history wars', currently being played out in Australian political, social and academic circles.

After Wedge first showed his work with Ian Abdulla at Boomalli Aboriginal Artists Co-operative in Sydney in 1991, a new aesthetic of Aboriginal art seemed to emerge, where the subject matter rather than artistic technique was of primary concern. Other Indigenous artists, such as Elaine Russell, Leonie Dennis and, recently, Roy Kennedy developed a bold, naive style to illustrate their memories of growing up in rural Australia, in many instances focusing on the defining factors of poverty and discrimination, but also on how Indigenous people made the most of their lives and experiences. This graphic, naive style of making art has allowed many Aboriginal people with local histories and stories that challenge the one-sided historical record in Australian museums and libraries access to contemporary art. And it is a way of making art that suits older artists who lack the formal education most non-Indigenous people take for granted.

H.J. Wedge has suffered many personal setbacks, which have inevitably shaped his art, including alcoholism, hospitalisation and imprisonment. Many other Australian artists represented in our state and national art collections have also lived outside mainstream society and rejected society's dominant values, yet they have ultimately had acceptance in wider society.

For Wedge, his outsider status has affected his relationship with his family, his community and other Aboriginal artists. He is an outsider within his own community and is outside the Australian art establishment. His lack of education is the barrier, but it is also what makes Wedge's art unique. And this duality in his paintings is evidence that what can give a work of art its power is that its very status as art would be vehemently disputed by some.

PHOTOGRAPHS ON PAGE 172

MAIN IMAGE: H.J. Wedge, Budapest, 1993, photograph by Brenda L. Croft

CLOCKWISE FROM TOP RIGHT: Wedge with his work, Budapest, 1993, photograph by Brenda L. Croft; Wedge at Boomalli Aboriginal Artists Co-operative Ltd, Sydney, 1994–05, photograph by Brenda L. Croft; Wedge and Gordon Hookey at Boomalli Aboriginal Artists Co-operative Ltd, Sydney, 1994–95, photograph by Brenda L. Croft; Wedge creating work, Budapest, 1993, photograph by Brenda L. Croft

1 H.J. Wedge, interview by Matthew Poll.

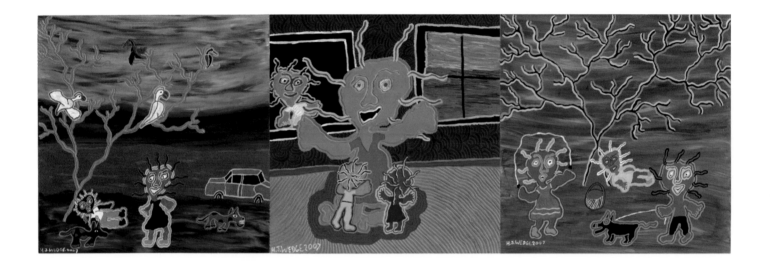

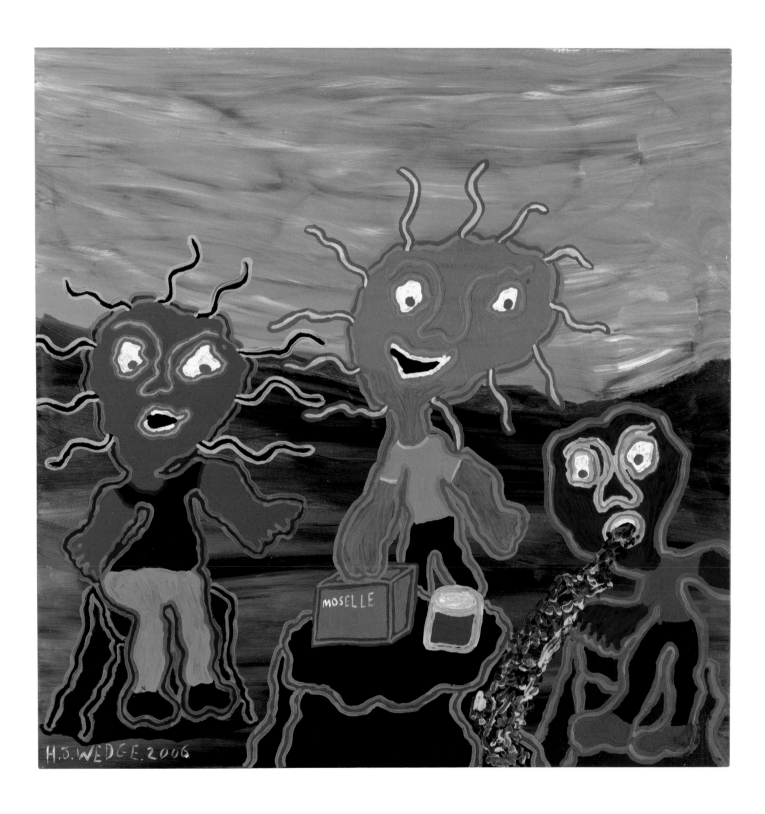

No more drinking 2006

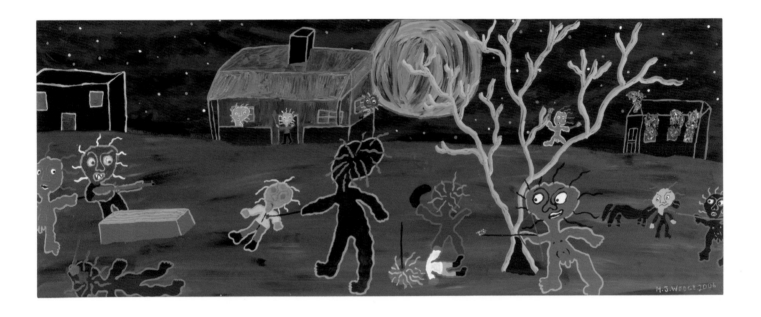

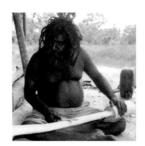
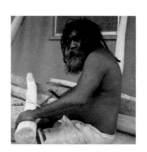
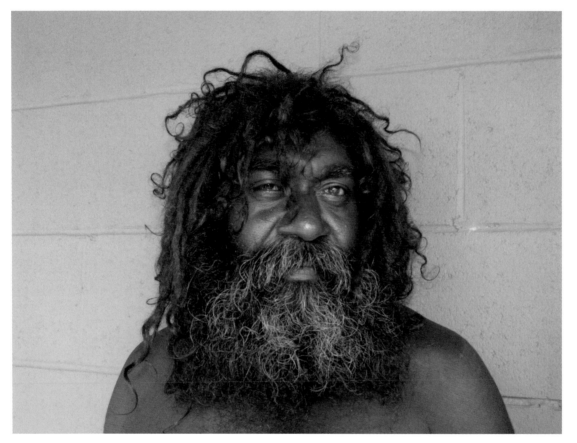
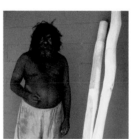
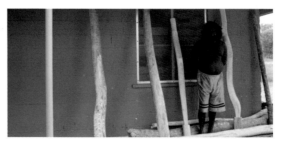

OWEN YALANDJA

I always use the same wood, kurrajong [*Brachychiton diversifolius*], to make my sculptures. My father [Crusoe Kuningbal] used the same wood and taught me and my brother [Crusoe Kurddal] how to carve. He only did *mimih* spirit figures and when I first started as an artist, I used to make *mimih* figures as well. Then I decided to change and to start representing *yawkyawk* spirit figures.

Yawkyawk is a bit the equivalent of a mermaid in *balanda* culture. *Yawkyawk* is my Dreaming and she lives in the water at Barrihdjowkkeng near where I have set up my outstation. She has always been there. I often visit this place.

I love making these sculptures and I have invented a way to represent the fish scales on her body. The colours I use have particular meanings [which are not public]. I make them either red or black. I am now teaching all my kids to carve, just like my father did for us. My son Dustin Bonson is already working for the arts centre.[1]

Gary Lee

Owen Yalandja is a Kuninjku artist from Maningrida in Central Arnhem Land and a senior member of the Dangkorlo clan. Born in 1962, he is a noted sculptor whose exceptional works have gained much attention and prominence in recent times, particularly his exquisitely carved *yawkyawk* spirit figures.

The *yawkyawk* are believed by Kuninjku to be young girl spirits or ancestors who live in the water and whose shadows can sometimes be seen as they run away from humans who might come near. *Yawkyawk* are a recurring theme in Kuninjku bark paintings.

Yalandja's father, the late Crusoe Kuningbal, was a famed Kuninjku singer, dancer and ceremonial leader, as well as an accomplished painter of barks and a carver of the *mimih* spirits. *Mimih* spirits are believed by Kuninjku to be long, thin, mischievous beings who inhabit the rocks of the escarpment country. Kuningbal is said to have invented the songs and dances of a public Kuninjku ceremony called Mamurrng for which he danced the *mimih* and in which he incorporated life-sized carvings of them.

After their father's death in 1984, both Yalandja and his brother Crusoe Kurddal produced large *mimih* carvings similar to the ones made by their father for the Mamurrng ceremony. In the 1990s Yalandja began to experiment with the dot patterning taught by his father, and created the 'v' shaped fish-scale patterning in his sculptural representations:

> I make it [*yawkyawk*] according to my individual ideas ... My father used to decorate them with dots. A long time ago, he showed me how to do this. But this style is my own, no one else does them like this.[2]

Yalandja's brother Kurrdal has continued to carve *mimih* spirits while Yalandja now concentrates on the *yawkyawk*.

Since the *yawkyawk* are imagined as spirit girls who were transformed into mermaid-like figures with fish tails, in depicting scales on his sculptures – first as arc-like shapes and later refined to the 'v' shape – Yalandja has effected a unique innovation. He has also experimented with using black as a ground colour, rather than the red other family members use. Yalandja's *yawkyawk* sculptures also tend to have a tapering body ending with a forked fish tail. He selects pieces of wood that best suggest movements in the fish-like forms, sometimes making use of natural forks to portray the tail. In other works he has selected curvilinear tree trunks to depict the slender and sensuous *yawkyawk* forms. These *yawkyawk* sculptures, with their exquisitely rendered scales, have a special beauty and sensuality not always associated with three-dimensional Aboriginal forms of art.

Yalandja is one of Australia's most accomplished sculptors. He is also a recorded didjeridu player and a well-known singer for *yawkyawk* style diplomacy ceremonies. The five magnificent *yawkyawk* sculptures he has contributed to *Culture Warriors* attest to his respect for tradition and his capacity for artistic innovation, for which we can all be grateful.

PHOTOGRAPHS ON PAGE 178
Owen Yalandja, Cadell outstation, near Maningrida, 2007, photographs by Apolline Kohen

1 Owen Yalandja, interview by Apolline Kohen, 4 February 2007, Cadell Outstation, Northern Territory.

2 Maningrida Arts and Culture website, viewed 2 April 2007, maningrida.com.

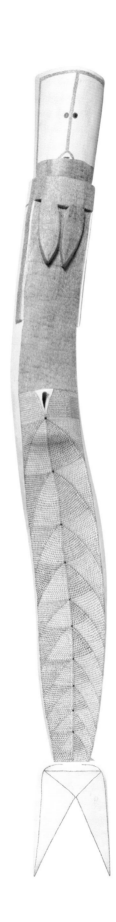

Yawkyawk 2007 332.0 x 35.0 x 37.0 cm

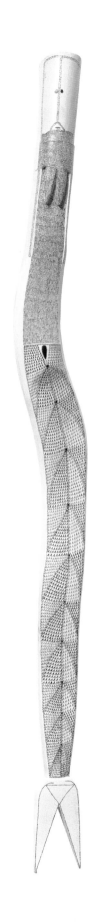

Yawkyawk 2007 212.0 x 16.0 x 40.0 cm

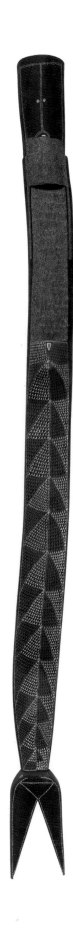

Yawkyawk 2007 240.0 x 16.0 x 49.5 cm

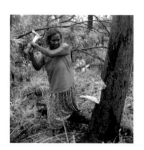
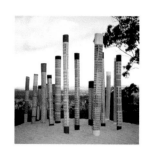

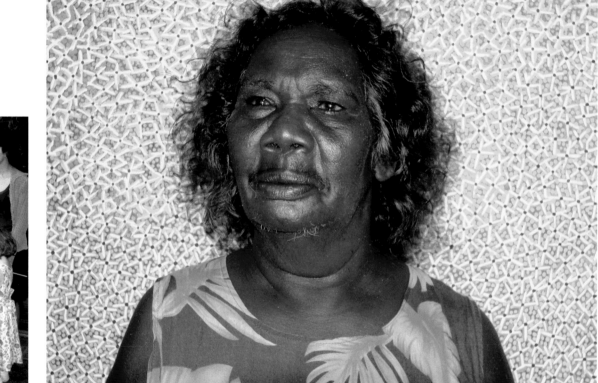

GULUMBU YUNUPINGU

... I have this knowledge that my father told me, about the seven sisters and about the sky ... I had this knowledge that these stars are in the sky, and this came to me about the universe.

Then I had this dream ... one night; we were sleeping outside, my sisters and me, and we were looking up in the sky, and we saw a beautiful sky ... it was bright and the sky was blue and light stars everywhere.

[When] I woke up ... in the morning I had this vision and [was] told: 'do this'. Maybe hiding somewhere at the back of my mind [was] knowledge my father had. Then I got these rocks and paints and brushes and hairbrush and then I did this first one ... little piece of bark ... and then I tried these stars.[1]

Brenda L. Croft

In the Indigenous visual art scene many emerging artists, particularly those from more remote regions of Australia (that is, far from metropolitan art school training), are highly placed within their communities as ceremonial leaders and/or healers. Their profound knowledge is manifest in their art practice. So it is with Gumatj/Rrakpala artist Gulumbu Yunupingu, who is an important leader in her community at Yirrkala in North-East Arnhem Land. With connections to one of its most important cultural dynasties, and although relatively unknown in the art world only a few years ago, Yunupingu is now considered one of the most innovative of contemporary Indigenous artists.

I first became aware of Gulumbu Yunupingu's art at the 2004 Garma Festival of Traditional Culture[2], held annually at Gulkula, an outstation and important ceremonial site forty kilometres from Nhulunbuy in North-East Arnhem Land. Walking along a track towards an outcrop overlooking an escarpment, with the ocean vanishing in the distance, I was entranced by the sight of a cluster of stunning *larrakitj* (funerary hollow log coffins), of which one, covered in a swathe of shimmering ochre stars, held me transfixed. The shining galaxy depicted on this particular *larrakitj* led to me to seek out the artist's identity.

The installation was on loan from a private collection for the duration of the Festival, and each evening at dusk every *larrakitj* would be covered with a shroud to protect them from the quicksilver tropical elements. Will Stubbs, the co-ordinator at Buku-Larrnggay Mulka Art Centre (who is also Yunupingu's son-in-law), oversaw this task. It was magical observing the light shift from palest pink through lavender and purple tones, with the luminescent moon rising over the sea and the first night stars commencing their trajectory, all accompanied by the sounds of Garma's *Bunggul* (ceremonial performance) with the hypnotic resonance of the *yidaki* (didjeridu) in the near distance.[3]

Yunupingu's source of inspiration is *Garak (the Universe)*, which in her work appears to represent the Milky Way, an important ancestral story especially for the Yolngu people of North-East Arnhem Land where the artist lives. However, she has said that her art is about far more than this: it incorporates the entire universe, all the stars that can be seen by the naked eye and everything that exists beyond scientific exploration; everything that can be imagined, and all that is beyond the imagination.

Yunupingu's high degree of skill and innovation in her work made her a clear choice for inclusion in the prestigious Australian Indigenous Art Commission for the Musée du quai Branly in Paris, which opened last year.[4] Working on the Commission necessitated visits by the curatorial team to North-East Arnhem Land, sitting down with Gulumbu in her country and hearing her clan's customary stories handed down to her by her father, senior Yolngu law man Mungurruwuy Yunupingu[5], then gaining formal approval from her for the adaptation of her work of art into a design embedded into the building fabric in Paris, a hundred times larger than the original.

On one of these visits I was fortunate be with Yunupingu when she collected a raw hollow log, which subsequently became a magnificent *larrakitj*. I saw her spot the right tree from a moving troopie (troop carrier: the vehicle of choice in Arnhem Land), then watched in amazement as this grandmother, her feet planted firmly on her land, swung an axe with colossal strokes, felling the tree with a minimum of fuss. A bonus was discovering three squawking baby red-wing parrots at the bottom of the hollowed-out trunk, perhaps placed there for protection by their mother as a cyclone had recently swept through the region. Yunupingu's finished *larrakitj* is now part of the national collection and is included in *Culture Warriors*.

At the official Sydney launch of the Commission for the Musée du quai Branly in December 2005, Gulumbu's eloquent speech brought many to tears as she stressed the importance for her to share her art and culture with the world for future generations to see, long after she is physically gone from this earth, her spirit taking its place with her ancestors in the night sky above.

This is from my heart, to you, to share, for the whole world to understand my culture.

PHOTOGRAPHS ON PAGE 184

MAIN IMAGE: Gulumbu Yunupingu with *Garak (the Universe)* 2007, Yirrkala, 2007, photograph by Andrew Blake

CLOCKWISE FROM TOP RIGHT: Larrakitj installation, Kerry Stokes Collection, Gulkala 2004, photograph by Brenda L. Croft; Sienna Mununggurr-Stubbs, Yunupingu, Merriki Munungurr-Stubbs, Presidential Palace, Paris, 2006, photograph by Brenda L. Croft; Detail of Yunupingu ceiling, Australian Indigenous Art Commission, Musée du quai Branly, 2006, photograph by Brenda L. Croft; Yunupingu and Brenda L. Croft, Garma Festival, Gulkala, 2004, photograph by Beverly Knight; Yunupingu, Sienna Mununggurr-Stubbs, Hetti Perkins, Judy Watson and Rani Carmichael, Musée du quai Branly, Paris, 2006, photograph by Brenda L. Croft; Yunupingu cutting down *larrakitj* (hollow log), Yirrkala, 2005, photograph by Brenda L. Croft

1 Yunupingu, Yirrkala, March 2007.

2 The Festival brings together over twenty clan groups from the region, as well as Indigenous and non-Indigenous participants and visitors from Australia and an expanding international audience.

3 The ancient sound of the *yidaki* (didjeridu) is a call to all people to come together in unity.

4 Eight artists were selected to participate, funded by both the French and Australian governments and corporate sponsors.

5 Mungurruwuy (c.1907–1978) was a renowned cultural activist, artist and ceremonial leader, and was one of the main proponents of the Yirrkala Bark Petition. Presented to the Commonwealth Parliament in 1963, this was a landmark example of utilising the power of visual art and culture to exemplify the customary land rights of Yolngu people within the Australian constitutional and legal system.

LEFT: *Garak (the Universe)* 2005 RIGHT: *Gan'yu (Stars)* 2005 234.0 x 21.0 x 59.9 cm

LEFT: *Gan'yu (Stars)* 2005 254.0 x 12.0 x 45.3 cm RIGHT: *Gan'yu (Stars)* 2005 254.0 x 17.0 x 51.0 cm

Garak (the Universe) 2007

CHECKLIST

Measurements are given height before width. For three-dimensional objects, the diameter or depth is given last.

VERNON AH KEE

Kuku Yalanji/Waanyi/Yidinyji/ Gugu Yimithirr peoples born 1967, Innisfail, Queensland, Australia

mythread
2007, Brisbane, Queensland
synthetic polymer paint, charcoal and crayon on canvas
overall 177.0 x 720.0 cm
each 177.0 x 240.0 cm
National Gallery of Australia, Canberra
Purchased 2007
Courtesy of the artist and Bellas Milani Gallery

not an animal or a plant
2006, Brisbane, Queensland
vinyl lettering
300.0 x 300.0 cm
Courtesy of the artist and Bellas Milani Gallery

hang ten
2006, Brisbane, Queensland
vinyl lettering on PVC
122.0 x 180.0 cm
Courtesy of the artist and Bellas Milani Gallery

stolen/removed
2006, Brisbane, Queensland
vinyl lettering on PVC
122.0 x 180.0 cm
Courtesy of the artist and Bellas Milani Gallery

strange fruit
2006, Brisbane, Queensland
vinyl lettering on PVC
122.0 x 180.0 cm
Courtesy of the artist and Bellas Milani Gallery

JEAN BAPTISTE APUATIMI

Tiwi people, Tapatapunga (March Fly) skin group, Jarrangini (Buffalo) dance born 1940, Pirlangimpi (Garden Point), Tiwi Island, Northern Territory, Australia

Jikapayinga
2007, Nguiu, Bathurst Island, Northern Territory
natural earth pigments on canvas
160.0 x 200.0 cm

National Gallery of Australia, Canberra
Purchased 2007
© Jean Baptiste Apuatimi

Yirrikamini
2007, Nguiu, Bathurst Island, Northern Territory
natural earth pigments on canvas
160.0 x 200.0 cm
National Gallery of Australia, Canberra
Purchased 2007
© Jean Baptiste Apuatimi

Yirrikapayi
2007, Nguiu, Bathurst Island, Northern Territory
natural earth pigments on canvas
160.0 x 200.0 cm
National Gallery of Australia, Canberra
Purchased 2007
© Jean Baptiste Apuatimi

JIMMY BAKER

Pitjantjatjara people born c.1915, Malumpa, South Australia, Australia

Katatjita
2006, Nyapari, South Australia
synthetic polymer paint on canvas
142.0 x 201.5 cm
Courtesy of Marshall Arts Aboriginal Fine Art Gallery
© Jimmy Baker

Piltati
2007, Nyapari, South Australia
synthetic polymer paint on canvas
201.0 x 107.0 cm
Courtesy of Jo Lagerberg
© Jimmy Baker

Wanampi Kutjara (Two Serpent Men's Creation Story)
2006, Nyapari, South Australia
synthetic polymer paint on canvas
147.5 x 203.5 cm
Art Gallery of South Australia, Adelaide
Gift of the South Australian Government to commemorate the 125th anniversary of the Art Gallery of South Australia 2006
© Jimmy Baker

MARINGKA BAKER

Pitjantjatjara people born c.1952, Kanpi, South Australia, Australia

Kuru Ala
2007, Nyapari, South Australia
synthetic polymer paint on canvas

153.5 x 200.0 cm
National Gallery of Australia, Canberra
Purchased 2007
© Maringka Baker

Anmangunga
2006, Nyapari, South Australia
synthetic polymer paint on canvas
136.5 x 202.5 cm
Art Gallery of South Australia, Adelaide
Gift of the South Australian Government to commemorate the 125th anniversary of the Art Gallery of South Australia 2006
© Maringka Baker

Kata Ala
2006, Nyapari, South Australia
synthetic polymer paint on canvas
124.0 x 157.0 cm
Courtesy of a private collection
© Maringka Baker

Ngura Mankurpa
2006, Nyapari, South Australia
synthetic polymer paint on canvas
148.0 x 199.0 cm
Courtesy of Marshall Arts Aboriginal Fine Art Gallery
© Maringka Baker

RICHARD BELL

Kamilaroi/Kooma/Jiman/ Gurang Gurang peoples born 1953, Charleville, Queensland, Australia

Australian Art it's an Aboriginal Thing
2006, Brisbane, Queensland
synthetic polymer paint on canvas
overall 240.0 x 360.0 cm
each 240.0 x 180.0 cm
TarraWarra Museum of Art Collection
Acquired 2006
Courtesy of the artist and Bellas Milani Gallery

Psalm singing
2007, Brisbane, Queensland
synthetic polymer paint on canvas
240.0 x 350.0 cm
National Gallery of Australia, Canberra
Purchased 2007
Courtesy of the artist and Bellas Milani Gallery

Big brush stroke
2005, Brisbane, Queensland
synthetic polymer paint on canvas
overall 240.0 x 270.0 cm
each 240.0 x 90.0 cm
National Gallery of Australia, Canberra
Purchased 2007

Courtesy of the artist and Bellas Milani Gallery

Palm Island
2006, Brisbane, Queensland
synthetic polymer paint on canvas
175.0 x 240.0 cm
Courtesy of the artist and Bellas Milani Gallery

Uz vs Them
2006, Brisbane, Queensland
digital media on DVD
2.47 minutes
Courtesy of the artist and Bellas Milani Gallery

JAN BILLYCAN (DJAN NANUNDIE)

Yulparija people, Karrimarra skin group born c.1930, Ilyarra, Great Sandy Desert, Western Australia, Australia

All that Jila
2004, Broome, Western Australia
synthetic polymer paint on canvas
140.0 x 100.0 cm
Courtesy of a private lender via William Mora Galleries
© Jan Billycan (Djan Nanundie)

All that Jila
2005, Broome, Western Australia
synthetic polymer paint on canvas
121.5 x 121.5 cm
Courtesy of a private collection, Melbourne
© Jan Billycan (Djan Nanundie)

All the Jila
2006, Broome, Western Australia
acrylic binder with langridge dry pigment and marble dust on plyboard
overall 180.0 x 240.0 cm
each 90.0 x 60.0 cm
National Gallery of Australia, Canberra
Purchased 2007
© Jan Billycan (Djan Nanundie)

DANIEL BOYD

Kudjla/Gangalu peoples born 1982, Cairns, Queensland, Australia

King No Beard
2007, Blue Mountains, New South Wales
oil on canvas
290.7 x 178.9 cm
National Gallery of Australia, Canberra
Purchased 2007

Treasure Island
2005, Canberra, Australian Capital Territory/ Blue Mountains, New South Wales
oil on canvas
192.5 x 220.0 cm
National Gallery of Australia, Canberra
Purchased 2006

Governor No Beard
2007, Canberra, Australian Capital Territory/ Blue Mountains, New South Wales
oil on canvas
195.0 x 158.0 cm
Courtesy of Kay O'Donnell

Fall and expulsion
2006, Canberra, Australian Capital Territory/ Blue Mountains, New South Wales
oil on canvas
167.5 x 101.4 cm
Courtesy of Bernard and Anna Shafer

TREVOR 'TURBO' BROWN

Latje Latje people born 1967, Mildura, Victoria, Australia

Dreamtime kangaroo and bird
2006, Melbourne, Victoria
synthetic polymer paint on canvas
152.0 x 122.0 cm
Courtesy of Indigenart, The Mossenson Galleries
© Trevor 'Turbo' Brown

Koala and babies
2005, Melbourne, Victoria
synthetic polymer paint on canvas
152.5 x 122.0 cm
National Gallery of Australia, Canberra
Purchased 2007
© Trevor 'Turbo' Brown

Sugar gliders
2006, Melbourne, Victoria
synthetic polymer paint on canvas
121.5 x 91.5 cm
Courtesy of Indigenart, The Mossenson Galleries
© Trevor 'Turbo' Brown

Three wombats
2006, Melbourne, Victoria
synthetic polymer paint on canvas
121.5 x 121.5 cm
National Gallery of Australia, Canberra
Purchased 2007
© Trevor 'Turbo' Brown

CHRISTINE CHRISTOPHERSEN

Iwatja/Iwaidja people, Mirrar/Murran clan
born 1959, Darwin, Northern Territory, Australia

Blue print
2006, Darwin, Northern Territory
synthetic polymer paint
on canvas
200.0 x 250.0 cm
National Gallery of Australia, Canberra
Purchased 2007

The past, the present, the future
2006, Darwin, Northern Territory
synthetic polymer paint
on canvas
200.0 x 248.0 cm
National Gallery of Australia, Canberra
Purchased 2007

Cognition
2007, Darwin, Northern Territory
synthetic polymer paint
on canvas
200.0 x 200.0 cm
Courtesy of the artist

Blue print
2006, Darwin, Northern Territory
digital media on DVD
21.41 minutes
Courtesy of Boomalli Aboriginal Artist Co-operative Ltd

DESTINY DEACON

Kugu/Kuku/Erub/Mer peoples
born 1957 Maryborough, Queensland, Australia

Man and doll (a) from the series
Colour blinded
2005, Melbourne, Victoria
lightjet print from
orthochromatic film negative
81.0 x 111.2 cm
Courtesy of the artist and
Roslyn Oxley9 Gallery

Man and doll (b) from the series
Colour blinded
2005, Melbourne, Victoria
lightjet print from
orthochromatic film negative
81.0 x 111.2 cm
Courtesy of the artist and
Roslyn Oxley9 Gallery

Man and doll (c) from the series
Colour blinded
2005, Melbourne, Victoria
lightjet print from
orthochromatic film negative

81.0 x 111.2 cm
Courtesy of the artist and
Roslyn Oxley9 Gallery

Baby boomer from the series
Colour blinded
2005, Melbourne, Victoria
lightjet print from
orthochromatic film negative
81.0 x 111.2 cm
Courtesy of the artist and
Roslyn Oxley9 Gallery

Back up from the series
Colour blinded
2005, Melbourne, Victoria
lightjet print from
orthochromatic film negative
81.0 x 111.2 cm
Courtesy of the artist and
Roslyn Oxley9 Gallery

Pacified from the series
Colour blinded
2005, Melbourne, Victoria
lightjet print from
orthochromatic film negative
81.0 x 111.2 cm
Courtesy of the artist and
Roslyn Oxley9 Gallery

Snow storm from the series
Colour blinded
2005, Melbourne, Victoria
golliwog dolls, polystyrene and
perspex cube
40.0 x 40.0 x 40.0 cm
Courtesy of the artist and
Roslyn Oxley9 Gallery

Snow storm from the series
Colour blinded
2005, Melbourne, Victoria
golliwog dolls, polystyrene and
perspex cube
44.0 x 44.0 x 44.0 cm
Courtesy of the artist and
Roslyn Oxley9 Gallery

DESTINY DEACON

Kugu/Kuku/Erub/Mer peoples
born 1957 Maryborough, Queensland, Australia

VIRGINIA FRASER

born Melbourne, Victoria, Australia

Good golly miss dolly from the
series *Colour blinded*
2005, Melbourne, Victoria
digital media on DVD
4.30 minutes
Courtesy of the artists and
Roslyn Oxley9 Gallery

JULIE DOWLING

Badimaya/Yamatji/ Widi peoples
born 1969, Perth, Western Australia, Australia

Walyer
2006, Perth, Western Australia
synthetic polymer paint and
red ochre on canvas
200.0 x 150.0 cm
National Gallery of Australia, Canberra
Purchased 2007
© Ms Julie Dowling

The nurse maid (Biddy)
2005, Perth, Western Australia
synthetic polymer paint, plastic
and gold leaf on canvas
142.0 x 91.0 cm
National Gallery of Australia, Canberra
Purchased 2006
© Ms Julie Dowling

Burrup
2007, Perth, Western Australia
synthetic polymer paint, plastic
polymer and natural earth
pigments on canvas
150.0 x 200.0 cm
© Ms Julie Dowling

The meeting
2007, Perth, Western Australia
synthetic polymer paint, plastic
polymer and natural earth
pigments on canvas
160.0 x 160.0 cm
© Ms Julie Dowling

PHILIP GUDTHAYKUDTHAY

Liyagalawumirr people, Galwanuc clan, *Dhuwa* moiety
born c. 1925, Ramingining, Northern Territory, Australia

Goanna and rarrk
2006, Ramingining, Central
Arnhem Land, Northern Territory
natural earth pigments on
hollow log
230.0 x 13.5 x 49.0 cm
National Gallery of Australia, Canberra
Purchased 2006
© Philip Gudthaykudthay

Goannas
2007, Ramingining, Central
Arnhem Land, Northern Territory
natural earth pigments on
hollow log
193.0 x 12.5 x 45.0 cm

National Gallery of Australia, Canberra
Purchased 2007
© Philip Gudthaykudthay

Wititj (olive python)
2007, Ramingining, Central
Arnhem Land, Northern Territory
natural earth pigments on
hollow log
189.5 x 12.5 x 40.0 cm
National Gallery of Australia, Canberra
Purchased 2007
© Philip Gudthaykudthay

Gunyunmirringu
2007, Ramingining, Central
Arnhem Land, Northern Territory
natural earth pigments on
hollow log
198.0 x 15.5 x 46.0 cm
National Gallery of Australia, Canberra
Purchased 2007
© Philip Gudthaykudthay

Gunyunmirringa (landscape)
2007, Ramingining, Central
Arnhem Land, Northern Territory
natural earth pigments on
hollow log
106.0 x 11.5 x 33.8 cm
National Gallery of Australia, Canberra
Purchased 2007
© Philip Gudthaykudthay

Wagilag Sisters, with child
2007, Ramingining, Central
Arnhem Land, Northern Territory
natural earth pigments
on canvas
172.0 x 120.0 cm
National Gallery of Australia, Canberra
Purchased 2007
© Philip Gudthaykudthay

TREAHNA HAMM

Yorta Yorta people
born 1965, Melbourne, Victoria, Australia

*Barmah nurrtja biganga (Barmah
Forest possum-skin cloak)*
2005, Albury, New South Wales
common brushtail possum
(*Trichosurus vulpecula*) skin pelts,
thread and natural earth
pigments
162.0 x 94.0 cm
National Gallery of Australia, Canberra
Purchased 2007
© Treahna Hamm

*Yakapna yenbena dungudja
nyinidhan biganga
(Family ancestor strong fight
possum cloak)*
2007, Albury, New South Wales
common brushtail possum
(*Trichosurus vulpecula*)
skin pelts, thread and natural
earth pigments
210.0 x 133.0 x 84.0 cm
National Gallery of Australia, Canberra
Purchased 2007
© Treahna Hamm

Digging stick
2007, Albury, New South Wales
wood
68.3 x 3.0 x 9.0 cm
National Gallery of Australia, Canberra
Purchased 2007
© Treahna Hamm

Yabby
2005, Albury, New South Wales
sedge grass (*Cyperus involucratus*),
gumnuts and wire
76.0 x 70.0 x 84.0 cm
National Gallery of Australia, Canberra
Purchased 2007
© Treahna Hamm

GORDON HOOKEY

Waanyi/Waanjiminjin peoples
born 1961, Cloncurry, Queensland, Australia

FIGHT: To Survive; To Live; To Die!
2007, Brisbane, Queensland
oil on canvas
overall 240.0 x 603.70 cm
outer each 167.5 x 121.6 cm
inner each 240.0 x 180.1 cm
National Gallery of Australia, Canberra
Purchased 2007
© Gordon Hookey

A painting for the underdawg
2005, Vincent, Queensland
oil on canvas
133.0 x 250.0 cm
National Gallery of Australia, Canberra
Purchased 2005
© Gordon Hookey

Grog Gott'im
2005, Brisbane, Queensland
oil on canvas
213.0 x 200.0 cm
Courtesy of Nellie Castan Gallery
© Gordon Hookey

ANNIEBELL MARRNGAMARRNGA

Kuninjku people, Bangardidjan subsection, *Yirritja* moiety
born 1968, Western Arnhem Land, Northern Territory, Australia

Yawkyawk mother and babies
2006, Maningrida, Western Arnhem Land, Northern Territory
natural earth pigments dyed on woven pandanus (*Pandanus spiralis*)
285.0 x 172.0 x 3.5 cm
National Gallery of Australia, Canberra
Purchased 2007
Courtesy of Maningrida Arts and Culture
© Anniebell Marrngamarrnga

Yawkyawk
2007, Maningrida, Western Arnhem Land, Northern Territory
natural earth pigments dyed on woven pandanus (*Pandanus spiralis*)
215.0 x 63.0 x 3.3 cm
National Gallery of Australia, Canberra
Purchased 2007
Courtesy of Maningrida Arts and Culture
© Anniebell Marrngamarrnga

Yawkyawk
2007, Maningrida, Western Arnhem Land, Northern Territory
natural earth pigments dyed on woven pandanus (*Pandanus spiralis*)
224.0 x 90.0 x 2.9 cm
National Gallery of Australia, Canberra
Purchased 2007
Courtesy of Maningrida Arts and Culture
© Anniebell Marrngamarrnga

Yawkyawk
2007, Maningrida, Western Arnhem Land, Northern Territory
natural earth pigments dyed on woven pandanus (*Pandanus spiralis*)
216.0 x 65.0 x 2.9 cm
National Gallery of Australia, Canberra
Purchased 2007
Courtesy of Maningrida Arts and Culture
© Anniebell Marrngamarrnga

Crocodile
2007, Maningrida, Western Arnhem Land, Northern Territory
natural earth pigments dyed on woven pandanus (*Pandanus spiralis*)
270.0 x 70.0 x 3.0 cm
National Gallery of Australia, Canberra
Purchased 2007
Courtesy of Maningrida Arts and Culture
© Anniebell Marrngamarrnga

JOHN MAWURNDJUL

Kuninjku (eastern Kunwinjku) people, Kurulk clan, *Dhuwa* moiety, Balang subsection
born 1952, Mumeka/ Milmilngkan area, Northern Territory, Australia

Mardayin design at Dilebang
2006, Maningrida, Western Arnhem Land, Northern Territory
natural earth pigments on stringybark
200.0 x 47.0 cm
National Gallery of Australia, Canberra
Purchased 2007
Courtesy of Maningrida Arts and Culture
© John Mawurndjul

Lorrkon
2004, Maningrida, Western Arnhem Land, Northern Territory
natural earth pigments and PVA fixative on hollow log
243.0 x 20.0 x 56.8 cm
National Gallery of Australia, Canberra
Purchased 2005
Courtesy of Maningrida Arts and Culture
© John Mawurndjul

Lorrkon (Mardayin design)
2004, Maningrida, Western Arnhem Land, Northern Territory
natural earth pigments and PVA fixative on hollow log
213.0 x 23.0 x 68.3 cm
National Gallery of Australia, Canberra
Purchased 2005
Courtesy of Maningrida Arts and Culture
© John Mawurndjul

Lorrkon
2006, Maningrida, Western Arnhem Land, Northern Territory
natural earth pigments and PVA fixative on hollow log
221.0 x 27.0 79.0 cm
National Gallery of Australia, Canberra
Purchased 2007
Courtesy of Maningrida Arts and Culture
© John Mawurndjul

Mardayin
2004, Maningrida, Western Arnhem Land, Northern Territory
natural earth pigments on hollow wood
188.0 x 85.0 cm
National Gallery of Australia, Canberra
Purchased 2005
Courtesy of Maningrida Arts and Culture
© John Mawurndjul

Mardayin at Milmilngkan
2006, Maningrida, Western Arnhem Land, Northern Territory
natural earth pigments on hollow log
180.0 x 52.0 cm
National Gallery of Australia, Canberra
Purchased 2007
Courtesy of Maningrida Arts and Culture
© John Mawurndjul

RICKY MAYNARD

Ben Lomond/Big River peoples
born 1953, Launceston, Tasmania, Australia
Sandy Barnard, printer

Broken Heart
2007, Sydney, New South Wales
silver gelatin photograph
image 45.2 x 45.4 cm
Courtesy of the artist and Stills Gallery

Coming home
2007, Sydney, New South Wales
silver gelatin photograph
image 40.6 x 58.4 cm
Courtesy of the artist and Stills Gallery

Custodians
2007, Sydney, New South Wales
silver gelatin photograph
image 45.2 x 45.4 cm

Lorrkon
2006, Maningrida, Western Arnhem Land, Northern Territory
natural earth pigments and PVA fixative on hollow log
221.0 x 27.0 79.0 cm
National Gallery of Australia, Canberra
Purchased 2007
Courtesy of Maningrida Arts and Culture
© John Mawurndjul

Mardayin
2004, Maningrida, Western Arnhem Land, Northern Territory
natural earth pigments on hollow wood
188.0 x 85.0 cm
National Gallery of Australia, Canberra
Purchased 2005
Courtesy of Maningrida Arts and Culture
© John Mawurndjul

Mardayin at Milmilngkan
2006, Maningrida, Western Arnhem Land, Northern Territory
natural earth pigments on hollow log
180.0 x 52.0 cm
National Gallery of Australia, Canberra
Purchased 2007
Courtesy of Maningrida Arts and Culture
© John Mawurndjul

Courtesy of the artist and Stills Gallery

Death in exile
2007, Sydney, New South Wales
silver gelatin photograph
image 40.6 x 58.2 cm
Courtesy of the artist and Stills Gallery

Free country
2007, Sydney, New South Wales
silver gelatin photograph
image 45.3 x 45.3 cm
Courtesy of the artist and Stills Gallery

The healing garden
2007, Sydney, New South Wales
silver gelatin photograph
image 40.7 x 58.2 cm
Courtesy of the artist and Stills Gallery

Mission
2007, Sydney, New South Wales
silver gelatin photograph
image 45.6 x 45.4 cm
Courtesy of the artist and Stills Gallery

The Spit
2007, Sydney, New South Wales
silver gelatin photograph
image 40.4 x57.8 cm
Courtesy of the artist and Stills Gallery

Traitor
2007, Sydney, New South Wales
silver gelatin photograph
image 45.6 x 58.2 cm
Courtesy of the artist and Stills Gallery

Vansittart Island
2007, Sydney, New South Wales
silver gelatin photograph
image 40.8 x 58.6 cm
Courtesy of the artist and Stills Gallery

DANIE MELLOR

Mamu/Ngagen/Ngajan peoples
born 1971, Mackay, Queensland, Australia

The contrivance of a vintage wonderland (A magnificent flight of curious fancy for science buffs … a china ark of seductive whimsy … a divinely ordered special attraction … upheld in multifariousness)
2007, Canberra, Australian Capital Territory/Sydney, New South Wales
installation mixed media, kangaroo skin, ceramic, synthetic eyeballs, wood and birds

overall major work
400.0 x 783.0 x 496.6 cm
overall minor work
290.0 x 184.0 cm
Courtesy of the artist

In memory (absentia)
2007, Canberra, Australian Capital Territory
metal
77.2 x 36.0 cm
Courtesy of the artist

Of dreams the parting
2007, Canberra, Australian Capital Territory
metal
82.6 x 41.0 cm
Courtesy of the artist

£5 of culture
2007, Canberra, Australian Capital Territory
metal
88.1 x 43.0 cm
Courtesy of the artist

The Heart's tale
2007, Canberra, Australian Capital Territory
metal
87.0 x 43.0 cm
Courtesy of the artist

The biggest yet
2007, Canberra, Australian Capital Territory
metal
136.6 x 66.6 cm
Courtesy of the artist

LOFTY BARDAYAL NADJAMERREK AO

Kundedjnjenghmi people, Mok clan, Wamud/ Na-Kodjok affiliation
born c. 1926, Kukkulumurr, Western Arnhem Land, Northern Territory, Australia

Barrk – black wallaroo after fire
2005, Kabulwarnamyo, Western Arnhem Land, Northern Territory
natural earth pigments on stringybark
159.0 x 79.0 cm
National Gallery of Australia, Canberra
Purchased 2006
© Lofty Bardayal Nadjamerrek, Injalak Arts

Kurdukadj (Emu)
2004, Kabulwarnamyo, Western Arnhem Land, Northern Territory
natural earth pigments on paper
150.0 x 105.0 cm
National Gallery of Australia, Canberra

Purchased 2007
© Lofty Bardayal Nadjamerrek,
Injalak Arts

Bininj Daluk (husband and wife)
2004, Kabulwarnamyo, Western
Arnhem Land, Northern Territory
natural earth pigments
on stringybark
129.0 x 57.0 cm
National Gallery of Australia,
Canberra
Purchased 2006
© Lofty Bardayal Nadjamerrek,
Injalak Arts

*Dulklorrkelorrkeng and
Wakkewakken*
2005, Kabulwarnamyo, Western
Arnhem Land, Northern Territory
natural earth pigments
on stringybark
83.0 x 151.0 cm
Collection of Michael and
Eleonora Triguboff
© Lofty Bardayal Nadjamerrek,
Injalak Arts

Ngalyod I
2005, Kabulwarnamyo, Western
Arnhem Land, Northern Territory
natural earth pigments on bark
45.0 x 134.0 cm
Courtesy of a private collection
© Lofty Bardayal Nadjamerrek,
Injalak Arts

DOREEN REID
NAKAMARRA

**Pintupi/Ngaatjatgarra peoples,
Nakamarra subsection
born c. 1950, Warburton Ranges,
Northern Territory/Western
Australia, Australia**

Untitled
2005, Kiwirrkura, Western Desert,
Western Australia
synthetic polymer paint on canvas
122.0 x 153.0 cm
National Gallery of Australia,
Canberra
Purchased 2005
© Doreen Reid Nakamarra,
courtesy of Pupunya Tula Artists
Pty Ltd

Untitled
2007, Kiwirrkura, Western Desert,
Western Australia
synthetic polymer paint on canvas
183.0 x 244.0 cm
National Gallery of Australia,
Canberra
Purchased 2007
© Doreen Reid Nakamarra,
courtesy of Pupunya Tula Artists
Pty Ltd

Untitled
2006, Kiwirrkura, Western Desert,
Western Australia
synthetic polymer paint
on canvas
183.0 x 153.0 cm
Courtesy of a private collection,
Melbourne
© Doreen Reid Nakamarra,
courtesy of Pupunya Tula Artists
Pty Ltd

Untitled
2006, Kiwirrkura, Western Desert,
Western Australia
synthetic polymer paint on canvas
122.0 x 153.0 cm
© Doreen Reid Nakamarra,
courtesy of Pupunya Tula Artists
Pty Ltd

DENNIS
NONA

**Kala Lagaw Ya (Western
Torres Strait Island) people,
Tabu (Snake) and Tupmul
(Stingray) totems
born 1973, Badu (Mulgrave)
Island, Torres Strait Islands,
Queensland, Australia**

**Urban Art Projects, Brisbane,
fabricators**

Apu Kaz (Mother and baby dugong)
2007, Brisbane, Queensland
bronze
55.0 x 70.0 x 200.0 cm (mother)
25.0 x 25.0 x 80.0 cm (baby)
National Gallery of Australia,
Canberra
Purchased 2007
Courtesy of the artist and the
Australian Art Print Network

Ubirikubiri
2007, Brisbane, Queensland
bronze and pearlshell
overall 110.0 x 360.0 x 120.0 cm
National Gallery of Australia,
Canberra
Purchased 2007
Courtesy of the artist and the
Australian Art Print Network

DENNIS
NONA

**Kala Lagaw Ya (Western
Torres Strait Island) people,
Tabu (Snake) and Tupmul
(Stingray) totems
born 1973, Badu (Mulgrave)
Island, Torres Strait Islands,
Queensland, Australia**

Theo Tremblay, printer

Yarwarr
2007, Cairns, Queensland
linoleum block relief print on
Hahnemüle paper
paper 122.5 x 610.0 cm
image 119.5 x 599.5 cm
National Gallery of Australia,
Canberra
Purchased 2007
Courtesy of the artist and the
Australian Art Print Network

ARTHUR KOO'EKKA
PAMBEGAN JR

**Wik-Mungkan/Winchanam
peoples, Kalben (Flying Fox
Story Place) totem
born 1936, Aurukun,
Cape York Peninsula,
Queensland, Australia**

Face painting
2006, Aurukun, Cape York
Peninsula, Queensland
natural earth pigments and
hibiscus charcoal with
synthetic polymer binder
on canvas
overall 56.0 x 168.0 cm
each 56.0 x 81.0 cm
National Gallery of Australia,
Canberra
Purchased 2007
© Arthur Koo'ekka Pambegan Jr,
courtesy of Andrew Baker Art
Dealer, Brisbane

Flying fox
2007, Aurukun, Cape York
Peninsula, Queensland
natural earth pigments on
carved wood
overall 174.0 x 178.0 x 31.0 cm
National Gallery of Australia,
Canberra
Purchased 2007
© Arthur Koo'ekka Pambegan Jr,
courtesy of Andrew Baker Art
Dealer, Brisbane

Flying fox (red back)
2007, Aurukun, Cape York
Peninsula, Queensland
natural earth pigments on
carved wood
overall 177.0 x 179.0 x 30.5 cm
National Gallery of Australia,
Canberra
Purchased 2007
© Arthur Koo'ekka Pambegan Jr,
courtesy of Andrew Baker Art
Dealer, Brisbane

Red-backed flying fox
2006, Aurukun, Cape York
Peninsula, Queensland
natural earth pigments and
hibiscus charcoal with
synthetic polymer binder
on canvas
overall 56.0 x 168.0 cm
each 56.0 x 81.0 cm
National Gallery of Australia,
Canberra
Purchased 2007
© Arthur Koo'ekka Pambegan Jr,
courtesy of Andrew Baker Art
Dealer, Brisbane

CHRISTOPHER
PEASE

**Minang/Wardandi/Balardung/
Nyoongar peoples
born 1969, Perth,
Western Australia, Australia**

New Water Dreaming
2005, Perth, Western Australia
oil on canvas
100.0 x 180.0 cm
National Gallery of Australia,
Canberra
Purchased 2005

Swan River 50 miles up
2006, Perth, Western Australia
oil on canvas
100.0 x 143.0 cm
Courtesy of the Kerry Stokes
Collection, Perth

Target
2005, Perth, Western Australia
oil on canvas
100.0 x 180.0 cm
Courtesy of the Nelson Family
Collection

Wrong side of the Hay
2005, Perth, Western Australia
oil on canvas
122.0 x 182.0 cm
Courtesy of the Wesfarmers
Collection of Australian Art

SHANE
PICKETT

**Balardung/Nyoongar peoples
born 1957, Quairading,
Western Australia, Australia**

*On the Horizon of the
Dreaming Boodja*
2005, Perth, Western Australia
synthetic polymer paint on canvas
153.0 x 122.0 cm
National Gallery of Australia,
Canberra
Gift of Roslynne Bracher 2006
© Shane Pickett

*Bunuroo afternoon moods of
a hot humid day*
2006, Perth, Western Australia

synthetic polymer paint
on canvas
153.0 x 122.0 cm
Courtesy of Indigenart,
The Mossenson Galleries
© Shane Pickett

*Dreaming path of the Milky Way
(Moorndaam)*
2006, Perth, Western Australia
synthetic polymer paint
on canvas
153.0 x 122.0 cm
Courtesy of Indigenart,
The Mossenson Galleries
© Shane Pickett

*Landscape with a morning
touch of Wanyarang*
2006, Perth, Western Australia
synthetic polymer paint
on canvas
153.0 x 122.0 cm
Courtesy of a private collection,
Victoria
© Shane Pickett

ELAINE
RUSSELL

**Kamilaroi people
born 1941, Tingha,
New South Wales, Australia**

Bagging potatoes
2004, Sydney, New South Wales
synthetic polymer paint on paper
78.0 x 97.0 cm
National Gallery of Australia,
Canberra
Purchased 2004
© Elaine Russell

Catching yabbies
2006, Sydney, New South Wales
synthetic polymer paint on canvas
85.0 x 110.0 cm
National Gallery of Australia,
Canberra
Purchased 2006
© Elaine Russell

Inspecting our houses
2004, Sydney, New South Wales
synthetic polymer paint on paper
78.0 x 97.0 cm
National Gallery of Australia,
Canberra
Purchased 2004
© Elaine Russell

Untitled from the *Mission* series
2006, Sydney, New South Wales
synthetic polymer paint on canvas
80.0 x 110.0 cm
National Gallery of Australia,
Canberra
Purchased 2006
© Elaine Russell

CHRISTIAN BUMBARRA THOMPSON

**Bidjara people
born 1978, Gawler,
South Australia, Australia**

Tracey Moffatt from the series
Gates of Tambo
2004, Melbourne, Victoria
C-type print
124.0 x 125.0 cm
National Gallery of Australia,
Canberra
Purchased 2007
Courtesy of the artist and
Gallery Gabrielle Pizzi

Christian Thompson from the
series *Gates of Tambo*
2004, Melbourne, Victoria
C-type print
124.0 x 125.0 cm
National Gallery of Australia,
Canberra
Purchased 2007
Courtesy of the artist and
Gallery Gabrielle Pizzi

A woman from Peppimenarti from
the series *Gates of Tambo*
2004, Melbourne, Victoria
C-type print
124.0 x 125.0 cm
National Gallery of Australia,
Canberra
Purchased 2007
Courtesy of the artist and
Gallery Gabrielle Pizzi

Rusty Peters from the series
Gates of Tambo
2004, Melbourne, Victoria
C-type print
124.0 x 125.0 cm
National Gallery of Australia,
Canberra
Purchased 2007
Courtesy of the artist and
Gallery Gabrielle Pizzi

Andy Warhol from the series
Gates of Tambo
2004, Melbourne, Victoria
C-type print
124.0 x 125.0 cm
National Gallery of Australia,
Canberra
Purchased 2007
Courtesy of the artist and
Gallery Gabrielle Pizzi

Desert Slippers
2006, Melbourne, Victoria
digital media on DVD
34.0 minutes
Courtesy of the artist and
Gallery Gabrielle Pizzi

The Sixth Mile
2006, Melbourne, Victoria
digital media on DVD
6.10 minutes
Courtesy of the artist and
Gallery Gabrielle Pizzi

JUDY WATSON

**Waanyi people
born 1959, Mundubbera,
Queensland, Australia**

big blue world with three stupas
2004, Brisbane, Queensland
synthetic polymer paint and
pigment on canvas
287.0 x 210.0 cm
Courtesy of the artist and
Tolarno Galleries
© Judy Watson

headhunter
2006, Brisbane, Queensland
pigment, pastel and acquarelle
pencil on canvas
192.0 x 103.0 cm
Courtesy of Richard and
Catherine Williamson
© Judy Watson

headpiece
2004, Brisbane, Queensland
charcoal, pigment and
synthetic polymer paint on
canvas
193.0 x 151.0 cm
Courtesy of a private collection
© Judy Watson

palm cluster
2007, Brisbane, Queensland
pigment, pastel,
synthetic polymer paint and
carbon ink
196.0 x 106.0 cm
National Gallery of Australia,
Canberra
Purchased 2007
© Judy Watson

JUDY WATSON

**Waanyi people
born 1959, Mundubbera,
Queensland, Australia**

numero uno publications:
Noreen Grahame
photographers: Matt
Mainsbridge, Carl Warner
(frontispiece)
printers: Basil Hall,
Jacqueline Gribbin
archivists: Margaret Reid, Tilly
Geary and Maianna Tetuira
binder: Fred Pohlmann

under the act
2007, Brisbane, Queensland
20 etchings on chine collé paper
each 43.0 x 32.0 cm,
open 71.3 x 99.2 cm
Courtesy of Grahame Galleries
+ Editions
© Judy Watson

H. J. WEDGE

**Wiradjuri people
born c. 1958, Erambie Mission,
Cowra, New South Wales,
Australia**

Country swimming hole
2006, Cowra, New South Wales
synthetic polymer paint on canvas
70.0 x 177.5 cm
Courtesy of The Collectors,
Melbourne
© H.J. Wedge

No more drinking
2006, Cowra, New South Wales
synthetic polymer paint on canvas
120.0 x 120.0 cm
Courtesy of Boomalli Aboriginal
Artist Co-operative Ltd
© H.J. Wedge

Untitled
2006, Cowra, New South Wales
synthetic polymer paint on canvas
120.0 x 120.0 cm
Courtesy of Boomalli Aboriginal
Artist Co-operative Ltd
© H.J. Wedge

Taking the land away
2006, Cowra, New South Wales
synthetic polymer paint on canvas
71.0 x 178.0 cm
Courtesy of The Big River
Collection, Tasmania
© H.J. Wedge

Can't stop thinking about it I, II, III
2007, Cowra, New South Wales
synthetic polymer paint on canvas
each 120.0 x 120.0 cm
Courtesy of Boomalli Aboriginal
Artist Co-operative Ltd
© H.J. Wedge

OWEN YALANDJA

**Kuninjku (eastern Kunwinjku)
people, Dangkorlo clan, *Yirritja*
moiety, Njarridja subsection
born 1962, Barrihdjowkkeng,
Western Arnhem Land,
Northern Territory, Australia**

Yawkyawk
2007, Maningrida, Western
Arnhem Land, Northern Territory
natural earth pigment and
PVA fixative on kurrajong wood
(*Brachychiton diversifolius*)
332.0 x 35.0 x 37.0 cm
National Gallery of Australia,
Canberra
Purchased 2007

Yawkyawk
2007, Maningrida, Western
Arnhem Land, Northern Territory
natural earth pigment and
PVA fixative on kurrajong wood
(*Brachychiton diversifolius*)
280.0 x 15.0 x 52.3 cm
Courtesy of the artist and
Maningrida Arts and Culture
© Owen Yalandja

Yawkyawk
2007, Maningrida, Western
Arnhem Land, Northern Territory
natural earth pigment and
PVA fixative on kurrajong wood
(*Brachychiton diversifolius*)
240.0 x 16.0 x 49.5 cm
Courtesy of the artist and
Maningrida Arts and Culture
© Owen Yalandja

Yawkyawk
2007, Maningrida, Western
Arnhem Land, Northern Territory
natural earth pigment and
PVA fixative on kurrajong wood
(*Brachychiton diversifolius*)
225.0 x 18.0 x 44.8 cm
Courtesy of the artist and
Maningrida Arts and Culture
© Owen Yalandja

Yawkyawk
2007, Maningrida, Western
Arnhem Land, Northern Territory
natural earth pigment and
PVA fixative on kurrajong wood
(*Brachychiton diversifolius*)
212.0 x 16.0 x 40.0 cm
Courtesy of Ron and Patricia May
© Owen Yalandja

GULUMBU YUNUPINGU

**Gumatj/Rrakpala peoples,
Yirritja moiety
born c. 1945, Biranybirany,
Dhanaya homelands, North-East
Arnhem Land, Northern
Territory, Australia**

Gan'yu (Stars)
2005, Yirrkala, North-East
Arnhem Land, Northern Territory
natural earth pigments on
hollow log
254.0 x 12.0 cm
National Gallery of Australia,
Canberra

Purchased 2006
© Gulumbu Yunupingu

Gan'yu (Stars)
2005, Yirrkala, North-East
Arnhem Land, Northern Territory
natural earth pigments on
hollow log
254.0 x 17.0 x 51.0 cm
National Gallery of Australia,
Canberra
Purchased 2006
© Gulumbu Yunupingu

Gan'yu (Stars)
2005, Yirrkala, North-East
Arnhem Land, Northern Territory
natural earth pigment on
hollow log
variable 234.0 x 21.0 x 59.9 cm
Courtesy of Annabel and
Rupert Myer
© Gulumbu Yunupingu

Garak (the Universe)
2005, Yirrkala, North-East
Arnhem Land, Northern Territory
natural earth pigments on
hollow log
304.0 x 24.0 x 90.0 cm
National Gallery of Australia,
Canberra
Purchased 2005
© Gulumbu Yunupingu

Garak (the Universe)
2007, Yirrkala, North-East
Arnhem Land, Northern Territory
natural earth pigments on
hollow log
227.0 x 91.0 cm
National Gallery of Australia,
Canberra
Purchased 2007
© Gulumbu Yunupingu

VERNON AH KEE

**Kuku Yalanji/Waanyi/Yidinyji/
Gugu Yimithirr peoples,
Far North Queensland
born 1967, Innisfail, Queensland
lives and works Brisbane,
Queensland**

Selected solo exhibitions

Not an animal or a plant, Bellas
Milani Gallery, Brisbane, 2006;
Mythunderstanding, Contemporary
Art Centre of South Australia,
Adelaide, 2005; *You must hit*, Bellas
Milani Gallery, Brisbane, 2005;
Fantasies of the good, Bellas Milani
Gallery, Brisbane, 2004

Selected group exhibitions

*Queensland live: contemporary art
on tour*, Queensland Art Gallery,
regional touring exhibition, 2006;
This is not America, National
Gallery of Victoria and Australian
Centre for the Moving Image
(ACMI), Melbourne, touring
Australia and Germany, 2003–04;
*Feedback: art, social consciousness
and resistance*, Monash Museum
of Art, Monash University,
Melbourne, 2003; *Story place:
Indigenous art of Cape York and the
rainforest*, Queensland Art Gallery,
Brisbane, 2003; *Abstractions*, Drill
Hall Gallery, Australian National
University, Canberra, 2003;
*Places that name us: RAKA Award:
contemporary Indigenous visual
arts #3*, Melbourne, The Ian Potter
Museum of Art, The University of
Melbourne, 2003; *Traffic: crossing
currents in Indigenous photomedia*,
Australian Centre for Photography,
Sydney, 2003; *Transit narratives*,
touring exhibition, Centro per la
Arti Visive le Venezie, Villa Letizia,
Treviso, Italy; Auronzo di Cadore,
Salone espositivo Municipio;
Queensland College of Art,
Brisbane, 2003; Victorian College
of the Arts, Melbourne, 2003;
Tasmanian School of Art, Hobart;
Place/Displace, QCA Gallery,
Queensland College of Art,
Griffith University, Brisbane, 2002

Collections

Museum of Contemporary Art,
Sydney; National Gallery of
Australia, Canberra; National
Gallery of Victoria, Melbourne;
Queensland Art Gallery/
Gallery of Modern Art, Brisbane;
University of Technology, Sydney

Represented by

Bellas Milani Gallery, Brisbane

JEAN BAPTISTE APUATIMI

**Tiwi people, Bathurst Island,
Northern Territory, Tapatapunga
(March Fly) skin group,
Jarrangini (Buffalo) dance
born 1940, Pirlangimpi,
Bathurst Island
lives and works Nguiu, Bathurst
Island, Northern Territory**

Solo exhibitions

Makatingari, Aboriginal and
Pacific Art, Sydney, 2006;
Mirripaka Winga, RAFT Artspace,
Darwin, 2005; *Jean Baptiste
Apuatimi*, Aboriginal and Pacific
Art, Sydney, 2004 and 2003;
Paparluwi Jilamara, Sutton Gallery,
Melbourne, 1999

Selected group exhibitions

Object Gallery, Sydney, 2007;
*In the world: head, hand, heart:
17th Tamworth fibre textile
biennale*, Tamworth Regional
Gallery, touring exhibition,
2006–08; *Freestyle: new Australian
design for living*, touring nationally
and internationally: Melbourne
Museum, Melbourne, 2006;
*Dreaming their way: Australian
Aboriginal women painters*,
National Museum of Women in
the Arts, Washington DC, USA;
Hood Museum of Art, Dartmouth
College, New Hampshire,
USA, 2006; *Kiripapurajuwi
Ngini Ngawula Jilimara*, RAFT
Artspace, Darwin, 2006; *23rd
Telstra National Aboriginal and
Torres Strait Islander Art Award*,
Museum and Art Gallery of the
Northern Territory, Darwin,
2006; *Right here, right now:
recent Aboriginal and Torres Strait
Islander art acquisitions*, National
Gallery of Australia, Canberra,
2006; *Kiripuranji: contemporary
art from the Tiwi Islands*, Artbank
collection, DFAT international
touring exhibition 2002–06;
*Islands in the sun: prints by
Indigenous artists of Australia and
the Australasian region*, National
Gallery of Australia, Canberra,
2001; *Tiwi Dreaming*, Taos,
New Mexico, USA, 2000

Collections

Artbank, Sydney; Art Gallery
of New South Wales, Sydney;
Art Gallery of South Australia,
Adelaide; Essl Museum,
Klosterneuburg, Austria;
Museum and Art Gallery of

the Northern Territory, Darwin;
Museum Victoria, Melbourne;
National Gallery of Australia,
Canberra; National Gallery of
Victoria, Melbourne; National
Museum of Women in the Arts,
Washington DC, USA

Represented by

Aboriginal and Pacific Art, Sydney;
RAFT Artspace, Darwin; Tiwi
Design, Nguiu, Bathurst Island

JIMMY BAKER

**Pitjantjatjara people, Anangu
Pitjantjatjara Yankunytjatjara
(APY) Lands, South Australia
born c. 1915, Malumpa
rock hole, near Kanpi,
South Australia
lives and works Nyapari,
South Australia**

Selected group exhibitions

*Walytja: works from the Baker
family*, Marshall Arts Aboriginal
Fine Art Gallery, Adelaide, 2007;
*Nganampa Tjukurpa Nganampa
Ngura*, Marshall Arts Aboriginal
Fine Art Gallery, Adelaide,
2006; *Desert mob 2006*, Araluen
Galleries, Araluen Cultural
Precinct, Alice Springs, 2006;
Art from the APY Lands, Marshall
Arts Aboriginal Fine Art Gallery,
Adelaide, 2005; *Nganampa Ngura*,
Aboriginal and Pacific Art, Sydney,
2005; *Desert mob 2005*, Araluen
Galleries, Araluen Cultural
Precinct, Alice Springs, 2005;
New works from the APY Lands,
South Australian Museum,
Adelaide, 2005

Collections

Art Gallery of South Australia,
Adelaide; Gavan Fox Collection,
Adelaide; Lagerberg–Swift
Collection, Perth; National
Gallery of Australia, Canberra;
National Gallery of Victoria,
Melbourne; The Marshall
Collection, Adelaide; The
Merenda Collection, Perth;
Wyner Collection, Adelaide

Represented by

Marshall Arts Aboriginal Fine Art
Gallery, Adelaide; Tjungu Palya
Artists, South Australia

MARINGKA BAKER

**Pitjantjatjara people, Anangu
Pitjantjatjara Yankunytjatjara
(APY) Lands, South Australia**

**born c. 1952, Kaliumpil,
South Australia
lives and works Nyapari,
South Australia**

Selected group exhibitions

Skin to skin, Tuggeranong Arts
Centre, Canberra, 2007; *Walytja:
works from the Baker family*,
Marshall Arts Aboriginal Fine Art
Gallery, Adelaide, 2007; *Tjukurpa
Mantatja*, Randell Lane Fine Art,
Perth, 2006; *Nganampa Tjukurpa
Nganampa Ngura*, Marshall Arts
Aboriginal Fine Art Gallery,
Adelaide, 2006; *Our mob: a
statewide celebration of regional and
remote South Australian Aboriginal
artists*, Artspace, Adelaide Festival
Centre, Adelaide, 2006; *Minyma
Kutjara: four women of Tjungu
Palya*, Vivien Anderson Gallery,
Melbourne, 2006; *Desert mob
2006*, Araluen Galleries, Araluen
Cultural Precinct, Alice Springs,
2006; *Art from the APY Lands*,
Marshall Arts Aboriginal Fine
Art Gallery, Adelaide, 2005;
New works from the APY Lands,
South Australian Museum,
Adelaide, 2005

Collections

Art Gallery of South Australia,
Adelaide; National Gallery of
Australia, Canberra

Represented by

Marshall Arts Aboriginal Fine Art
Gallery, Adelaide; Tjungu Palya
Artists, South Australia

RICHARD BELL

**Kamilaroi/Kooma/Jiman/
Gurang Gurang peoples,
New South Wales/Queensland
born 1953, Charleville,
Queensland
lives and works Brisbane,
Queensland**

Selected solo exhibitions

Psalm singing, Bellas Milani
Gallery, Brisbane, 2007; *Positivity*,
survey exhibition, Institute of
Modern Art, Brisbane, 2006;
Transition, Bellas Milani Gallery,
Brisbane, 2005; *Colour*,
Bellas Milani Gallery, Brisbane,
2004; *Made men*, Metro Arts,
Brisbane, 2003

Selected group exhibitions

Sunshine state: smart state,
Campbelltown Arts Centre,
Campbelltown, 2007; *Parallel
lives: Australian painting today*,

TarraWarra Museum of Art, Yarra
Valley, 2006; *Recent acquisitions*,
Museum of Contemporary Art,
Sydney, 2004; *The Archibald
Prize 2004*, Art Gallery of
New South Wales, Sydney,
2004, finalist; *Blak insights:
Contemporary Indigenous Art
from the Queensland Art Gallery
Collection*, Brisbane, 2004; *20th
Telstra National Aboriginal and
Torres Strait Islander Art Award*,
Museum and Art Gallery of the
Northern Territory, Darwin,
2003, winner; *The white show*,
Bellas Gallery, Brisbane, 2002;
Dreamtime: the dark and the light,
Sammlung Essl, Austria, 2001;
The white desert, Bellas Gallery,
Brisbane, 2001; *True colours:
Aboriginal and Torres Strait Islander
artists raise the flag*, Boomalli
Aboriginal Artists Co-operative
Ltd, Sydney, with Institute of
International Visual Art (INIVA),
toured UK and Australia, 1994–
96; *The new republics: contemporary
art from Australia, Canada and
South Africa*, Adelaide, England,
Canada, South Africa, 1995

Selected collections

Artbank, Sydney; Art Gallery
of New South Wales, Sydney;
Flinders University Art Museum,
Adelaide; Gold Coast City Art
Gallery, Gold Coast, Queensland;
Museum of Contemporary Art,
Sydney; National Gallery of
Australia, Canberra; National
Gallery of Victoria, Melbourne;
Perc Tucker Regional Gallery,
Townsville, Queensland;
Queensland Art Gallery, Brisbane;
Queensland University of
Technology, Brisbane; University
of Queensland, Brisbane

Represented by

Bellas Milani Gallery, Brisbane

JAN BILLYCAN (DJAN NANUNDIE)

**Yulparija people, Karrimarra
skin, Western Australia
born c. 1930 Ilyara, Great Sandy
Desert, Western Australia
lives and works at Bidyadanga
and Broome, Western Australia**

Solo exhibitions

Jan Billycan, William Mora
Galleries, Melbourne, 2007

Selected group exhibitions

Desert heart, Neville Keating
Pictures Ltd, London, UK, 2007;

From the Bungalow I: Yulparija artists, Johnston Gallery, Perth, 2007; *Northern journey*, The Priory at Bingie, Bingie, 2006; *Jan Billycan recent paintings & Weaver Jack that is me*, William Mora Galleries, Melbourne, 2006; *23rd Telstra National Aboriginal and Torres Strait Islander Art Award*, Museum and Art Gallery of the Northern Territory, Darwin, 2006; *The return of our land*, Gallery Gondwana, Alice Springs, 2005; *Mummy + daughter*, William Mora Galleries, Melbourne, 2005; *22nd Telstra National Aboriginal and Torres Strait Islander Award*, Museum and Art Gallery of the Northern Territory, Darwin, 2005; *Bidyadanga 2005: recent works*, Short St Gallery, Broome, 2005; *Desert ocean*, Short St Gallery @ Kidogo Gallery, Fremantle, 2004

Collections
Dr Ian Berndt Collection, Perth; Dr Ian Constable Collection, Perth; Harvey Wagner Collection, USA; Laverty Collection, Sydney; Myer Collection, Melbourne; National Gallery of Australia, Canberra; National Gallery of Victoria, Melbourne; Sam Barry Collection, Queensland; William Mora Collection, Melbourne

Represented by
Short St Gallery, Broome; William Mora Galleries, Melbourne

DANIEL BOYD

Kudjla/Gangalu peoples, Far North Queensland
born 1982, Cairns
lives and works Blue Mountains, New South Wales
Solo exhibitions
The righteous will reign, Mori Gallery, Sydney, 2006; *Polly don't want no cracker neither*, Mori Gallery, Sydney, 2005; *Untitled*, Mori Gallery, Sydney, 2005

Group exhibitions
Right here, right now: recent Aboriginal and Torres Strait Islander art acquisitions, National Gallery of Australia, Canberra, 2006; *From the edge*, Wagga Wagga Regional Gallery, Wagga Wagga; Ivan Doherty Gallery, UNSW, Sydney, 2006; *What the world needs now*, Phatspace, Sydney,

2005; *Superspective*, Canberra Contemporary Art Space, Canberra, 2005; *No war fundraiser*, Mori Gallery, Sydney, 2005; *Checkpoint*, Mori Gallery, Sydney, 2005

Collections
National Gallery of Australia, Canberra

Represented by
Mori Gallery, Sydney

TREVOR 'TURBO' BROWN

Latje Latje people, Victoria
born 1967, Mildura, Victoria
lives and works Melbourne, Victoria
Solo exhibitions
Australia Dreaming Gallery, Melbourne, 2007; *Turbo Brown*, Koorie Heritage Trust, Melbourne, 2006; Koorie Heritage Trust, Melbourne, 2004

Group exhibitions
Land marks, National Gallery of Victoria, Melbourne, 2006; *Tribal expressions Indigenous showcase*, Commonwealth Games, Arts Showcase, Black Box, Victorian Arts Centre, Melbourne, 2006; *Koorie alchemy: Turbo Brown and Lorraine Connelly-Northey*, Indigenart in association with the Koorie Heritage Trust Melbourne, Indigenart, Fremantle, 2006; *Melbourne affordable art show*, Koorie Heritage Trust stand, Melbourne, 2005; *Sorry seems so hard to say*, Bundoora Homestead Art Centre, Darebin City Council, Victoria, 2005; *Grugidj (White Cockatoo)*, Faculty Gallery, RMIT, Melbourne, 2005; *22nd Telstra National Aboriginal and Torres Strait Islander Art Award*, Museum and Art Gallery of the Northern Territory, Darwin, 2005; *Victorian Indigenous Art Award*, gallery, Arts Victoria, Melbourne, 2005; *Urban yarns: southern region Indigenous arts*, Counihan Gallery, City of Moreland, 2005; *Reconciliation show Aboriginal Affairs Victoria*, Latrobe Street Gallery: Melbourne, 2004; *Gumbri: white dove*, exhibition and art award, Bundoora Homestead Art Centre in conjunction with Darebin Aboriginal and Torres Strait Islander Community Council (DATSICC), Bundoora Homestead Art Centre, City of Darebin, winner; *Us mob too*,

PIT Space Gallery, RMIT, Melbourne, 2003

Represented by
Indigenart, The Mossenson Galleries, Fremantle and Carlton; Koorie Heritage Trust, Melbourne

CHRISTINE CHRISTOPHERSEN

Iwatja/Iwaidja people, Arnhem Land, Northern Territory
born 1959, Darwin, Northern Territory
lives and works, Darwin and Jabiru, Northern Territory
Selected solo exhibitions
In the present, Darwin Entertainment Centre Gallery, Darwin, 2007; *Blue print*, Boomalli Aboriginal Artists Co-operative, Sydney, 2006; *Blue print*, Maison Follie, Lille, France, 2005; *Blue print*, Philip Neville Gallery, Darwin, 2005; *It's about women*, Raintree Gallery, Darwin, 2004

Selected group exhibitions
Right here, right now: recent Aboriginal and Torres Strait Islander art acquisitions, National Gallery of Australia, Canberra, 2006; *Fremantle Print Award*, Fremantle Arts Centre, Fremantle, 2006, highly commended; *Notable book, Children's Book Council of Australia 2006 Book of the Year, Children's Picture Book Award*: Jane and Christine Christophersen (illustrator), *My home in Kakadu*, Broome: Magabala Books, 2005; *21st Telstra National Aboriginal and Torres Strait Islander Art Award*, Museum and Art Gallery of the Northern Territory, Darwin, 2004, highly commended; *Portrait of a Senior Territorian Art Award*, Parliament House, Darwin, 2003; *Annual members exhibition*, Boomalli Aboriginal Artists Co-operative Ltd, Sydney, 2000; *5th National Indigenous Heritage Art Award*, Old Parliament House, Canberra, 2000

Collections
National Gallery of Australia, Canberra; Museum and Art Gallery of the Northern Territory, Darwin

Represented by
Boomalli Aboriginal Artists Co-operative Ltd, Sydney

DESTINY DEACON

Kugu/KuKu/Erub/Mer peoples, Far North Queensland/ Torres Strait Islands
born Maryborough, Queensland, lives and works in Melbourne, Victoria
Solo exhibitions
Destiny Deacon: walk & don't look blak, Museum of Contemporary Art, Sydney, 2004, toured various Australian and International venues including Sydney; New Zealand; New Caledonia; Japan; Melbourne 2004–06; *Totemistical*, Roslyn Oxley9 Gallery, Sydney, 2006; *d-coy: Destiny Deacon*, 24HR Art: Northern Territory Centre for Contemporary Art, Darwin, 2004; *Destiny Deacon/Lisl Ponger*, Künstlerhaus, Salzburger Kunstverein, Salzburg, Austria, 2003; *Destiny Deacon*, Galleria Raffaella Cortese, Milan, Italy, 2003

Selected group exhibitions
Stolen ritual, Roslyn Oxley9 Gallery, Sydney, 2006; *Image & imagination*, Les Mois de la Photo a Montreal, Montreal, Canada, 2005; *Why pictures now: photography, film, video today*, MUMOK (Museum Moderner Kunst), Vienna, Austria, 2006; *NEW05*, Australian Centre for Contemporary Art, Southbank, Melbourne, 2005; *Latitudes 2005*, Hotel de Ville, Paris; *Faces in the crowd: picturing modern life from Manet to today*, Whitechapel Art Gallery, London, England; Castello di Rivoli Museo d'Arte Contemporanea, Turin, Italy, 2004–05; *Contemporary photo-media art: 2004 Adelaide Biennial of Australian Art*, Adelaide Festival, Art Gallery of South Australia, Adelaide, 2004; *Documenta 11, video: Forced into images* with Virginia Fraser, Museum Fridericianum, Kassel, Germany, 2002; *Yokohama International Triennial of Contemporary Art*, Pacifico Yokohama Exhibition Hall, Yokohama, Japan, 2001; *Das Lied Von Der Erde (Songs of the earth)*, Museum Fridericianum, Kassel, Germany, 2001; *Beyond the pale: contemporary Indigenous art*, Adelaide Biennial of Australian Art, 2000

Represented by
Galleria Raffaella Cortese, Milan, Italy; Roslyn Oxley9 Gallery, Sydney

JULIE DOWLING

Badimaya/Yamatji/Widi peoples, Western Australia
born 1969, Subiaco, Perth, Western Australia
lives and works Perth, Western Australia
Selected solo exhibitions
Strange fruit: testimony and memory in Julie Dowling's portraits, Ian Potter Museum of Art, The University of Melbourne, Melbourne, 2007; *Widi Boornoo (Wild message)*, fortyfivedownstairs, Melbourne, 2006; *Contrary Marban (Magic)*, Caruana + Reid Fine Art, Sydney, 2006; *Nidja Widi (This is wild)*, works on paper, Brigitte Braun Art Dealer, Melbourne, 2006; *Marban Unna'*, Galerie Seippel, Cologne, Germany, 2005; *Warridah sovereignty: Julie Dowling*, Artplace, Perth, 2004; *... Yes, Boss!*, fortyfivedownstairs, Melbourne, 2003

Selected group exhibitions
Right here, right now: recent Aboriginal and Torres Strait Islander art acquisitions, National Gallery of Australia, Canberra, 2006; *Prism: contemporary Australian art*, Bridgestone Museum of Art, Tokyo, Japan, 2006; *Stories: country, spirit, knowledge and politics*, Lake Macquarie City Art Gallery, Booragul, 2006; *Dreaming their way: Australian Aboriginal women painters*, National Museum of Women in the Arts Washington DC, USA, 2006; Hood Museum of Art, Dartmouth College, New Hampshire, USA, 2006; *Sub-terrain*, UWA Perth International Arts Festival, Perth Institute of Contemporary Art, Perth, 2006; *Dancelines*, George Adams Gallery, The Arts Centre, Melbourne, 2006; *Land marks*, National Gallery of Victoria, Melbourne, 2006; *Seeing the other: the human image by Indigenous and non-Indigenous artists*, Kluge-Ruhe Collection, University of Virginia, USA, 2006; *Colour power: Aboriginal art post 1984*, National Gallery of Victoria, Melbourne,

2004; *Terra Alterius: land of another*, Ivan Dougherty Gallery, COFA, UNSW, Paddington, 2004; Beyond the pale: contemporary Indigenous art, Adelaide Biennial of Australian Art, 2000

Selected collections
Artbank, Sydney; Art Gallery of South Australia, Adelaide; Art Gallery of Western Australia, Perth; Berndt Museum of Anthropology, Perth; Edith Cowan University, Perth; Kelton Foundation, USA; Kerry Stokes Collection, Perth; Museum and Art Gallery of the Northern Territory, Darwin; National Gallery of Australia, Canberra; National Gallery of Victoria, Melbourne; National Native Title Tribunal, Australia; Western Australian Museum, Perth

Represented by
Brigitte Braun Gallery, Melbourne; Caruana + Reid Fine Art, Sydney

VIRGINIA FRASER

born Melbourne, Victoria
lives and works Melbourne, Victoria

Selected solo and collaborative exhibitions
Destiny Deacon: colour blinded, Roslyn Oxley9 Gallery, Sydney, 2005 (with Destiny Deacon); *d-coy: Destiny Deacon*, 24HR Art: Northern Territory Centre for Contemporary Art, Darwin, 2004 (with Destiny Deacon); *Nothing left to steal*, Conical, Melbourne, 2003 (with Corinne Gwyther and Lorraine Austin); *Unsettled*, installations, Kraznapolsky Gallery, Melbourne, 2002 (with Lorraine Austin and Dirk de Bruyn)

Selected group exhibitions
Chopped liver (play, video set design and production), Ilbijerri Aboriginal and Torres Strait Islander Theatre Co-operative, Melbourne (touring regional Victoria, South Australia and Adelaide), 2006–07; *Yours, mine and ours: 50 years of ABC TV*, Penrith Regional Gallery, Penrith, 2006; *High tide: currents in contemporary Australian and New Zealand art*, Zacheta National Gallery of Art, Warsaw, Poland; Contemporary Art Centre Vilnius,

Lithuania, 2006; *Latitudes 2005*, Hotel de Ville, Paris, France, 2005; *NEW05*, Australian Centre for Contemporary Art, Southbank, Melbourne, 2005; *Faces in the crowd: picturing modern life from Manet to today*, Whitechapel Art Gallery, London, England; Castello di Rivoli Museo d'Arte Contemporanea, Turin, Italy, 2004–05; *I thought I knew but I was wrong: new video art from Australia*, ACMI: Australian Centre for the Moving Image, Melbourne; Bangkok, Beijing, Seoul and Singapore 2004–05; *Blak insights: contemporary Indigenous art from the Queensland Art Gallery collection*, Queensland Art Gallery, Brisbane, 2005

Represented by (collaborative work)
Roslyn Oxley9 Gallery, Sydney

PHILIP GUDTHAYKUDTHAY

Liyagalawumirr people, Galwanuk clan, Dhuwa moiety, Central Arnhem Land, Northern Territory
born c. 1925 east of Ramingining, Central Arnhem Land, Northern Territory
lives and works Ramingining, Northern Territory

Solo exhibitions
Pussycat: the sorcerer, Aboriginal and Pacific Art, Sydney, 2006; *My art, my country*, Aboriginal and Pacific Art, Sydney, 2003; *Philip Gudthaykudthay: Wititj & Wagilag Man*, Karen Brown Gallery, Darwin, 2002; *Philip Gudthaykudthay: works from Ramingining*, Roslyn Oxley9 Gallery, Sydney, 1991; *Philip Gudthaykudthay*, Garry Anderson Gallery, Sydney, 1983

Selected group exhibitions
Our home: Charles Darwin University art collection, recent acquisitions, Charles Darwin University, Darwin, 2006; *Australian Aboriginal art*, Robert Steele Gallery, New York, New York, USA, 2006; *13 Canoes*, Adelaide Fringe, South Australian Museum, Adelaide, 2006; *Pussycat and friends*, William Mora Galleries, Melbourne, 2005; *Yaku Yindi: big names from Ramingining*, Hogarth Galleries, Sydney, 2005;

Dupun, Djalumbu, Badurru: hollow logs from Ramingining, Gallery Gabrielle Pizzi, Melbourne, 2004; *Blak insights: contemporary Indigenous art from the Queensland Art Gallery collection*, Brisbane, 2004; *Explained, a closer look at Aboriginal art*, Aboriginal Art Museum, Utrecht, the Netherlands, 2004; *Power of the land: masterpieces of Aboriginal art*, National Gallery of Victoria, Melbourne, 1994; *Aratjara: art of the First Australians: traditional and contemporary works by Aboriginal and Torres Strait Islander artists*, Kunstammlung Nordrhein, Westfalen, Düsseldorf; Hayward Gallery, London; Louisiana Museum, Humlebaek, Denmark, 1993–94

Collections
Art Gallery of New South Wales, Sydney; Art Gallery of South Australia, Adelaide; Flinders University Art Museum, Adelaide; Kluge-Ruhe Aboriginal Art Collection, University of Virginia, Virginia, USA; Linden Museum, Stuttgart, Germany; Museum and Art Gallery of the Northern Territory, Darwin; Museum of Contemporary Art, Ramingining Collection, Sydney; National Gallery of Australia, Canberra; National Gallery of Victoria, Melbourne; Seattle Art Museum, Seattle, USA; The Holmes à Court Collection, Perth

Represented by
Aboriginal and Pacific Arts, Sydney; Bula'bula Arts, Ramingining, Central Arnhem Land, Northern Territory; William Mora Galleries, Melbourne

TREAHNA HAMM

Yorta Yorta people, Victoria
born 1965, Albury-Wodonga, Victoria
lives and works Albury, Victoria

Selected solo exhibitions
Brücke zwischen Zeiten und Welten [*Bridge between times and worlds*], Museum of World Cultures, Frankfurt, Germany, 2001 (with Peter Hupfauf); *Imprints: the life and landscape of Treahna Hamm*, Charles Sturt University, Wagga Wagga; Bathurst, 1997; *Treahna Hamm: coming into being*, Wagga

Wagga City Art Gallery, Griffith Regional Art Gallery; Albury Regional Art Centre, Albury; Davidson Gallery, Seattle, USA 1994–96; *Treahna Hamm: etchings*, Hogarth Galleries, Sydney, 1992

Selected group exhibitions
Burwarr, Albury Museum, Albury, 2007; *Land marks*, National Gallery of Victoria, Melbourne, 2006; *Biganga*, Bunjilaka, Melbourne Museum, Melbourne, 2006; *Cross currents*, Linden Centre for Contemporary Arts, Melbourne, 2005; *Awakenings*, Koorie Heritage Trust, Melbourne, 2003; *Tooloyn Koortakay*, National Museum of Australia, Canberra, 2002; *Decalogue: a catalogue of ten years of Australian printmaking, 1987–1997*, Metropolitan Museum of Seoul, Korea, 1998; Shell Art Prize, Melbourne, 1998; *First person plural: contemporary Australian Aboriginal art*, Betty Rymer Gallery, The School of the Art Institute of Chicago, Illinois, USA, 1997; *Contemporary Aboriginal art*, Museum of African and Oceanic Arts, Paris, France; New Jersey Centre for Visual Arts, New York, USA, 1995–96

Collections
National Gallery of Australia, Canberra; National Gallery of Victoria, Melbourne

Represented by
Koorie Heritage Trust, Melbourne

GORDON HOOKEY

Waanyi/Waanjiminjin people, Queensland
born 1961 Cloncurry, Queensland
lives and works, Brisbane and Townsville, Queensland

Solo exhibitions
Gordon Hookey, Bellas Milani Gallery, Brisbane, 2007; *Contempt free hart, contemporary art*, umbrella studio contemporary arts, Townsville, 2007; *Con Ject Charr-Jarr-Yarh-'Arrgh'*, Koorie Heritage Trust, Melbourne, 2007; *www.gordonhoo.com*, Nellie Castan Gallery, Melbourne, 2005; *Ruddock's wheel*, Casula Powerhouse Arts Centre, Casula, 2001; *Untitled*, Villa van Delden, Ahaus, Germany, 2000; *Terraism*,

Red Sheal Gallery, Adelaide, 1996; *Interface inya face*, Canberra Contemporary Art Space, Canberra, 1995

Selected group exhibitions
Right here, right now: recent Aboriginal and Torres Strait Islander art acquisitions, National Gallery of Australia, Canberra, 2006; *On reason and emotion*, Biennale of Sydney, Museum of Contemporary Art, Sydney, 2004; *Colour power: Aboriginal art post 1984*, National Gallery of Victoria, Melbourne, 2004; *Con-Sen-Trick-Sir-Kills*, Linden Centre for Contemporary Arts, Melbourne, 2003; *One square mile: Brisbane boundaries*, Museum of Brisbane, Brisbane, 2004; *The history of things to come*, Casula Powerhouse Arts Centre, Casula, 2002; *In ya face* (with Gordon Syron), Boomalli Aboriginal Artists Co-operative Ltd, Sydney, 2001; *Uncommon world: aspects of contemporary Australian art*, National Gallery of Australia, Canberra, 2000; *Beyond the pale: contemporary Indigenous art: 2000 Adelaide Biennial of Australian Art*, Art Gallery of South Australia, Adelaide, 2000; *Native Title business: contemporary Indigenous art*, a national travelling exhibition, presented by the Gurang Land Council (Aboriginal Corporation), toured by the Regional Galleries Association of Queensland, 2002–05; *16 songs: issues of personal assessment and Indigenous renewal*, The University Art Museum, University of California at Santa Barbara, Santa Barbara, USA, 1997

Collections
Art Gallery of Western Australia, Perth; National Gallery of Australia, Canberra; National Gallery of Victoria, Melbourne; Osaka Museum of Ethnology, Osaka, Japan; Queensland Art Gallery, Brisbane; Tjibaou Cultural Centre, Noumea, New Caledonia; University of Technology, Sydney; University of Wollongong, Wollongong

Represented by
Bellas Milani Gallery, Brisbane; Boomalli Aboriginal Artists Co-operative Ltd, Sydney; Nellie Castan Gallery, Melbourne

ANNIEBELL MARRNGAMARRNGA

Kuninjku people, Yirritja moiety, Bangardidjan subsection, Western Arnhem Land, Northern Territory
born 1968 Yikarrakkal, Western Arnhem Land
lives and works Maningrida, Western Arnhem Land, Northern Territory
Solo exhibitions
Anniebell Marrngamarrnga: first solo show, William Mora Galleries, Melbourne, in association with Maningrida Arts and Culture, 2007
Selected group exhibitions
The women's show, Vivien Anderson Gallery, Melbourne, 2007; *23rd Telstra National Aboriginal & Torres Strait Islander Art Award*, Museum and Art Gallery of the Northern Territory, Darwin, 2006; *Weave*, Federation Centre for the Arts, Bundoora Homestead, City of Darebin, 2003
Collections
National Gallery of Australia, Canberra
Represented by
Maningrida Arts and Culture, Maningrida, Western Arnhem Land, Northern Territory; William Mora Galleries, Melbourne

JOHN MAWURNDJUL

Kuninjku (Eastern Kunwinjku) people, Kurulk clan, *Dhuwa* moiety, Balang subsection, Western Arnhem Land, Northern Territory
born 1952, Mumeka, Western Arnhem Land, Northern Territory
lives and works Milmilngkan, Western Arnhem Land, Northern Territory
Solo exhibitions
John Mawurndjul: mapping Djang, Annandale Galleries, Sydney, 2006; *<< Rarrk >> – John Mawurndjul: journey through time in Northern Australia*, Museum Tinguely, Basel, Switzerland; Sprengel Museum, Hanover, Germany, 2005–06; *John Mawurndjul – new barks*, Annandale Galleries, Sydney, 2004; *Kabarlekidyo to Milmilngkan:*

John Mawurndjul's country, Gallery Gabrielle Pizzi, Melbourne, 2002; *John Mawurndjul*, Annandale Galleries, Sydney, 1999
Selected group exhibitions
Cornice art fair (in association with the Venice Biennale), Venice, Italy, 2007; *Australian Indigenous Art Commission*, Musée du quai Branly, Paris, France, 2006; *Mumeka to Milmilngkan: innovation in Kurulk bark painting*, Drill Hall Gallery, Canberra, 2006; *Rarrk! flowing on from crossing country*, Annandale Galleries, Sydney, 2005; *Crossing country: the alchemy of Western Arnhem Land art*, Art Gallery of New South Wales, Sydney, 2004; *19th Telstra National Aboriginal & Torres Strait Islander Art Award*, Museum and Art Gallery of the Northern Territory, Darwin, 2002, bark painting award; *Clemenger Contemporary Art Prize*, National Gallery of Victoria, Melbourne, 2003, winner; *In the heart of Arnhem Land: myth and the making of contemporary Aboriginal art*, Musée de l'Hôtel-Dieu, Mantes-La-Jolie, France, 2001; *Sydney 2000: Biennale of Sydney*, Museum of Contemporary Art, Sydney, 2000; *16th Telstra National Aboriginal and Torres Strait Islander Art Award*, Museum and Art Gallery of the Northern Territory, Darwin, 1999, bark painting award; *Eye of the storm: eight contemporary Indigenous Australian artists*, National Gallery of Australia, Canberra; National Gallery of Modern Art, New Delhi, India, 1996; *Power of the land: masterpieces of Aboriginal art*, National Gallery of Victoria, Melbourne, 1994
Collections
Artbank, Sydney; Art Gallery of New South Wales, Sydney; Art Gallery of South Australia, Adelaide; Art Gallery of Western Australia, Perth; Kluge-Ruhe Aboriginal Art Collection, University of Virginia, Virginia, USA; Museum and Art Gallery of the Northern Territory, Darwin; Museum of Contemporary Art, Sydney; Musée du quai Branly, Paris, France; National Gallery of Australia, Canberra; National Gallery of Victoria, Melbourne; Queensland Art Gallery, Brisbane

Represented by
Annandale Galleries, Sydney; Gallery Gabrielle Pizzi, Melbourne; Maningrida Arts and Culture, Maningrida, Western Arnhem Land, Northern Territory

RICKY MAYNARD

Ben Lomond/Big River people, Tasmania
born 1953, Launceston, Tasmania
lives and works Cape Barren Island, Tasmania
Selected solo exhibitions
Portrait of a distant land, inaugural Photoquai Biennale, Australian Embassy, Paris, France, 2007; *In response to place: recent photographs from Ricky Maynard*, City Gallery, Melbourne Town Hall, 2007; *Returning to places that name us*, Stills Gallery, Sydney, 2001; *Urban diary*, Manly Art Gallery and Museum, Sydney, 1997; *No more than what you see*, touring nationally, Australia 1995–1997; *The moonbird people*, Tandanya National Aboriginal Cultural Institute, Adelaide, 1992
Selected group exhibitions
Portrait of a distant land, billboards, Ten Days on the Island Festival, Tasmania; Busan Biennale, Busan, Korea 2006–07; *Interesting times: focus on contemporary Australian art*, Museum of Contemporary Art, Sydney, 2005; *Our place: Indigenous Australia now*, Cultural Olympiad of the Athens 2004 Olympic games, Benaki Museum, Athens, Greece; National Museum of China, Beijing, China, 2004–05; *Kate Challis RAKA Award for Contemporary Indigenous Creative Arts*, Melbourne, 2003, winner; *15 Australian photographers*, La Galerie Photo, Montpellier, France, 2000; *Re-take: contemporary Aboriginal and Torres Strait Islander photography*, National Gallery of Australia, Canberra, 1999, touring exhibition; *Off shore: on site*, The Festival of the Dreaming, Olympic Arts Festival, International and National artists' camp and exhibition, Sydney Olympic Games Organising Committee, Casula Powerhouse, Sydney, 1997; *Australian Human Rights*

Award for Photography, 1997; *The power to move: aspects of Australian photography*, Queensland Art Gallery, Brisbane, 1996
Collections
Art Gallery of New South Wales, Sydney; Australian Institute of Aboriginal and Torres Strait Islander Studies, Canberra; Museum of Contemporary Art, Sydney; National Gallery of Australia, Canberra; National Gallery of Victoria, Melbourne; National Library of Australia, Canberra; National Museum of Australia, Canberra; Queensland Art Gallery, Brisbane; Tasmanian Museum and Art Gallery, Hobart
Represented by
Stills Gallery, Sydney

DANIE MELLOR

Mamu/Ngagen, Atherton Tablelands, Far North Queensland
born 1971, Mackay, Queensland
lives and works Canberra, Australian Capital Territory
Solo exhibitions
Voyages of recovery or an ongoing catalogue with moments of reason from the cabinet, Canberra Museum and Gallery, Canberra, 2006; *In memories lie fragile dreams*, Solander Gallery, Canberra, 2006
Group exhibitions
Voyage + recovery, Fireworks Gallery, Brisbane, 2007; *Artbank: celebrating 25 years of Australian art*, Artbank, Sydney, 2006, national touring exhibition; *Important works on paper & sculpture*, Rex Irwin Art Dealer, Woollahra, 2005: *Predominantly White*, Fireworks Gallery, Brisbane, 2005; *Primavera 2005: exhibition by young Australian artists*, Museum of Contemporary Art, Sydney, 2005; *2004 National works on paper*, Mornington Peninsula Regional Gallery, Mornington, 2004; *21st Telstra National Aboriginal and Torres Strait Islander Art Award*, Museum and Gallery of the Northern Territory, Darwin, 2004; *Story place: Indigenous art of Cape York and the rainforest*, Queensland Art Gallery, Brisbane, 2003; *Fremantle Print Award and exhibition*, Fremantle Arts Centre, Fremantle, 2003; *The art of place: national*

Indigenous heritage art award, Australian Heritage Commission, Old Parliament House, Canberra, 2001
Collections
Artbank, Sydney; Australian Capital Equity/Kerry Stokes Collection, Perth; Art Gallery of South Australia, Adelaide; Canberra Museum and Gallery, Canberra; Museum and Art Gallery of the Northern Territory, Darwin; National Gallery of Australia, Canberra; National Gallery of Victoria, Melbourne; Queensland Art Gallery, Brisbane; Parliament House Art Collection, Canberra; Australian National University, Canberra; Flinders University Art Museum, Adelaide
Represented by
Caruana & Reid Fine Art, Sydney; Solander Gallery, Canberra

LOFTY BARDAYAL NADJAMERREK AO

Kundedjnjenghmi people, Mok clan, Wamud/Na-Kodjok affiliation, Western Arnhem Land, Northern Territory
born c.1926, Kukkulumurr, Western Arnhem Land, Northern Territory
lives and works Kabulwarnamyo, Western Arnhem Land, Northern Territory
Solo exhibitions
Lofty Bardayal Nadjamerrek AO: late works, Annandale Galleries, Sydney, 2006; *Bim Yolyolmi: picture told story*, Indigenart, Melbourne, 2006; *Lofty Bardayal Nadjamerrek: new work on bark*, Annandale Galleries, Sydney, 2004; *Kabulwarnamyo Kunred Ngarduk – My country Kabulwarnamyo* Annandale Galleries, Sydney, 2003
Group exhibitions
Land marks, National Gallery of Victoria, Melbourne, 2006; *One way: line artists of the stone country*, RAFT Artspace, Darwin, 2005; *Crossing country: the alchemy of Western Arnhem Land art*, Art Gallery of New South Wales, Sydney, 2004; *Rainbow, sugarbag and moon: two artists of the stone country*, *Bardayal Nadjamerrek and Mick Kubarkku*, Museum and Art Gallery of the Northern

Territory, Darwin, 1995; *Power of the land: masterpieces of Aboriginal art*, National Gallery of Victoria, Melbourne, 1994; *15th Telstra National Aboriginal and Torres Strait Islander Art Award*, Museum and Art Gallery of the Northern Territory, Darwin, 1998, winner; *Aboriginal art of the top end: c.1935 – early 1970s*, National Gallery of Victoria, Melbourne, 1988; *The inspired dream: life as art in Aboriginal Australia*, Museum and Art Gallery of the Northern Territory, Darwin in association with the Queensland Art Gallery for World Expo 88, 1988 and international tour; *The art of the first Australians*, Kobe City Museum, Kobe, Japan,1986; *Kunwinjku Bim: Western Arnhem Land paintings from the collection of the Aboriginal Arts Board*, National Gallery of Victoria, Melbourne, 1984

Collections
Art Gallery of New South Wales, Sydney; Art Gallery of South Australia, Adelaide; Australian Museum, Sydney; Museum and Art Gallery of the Northern Territory, Darwin; Museum of Contemporary Art, Sydney; National Gallery of Australia, Canberra; National Gallery of Victoria, Melbourne; National Maritime Museum, Sydney; National Museum of Australia, Canberra; Queensland Art Gallery, Brisbane; Holmes à Court Collection, Perth; Sean Scully and Liliane Tomesko, USA

Represented by
Annandale Galleries, Sydney; Indigenart, the Mossenson Galleries, Melbourne; Injalak Arts and Crafts Association, Gunbalanya/Kunbarlanya (Oenpelli), Western Arnhem Land

DOREEN REID NAKAMARRA

Pintupi/Ngaatjatjarra peoples, Western Australia/Northern Territory
born c.1955, Warburton Ranges, Western Australia
lives and works Kiwirrkura, Western Australia and Alice Springs, Northern Territory
Group exhibitions
Survey: group show of emerging artists from Papunya Tula, RAFT

Artspace, Darwin, 2007; *Papunya Tula*, Short St Gallery, Broome, in association with Papunya Tula Artists, Alice Springs, 2007; *Yawulyurru kapalilu palyara nintilpayi: grandmothers teaching culture and ceremony*, Papunya Tula Artists, Alice Springs, 2006; *Pintupi Dreamtime*, Red Dot Gallery, Singapore, 2006; *Rising stars 2006*, Gallery Gabrielle Pizzi, Melbourne, 2006; *Pintupi: 20 contemporary paintings from the Pintupi homelands*, Hamiltons Gallery, London, England, 2006; *Right here, right now: recent Aboriginal and Torres Strait Islander art acquisitions*, National Gallery of Australia, Canberra, 2006; *Across the board*, Utopia Art Sydney, Sydney, 2006; *Pintupi artists*, Papunya Tula Artists, Alice Springs, 2005

Collections
National Gallery of Australia, Canberra; National Gallery of Victoria, Melbourne

Represented by
Papunya Tula Artists, Alice Springs, Northern Territory

DENNIS NONA

Kala Lagaw Ya (Western Torres Strait Island) people, Torres Strait Islands
born 1973, Badu (Mulgrave) Island, Western Torres Strait, Queensland
lives and works Cairns and Brisbane, Queensland
Solo exhibitions
Dennis Nona: new works, Impressions on Paper Gallery, Canberra, 2007; *Sesserae and other stories*, KickArts Contemporary Arts, Cairns, travelling exhibition, 2006–08, Australian Embassy, Paris, France; Rebecca Hossack Gallery, London, 2006; *Sesserae: new works by Dennis Nona*, Dell Gallery, Queensland College of Art, Brisbane, 2005

Selected group exhibitions
24th Telstra National Aboriginal and Torres Strait Islander Art Award, Museum and Art Gallery of the Northern Territory, Darwin, 2007, winner; *The story of Australian printmaking 1801–2005*, National Gallery of Australia, Canberra, 2007; *5th Asia-Pacific Triennial of*

Contemporary Art, Queensland Art Gallery/Gallery of Modern Art, Brisbane, 2006; *Right here, right now: recent Aboriginal and Torres Strait Islander art acquisitions*, National Gallery of Australia, Canberra, 2006; *Busan international print art festival 2005*, Busan Citizens Hall, Busan, South Korea, 2005; *4th International Angel Orensanz Foundation Art Award*, Angel Orensanz Foundation Center for the Arts, New York, New York, USA, 2004; *Gelam Nguzu Kazi: Dugong my son*, Organised by the Australian Art Print Network, toured Australia and Internationally from 2000–04; *Machida International Print Art Award and Exhibition*, Machida International Print Museum, Tokyo, Japan, 2004, winner; *Native Title business: contemporary Indigenous art*, national travelling exhibition, organised by the Gurang Land Council Aboriginal Corporation, Bundaberg, toured by the Regional Galleries Association of Queensland, 2000–05

Collections
Artbank, Sydney; Art Gallery of New South Wales, Sydney; Art Gallery of South Australia, Adelaide; British Museum, London, England; Cambridge University Museum, Cambridge, England; Machida Graphic Arts Museum, Tokyo, Japan; Museum of Contemporary Art, Sydney; Muséum d'histoire naturelle de Lyon, Lyon, France; National Gallery of Australia, Canberra; National Gallery of Victoria, Melbourne; National Maritime Museum, Darling Harbour, Sydney; Queensland Art Gallery, Brisbane; Queensland Museum, Brisbane; Victoria and Albert Museum, London, England

Represented by
Australian Art Print Network, Sydney

ARTHUR KOO'EKKA PAMBEGAN JR

Wik-Mungkan/Winchanam peoples, Kalben (Flying Fox Story Place) totem, Far North Queensland
born 1936, Aurukun, Far North Queensland
lives and works Aurukun, Far North Queensland

Selected group exhibitions
Aurukun artists: paintings and sculptures, Andrew Baker Art Dealer, Brisbane, 2005; *Wik Kaa'th Pii'tha – Wik, stories of our dreams*, Hogarth Galleries, Sydney, 2004; *Hitting on and kicking off*, Centre of Contemporary Arts, Cairns, 2004; *Story place: Indigenous art of Cape York and the rainforest*, Queensland Art Gallery, Brisbane, 2003; *The Queensland/Berlin Indigenous art exhibition*, Ludwig Erhard Haus, Berlin, Germany, 2002; *Kank inum–Nink inum* (old way–new way), Commonwealth Heads of Government Meeting (CHOGM), Coolum: Queensland, Australia, 2002; *Journey*, Urban Art Projects, Brisbane, 2002; *World of Dreamings*, National Gallery of Australia exhibition, State Hermitage Museum, St Petersburg, Russia, 2000, exhibited as *Aboriginal art in modern worlds*, National Gallery of Australia, Canberra, 2000

Collections
Artbank, Sydney, National Gallery of Australia, Canberra; National Museum of Australia, Canberra; Queensland Art Gallery, Brisbane

Represented by
Andrew Baker Art Dealer, Brisbane; Gallery Gabrielle Pizzi, Melbourne; Wik and Kugu Arts and Crafts Centre, Aurukun, Far North Queensland

CHRISTOPHER PEASE

Minang/Wardandi/ Balardung/ Nyoongar peoples, Western Australia
born 1969, Perth, Western Australia
lives and works Perth, Western Australia
Solo exhibitions
Christopher Pease, Goddard de Fiddes Gallery, Perth, 2005; *Christopher Pease*, Goddard de Fiddes Gallery, Perth, 2003; *Christopher Pease*, Goddard de Fiddes Gallery, Perth, 2000

Selected group exhibitions
Contemporary Nyoongar painting, Goddard de Fiddes Gallery, Perth, 2007; *Noongar Native Title: Noongar works from the Curtin University of Technology art collection*, John Curtin Gallery, Perth, 2007; *Melbourne art Fair*,

Goddard de Fiddes Gallery stand, Melbourne, 2006; *Right here, right now: recent Aboriginal and Torres Strait Islander art acquisitions*, National Gallery of Australia, Canberra, 2006; *22nd Telstra National Aboriginal and Torres Strait Islander Art Award*, Museum and Art Gallery of the Northern Territory, Darwin, 2005; *19th Telstra National Aboriginal and Torres Strait Islander Art Award*, Museum and Art Gallery of the Northern Territory, Darwin, 2002, general painting award; *Works from the collection*, John Curtin Gallery, Perth, 2004; *South west central: Indigenous art from south Western Australia 1833–2002*, Art Gallery of Western Australia, Perth, 2003; *Christopher Pease, with Ben Pushman and Sandra Hill*, Goddard de Fiddes Gallery, Perth, 2002; *Mine own executioner: a decade of self portraiture*, Mundaring Art Centre, Perth, 2001; *Wide open*, Lawrence Wilson Art Gallery, University of Western Australia, Perth, 2001

Collections
Art Gallery of Western Australia, Perth; BHP Billiton Art Collection, Australia; Holmes à Court Collection, Perth; Kerry Stokes/Australian Capital Equity Collection, Perth; Murdoch University, Perth; National Gallery of Australia, Canberra; National Gallery of Victoria, Melbourne; Wesfarmers Australia, Perth

Represented by
Goddard de Fiddes Gallery, Perth

SHANE PICKETT

Balardung/Nyoongar peoples, Western Australia
born 1957, Quairading, Western Australia
lives and works Perth, Western Australia

Selected solo exhibitions
Dreaming painting: Shane Pickett, Perth Institute of Contemporary Arts (PICA), Perth, 2006; *Meeyakba: new paintings by Shane Pickett*, Indigenart, The Mossenson Galleries, Carlton, Victoria, 2006; *Kaanarn*, Indigenart, The Mossenson Galleries, Perth, 2006; *Kooralong Moorndaan – Avant la Création*,

Contemporary Aboriginal Art, Paris, France, 2006; *Shane Pickett*, New Era Aboriginal Centre, Perth, 1976

Selected group exhibitions

Drawing together, National Archives of Australia, Canberra, 2007, winner; *24th Telstra National Aboriginal and Torres Strait Islander Art Award*, Museum and Art Gallery of the Northern Territory, Darwin, 2007; *Koorah Coolingah: children long ago*, Western Australian Museum, Perth, 2006; *Identity and change: representation and Nyoongar people*, Art Gallery of Western Australia, Perth, 2006; *Joondalup Invitation Art Award*, Joondalup, 2006, winner; *Sunshine Coast Art Prize*, Caloundra Regional Art Gallery, Caloundra, 2006, winner; *Noongar Moorditj, Noongar country*, Bunbury Regional Art Galleries, Bunbury, 2005; *Australia Day exhibition*, Australian Embassy, Seoul, South Korea, 2005; *On track: contemporary Aboriginal art from Western Australia*, Western Australian Museum, presented by the Berndt Museum of Anthropology, University of Western Australia, Perth, as part of the Government of Western Australia's 175th Anniversary Celebrations, 2004; *Southwest central: Indigenous art from south Western Australia 1833–2002*, Art Gallery of Western Australia, Perth, 2003

Collections

Art Gallery of Western Australia, Perth; Australian Institute of Aboriginal and Torres Strait Islander Studies, Canberra; Berndt Museum of Anthropology, University of Western Australia, Perth; BHP Billiton Art Collection, Australia; Burswood Collection, Western Australia; City of Fremantle Collection, Fremantle; Edith Cowan University, Perth; Ernie Dingo Collection, Sydney; The Holmes à Court Collection, Perth; King Edward Memorial Hospital, Perth; Museum and Art Gallery of the Northern Territory, Darwin; National Gallery of Australia, Canberra

Represented by

Indigenart, The Mossenson Galleries, Fremantle, Melbourne

ELAINE RUSSELL

Kamilaroi people, New South Wales
born 1941, Tingha New South Wales
lives and works Sydney, New South Wales

Solo exhibitions

Marbles: Koori style, artist in residence, National Museum of Australia, Canberra, 2002; *Elaine Russell*, Aboriginal and South Pacific Gallery, Sydney, 1995; *Elaine Russell*, Gallery Gabrielle Pizzi, Melbourne, 1994

Group exhibitions

Redlands Westpac Art Prize, Hyatt Regency, Sydney, 2006; *Native Title business: contemporary Indigenous art*, national travelling exhibition, organised by the Gurang Land Council Aboriginal Corporation, Bundaberg, toured by the Regional Galleries Association of Queensland, 2002–05; *Bringing it home nure style*, Boomalli Aboriginal Artists Co-operative Ltd, Sydney, 2002; *Faces of hope*, Amnesty International, Art Gallery of New South Wales, 1996; *Chip on the shoulder*, Boomalli Aboriginal Artists Co-operative Ltd, Sydney, 1996; *12th National Aboriginal Art Award*, Museum and Art Gallery of the Northern Territory, Darwin, 1995; *On a mission*, Boomalli Aboriginal Artists Co-operative Ltd, Sydney, 1995; *11th National Aboriginal Art Award*, Museum and Art Gallery of the Northern Territory, Darwin, 1994, best painting in a European medium; *Narratives: Kerry Giles, Peta Lonsdale, Panjiti Mary McLean, Elaine Russell*, Boomalli Aboriginal Artists Co-operative Ltd, Sydney, 1994; *Sayin' something: Aboriginal art in New South Wales: 10 years of land rights in New South Wales*, Boomalli Aboriginal Artists Co-operative Ltd and New South Wales Aboriginal Land Council, Sydney, 1993

Collections

Artbank, Sydney; Art Gallery of New South Wales, Sydney; Channel 7 Television Collection, NSW; Museum and Art Gallery of the Northern Territory, Darwin; New Children's Hospital, Parramatta; New South Wales

Government, Sydney; Office of the Premier New South Wales, Sydney; Office of the Minister for Aboriginal Affairs and Health, Sydney

Represented by

Boomalli Aboriginal Artists Co-operative Ltd, Sydney

CHRISTIAN BUMBARRA THOMPSON

Bidjara people, Queensland
born 1978, Gawler, South Australia
lives and works Melbourne, Victoria, Australia

Solo exhibitions

The sixth mile, Centre of Contemporary Photography, Melbourne, 2007; *New work by Christian Thompson*, Gallery Gabrielle Pizzi, Melbourne, 2007; *EthnoAerobics: the Percy Leason performance at Experimedia space*, State Library of Victoria, Melbourne, 2006; *The Gates of Tambo*, Gallery Gabrielle Pizzi, Melbourne, 2004; *Emotional striptease*, Gallery Gabrielle Pizzi, Melbourne, 2003; *Blaks palace*, Gallery Gabrielle Pizzi, Melbourne, 2002

Selected group exhibitions

Art and Culture Grant, City of Melbourne, 2007; *Brilliance: a world of shimmer, rarrk and glitter*, Aboriginal Art Museum, Utrecht, the Netherlands, 2007; *Raised by wolves*, Art Gallery of Western Australia, Perth, 2007; *Army brats*, Shrine of Remembrance, Melbourne, 2006; Studio Artist 2006–08, first Aboriginal studio artist, Gertrude contemporary art spaces, 2006; *Terra Incognita*, Gertrude contemporary art spaces, Melbourne, 2006; *16th Tamworth Fibre Textile Biennial: a matter of time*, Tamworth City Gallery, Tamworth, 2004; *Spirit & Vision*, Kunst der Gegenwart, Sammlung Essl, Vienna, Austria, 2004; *Image: contemporary Aboriginal art*, Aboriginal Art Museum, Utrecht, the Netherlands, 2004; *The space between*, John Curtin Gallery, Curtin University of Technology, Perth, 2004; *Drama is conflict*, Linden Centre for Contemporary Arts, Melbourne, 2003; *LUMO Intohimo*, Photographic Triennial of Finland, Helsinki, Finland, 2001

Collections

Aboriginal Art Museum, Utrecht, the Netherlands; National Gallery of Australia, Canberra; National Gallery of Victoria, Melbourne

Represented by

Gallery Gabrielle Pizzi, Melbourne

JUDY WATSON

Waanyi people, Queensland
born 1959, Mundubbera, Queensland
lives and works Brisbane, Queensland

Selected solo exhibitions

A complicated fall, Bellas Milani Gallery, Brisbane, 2007; *shell*, GrantPirrie Gallery7, Sydney, 2006; *Judy Watson: selected works 1990–2005*, University Art Museum, University of Queensland, Brisbane, 2005; *conchology*, Helen Maxwell Gallery, Canberra, 2004; *Swallowing culture*, Bellas Milani Gallery, Brisbane, 2004; *sacred ground, beating heart: works by Judy Watson 1989–2003*, touring Australia 2003–07 John Curtin Gallery, Curtin University of Technology and Asialink Centre

Selected group exhibitions

Sunshine state: smart state, Campbelltown Arts Centre, Campbelltown, 2007; *2006 Clemenger Contemporary Art Award*, National Gallery of Victoria, Melbourne, winner; *Glass house mountains* (collaboration with Liza Lim), Institute of Modern Art, Brisbane; Tolarno Galleries, Melbourne, 2005–06; *Out of country*, Kluge-Ruhe Aboriginal Art Museum, University of Virginia, Charlottesville, Virginia, USA touring, 2004; *Beyond the pale: contemporary Indigenous art: 2000 Adelaide Biennial of Australian Art*, Art Gallery of South Australia, Adelaide, 2000; *fluent: Emily Kame Kngwarreye, Yvonne Koolmatrie, Judy Watson*, Australia's representation at the XLVII Venice Biennale, Venice, Italy, 1997, touring Australia, 1998; *Spirit + place: art in Australia 1861–1996*, Museum of Contemporary Art, Sydney, 1996; *Island to island: Australia to Cheju*, Cheju Pre-Biennale 1995, Cheju

City, Korea, touring exhibition, 1995; *Antipodean currents: ten contemporary artists from Australia*, Guggenheim Museum, Soho, New York, 1995; *True colours: Aboriginal and Torres Strait Islander artists raise the flag*, Boomalli Aboriginal Artists Co-operative Ltd, Sydney, with Institute of International Visual Art (INIVA), toured UK and Australia, 1994–96

Collections

Art Bank, Sydney; Art Gallery of New South Wales, Sydney; Art Gallery of South Australia, Adelaide; Art Gallery of Western Australia, Perth; Cruthers Collection, Perth; Chartwell Collection, Auckland Art Gallery, New Zealand; Musée du quai Branly, Paris, France; Museum and Art Gallery of the Northern Territory, Darwin; National Gallery of Australia, Canberra; National Gallery of Victoria, Melbourne; National Museum of Australia, Canberra; Queensland Art Gallery, Brisbane; Queensland Museum, Brisbane; South Australian Museum, Adelaide; Tasmanian Museum and Art Gallery, Hobart; The Holmes à Court Collection, Perth; Westfarmers, Perth

Represented by

Bellas Milani Gallery, Brisbane; GrantPirrie Gallery, Sydney; Tolarno Galleries, Melbourne

H.J. WEDGE

Wiradjuri people, New South Wales
born 1957, Erambie Mission, Cowra, New South Wales
lives and works Erambie, Cowra, New South Wales

Solo exhibitions

Harry J Wedge, Gallery Gabrielle Pizzi, Melbourne, 2006; *Wiradjuri spirit man*, Boomalli Aboriginal Artists Co-operative Ltd, Sydney; Tandanya National Aboriginal Cultural Institute, Adelaide, 1993–94; *Brainwash*, Gallery Gabrielle Pizzi, Melbourne, 1994

Selected group exhibitions

Colour power: Aboriginal art post 1984, National Gallery of Victoria, Melbourne, 2004; *Wiyana/Perisferia (Periphery)*, a satellite event of the Biennale

of Sydney, Boomalli Aboriginal Artists Co-operative Ltd at The Performance Space, Sydney, 1994; *True colours: Aboriginal and Torres Strait Islander artists raise the flag*, Boomalli Aboriginal Artists Co-operative Ltd, Sydney, with Institute of International Visual Art (INIVA), toured UK and Australia, 1994–96; *Power of the land: masterpieces of Aboriginal art*, National Gallery of Victoria, Melbourne, 1994; *Australian Perspecta 1993*, Art Gallery of New South Wales, Sydney, 1993; *Don't leave me this way: art in the age of AIDS*, National Gallery of Australia, Canberra, 1994; *Dream Time (alomido)*, Vigado Galeria and Boomalli Aboriginal Artists Co-operative Ltd, Budapest, Hungary, 1993; *Sayin' something: Aboriginal art in New South Wales: 10 years of land rights in New South Wales*, Boomalli Aboriginal Artists Co-operative Ltd and New South Wales Aboriginal Land Council, Sydney, 1993; *Ian Abdulla (Njarrindjeri) & Harry Wedge (Wiradjuri)*, Boomalli Aboriginal Artists Co-operative Ltd, Sydney, 1991

Collections
Art Gallery of New South Wales, Sydney; Arts Council of New South Wales, Sydney; Boomalli Aboriginal Artists Co-operative Collection, Sydney; Campbelltown City Gallery, Campbelltown; Cowra Shire Council, Cowra; Moree Plains Gallery, Moree; National Gallery of Australia, Canberra; National Gallery of Victoria, Melbourne

Represented by
Boomalli Aboriginal Artists Co-operative Ltd, Sydney; Gallery Gabrielle Pizzi

OWEN YALANDJA

**Kuninjku (eastern Kunwinjku) people, Western Arnhem Land, Northern Territory
born 1962, Barrihdjowkkeng, Western Arnhem Land
lives and works Barrihdjowkkeng, Western Arnhem Land, Northern Territory**

Selected solo exhibitions
Owen Yalandja, William Mora Galleries, Melbourne, 2005: *Owen Yalandja*, Annandale Galleries, Sydney, 2004; *Owen Yalandja*, Redback Art Gallery, Brisbane, 2002; *Owen Yalandja, water spirit sculptures from Barrihdjowkkeng*, Aboriginal and Pacific Arts, Sydney, 2000

Selected group exhibitions
23rd Telstra National Aboriginal and Torres Strait Islander Art Award, Museum and Art Gallery of the Northern Territory, Darwin, 2006; *Rarrk! Flowing on from crossing country*, Annandale Galleries, Sydney, 2005; *Crossing country: the alchemy of Western Arnhem Land art*, Art Gallery of New South Wales, Sydney, 2004; *Next generation*, William Mora Galleries, Melbourne, 2003; *East + West, Annandale Galleries*, Sydney, 2002; *In the heart of Arnhem Land: myth and the making of contemporary Aboriginal art*, Musée de l'Hôtel-Dieu, Mantes-La-Jolie, France, 2001; *Sydney 2000: Biennale of Sydney*, Museum of Contemporary Art, Sydney, 2000; *Spirit country: contemporary Australian Aboriginal art from the Gantner Myer collection*, Fine Art Museum of San Francisco, San Francisco, California, USA, 1999; *10th National Aboriginal Art Award*, Museum and Art Gallery of Northern Territory, Darwin, 1993

Represented by
Annandale Galleries, Sydney; Gallery Gabrielle Pizzi, Melbourne; Maningrida Arts and Culture, Maningrida, Western Arnhem Land, Northern Territory; William Mora Galleries, Melbourne

GULUMBU YUNUPINGU

**Gumatj/Rrakpala people, Yirritja moiety, Yolngu people, North-east Arnhem Land, Northern Territory
born c. 1945, Biranybirany, Dhanaya homelands, North-east Arnhem Land, Northern Territory
lives and works Yirrkala, North-east Arnhem Land, Northern Territory**

Selected solo exhibitions
Star works, Depot Gallery, Sydney, with Alcaston Gallery, Melbourne, 2007; *Garak: the Universe*, Alcaston Gallery, Melbourne, 2004

Selected group exhibitions
TogArt Contemporary Art Award, Parliament House, Darwin, 2007; *l'Espirit de la Terre d'Arnhem, Art Aborigine du Nord de l'Australie*, passage de Retz, Paris, France, 2006; *The roving eye*, Gigantic Art Space, New York, New York, USA, 2006; Australian Indigenous Art Commission, Musée du quai Branly, Paris, France, 2006; *Transformations: the language of craft*, National Gallery of Australia, Canberra, 2005; *Yakumirri*, RAFT Artspace, Darwin; Holmes à Court Gallery, Perth, 2005; *Larrakitj*, installation of hollow logs on the escarpment at Garma Festival, Gulkula, North-east Arnhem Land, Northern Territory, 2003; *Miami Art Fair*, Florida, USA, 2003; *21st Telstra National Aboriginal and Torres Strait Islander Art Award*, Museum and Art Gallery of the Northern Territory Darwin, 2004, winner; *Telstra National Aboriginal and Torres Strait Islander Art Award/s*, Museum and Art Gallery of the Northern Territory, Darwin, 2003, 2005 and 2007

Collections
Art Gallery of South Australia, Adelaide; Kerry Stokes Collection, Perth; Musée du quai Branly, Paris, France; National Gallery of Australia, Canberra; National Gallery of Victoria, Melbourne; Queensland Art Gallery, Brisbane

Represented by
Alcaston Gallery, Melbourne; Buku-Larrnggay Mulka Centre, Yirrkala, North-east Arnhem Land, Northern Territory

MAP

1 **VERNON AH KEE**
Kuku Yalanji/Waanyi/Yidinyji/Gugu Yimithirr peoples,
Far North Queensland; lives and works Brisbane, Queensland

2 **JEAN BAPTISTE APUATIMI**
Tiwi people, Bathurst Island, Northern Territory,
Tapatapunga (March Fly) skin group; lives and works Nguiu,
Bathurst Island, Northern Territory

3 **JIMMY BAKER**
Pitjantjatjara people, Anangu Pitjantjatjara Yankunytjatjara (APY)
Lands, South Australia; lives and works Nyapari, South Australia

4 **MARINGKA BAKER**
Pitjantjatjara people, Anangu Pitjantjatjara Yankunytjatjara (APY)
Lands, South Australia; lives and works Nyapari, South Australia

5 **RICHARD BELL**
Kamilaroi/Kooma/Jiman/Gurang Gurang peoples, New South
Wales/Queensland; lives and works, Brisbane, Queensland

6 **JAN BILLYCAN (DJAN NANUNDIE)**
Yulparija people, Karrimarra skin group, Western Australia;
lives and works Bidyadanga and Broome, Western Australia

7 **DANIEL BOYD**
Kudjla/Gangalu peoples, Far North Queensland; lives and works
Blue Mountains, New South Wales

8 **TREVOR 'TURBO' BROWN**
Latje Latje people, Victoria; lives and works Melbourne,
Victoria

9 **CHRISTINE CHRISTOPHERSEN**
Iwatja/Iwaidja people, Arnhem Land, Northern Territory; lives and
works Darwin and Jabiru, Northern Territory

10 **DESTINY DEACON**
Kugu/Kuku/Erub/Mer peoples, Far North Queensland/Torres Strait
Islands; lives and works Melbourne, Victoria

11 **JULIE DOWLING**
Badimaya/Yamatji/Widi peoples, Western Australia; lives and works
Perth, Western Australia

12 **VIRGINIA FRASER**
born Melbourne, Victoria; lives and works Melbourne, Victoria

13 **PHILIP GUDTHAYKUDTHAY**
Liyagalawumirr people, Galwanuk clan, *Dhuwa* moiety, Central
Arnhem Land, Northern Territory; lives and works Ramingining,
Northern Territory

14 **TREAHNA HAMM**
Yorta Yorta people, Victoria; lives and works Albury, Victoria

15 **GORDON HOOKEY**
Waanyi/Waanjiminjin peoples, Queensland; lives and works
Brisbane and Townsville, Queensland

16 **ANNIEBELL MARRNGAMARRNGA**
Kuninjku people, Yirritja moiety, Bangardidjan subsection, Western
Arnhem Land, Northern Territory; lives and works Maningrida,
Western Arnhem Land, Northern Territory

17 **JOHN MAWURNDJUL**
Kuninjku (eastern Kunwinjku) people, Kurulk clan, *Dhuwa* moiety,
Balang subsection, Western Arnhem Land, Northern Territory; lives
and works Milmilngkan, Western Arnhem Land, Northern Territory

18 **RICKY MAYNARD**
Ben Lomond/Big River peoples, Tasmania; lives and works
Cape Barren Island, Tasmania

19 **DANIE MELLOR**
Mamu/Ngagen/Ngajan peoples, Atherton Tablelands, Far North
Queensland; lives and works Canberra, Australian Capital Territory

20 **LOFTY BARDAYAL NADJAMERREK AO**
Kundedjnjenghmi people, Mok clan, Wamud/Na-Kodjok affiliation,
Western Arnhem Land, Northern Territory; lives and works
Kabulwarnamyo, Western Arnhem Land, Northern Territory

21 **DOREEN REID NAKAMARRA**
Pintupi/Ngaatjatjarra peoples, Western Australia/Northern Territory;
lives and works Kiwirrkura, Western Australia and Alice Springs,
Northern Territory

22 **DENNIS NONA**
Kala Lagaw Ya people, Western Torres Strait Islands, Bardu
(Mulgrave) Island; lives and works Cairns and Brisbane, Queensland

23 **ARTHUR KOO'EKKA PAMBEGAN JR**
Wik-Mungkan/Winchanam peoples, Kalben (Flying Fox Story Place)
totem, Far North Queensland; lives and works Aurukun, Far North
Queensland

24 **CHRISTOPHER PEASE**
Minang/Wardandi/Balardung/Nyoongar peoples, Western Australia;
lives and works Perth, Western Australia

25 **SHANE PICKETT**
Balardung/Nyoongar peoples, Western Australia; lives and works
Perth, Western Australia

26 **ELAINE RUSSELL**
Kamilaroi people, New South Wales; lives and works Sydney,
New South Wales

27 **CHRISTIAN BUMBARRA THOMPSON**
Bidjara people, Queensland; lives and works Melbourne, Victoria

28 **JUDY WATSON**
Waanyi people, Queensland; lives and works Brisbane,
Queensland

29 **H. J. WEDGE**
Wiradjuri people, New South Wales; lives and works Erambie,
Cowra, New South Wales

30 **OWEN YALANDJA**
Kuninjku people, Western Arnhem Land, Northern Territory;
lives and works Barrihdjowkkeng, Western Arnhem Land,
Northern Territory

31 **GULUMBU YUNUPINGU**
Gumat/Rrakpala peoples, Yirritja moiety, Yolngu people, North-East
Arnhem Land, Northern Territory; lives and works Yirrkala,
North-East Arnhem Land, Northern Territory

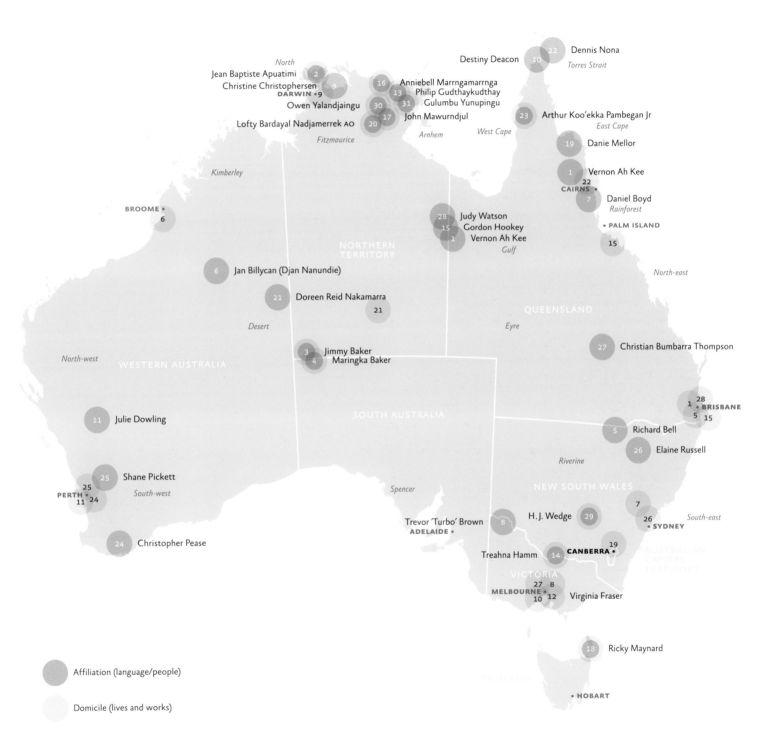

Dennis Nona
22
10
Torres Strait

North
Jean Baptiste Apuatimi
Christine Christophersen
DARWIN •9

Anniebell Marrngamarrnga
Philip Gudthaykudthay
Gulumbu Yunupingu

2
9
16
13
31
30
17
20

Owen Yalandjaingu

John Mawurndjul

Lofty Bardayal Nadjamerrek AO

Fitzmaurice

Arnhem

West Cape

23 Arthur Koo'ekka Pambegan Jr
East Cape

19 Danie Mellor

1 Vernon Ah Kee
22
CAIRNS •

7 Daniel Boyd
Rainforest

• PALM ISLAND

Kimberley

BROOME •
6

28
15
1

Judy Watson
Gordon Hookey
Vernon Ah Kee
Gulf

15

North-east

NORTHERN
TERRITORY

6 Jan Billycan (Djan Nanundie)

21 Doreen Reid Nakamarra
21

Desert

QUEENSLAND

Eyre

North-west
WESTERN AUSTRALIA

3 Jimmy Baker
4 Maringka Baker

27 Christian Bumbarra Thompson

11 Julie Dowling

SOUTH AUSTRALIA

1 28
• BRISBANE
5 15

5 Richard Bell

26 Elaine Russell

Riverine

25 Shane Pickett
PERTH
25
11 24
South-west

Spencer

NEW SOUTH WALES

7

26 • SYDNEY
South-east

24 Christopher Pease

Trevor 'Turbo' Brown
ADELAIDE •

8 H. J. Wedge 29

19
CANBERRA •

14 Treahna Hamm

VICTORIA
27 8
MELBOURNE •
10 12

Virginia Fraser

18 Ricky Maynard

• HOBART

Affiliation (language/people)

Domicile (lives and works)

1770 Captain James Cook surveys the eastern coast of Australia.

1788 Captain Arthur Phillip oversees the arrival of the First Fleet in Botany Bay before moving to Port Jackson and claiming the land for the English monarch, King George III, as its first governor of New South Wales, founding the site of Sydney.

1879 First exhibition of bark paintings shown as 'anthropological material culture' at the Linnean Society of New South Wales, Sydney.

1884 Captain F. Carrington, who had collected works on bark from the South Alligator River region, Arnhem Land in 1881, removes five bark paintings from inside a bark shelter at Field Island, Northern Territory, which eventually enter the collection of the South Australian Museum.

c. 1888 The first exhibition of Aboriginal art, *Dawn of art,* opens in Adelaide.

1889 The legal doctrine of *terra nullius* is first proclaimed as grounds for the Crown owning all Australian land from 1788.

1912 Anthropologist Baldwin Spencer (1860–1929) makes the first substantial collection of Aboriginal bark paintings from Arnhem Land. The growing numbers of Europeans in this region leads to the discovery and documentation of the rich and diverse body of rock art that adorns its caves.

1915 Thirty-eight bark paintings collected by Baldwin Spencer are exhibited at the Museum of Victoria, Melbourne.

1936 Western Arrernte artist Albert Namatjira (b. 1902), begins painting in watercolours. Namatjira's paintings, which depict landscapes from his traditional homelands, are highly sought after by European collectors and he becomes the first successful contemporary Aboriginal artist.

1938 26 January Australia Day is declared the inaugural 'Day

of Mourning' for Aboriginal people on the 150th anniversary of Australia's settlement by Europeans.

31 January An Aboriginal deputation requests that Prime Minister Lyons makes Aboriginal affairs a Commonwealth responsibility.

1939 Albert Namatjira's painting *Illum-Baura (Haasts Bluff)* 1939 is purchased by the Art Gallery of South Australia, the first acquisition of an Aboriginal painting by an art gallery.

1941 *Art of Australia 1788–1941,* curated by the Museum of Modern Art and shown in the USA and Canada, is the first recorded overseas exhibition to include Aboriginal art.

1947 Queensland Art Gallery purchases the watercolour *Western MacDonnells* c. 1945 by Albert Namatjira.

1948 Anthropologist Charles Percy Mountford leads a party of scientists and naturalists on an expedition to Arnhem Land, sponsored by the National Geographic Society and the Smithsonian Institute in cooperation with the Commonwealth of Australia. The American-Australian Scientific Expedition to Arnhem Land (AASEAL) collects 275 paintings and numerous carved and painted figures.

1951 Aranda Arts Council (formally The Hermannsburg Mission Arts Advisory Council) is the first business formed to promote and sell Aboriginal art.

1953 Albert Namatjira is awarded the Queen's Coronation Medal for services to the Arts.

1956 The Commonwealth Department for the Interior distributes 144 of 275 works collected by the 1948 American-Australian Scientific Expedition to Arnhem Land (AASEAL) to six state galleries, known as the commonwealth bequest.

1957 Albert Namatjira becomes an Australian citizen.
July National Aborigines Day Observance Committee

(NADOC) is founded to promote the first Sunday in July as a day for focusing attention on Aboriginal issues.

Charles Mountford organises a major travelling exhibition of thirty-one bark paintings from the South Australian Museum. It opens at the Institute of Contemporary Arts in London, and travels to Edinburgh, Zurich, Göteborg, Paris and Cologne.

The art of Arnhem Land, organised by anthropologists Ronald and Catherine Berndt, is held at the Western Australian Museum and Art Gallery, Perth.

1958 *Kunst der Australier,* organised by Karel Kupka, is shown at the Museum für Volkerkunde, Basel, and the Schweizerische Museum für Volkskunde, Switzerland.

The Federal Council for the Advancement of Aborigines and Torres Strait Islanders (FCAATSI) is formed. Its membership included Indigenous and non-Indigenous Australians and had links in different states. The main aim was to push for a referendum.

Albert Namatjira buys alcohol for family members, following his customary obligations. A woman dies in a fight and Namatjira is gaoled for three months.

1959 Albert Namatjira dies, shortly after being released from gaol.

The Art Gallery of New South Wales first exhibits *pukumani* (funerary) poles from Melville Island as art.

The first Aboriginal works acquired for the national collection (for the yet to be established Australian National Gallery) are by Hermannsburg artists, including Albert Namatjira.

1960 *Australian Aboriginal art* is shown at the Art Gallery of New South Wales, Sydney.

1963 The Yolngu people of Yirrkala in North-East Arnhem Land, concerned about mining on their land, protest to federal parliament through a bark petition. They lose the landmark Supreme Court case in 1970, but the need for revision of the law is established.

Prime Minister Robert Menzies receives an Aboriginal delegation seeking a referendum on racial discrimination.

1965 Works from the Cahill and Chaseling collections at the Museum of Victoria, Melbourne, are included in *Aboriginal bark paintings from Australia,* shown at the Museum of Fine Arts, Houston, Texas, USA.

'The Freedom Ride', organised by University of Sydney students, including Charles Perkins, travels through regional New South Wales, demanding civil rights for Aboriginal people.

1966 Nine days before the introduction of decimal currency, a South Australian newspaper publicises the unauthorised use of an image – based on a bark painting by Manharrngu artist, David Malangi (1927–1999) – by the Reserve Bank of Australia.

Aboriginal people at Wave Hill Station, Northern Territory, begin the Gurindji Walk-off or Wave Hill Strike, to obtain title to their traditional land at Daguragu (Wattie Creek), on the largest cattle station in the world, Victoria River Downs, owned by the British Lord Vestey. They stay on strike for eight years.

1967 The Referendum (Aboriginals) is overwhelmingly supported (90.77%) by Australians, enabling Aboriginal people to be counted as citizens of their own country and included in the census.

1970 The Australian Council for the Arts, the predecessor of the Australia Council, establishes an Aboriginal Arts Advisory Committee and commonwealth funding for Aboriginal arts begins.

1971 Geoffrey Bardon, an Australian schoolteacher at the Aboriginal community of Papunya in the Western Desert, encourages a group of senior Aboriginal men to paint a mural depicting an important local ancestral story – Honey Ant Dreaming – on the wall of the community school. The men go on to create smaller paintings in acrylic on plywood, linoleum, and later art board and canvas.

These works represent the first contemporary Western Desert acrylic paintings, also sometimes called 'dot' paintings because of their distinctive dotted backgrounds.

The Aboriginal flag, designed by Luritja/Wombai artist Harold Thomas, is raised during National Aborigines Day Observance Committee (NADOC) events in Adelaide.

Aboriginal Arts and Crafts Pty Ltd (AAC) is established by the federal Office of Aboriginal Affairs, one of its aims being to assist in the promotion of Aboriginal art, with the company establishing a number of galleries between 1972 and 1976.

Kuninjku artist Yirawala (1901–1976) is awarded an MBE for his services to Aboriginal art. In this year he also holds the first solo exhibition of bark paintings at the University of Sydney.

1972 The federal Department of Aboriginal Affairs (DAA) is established in Canberra, replacing the Office of Aboriginal Affairs.

105 early Papunya Tula works are acquired by the Museum and Art Gallery of the Northern Territory and are the first major purchase by a public gallery.

1973 The Aboriginal Arts Board is established by the Whitlam Government. Its predecessor was the Aboriginal Arts Advisory Committee, formed in 1970. Goobalathaldin Dick Roughsey (1924–1985), a Lardil man from Mornington Island, Queensland, is appointed the first chairman. From its inception, the board of fourteen members is made up entirely of Indigenous people.

The first national gathering on Aboriginal and Torres Strait Islander visual arts is held at the Australian National University in Canberra, opened by Prime Minister Gough Whitlam. Indigenous Australian artists were joined by international Indigenous artists from the Pacific, Africa, India, Papua New Guinea and North America.

1974 *Art of Aboriginal Australia,* presented by Rothmans of Pall Mall Canada under the sponsorship of the Aboriginal

Arts Board and with the assistance of the Peter Stuyvesant Trust, tours to twelve Canadian museums for eighteen months, beginning its tour at the Musée d'art contemporain, Montréal, Canada.

1975 *Art of the Western Desert* opens at the Australian National University, Canberra, and tours to forty-four venues across Australia between 1975 and 1980. The entire collection of thirty paintings is later gifted to the Art Gallery of Western Australia.

1976 The Aboriginal Artists Agency is established to protect the copyright interest of Aboriginal artists.

The Australian National Gallery, yet to be opened, acquires an outstanding collection of 139 bark paintings by Yirawala.

1977 *Oenpelli paintings on bark (Gunbalanya bim)*, is shown at the Australian Museum, Sydney. The collection of fifty-two paintings is circulated in Australia and in Europe by the Australian Gallery Directors Council.

1980 Ron Radford, Curator of Paintings, Art Gallery of South Australia, includes Clifford Possum Tjapaltjarri's *Man's love story 1978*, in his rehang of contemporary Australian art, at the Art Gallery of South Australia – the first time Aboriginal art is included in a survey of contemporary Australian art.

1981 *Aboriginal Australia*, organised by the Australian Gallery Directors Council, the National Gallery of Victoria and the Aboriginal Arts Board, is shown in the National Gallery of Victoria, Melbourne; the Australian Museum, Sydney; and the Art Gallery of Western Australia, Perth.

1982 The Australian National Gallery opens in Canberra.

Queensland Art Gallery purchases its first Western Desert work, *Untitled* c. 1980–82, by Johnny Warangkula Tjupurrula.

Aboriginal artists from Lajamanu, Northern Territory, are included in the Biennale of Sydney for the first time.

1983 Australia is represented by Papunya Tula artists at the Bienal, Brazil.

Liyagalawumirr artist Philip Gudthaykudthay holds his first solo exhibition at Garry Anderson Gallery, arguably the first solo exhibition by an Aboriginal artist in a contemporary art space.

Elders at Yuendumu community in central Australia paint scenes from their traditional mythology, or Dreaming, on the doors of the local school. Receiving wide critical acclaim in the art world, the creation of the *Yuendumu doors* becomes an important event in the history of contemporary Aboriginal art.

The Australian National Gallery purchases 137 works, objects and paintings from Arnhem Land, from the collection of artist Karel Kupka in France.

1984 *The National Aboriginal Art Award* is established by the Museum and Art Gallery of the Northern Territory, Darwin. Michael Nelson Jagamarra wins the inaugural award with *Three Dreamings 1984*.

Koori art '84, the first major exhibition of works by contemporary urban Aboriginal artists, is held in Sydney.

1985 The first large collaborative canvas to be painted at Yuendumu, *Yanjilypiri Jukurrpa (Star Dreaming) 1985*, is later acquired by the Australian National Gallery in 1989.

1986 Michael Nelson Jagamarra is included in the 6th Biennale of Sydney.

The Australian National Gallery holds its first exhibitions of Indigenous art since its opening with *My country, my story, my painting: recent paintings by twelve Arnhem Land artists* and *Painted objects from Arnhem Land*.

The first Indigenous photography exhibition, *NADOC '86 exhibition of Aboriginal and Islander photographers*, is held at the Aboriginal Artists Gallery, Sydney.

1987 The Association of Northern and Central Aboriginal Artists (ANCAA) is founded by sixteen Aboriginal-owned and controlled community art and craft centres from Northern Territory, Western Australia, and South Australia, representing over 2500 artists.

Boomalli Aboriginal Artists Co-operative Ltd, the first co-operative for the encouragement and display of works by urban-based Aboriginal artists, is established in Sydney by ten Sydney-based Indigenous artists.

The report *Return to country: the Aboriginal homelands movement in Australia,* shows that the Aboriginal arts and crafts industry is the major source of cash income aside from the public sector.

The *Aboriginal memorial* is commissioned by the Australian National Gallery. The installation, comprising 200 hollow-log coffins (one to represent each year of colonisation) is created by forty-two artists from communities along the Glyde River in Arnhem Land.

1988 Australia celebrates its bicentenary. Protests by Aboriginal and Torres Strait Islander people throughout Australia mark this event. 60 000 Indigenous and non-Indigenous people march through Sydney on 26 January, on the 'Long March of Freedom, Justice and Hope'.

The *Aboriginal memorial* 1987–88, made to mark Australia's bicentenary, is included in the Biennale of Sydney and then enters the collection of the Australian National Gallery, Canberra.

American Jerome Gould's collection of 273 bark paintings is acquired by Arnott's Biscuits Ltd, which is donated to the Museum of Contemporary Art, Sydney in 1993.

Dreamings: the art of Aboriginal Australia, organised by the Asia Society Galleries and the South Australian Museum, is shown in New York, USA, and eventually tours to Chicago and Los Angeles, USA, and Melbourne and Adelaide, Australia.

1989 The *Aboriginal memorial* 1987–88, forms part of the Australian National Gallery's first major exhibition of Indigenous Australian art, *Aboriginal art: the continuing tradition*, staged in Canberra, comprising more than 500 works by over 200 artists.

The exhibition *Magiciens de la terre* is exhibited in Paris for the French bicentennial celebrations.

Tandanya National Aboriginal Cultural Institute opens in Adelaide.

The Royal Commission into Black Deaths in Custody is established.

1990 For the first time, the Australian National Gallery tours Aboriginal art overseas in the exhibition *L'été australien à Montpelier*, France.

Rover Thomas (c. 1926–1998) and Trevor Nickolls are the first Aboriginal artists to be selected as Australia's representatives at the Venice Biennale, Italy.

Balance 1990: views, visions, influences is held at the Queensland Art Gallery, leading to the establishment of Fireworks Gallery.

1991 *Flash pictures: by Aboriginal and Torres Strait Islander artists* is held at the Australian National Gallery, with Indigenous artists from around the country, including Richard Bell, John Mawurndjul and Judy Watson.

Desart, the Association of Central Australian Aboriginal Art and Craft Centres, is incorporated in Alice Springs.

Aboriginal art and spirituality is held at the High Court of Australia in Canberra to coincide with the Commonwealth Heads of Government meeting and World Council of Churches, and then tours.

The Museum of Contemporary Art opens in Sydney.

1992 The High Court of Australia brings down its landmark decision in *Mabo and Others v. The State of Queensland,* which holds that Australia was not *terra nullius* (empty land) at the time of British settlement.

Labor Prime Minister Paul Keating launches the 1993 International Year for the World's Indigenous People, with a speech at Redfern Park, Sydney.

Tyerabarrbowaryaou: I shall never become a white man, opens at the Museum of Contemporary Art, Sydney.

Bernard Namok designs the Torres Strait Islander flag.

1993 International Year for the World's Indigenous People.

Aratjara – art of the first Australians is held at the Kunstsammling Nordrhein-Wesfalen, Düsseldorf, and then tours to the Hayward Gallery, London, and the Louisiana Museum Humlebaek, Denmark, but is never shown in Australia.

La peinture des Aborigines d'Australie opens at the Le Musée des Arts d'Afrique et d'Océanie, Paris, France.

Ganalbingu bark painter George Milpurrurru (1938–1998) becomes the first Aboriginal artist honoured with a solo exhibition at the National Gallery of Australia.

The *First Asia-Pacific Triennial of Contemporary Art* is held at the Queensland Art Gallery, and includes four Indigenous Australian artists.

1994 *Pitture e sculture del Australia Aborigena* is shown at Spazio Krizia, Milan, and then at the Palazzo Butera, Palermo, Italy.

Power of the land: masterpieces of Aboriginal art is shown at the National Gallery of Victoria, Melbourne.

Tyerrabarrbowaryaou II (I shall never become a white man) represents Australia at the Havana Bienal, Cuba.

Yiribana gallery opens at the Art Gallery of New South Wales, at the time the largest permanent collection display for Indigenous art in Australia.

The Federal Court of Australia awards record damages of $188 000 to eight Aboriginal artists for works reproduced on carpets without permission. This is known as 'The carpets case'.

Roads cross: the paintings of Rover Thomas is the second National Gallery of Australia exhibition to focus on the achievements of an individual Aboriginal artist.

Urban focus: Aboriginal and Torres Strait Islander art from the urban areas of Australia is held at the National Gallery of Australia.

Anmatyerre artist Emily Kam Kngwarray is awarded an Australian Artists Creative Fellowship by the federal government.

1995 *Rainbow sugarbag and moon: two artists of the stone country – Bardayal Dajamerrek and Mick Kubarrku* is held at the Museum and Art Gallery of the Northern Territory, Darwin, and then tours.

Maningrida: the language of weaving begins its tour and the collection is eventually donated to Museum and Art Gallery of the Northern Territory – the first such major donation from an Aboriginal community.

The inaugural *Africus: Johannesburg Biennale* has two Indigenous artists representing Australia.

1996 *The eye of the storm: eight contemporary Indigenous Australian artists,* from the National Gallery of Australia, shows at the National Gallery of Modern Art, New Delhi, India, Sydney and Melbourne.

1997 *The painters of the Wagilag Sisters story 1937–1997* is held at the National Gallery of Australia.

Fluent: Emily Kame Kngwarreye, Yvonne Koolmatrie, Judy Watson: XLVII esposizione internazionale d'arte La Biennale di Venezia 1997, is the first time Indigenous women artists represent Australia at the Venice Biennale.

1998 *Re-take: contemporary Aboriginal and Torres Strait Islander photography* opens at the National Gallery of Australia followed by a national tour until 2000.

The Peter Fannin Collection of Early Western Desert Paintings of forty-eight works from Papunya Tula Artists is acquired by the National Gallery of Australia.

Emily Kame Kngwarreye: Alhalkere: paintings from Utopia opens at the Queensland Art Gallery.

1999 The *Aboriginal memorial* travels to Europe in the exhibitions *Le mémorial: un chef-d'oeuvre d'art aborigène (The memorial: a masterpiece of Aboriginal art)* at Musée Olympique, Lausanne, Switzerland and *The Aboriginal memorial: Kunstler aus Ramingining* at Sprengel Museum, Hannover, Germany.

2000 The *Aboriginal memorial* becomes part of the exhibition *World of Dreamings: traditional and contemporary art of Aboriginal Australia* organised by the National Gallery of Australia in association with the National Museum of Australia and Art Exhibitions Australia at the State Hermitage Museum, St Petersburg, Russia.

Beyond the pale: contemporary Indigenous art: Adelaide Biennial of Australian Art is shown at the Art Gallery of South Australia during the 2000 Adelaide Festival. It is the first time the biennial is solely dedicated to Indigenous artists.

Urban dingo: the art of Lin Onus opens at the Museum of Contemporary Art, Sydney.

Papunya Tula: genesis and genius is held at the Art Gallery of New South Wales.

2001 Kukatja/Wangkajungka artist Rover Thomas's *All that big rain coming from topside* 1991, is acquired by the National Gallery of Australia, representing the highest price paid for an Indigenous work of art at the time.

2002 *Seeing the centre: the art of Albert Namatjira* opens at the National Gallery of Australia on the centenary of Namatjira's birth, followed by a national tour.

The federal government releases its *Report of the Contemporary Visual Arts and Crafts Industry* (the 'Myer Report'), which recommends enhanced support for Indigenous visual arts.

2003 *Story place: Indigenous art of Cape York and the rainforest* is held at the Queensland Art Gallery.

South west central: Indigenous art from south Western Australia 1833–2002, is held at the Art Gallery of Western Australia

Tactility: two centuries of Indigenous objects, textiles and fibre is held at the National Gallery of Australia.

John Mawurndjul wins the *Clemenger Contemporary Art Award* at the National Gallery of Victoria, Melbourne.

2004 *Crossing country: the alchemy of Western Arnhem Land art* is held at the Art Gallery of New South Wales.

Destiny Deacon: walk and don't look blak opens at the Museum of Contemporary Art, Sydney, before touring to Asia Pacific venues, including Japan.

Lofty Bardayal Nadjamerrek is awarded the Order of Australia.

proppaNOW is established in Brisbane, Queensland.

No ordinary place: the art of David Malangi opens at the National Gallery of Australia and then tours nationally.

Ricky Maynard: portraits of a distant land opens at the Museum of Contemporary Art, Sydney.

Colour power: Aboriginal art post 1984 opens at the National Gallery of Victoria, Melbourne.

2006 Judy Watson wins the *Clemenger Contemporary Art Award*, at the National Gallery of Victoria, Melbourne.

Land marks: Indigenous art in the National Gallery of Victoria opens.

Michael Riley: sights unseen is the first solo exhibition of an Indigenous artist from south-eastern Australia, at the National Gallery of Australia.

The *Australian Indigenous Art Commission*, jointly funded by the Australian and French governments is launched at the newly opened Musée du quai Branly, Paris, France, and includes John Mawurndjul, Judy Watson and Gulumbu Yunupingu.

<<rarrk>> John Mawurndjul: journey through time in northern Australia opens at the Museum Tinguely, Basel, Switzerland.

The *5th Asia-Pacific Triennial of Contemporary Art* opens at the Queensland Art Gallery in conjunction with the opening of Gallery of Modern Art, Brisbane.

2007 Dennis Nona is the first Torres Strait Islander artist to win the overall 24th Telstra National Aboriginal and Torres Strait Islander Art Award, held at the Museum and Art Gallery of the Northern Territory, Darwin, with his bronze sculpture *Ubirikubiri*.

The inaugural National Indigenous Art Triennial *Culture Warriors*, opens at the National Gallery of Australia.

Ricky Maynard: portraits of a distant land, a Museum of Contemporary Art, touring exhibition, opens at the Musée du quai Branly, Paris, France.

NOTES Information for this chronology has been drawn from various sources, including the following. In some instances, short passages of text have been directly quoted.

Caruana, Wally, *Aboriginal art*, 2nd, new edn, London: Thames and Hudson, 2003.

Croft, Brenda L. (ed.), *Michael Riley: sights unseen*, exhibition catalogue, Canberra: National Gallery of Australia, 2006.

Hardy, Jane, Megaw, J. V. S. and Megaw, M. Ruth (eds.), *The heritage of Namatjira: the watercolourists of central Australia*, Port Melbourne: William Heinemann Australia, 1992.

Jones, Philip and Sutton, Peter, *Art and land: Aboriginal sculptures from the Lake Eyre region*, Adelaide: South Australian Museum and Wakefield Press, 1986.

Kleinert, Sylvia and Neale, Margo (eds.), *Oxford companion to Aboriginal art and culture*, South Melbourne: Oxford University Press, 2000.

Morphy, Howard, *Aboriginal art*, London: Phaidon Press, 1998.

Perkins, Hetti and Willsteed, Theresa (eds.), *Crossing country: the alchemy of Western Arnhem Land art*, Sydney: Art Gallery of New South Wales, 2004.

Perkins, Hetti and Fink, Hannah (eds.), *Papunya Tula: genesis and genius,* Sydney: Art Gallery of New South Wales in association with Papunya Tula Artists, 2000.

Sayers, Andrew, *Aboriginal artists of the nineteenth century*, Melbourne: Oxford University Press in association with the National Gallery of Australia, 1994.

Australia, 1900 A. D. – present, viewed 13 September 2007, metmuseum.org/toah/ht/11/oca/ntlloca.htm

The Koori History Website, *Indigenous history archive and education resource site*, viewed 13 September 2007, kooriweb.org/foley/indexb.html

The Metropolitan Museum of Art, *Timeline of art history: Australia, 1900 A.D. – present*, viewed 13 September 2007, metmuseum.org/toah/ht/11/oca/ht11oca.htm

Message club, ABC, *Didj "u" know – stories*, viewed 13 September 2007, abc.net.au/messageclub/duknow/

Oz Outback, *Flags from Australia*, viewed 13 September 2007, ozoutback.com.au/flags/index.htm

Northern Territory Government, Museums and Art Galleries of the Northern Territory, *24th Telstra National Aboriginal & Torres Strait Islander Art Award*, viewed 13 September 2007, nt.gov.au/nreta/museums/exhibitions/natsiaa/index.html

Tjulyuru Regional Arts Gallery, Tjulyuru Cultural and Civic Centre, *Timeline*, viewed 13 September 2007, tjulyuru.com/timeline.asp

Aboriginal and Torres Strait Islander people/Indigenous people/person Someone who identifies as Aboriginal or Torres Strait Islander/Indigenous and is accepted as such by their specific Indigenous community or the one in which they live. The effects of colonisation and displacement over two centuries severely impacted upon thousands of Indigenous people, who were driven from their traditional lands and often had access to their languages and cultural practices denied or fractured. However, over the past three or so decades there has been a resurgence of cultural pride and activity throughout the country, particularly among Indigenous people living in towns and cities. Comprising less than 2 per cent of the overall population of Australia, they face many obstacles in gaining equal rights with non-Indigenous Australians.

Aboriginal flag The Aboriginal flag was designed by a Luritja/Wombai artist Harold Thomas in 1971. It was first raised by Thomas at Victoria Square, Adelaide, on National Aborigines Day, 12 July 1971. The black symbolises Aboriginal people, yellow represents the sun, the constant renewer of life, and red depicts the earth and also ochre, which is used by Aboriginal people in ceremonies.

Aboriginal Tent Embassy On the morning of 26 January 1972, the Aboriginal Tent Embassy appeared on the lawns of the Provisional Parliament House, Canberra, manned by a number of prominent Indigenous activists and drawing black and white supporters from everywhere. Both the embassy and the newly created Aboriginal flag, flying from the tent pole, represented the unity of purpose of Indigenous people across Australia. The embassy effectively demonstrated that Indigenous people are members of a nation separate to white Australia and that they intended to see this reflected in the political process.

Ancestral Beings Spiritual or mythical beings whose existence preceded human life on earth and who, through their epic journeys, created the landscape as it is today. They may be human or animal, animate or inanimate, and in many cases transform from one thing to another. They are a continuing influence on the world through processes such as spirit conception, and provide the underlying source of spiritual power.

Ancestral past refers to the time when ancestral beings occupied the earth or the dimension in which ancestral beings still exist.

Arnhem Land An area of approximately 150 000 square kilometres east of Darwin in the tropical north of the Northern Territory. The area is renowned for bark paintings, wood and fibre sculptures, and weaving.

assimilation A policy that was pursued by Australian governments towards Aboriginal people which forced them to adopt Euro-Australian lifestyles and eventually to become assimilated within the Australian population as a whole. The policy often involved the repression of Indigenous cultural practices, and in many parts of Australia was associated with the removal of Aboriginal children from their families. In the 1970s assimilation was replaced by policies that provided Indigenous people with far greater autonomy, resulting in increased recognition of their rights and the value of their cultural practices.

balanda The term used in Arnhem Land to refer to non-Indigenous people.

bark painting The practice of producing paintings on sheets of eucalyptus stringy-bark that have been flattened over an open fire. Today, the tradition is most closely associated with Arnhem Land in northern Australia, but evidence suggests it may have been more widespread at the time of European colonisation, in regions where bark was used to make huts and shelters. Brushes are made from hair tied or glued to a twig, or by chewing the end of a twig or certain grasses or rushes.

clan A group of people connected by descent who hold certain rights in common. In many parts of Australia, rights in land and paintings are vested in clans, often (but not always) formed on the basis of descent through the father (patrilineal clans). However, such clans are by no means a universal feature of Australia.

coolamon An all-purpose wooden carrying dish, usually with curved sides, used in the desert.

desert art Also described as the art of place and journey, desert art takes many forms, including painting and incised decoration of weapons and utensils, ceremonial body painting and sand painting. It is practiced in the vast desert areas of Central Australia, which include mountain ranges and rock formations, grassy plains, sandhills, and salt pans broken by seasonal watercourses and waterholes. The deserts of Central Australia are the home and origin of one of the most significant art movements in contemporary Australian art.

Dhuwa see moiety

digging stick A long wooden stick used to gather roots and root vegetables, and dig for water.

dilly bag A widespread term for bags and baskets woven from plant fibres and used in northern Australia for collecting and carrying food and personal possessions. Also used in ceremonies.

Dreaming/Dreamtime Terms first used by W. B. Spencer and F. Gillen to refer to the time of world creation or the ancestral past. It is a fairly literal translation of the Arrernte word *altyerrenge*, which corresponds with similar terms in many other central Australian languages. The term has been overused in popular literature and has almost become a cliche, but nonetheless refers to an important component of Aboriginal cosmologies.

Freedom Ride In 1965 a group of university students, led by Arrernte activist Charles Perkins,

conducted a highly publicised 'Freedom Ride' through northern New South Wales to expose the apartheid prevalent in the region.

Hermannsburg School A group of watercolour artists originally associated with the Lutheran Mission Station of Hermannsburg, south-west of Alice Springs. Its most famous representative was Albert Namatjira (1902–1959).

hollow-log coffin A tree trunk hollowed out by termites and subsequently painted, decorated and used as the final receptacle for the bones of the dead across many regions of northern Australia. The name for hollow log coffin and its associated ceremony varies in different parts of Arnhem Land according to language.

Indigenous There are two distinct Indigenous groups within Australian territory: Aboriginal people and Torres Strait Islander peoples, who are not a homogeneous mass but comprise hundreds of distinct nations throughout the continent, each with their own languages and dialects, just as many different nationalities constitute Europe.

Kimberley The Kimberley region lies in the extreme north-west of the continent. Famous among the rock paintings of the region are the images of the ancestral Wandjina and the Bradshaw figures. Decorated and engraved pearl shells are a feature of coastal areas. The art of the east Kimberley has flourished in recent decades.

kinship Connections between family members. Among Aboriginal groups this term covers relationships both within and between generations, and through both mothers' and fathers' lines of descent across many generations. People also have kinship with certain animals and plants through common descent from or relationship to a particular ancestral being/creation ancestor.

Koori/Koorie The generic term that Aboriginal people from the south-eastern region of Australia use in reference to themselves.

Indigenous people in some northern areas of New South Wales refer to themselves as Goori or Murri.

land rights Since the 1960s, the matter of land rights has been one of the major political issues for Indigenous people in Australia. Until the 1967 referendum, Aboriginal people were not even considered full citizens in their own country and had no rights to their land. Since the passing of the *Aboriginal Land Rights (Northern Territory) Act 1976*, Indigenous people in many parts of northern and central Australia have gained title to their land. However, in many other parts of Australia Aboriginal rights in land remain minimal. Since the Mabo judgment of the High Court in 1992, however, the possibility of extending land rights through native title claims has existed, though to date it remains largely untested. Indigenous people throughout southern regions of Australia, in the east and the west, are currently seeking native title to their traditional lands.

language/linguistic group In Australia more than 250 languages were spoken at the time of British colonisation and many continue to be spoken. Language is an important component of people's identity.

moiety Literally means a division in two halves. In Australia, it refers to a division of society into two intermarrying halves, with a corresponding division of the whole universe along the same lines. In Arnhem Land there are the *Yirritja/Yirridjdja* and *Dhuwa/Duwa* moieties.

Murri The generic term that Indigenous people from southern Queensland use in reference to themselves.

native title On 3 June 1992 the High Court of Australia passed a judgment in recognition of traditional laws and customs of Indigenous Australians in relation to land or waters, through the historic Mabo case. The High Court called this type of ownership 'native title', which means a title owned by Indigenous

people. The Commonwealth *Native Title Act 1993* recognises and protects the Aboriginal and Torres Strait Islander People's common law native title rights and interests. Land rights are grants created by governments. Native title is a right that has always been there from the beginning of time.

natural pigments *see* ochre

Noongar/Nyoongar/Nyungar/Nyungah/Nyoongah The term traditionally meant 'man', but today has come to refer to people who identify themselves as Aboriginal and claim heritage from the south-west region of Western Australia.

ochre Natural earth pigments. Various forms of iron oxide used as red and yellow pigments throughout Australia for body, rock or bark painting. Ochres are extracted from lime and sandstone and clay soil, and are prepared for use by crushing and rubbing to a powder and adding water and glue. Natural pigments were an important trading item and are still traded today.

outstation A small Aboriginal settlement of family members and kin living on their land. Outstations are generally located at geographically and culturally important locations.

Papunya Tula Artists A co-operative formed by Papunya artists in 1972 to represent the artists and market their works. Papunya, 150 kilometres west of Alice Springs, is the birthplace of the desert art movement, one of the most significant movements in modern Australian art.

pukumani The state of bereavement among the Tiwi of Melville and Bathurst Islands. The term is also applied to the ritual paraphernalia associated with the burial ceremony.

Rainbow Serpent/Snake The belief in a transforming python-like creative/Ancestral Being associated with rain and waterholes is widespread throughout Australia.

rarrk Crosshatched clan patterns in central and Western Arnhem Land. Also known as *dhulang*

in North-East Arnhem Land. *Rarrk* is clan-specific and serves as a means of identification or association in much the same way that tartan denotes distinct clans in Scotland.

referendum In 1967, non-Indigenous Australians responded overwhelmingly in the affirmative (90.77 per cent) to a referendum that proposed a law to alter the Australian Constitution entitled: *An Act to alter the Constitution so as to omit certain words relating to the People of the Aboriginal Race in any State and so that Aboriginals are to be counted in reckoning the Population.*

section/subsection Classificatory kinship terms used in many areas of central and northern Australia that place people into one of a set of four (section) or eight (subsection) categories. A person's subsection name can also be known as their skin name.

song cycle/songline Sets of songs that recount the actions of Ancestral Beings as they journeyed across the landscape in the ancestral past. The concept of 'songline' popularised by the writer Bruce Chatwin has a similar reference.

Stolen Generations Indigenous children have been forcibly removed from their families and communities since the very first days of the European occupation of Australia. In that time, very few Indigenous families have escaped the effects of the removal of one or more children. The National Inquiry into the Separation of Aboriginal and Torres Strait Islander Children from their Families concluded that between one in three and one in ten Indigenous children were forcibly removed from their families and communities between 1910 and 1970. These people are referred to as the 'Stolen Generations'.

Terra nullius Describes the British legal fiction that Australia was an unoccupied land at the time of its invasion by the British and therefore became a settled, as opposed to a conquered, land. Hence Indigenous people were deemed to have no existence in law. In 1770, Cook declared

Australia *terra nullius* – empty land – invalidating the 250 or so distinct nations that had inhabited the continent for thousands of generations. *Terra nullius* was overturned in 1992 by the High Court of Australia, following a ten-year action by Koiki (Eddie) Mabo and four other Torres Strait Islanders, inhabitants of the Murray Islands, for a declaration of native title to their traditional lands.

Tjukurrpa /Tjukurpa/Jukurrpa Dreaming A term used in the desert to refer to ancestral beings and to the places and times associated with them.

Torres Strait Island flag The Torres Strait Islander flag was designed by Bernard Namok in 1992. The black symbolises the Torres Strait Islander people, the blue the sea, green the land, and the white Dari headress and five-pointed star symbolises the five major island groups and navigation.

Torres Strait Islander people The Torres Strait Islands, which lie between Papua New Guinea and the tropical tip of Australia, are home to an Indigenous community with a rich history and unique culture.

totem For Indigenous peoples in Australia the relationship between human beings and the spiritual world is mediated through landscape and the environment. The word 'totem' is used to refer to the links between people, ancestral beings and the landscape, including the animals that are associated with it.

tribe Has not proved a useful term in Australia. 'Language group', 'peoples' and 'clan' or simply 'social group' are the preferred concepts.

urban Aboriginal art A term that first came to prominence in the 1980s in response to the new generation of urban-based Indigenous artists, working predominantly in Sydney, Brisbane, Melbourne and Perth. The term is somewhat problematic, suggesting a juxtaposition between urban

and traditional Indigenous art, which was never the intention of the original artists involved in the movement. 'Contemporary Indigenous art' is a more inclusive term and refers to all Indigenous art being created today, irrespective of media, style or geographic origin.

x-ray art Aboriginal art originating in Western Arnhem Land which characteristically depicts both internal and external organs of human and animal subjects.

yawkyawk Literally, young woman. These human/fishlike playful spirits are said to be friendly towards humans. The *yawkyawk* girls were originally devoured by the Rainbow Spirit and then spat back out again to become water spirits.

Yirritja/Yirridjdja *see* moiety

Yirrkala Bark Petition In 1963, the Yolngu people of North-East Arnhem Land in the Northern Territory, faced with their traditional lands being taken over by a huge bauxite mine, presented to the Australian Parliament a petition, in the form of a bark painting, calling for recognition of their land rights.

Yolngu A language group of Eastern and Central Arnhem Land. Also a generic name for Aboriginal people of the region. In Western Arnhem Land the corresponding term is *Bininj*.

NOTES This glossary draws on a number of sources, including those listed below. Some entries are direct quotations; in other cases the texts have been used as sources of information.

Aboriginal Western Australia, Perth: Aboriginal Arts Enterprise, 1997.

Arthur, Bill and Morphy, Frances (eds), *Macquarie atlas of Indigenous Australia: culture and society through space and time*, Macquarie: Macquarie University, NSW, 2005.

Bardon, Geoffrey and Bardon, James, *Papunya: a place made after the story: the beginnings of the western Desert painting movement*, Melbourne: Miegunyah Press, 2004.

Beyond the pale: contemporary Indigenous art: 2000 Adelaide biennial of Australian Art, Adelaide: Art Gallery of South Australia, 2000, pp. 8, 26, 55, 85.

Blakness: Blak city culture, exhibition catalogue, Melbourne: Australian Centre for Contemporary Art in conjunction with Boomalli Aboriginal Artists Co-operative, 1994, p. 18.

Carter, Paul and Hunt, Susan, *Terre Napoleon: Australia through French eyes 1800–1804*, Sydney: Historic Houses Trust of New South Wales in association with Hordern House, 1999, p. 64.

Caruana, Wally, *Aboriginal art*, New York: Thames & Hudson, 1993, p. 214.

Croft, Brenda L. (ed.), *Michael Riley: sights unseen*, exhibition catalogue, Canberra: National Gallery of Australia, 2006, pp. 159–62.

Horton, David (ed.), *Encyclopedia of Aboriginal Australia: Aboriginal and Torres Strait Islander history, society and culture*, Canberra: Aboriginal Studies Press for the Australian Institute of Aboriginal and Torres Strait Islander Studies, 1994, p. 754.

Ilan pasin (This is our way): Torres Strait art, exhibition catalogue, Cairns: Cairns Regional Gallery, 1998.

Isaacs, Jennifer, *Spirit country: contemporary Australian Aboriginal art*, Melbourne: Hardie Grant Books; San Francisco: Fine Arts Museum of San Francisco, 1999, p. 230.

Lüthi, Bernhard (ed.), *<<rärrk>>: John Mawurndul: journey through time in northern Australia*, exhibition catalogue, Adelaide: Crawford House Publishing, 2005.

Morphy, Howard, *Aboriginal art*, London: Phaidon Press, 1998, pp. 422–24.

National Inquiry into the Separation of Aboriginal and Torres Strait Islander Children from Their Families (Australia), *Bringing them home: report of the national inquiry into the separation of Aboriginal and Torres Strait Islander children from their families*, Sydney: Human Rights and Equal Opportunity Commission, 1997.

Perkins, Hetti and Willsteed, Theresa (eds), *Crossing country: the alchemy of Western Arnhem Land art*, exhibition catalogue, Sydney: Art Gallery of New South Wales, 2004.

Ryan, Judith, with Akerman, Kim, *Images of power: Aboriginal art of the Kimberley*, exhibition catalogue, Melbourne: National Gallery of Victoria, 1993, pp. 10–11, 112.

Taylor, Luke (ed.), *Painting the land story,* Canberra: National Museum of Australia, 1999, p. 101.

True colours: Aboriginal and Torres Strait Islander artists raise the flag, exhibition catalogue, Sydney: Boomalli Aboriginal Artists Co-operative, 1994, pp. 10–11.

Yallop, C., et al. (eds), *Macquarie dictionary,* 4th edn, North Ryde, New South Wales: Macquarie Library, 2005.

Online sources include:

Whitlam Institute, University of Western Sydney, *Aboriginal Arts Board, Press Statement No. 83*, #-collection, viewed 19 September 2007, whitlam. org/collection/1973/19730503_ Aboriginal_Arts/

Australia Dancing, *Aboriginal Islander Dance Theatre (1976–)*, online directory of dance resources, viewed 19 September 2007, australiadancing.org/ subjects/3081.html

City of Sydney, 'Aboriginal organisations in Sydney' on *Barani: Indigenous history of Sydney*, 2002, viewed 19 September 2007, cityofsydney.nsw.gov.au/barani/ themes/theme5.htm

Aboriginal art in modern worlds, exhibition catalogue, Canberra: National Gallery of Australia, 2000.

Across: an exhibition of Indigenous art and culture, exhibition catalogue, Acton, ACT: Canberra School of Art Gallery, Institute of the Arts, Australian National University, 2000.

Alberts, Franchesca, 'Grass castles: the making of an Aboriginal artist', *Periphery: A Quarterly Regional Art and Craft Magazine*, no. 34, Autumn 1999, pp. 6–8.

Annear, Judy (ed.), *Portraits of Oceania*, exhibition catalogue, Sydney: Art Gallery of New South Wales, 1997.

Artlink, Art & the spirit, vol.8, no. 1.

Artlink, Indigenous arts of the Pacific, vol. 16, no. 4.

Artlink, Reconciliation? Indigenous art for the 21st century, vol.20, no. 1.

Beyond the pale: contemporary Indigenous art: 2000 Adelaide biennial of Australian Art, exhibition catalogue, Adelaide: Art Gallery of South Australia, 2000.

Black humour: a Canberra Contemporary Art Space exhibition, exhibition catalogue, Canberra: Canberra Contemporary Art Space, 1997.

Brewster, Anne, O'Neill, Angeline and Van den Berg, Rosemary (eds), *Those who remain will always remember: an anthology of Aboriginal writing*, Fremantle, WA: Fremantle Arts Centre Press, 2000.

Brody, Anne Marie (ed.), *Stories: eleven Aboriginal artists (works from the Holmes à Court collection)*, Sydney: Craftsman House, 1997.

Budja Moort Djurah – Kutuanana: cultural survival and reconciliation, Perth: Centre for Indigenous History and the Arts, University of Western Australia, 1999.

Bush colour: works on paper by female artists from the Maningrida region, exhibition catalogue, Maningrida, NT: Maningrida Arts and Culture, 1999.

Carter, Paul and Hunt, Susan, *Terre Napoleon: Australia through French eyes 1800–1804*, Sydney: Historic Houses Trust of New South Wales in association with Hordern House, 1999.

Caruana, Wally, *Aboriginal art*, New York: Thames & Hudson, 1993.

Caruana, W., Jenkins, S. and Mundine, D., et al., *Le Mémorial: un chef-d'oeuvre d'art aborigine*, Lausanne: Musée Olympique, 1999.

Coates, Rebecca, Elliott, David and Morphy, Howard (eds), *In place (out of time): contemporary art in Australia*, Oxford: Museum of Modern Art, 1997.

Cochrane, Susan (ed.), *Aboriginal art collections: highlights from Australia's public museums and galleries*, St Leonards, NSW: Craftsman House, 2001.

Croft, Brenda L. (ed.), *Indigenous art: Art Gallery of Western Australia*, Perth: Art Gallery of Western Australia, 2001.

Croft, Brenda L. (ed.), *Southwest Central: Indigenous art from South Western Australia 1833–2002*, Perth: Art Gallery of Western Australia, 2003.

Croft, Brenda L. (ed.), *Michael Riley: sights unseen*, exhibition catalogue, Canberra: National Gallery of Australia, 2006.

Croft, Brenda L., Gilchrist, Stephen and Jenkins, Susan, *Tactility: two centuries of Indigenous objects, textiles and fibre*, exhibition catalogue, Canberra: National Gallery of Australia, 2003.

Fifth Asia-Pacific Triennial of contemporary art, exhibition catalogue, Brisbane: Queensland Art Gallery, 2005.

Flesh + blood: a Sydney story 1788–1998, Sydney: Historic Houses Trust of New South Wales, 1998.

Fourth Asia-Pacific triennial of contemporary art, exhibition catalogue, Brisbane: Queensland Art Gallery, 2002.

French, Alison, *Seeing the centre: the art of Albert Namatjira 1902–1959*, exhibition catalogue, Canberra: National Gallery of Australia, 2002.

Gatherings II: contemporary Aboriginal and Torres Strait Islander art from Queensland, Southport Qld: Keeaira Press, 2006.

Generations: the stolen years of fighters and singers, exhibition catalogue, Perth: Centre for Indigenous History and the Arts, University of Western Australia, 1999.

Gray, Anna (ed.), *Australian art in the National Gallery of Australia*, Canberra: National Gallery of Australia, 2002.

Haebich, Anna and Delroy, Ann, *The Stolen Generations: separation of Aboriginal children from their families in Western Australia*, Perth: Western Australian Museum, 1999.

Howie-Willis, Ian, 'Yirrkala Bark Petition', in David Horton (ed.), *Encyclopedia of Aboriginal Australia: Aboriginal and Torres Strait Islander history*, Canberra: Aboriginal Studies Press, 1994.

Isaacs, Jennifer, *Spirit country: contemporary Australian Aboriginal art*, South Yarra, VIC: Hardie Grant Books; San Francisco: Fine Arts Museum of San Francisco, 1999.

Jenkins, Susan (ed.), *No ordinary place: the art of David Malangi*, exhibition catalogue, Canberra: National Gallery of Australia, 2004.

Jenkins, Susan, 'Ramingining Artists, the *Aboriginal memorial* 1987–88', *Artonview*, no. 11, Spring 1997, pp. 27–34.

Keeping culture: Aboriginal art to keeping places and cultural centres, exhibition catalogue, Canberra: National Gallery of Australia, 2000.

Kleinert, Sylvia and Neale, Margo (eds), *Oxford companion to Aboriginal art and culture*, South Melbourne: Oxford University Press, 2000.

Lee, Gary, 'Picturing: Aboriginal social and solitical [sic] photography', *Artlink*, vol. 20, no. 1, pp. 45–49.

Living here now: art and politics: Australian perspecta 99, Sydney: Art Gallery of New South Wales, 1999.

McDonald, Ewen (ed.), *Biennale of Sydney 2000: 12th Biennale of Sydney, 26 May–30 July, 2000*, Sydney: Art Gallery of New South Wales, 2000.

Mapping identity, exhibition catalogue, Sydney: Centre for Contemporary Craft, 1998.

Mapping our countries: 9 October 1999 – 27 February 2000, exhibition catalogue, Sydney: Djamu Gallery, 1999.

Meridian: focus on contemporary Australian art, exhibition catalogue, Sydney: Museum of Contemporary Art, 2002.

Morphy, Howard, *Aboriginal art*, London: Phaidon Press, 1998.

Morphy, Howard and Smith Boles, Margot (eds), *Art from the land: dialogues with the Kluge-Ruhe collection of Australian Aboriginal art*, Charlottesville, Virginia USA: University of Virginia, 1999.

Motif & meaning: Aboriginal influences in Australian art, 1930–1970, exhibition catalogue, Ballarat, VIC: Ballarat Fine Art Gallery, 1999.

Myers, Fred R., *Painting culture: the making of an Aboriginal high art*, Durham: Duke University Press, 2002.

National Inquiry into the Separation of Aboriginal and Torres Strait Islander Children from Their Families (Australia), Bringing them home: report of the national inquiry into the separation of Aboriginal and Torres Strait Islander children from their families, Sydney: Human Rights and Equal Opportunity Commission, 1997.

Nugent, Mary-Lou, *Desert art: the Desert directory of central Australian Aboriginal art and craft centres*, compiled for Desart, Alice Springs, NT: Jukurrpa Books, 1998.

Outside in: research engagements with Arnhem Land art, exhibition catalogue, Canberra: Drill Hall Gallery, 2001.

Perkins, Hetti, *Fluent: Emily Kame Kngwarreye, Yvonne Koolmatrie, Judy Watson: XLVII esposizione internazionale d'arte La Biennale di Venezia 1997*, exhibition catalogue, Sydney: Art Gallery of New South Wales, 1997.

Perkins, Hetti and Fink, Hannah (eds), *Papunya Tula: genesis and genius*, Sydney: Art Gallery of New South Wales, 2000.

Perkins, Hetti and Willsteed, Theresa (eds), *Crossing country: the alchemy of Western Arnhem Land art*, Sydney: Art Gallery of New South Wales, 2004.

Re-take: contemporary Aboriginal and Torres Strait Islander photography, Canberra: National Gallery of Australia, 1998.

Reynolds, Henry, *This whispering in our hearts*, St Leonards, NSW: Allen & Unwin, 1998.

Ryan, Judith, *Colour power: Aboriginal art post 1984: in the collection of the National Gallery of Victoria*, exhibition catalogue, Melbourne: National Gallery of Victoria, 2004.

Ryan, Judith, *Land marks*, exhibition catalogue, Melbourne: National Gallery of Victoria, 2006.

Sabbioni, Jennifer, Schaffer, Kay and Smith, Sidonie (eds), *Indigenous Australian voices: a reader*, New Brunswick, NJ, USA: Rutgers University Press, 1998.

Signs of life: Melbourne international biennial 1999, Melbourne: City of Melbourne, 1999.

Stanton, John E., 'Innovation and change in the Aboriginal art of the Kimberley', *Anthropology News*, vol. 23, no. 1, 1986, pp. 4–11.

Stanton, John E., with Hill, Sandra, *Aboriginal artists of the south-west: Past and present*, Perth: Berndt Museum of Anthropology, University of Western Australia, 2000.

Story place: Indigenous art of Cape York and the rainforest, Brisbane: Queensland Art Gallery, 2003.

Taylor, Luke (ed.), *Painting the land story*, Canberra: National Museum of Australia, 1999.

Telstra presents Transitions: 17 years of the National Aboriginal and Torres Strait Islander Art Award, Darwin: Museum and Art Gallery of the Northern Territory, 2000.

The native born: objects and representations from Ramingining, Arnhem Land, Sydney: Museum of Contemporary Art in association with Bula'bula Arts, Ramingining, 2000.

Third Asia-Pacific triennial of contemporary art, exhibition catalogue, Brisbane: Queensland Art Gallery, 1999.

Tradition today: Indigenous art in Australia, Sydney: Art Gallery of New South Wales, 2004.

Utopia: ancient cultures, new forms, Perth: Heytesbury Holdings Ltd and Art Gallery of Western Australia, c. 1999.

West, M. (ed.), *Telstra National Aboriginal and Torres Strait Islander Art Award: celebrating 20 years*, Darwin: Museum and Art Gallery of the Northern Territory, 2004.

Wright, Felicity and Morphy, Frances (eds), *The art & craft centre story, in 3 vols*, Canberra: Aboriginal and Torres Strait Islander Commission, 1999–2000.

VERNON AH KEE

Bennett, Holly, 'Story place: Indigenous art of Cape York and the rainforest' exhibition review, *Local Art*, no. 8, November 2003, pp. 10–11.

Croft, Brenda, L., 'No need looking', *Photofile*, 'Traces', no. 66, September 2002, pp. 24–29.

McFarlane, Robert, 'Arresting images on the speed', *Sydney Morning Herald*, 7 October, 2003.

proppaNOW Artists Collective, exhibition brochure, Southport, Qld: Keeaira Press, 2005.

Story place: Indigenous art of Cape York and the rainforest, Brisbane: Queensland Art Gallery, 2003, pp. 174–175.

JEAN BAPTISTE APUATIMI

Art of the Tiwi from the collection of the National Gallery of Victoria, exhibition catalogue, Melbourne: National Gallery of Victoria, 1994.

Bennett, James, 'Narrative and decoration in Tiwi painting: Tiwi representations of the Purukuparli story', *Art Bulletin of Victoria*, no. 33, Melbourne, 1993, pp. 39–47.

Konnau, Britta (ed.), *Dreaming their way: Australian Aboriginal women painters*, exhibition catalogue, National Museum of Women in the Arts, London: Scala Publishers Ltd., 2006.

Parkes, Brian (ed.), *Freestyle: new Australian design for living*, Sydney: Object: Australian Centre for Craft and Design; Melbourne: Melbourne Museum, 2006.

The body Tiwi: Aboriginal art from Bathurst and Melville islands, exhibition catalogue, Launceston, TAS: The University Gallery, University of Tasmania, 1993.

Thwaites, Vivonne (ed.), *In the world: head, hand, heart: 17th Tamworth fibre textile biennial*, exhibition catalogue, Tamworth: Tamworth Regional Gallery, 2006.

JIMMY BAKER

Caruana, Wally and Jenkins, Susan (eds), *Desert mob 2006:*

Recent work from Aboriginal art centres in central Australia, exhibition catalogue, Alice Springs, NT: Araluen Galleries, 2006.

Edwards, Verity, 'At 90, Baker shows he's a master of art', *The Australian*, 13 April, 2007.

Henschke, Ian (reporter), 'New art dynasty', *Stateline*, ABC Television, 27 April, 2007, website viewed 14 September 2007, abc.net.au/stateline/sa/content/2006/s1909873.htm

NGANGKARI, National Indigenous documentary fund series 5, DVD, directed by Erica Glynn, Australia: Ronin Films, 2002.

Nunn, Louise, 'Key Aboriginal art being lost to the state', *The Advertiser*, 13 April 2007.

MARINGKA BAKER

Bevis, Stephen, 'Desert art drawcard', *The West Australian*, 1 November, 2006.

Henschke, Ian, (reporter), 'Boyds from the bush', *Australia wide*, ABC 2 Television, viewed 17 May, 2007, abc.net.au/tv/australiawide/stories/s1925925.htm

Our mob: a statewide celebration of regional and remote South Australian Aboriginal artists, Adelaide: Adelaide Festival Centre, 2006.

RICHARD BELL

Australian perspecta, Sydney: Art Gallery of New South Wales, 1993.

Balance 1990: views, visions, influences, Brisbane: Queensland Art Gallery, 1990.

Dreamtime: the dark and the light, exhibition catalogue, Vienna: Sannlung Essl.

Eather, Michael (ed.), *Shoosh: the history of the Campfire Group*, exhibition catalogue, Brisbane: Institute of Modern Art and the Campfire Group, 2005.

Green, Charles (ed.), *Australian culture now*, exhibition catalogue, Melbourne: National Gallery of Victoria, 2004.

Morrell, Timothy, *1992 Adelaide Biennial of Australian Art*, Adelaide: Art Gallery of South Australia, 1992.

Mundine, Djon, 'The first Koori', *Art Monthly Australia*, no. 76, 1994, p. 22.

Thomas, Nicholas, 'Richard Bell's Post-Aryanism', *Art Monthly Australia*, no. 77, 1995, pp. 20–21.

JAN BILLYCAN (DJAN NANUNDIE)

Aslet, Clive, 'Tribal landscapes', *The Financial Times*, London, 6 July, 2007, p. 9.

Crawford, Ashley, 'Yulparija show their colours', *The Age*, 19 April, 2004, p. 9.

McCulloch, Susan, 'West coast's late bloomers', *The Australian*, 13 April, 2004, p. 12.

Painting country – a west to east journey, exhibition catalogue, Australian Pavilion World Expo, Aichi, Japan, July, 2005, Perth: Department of Industry and Resources, 2005.

Rothwell, Nicolas, 'Remembrance of things past', *The Weekend Australian*, April 1–2, 2006, p. R18.

DANIEL BOYD

Creagh, Sunanda, 'The righteous will reign', *Sydney Morning Herald*, 1–2, July, 2006, p. 16.

Croft, Brenda L., *Right here right now: recent Aboriginal and Torres Strait Islander art acquisitions*, exhibition brochure, Canberra: National Gallery of Australia, 2006, pp. 2, 5.

Elphinstone, Kym, *MCA reveals recent acquisitions of Australian contemporary artists*, media release, Sydney: Museum of Contemporary Art, Thursday, 26 April, 2007, viewed 28 August 2007, mca.com.au/content/media/2878/NewAcquisitions2007.pdf

Hislop, Mark and Bailey, Toni (curators), *Someone shows something to someone*, exhibition catalogue, Canberra: Canberra Contemporary Art Space, 2006.

Iaccarino, Clara, 'Artistic teenager thriving after emerging from early blue period, *Sydney Morning Herald*, 10 November, 2006, p. 7.

TREVOR 'TURBO' BROWN

Clark, Deborah, 'Letter from Darwin', *Art Monthly Australia*, no. 184, October 2005, pp. 3–8.

'Facts of life: Indigenous celebrations', *Herald Sun*, 14 October, 2003.

'Fashion to the fore at RMIT celebration', *Koori Mail*, 22 October, 2003, p. 29.

Gough, Julie, 'Being there, then and now: aspects of south-east Aboriginal art', in Judith Ryan (ed.), *Land marks*, Melbourne: National Gallery of Victoria, 2006, p. 131.

Webb, Carolyn, 'Turbo-charged look at animal world', *The Age*, 21 May, 2005.

CHRISTINE CHRISTOPHERSEN

Christophersen, Christine with Langton, Marcia, 'Allarda!', *Arena*, no. 17, June/July, 1995, pp. 28–32.

Garlil Christophersen, Jane and Christophersen, Christine (ills), *Kakadu calling*, Broome: Magabala Books, 2007.

Garlil Christophersen, Jane and Christophersen, Christine (ills), *My home in Kakadu*, Broome: Magabala Books, 2005.

DESTINY DEACON

Amanshauser, Hildegund, 'Destiny Deacon', *Camera Austria*, no. 90, 2005, pp. 25–36.

Barlow, Geraldine, 'Destiny Deacon: reading across spaces', *Eyeline*, no. 62, Summer 2006/2007, pp. 52–55.

Broker, David and Deacon, Destiny, 'Interview: Destiny Deacon in conversation with David Broker', *Photofile*, no. 72, Spring 2004, pp. 18–21.

Croft, Brenda L. (ed.), *Beyond the pale: contemporary Indigenous art*, exhibition catalogue, for the Adelaide Biennial of Australian Art, Adelaide: Art Gallery of South Australia, 2000.

Fraser, Virginia and King, Natalie (eds), *Destiny Deacon: walk & don't look blak*, exhibition catalogue, Sydney: Museum of Contemporary Art, 2004.

Seear, Lynne and Ewington, Julie (eds), *Brought to light 2: Contemporary Australian art 1966–2006*, Brisbane: Queensland Art Gallery, 2007.

JULIE DOWLING

Croft, Brenda L. (ed.), *Beyond the pale: contemporary Indigenous art*, exhibition catalogue, for the Adelaide Biennial of Australian Art, Adelaide: Art Gallery of South Australia, 2000.

Dowling, Carol, 'Moorditj Djurapin' in *Julie Dowling: Winyarn Budjarri (sorry birth): Birth's end*, exhibition catalogue, fortyfivedownstairs, Melbourne, Perth: Artplace, 2005.

Dowling, Julie, *Strange fruit: testimony and memory in Julie Dowling's portraits*, exhibition catalogue, Parkville, VIC: Ian Potter Museum of Art, University of Melbourne, 2007.

Dowling, Julie, 'Moorditj Marbarn (Strong magic)' in Ryan, J. (ed.), *Colour power: Aboriginal art post 1984: in the collection of the National Gallery of Victoria*, Melbourne: National Gallery of Victoria, 2004, pp. 136–38.

Hoorn, Jeanette, 'Julie Dowling's strange fruit: Testimony and the uncanny in contemporary Australian painting', *Third text*, vol. 19, pt 3, no. 74, 2005, pp. 283–96.

Julie Dowling, videorecording, Sydney: Australian Broadcasting Corporation, 2004. First broadcast on the Obsessions section of the *Sunday afternoon* program on ABC on 13 June 2004, 27 minutes.

PHILIP GUDTHAYKUDTHAY

Aratjara: art of the first Australians: traditional and contemporary works by Aboriginal and Torres Strait Islander artists, exhibition catalogue, Düsseldorf: Kunstammlung Nordrhein – Westfalen, 1993, Koln: Dumont, Buchverlag, 1993.

Caruana, Wally (ed.), *Windows on the Dreaming*, Sydney: Ellsyd Press, 1989.

Caruana, Wally and Lendon, Nigel (eds), *The painters of the Wagilag Sisters story, 1937–1997*, exhibition catalogue, Canberra: National Gallery of Australia, 1997.

Caruana, W., Jenkins, S. and Mundine, D., et al., *Le mémorial: un chef-d'oeuvre d'art aborigine*, Lausanne: Musée Olympique, 1999.

Lendon, Nigel, 'Beyond translation: learning to look at Central Arnhem Land paintings' in *Outside in: research engagements with Arnhem Land art*, exhibition catalogue, Canberra: Drill Hall Gallery, 2001.

Mundine, Djon, 'Philip Gudthaykudthay' in Kleinert, Sylvia and Neale, Margo (eds), *Oxford companion to Aboriginal art and culture*, South Melbourne: Oxford University Press, 2000, pp. 598–599.

Mundine, Djon, 'Philip Gudthaykudthay: aspects of his world' in *Painting and sculptures from Ramingining: Jimmy Wululu and Philip Gudthaykudthay*, exhibition catalogue, Canberra: Drill Hall Gallery, 1992.

The native born: objects and representations from Ramingining, Arnhem Land, Sydney: Museum of Contemporary Art in association with Bula'bula Arts, Ramingining, 2000.

TREAHNA HAMM

Middlemost, Thomas, 'Treahna Hamm' in Kleinert, Sylvia and Neale, Margo (eds), *Oxford companion to Aboriginal art and culture*, South Melbourne: Oxford University Press, 2000, p. 603.

Reynolds, Amanda, *Wrapped in a possum skin cloak: the Tooloyn Koortakay collection in the National Museum of Australia*, Canberra: National Museum of Australia, 2005.

'Treahna Hamm' in McCulloch, Alan, McCulloch, Susan and McCulloch Childs, Emily (eds), *The new McCulloch's encyclopaedia of Australian art*, Fitzroy, VIC: Aus Art Editions; Carlton, VIC: The Miegunyah Press, 2006.

GORDON HOOKEY

Helmrich, Michelle, 'Mianjin ngatta yarrana: Brisbane, I'm goin' in *One square mile: Brisbane boundaries*, exhibition catalogue, Brisbane: City of Brisbane, 2003.

Hookey, Gordon with Ryan, Judith, 'Screaming out loud what people are whispering: Gordon Hookey on art' in Ryan, Judith, *Colour power: Aboriginal art post 1984: In the collection of the National Gallery of Victoria*, Melbourne: National Gallery of Victoria, 2004, pp. 139–41.

Kean, J., 'Political theatre in *Beyond the pale*', *Artlink*, vol. 20, no. 1, 2000, p. 68.

Pugliese, Joseph, 'Gordon Hookey: theatres of war' in *On reason and emotion: Biennale of Sydney 2004*, exhibition catalogue, Woolloomooloo, NSW: Biennale of Sydney, 2004. pp. 110–12.

Thompson, C., 'Operation honesty – the art of Gordon Hookey' in *Con-Sent-Trick Sir-Kills*, exhibition catalogue, St Kilda, VIC: Linden – St Kilda Centre for Contemporary Art, 2003.

Croft, Brenda L. (ed.), *Beyond the pale: contemporary Indigenous art*, exhibition catalogue, for the Adelaide Biennial of Australian Art, Adelaide: Art Gallery of South Australia, 2000.

ANNIEBELL MARRNGAMARRNGA

Altman, Jon (ed.), *Mumeka to Milmilngkan: innovation in Kurulk art*, exhibition catalogue, Canberra: Drill Hall Gallery, 2006.

Hamby, Louise (ed.), *Twined together: Kunmadj njalehnjaleken*, Gunbalanya: Injalak Arts and Crafts, 2005.

JOHN MAWURNDJUL

Crossman, S. and Barou, J. P. (eds), *L'ete australien a Montpellier: 100 chefs d'oeuvre de la peinture australienne*, Montpellier, France: Musée Fabre, 1990.

Hinkson, Melinda, '*Rarrk* – John Mawurndjul: a journey through time in northern Australia', *Art Monthly Australia*, no. 185, November 2005, pp. 14–19.

John Mawurndjul, exhibition catalogue, Sydney: Annandale Galleries, 2004.

John Mawurndjul, John Bulunbulun, exhibition catalogue, Sydney: Annandale Galleries in association with Maningrida Arts and Culture, 1997.

Lüthi, Bernhard (ed.), <<*rärrk*>>: *John Mawurndul: journey through time in northern Australia*, exhibition catalogue, Adelaide: Crawford House Publishing, 2005.

Mawurndjul, John, 'I'm a chemist man, myself' in Perkins, Hetti and Willsteed, Theresa (eds), *Crossing country: the alchemy of Western Arnhem Land art*, Sydney: Art Gallery of New South Wales, 2004, pp. 134–39.

Naumann, Peter, 'Aboriginal art in faraway places', *Art and Australia*, vol. 43, pt 4, Winter 2006, pp. 586–89.

Ryan, Judith, *Spirit in land: Bark paintings from Arnhem Land in the National Gallery of Victoria*, Melbourne: National Gallery of Victoria, 1990.

Smee, Sebastion, 'Shows take snapshot of now', *The Australian*, 25 November, 2005.

Taylor, Luke, 'John Mawurndjul: the resonating land', in Caruana, Wally (ed) *World of Dreamings*, electronic publication, Canberra: National Gallery of Australia and St Petersburg, Russia: State Hermitage Museum, 2000, viewed 14 September 2007, nga.gov.au/ Dreaming/Index.cfm, (*World of Dreamings* exhibited with new catalogue under title: *Aboriginal art in modern worlds*, Canberra: National Gallery of Australia, 2000).

RICKY MAYNARD

Birch, Tony and Maynard, Ricky (ills), *Reversing the negatives: a portrait of Aboriginal Victoria*, Melbourne: Museum Victoria, 2000.

Foley, Dennis and Maynard, Ricky (photographs), *Repossession of our spirit: traditional owners of northern Sydney*, Canberra: Aboriginal History Inc., 2001.

McFarlane, Robert, 'Arresting images on the speed', *Sydney Morning Herald*, 7 October, 2003.

Maynard, Ricky, *No more than what you see: photographic essay*, Adelaide: South Australian Department of Correctional Services, 1993.

Quaill, Avril, 'Freddie Timms and Ricky Maynard', in *Interesting times: focus on contemporary Australian art*, exhibition catalogue, Sydney: Museum of Contemporary Art, 2005.

DANIE MELLOR

Creagh, Sunanda, 'Young artists redraw perceptions of the land', *Sydney Morning Herald*, 8 September, 2005, p. 14.

McClean, Sandra, 'Art of the accidental', *The Courier Mail*, 12–13 March 2005, p. M03.

Snell, Ted, 'Unfolding a winner', *The Australian*, 15 September, 2003.

Story place: Indigenous art of Cape York and the rainforest, Brisbane: Queensland Art Gallery, 2003.

LOFTY BARDAYAL NADJAMERREK AO

Brody, A, *Kunwinjku Bim: Western Arnhem Land paintings from the collection of the Aboriginal Arts Board*, Melbourne: National Gallery of Victoria, 1984.

Chaloupka, George, *Barrk: black wallaroo*, video documentary of Bardayal painting on a rock shelter, on permanent viewing at Museum and Art Gallery of Northern Territory, Darwin, 2004.

McKenzie, Kim, *Warrluk Mukmuk: fragments of the owls egg*, a film about memory and place by Kim McKenzie, Canberra: Australian National University, 2006.

Nadjamerrek AO, Lofty Bardayal, *Lofty Bardayal Nadjamerrek AO: late works*, exhibition catalogue, Annandale NSW: Annandale Galleries in association with Marrawuddi Gallery, Kakadu, 2006.

Nadjamerrek AO, Lofty Bardayal, 'Barridjangonhmi bim! Paint it for me!' in Perkins, Hetti and Willsteed, Theresa (eds), *Crossing country: the alchemy of Western Arnhem Land art*, Sydney: Art Gallery of New South Wales, 2004, pp. 96–105.

Ryan, Judith, *Land marks*, exhibition catalogue, Melbourne: National Gallery of Victoria, 2006.

Taylor, Luke, 'Rainbows in the water: Western Arnhem Land, Northern Territory' in Taylor, Luke (ed.), *Painting the land story*, Canberra: National Museum of Australia, 1999, pp. 33–52.

Taylor, Luke, 'Flesh, bone and spirit: Western Arnhem Land bark painting' in Morphy, Howard and Smith Boles, Margot (eds), *Art from the land: dialogues with the Kluge-Ruhe collection of Australian Aboriginal art*, Charlottesville, Virginia, USA: University of Virginia, 1999, pp. 27–56.

West, Margaret, *Rainbow sugarbag and moon: two artists of the stone country: Bardayal Nadjamerrek and Mick Kubarkku*, exhibition catalogue, Darwin: Museum and Art Gallery of the Northern Territory, 1995.

DOREEN REID NAKAMARRA

Birnberg, Margo and Kreczmanski, Janusz, *Aboriginal artists: dictionary of biographies: western desert, central desert and Kimberley region*, Marleston, SA: J. B. Publishing, 2004.

Livesey, Scott and Williams, Jessica (eds), *Aboriginal art 2005*, exhibition catalogue, Melbourne: Scott Livesey Galleries, 2005.

Pintupi, exhibition catalogue, London: Hamiltons Gallery, 2006.

DENNIS NONA

Butler, R., *Islands in the sun: prints by Indigenous artists of Australia and the Australiasian region*, exhibition catalogue, Canberra: National Gallery of Australia, 2001.

Gelam Nguzu Kazi = Dugong my son: the first exhibition of limited edition linocuts by the artists of the

Mualgau Minaral Artist Collective from Mua Island in the Torres Strait, exhibition catalogue, Mua Island, Australia: Kubin Community Council, 2001.

Sesserae: the works of Dennis Nona, exhibition catalogue, Brisbane: Dell Gallery, Queensland College of Art, 2005.

Solomon, Selena with Nona, Dennis (ills), *Dabu, the baby dugong = Kazi Dhangal*, Broome: Magabala Books, 1992 and 2003.

ARTHUR KOO'EKKA PAMBEGAN JR

Aboriginal art in modern worlds, exhibition catalogue, Canberra: National Gallery of Australia, Canberra, 2000.

Caruana, Wally, *Aboriginal art*, New York: Thames & Hudson, 1993.

Denham, Peter, 'Not to give away, not to die away', an interview with Arthur Koo'ekka Pambegan Jr, in *Story place: Indigenous art of Cape York and the rainforest*, Brisbane: Queensland Art Gallery, 2003.

Kaus, David, 'National Museum of Australia, Canberra', in Cochrane, Susan (ed.), *Aboriginal art collections: highlights from Australia's public museums and galleries*, St Leonards, NSW: Craftsman House, 2001, pp. 22–28.

Morphy, Howard, *Aboriginal art*, London: Phaidon Press, 1998.

Story place: Indigenous art of Cape York and the rainforest, Brisbane: Queensland Art Gallery, 2003.

Sutton, Peter (ed.), *Dreamings: the art of Aboriginal Australia*, New York: Viking published in association with the Asian Society Galleries, New York, 1988.

Sutton, Peter, 'High art and religious intensity: a brief history Wik sculpture' in Caruana, Wally (ed), *World of Dreamings*, electronic publication, Canberra: National Gallery of Australia and St Petersburg, Russia: State Hermitage Museum, 2000, viewed 14 September 2007, nga.gov.au/ Dreaming/Index.cfm, (*World of Dreamings* exhibited with new

catalogue under title: *Aboriginal art in modern worlds*, Canberra: National Gallery of Australia, 2000).

CHRISTOPHER PEASE

Croft, Brenda L., 'I am not sorry: Beyond Capricornia', *Art Monthly Australia*, no. 154, October 2002, pp. 5–9.

Croft, Brenda L. (ed.), *Indigenous art: Art Gallery of Western Australia*, Perth: Art Gallery of Western Australia, 2001.

Croft, Brenda L., *Right here right now: recent Aboriginal and Torres Strait Islander art acquisitions*, exhibition brochure, Canberra: National Gallery of Australia, 2006.

Croft, Brenda L., *South west central: Indigenous art from south Western Australia 1833–2002*, Perth: Art Gallery of Western Australia, 2003.

McLean, Ian, 'New histories of Australian art: south west central – Indigenous art from south Western Australia 1833–2002', *Art Monthly Australia*, no. 158, April 2003, pp. 18–21.

SHANE PICKETT

Banks, R., 'New light on the seasons', *The West Australian*, 14 February, 2003.

Collard, Len with Pickett, Shane (ills), *The Waakarl Story*, Perth: Catholic Education Office of Western Australia, 2000.

Croft, Brenda L., *South west central: Indigenous art from south Western Australia 1833–2002*, Perth: Art Gallery of Western Australia, 2003.

'Curator's choice: Shane Pickett: the falling clouds and morning sky', *InSite Magazine*, Winter 2005.

Stanton, John, *On track: contemporary Aboriginal art from Western Australia*, exhibition catalogue, Perth: Berndt Museum of Anthropology, University of Western Australia and Western Australian Museum, 2004.

Winmar, Alta, 'Shane Pickett', *Artlink*, vol. 10, no. 1–2, Autumn– Winter 1990, p. 90.

ELAINE RUSSELL

Andrew, B., 'Narratives', *Periphery*, no. 20, August 1994, pp. 22–25.

Cochrane, Susan, 'The 1994 national Aboriginal art award, *Art Monthly Australia*, no. 75, November 1994, pp. 21–23.

Narratives: Kerry Giles, Peta Lonsdale, Pantjiti Mary McLean, Elaine Russell, exhibition catalogue, Strawberry Hills, NSW: Boomalli Aboriginal Artists Co-operative, 1994.

Native title business: contemporary Indigenous art: a national travelling exhibition, exhibition catalogue, Southport, QLD: Keeaira Press, 2002.

Sayin' something: Aboriginal art in New South Wales: ten years of land rights in New South Wales, exhibition catalogue, Chippendale, NSW: Boomalli Aboriginal Artists Co-operative, 1993.

CHRISTIAN BUMBARRA THOMPSON

Croft, Brenda L., Gilchrist, Stephen and Jenkins, Susan, *Tactility: two centuries of Indigenous objects, textiles and fibre*, exhibition catalogue, Canberra: National Gallery of Australia, 2003.

Langton, M., *Blaks' palace*, exhibition catalogue, Melbourne: Gallery Gabrielle Pizzi, 2000.

Lumo, L., *2001: 5th international photography triennial*, exhibition catalogue, Jyvaskyla: Jyvaskyla Art Museum, 2001.

Nicholls, C., 'Digital indigeneity', *Real Time*, no. 52, Dec 2002–Jan 2003, p. 17.

Strickland, J., 'Homostrata', exhibition review, *dB Magazine online*, c. 2004, viewed 14 September 2007, dbmagazine. com.au/318/viz-Homostrata.html

JUDY WATSON

Australian perspecta, exhibition catalogue, Sydney: Art Gallery of New South Wales, 1993.

Croft, Brenda L. (ed.), *Beyond the pale: contemporary Indigenous art*, exhibition catalogue, for the

Adelaide Biennial of Australian Art, Adelaide: Art Gallery of South Australia, 2000.

Hamersley, K., *sacred ground, beating heart: works by Judy Watson 1989–2003*, exhibition catalogue, Perth: John Curtin Gallery, 2003.

Naumann, Peter, 'Aboriginal art in faraway places', *Art and Australia*, vol. 43, pt 4, Winter 2006, pp. 586–89.

Perkins, Hetti, *fluent: Emily Kame Kngwarreye, Yvonne Koolmatrie, Judy Watson: XLVII esposizione internazionale d'arte La Biennale di Venezia 1997*, exhibition catalogue, Sydney: Art Gallery of New South Wales, 1997.

Stevenson, Karen, *Judy Watson: driftnet*, exhibition catalogue, New Zealand: McDougall Contemporary Art Annex, 1998.

Story place: Indigenous art of Cape York and the rainforest, Brisbane: Queensland Art Gallery, 2003.

Watson, J., *Judy Watson*, fellowship catalogue, France: Epernay and Coldstream, Victoria: Moet et Chandon, 1996.

Watson, J., 'Judy Watson in Italy', Aboriginal art in the public eye, *Art Monthly Australia*, supplement, 39.

H.J. WEDGE

Neale, Margo, *Yiribana: Aboriginal and Torres Strait Islander gallery*, Sydney: Art Gallery of New South Wales, 1994.

True colours: Aboriginal and Torres Strait Islander artists raise the flag, exhibition catalogue, Sydney: Boomalli Aboriginal Artists Co-operative, 1994.

Weight, G., 'Never ending story', *Australian Artist*, no. 124, October 1994, pp. 37–42.

Wedge, H. J., *Wiradjuri spirit man*, Roseville East, NSW: Craftsman House in association with Boomalli Aboriginal Artists Co-operative, 1996.

Wiyana/Perisferia (periphery): A collaborative temporal art installation by Aboriginal and Latin American artists, exhibition catalogue, Strawberry Hills NSW: Boomalli Aboriginal Artists Co-operative, 1992.

OWEN YALANDJA

Au centre de la terre d'Arnhem: entre mythes et réalité: art aborigène d'Australie, exhibition catalogue, Mantes-la-Jolie, France: Musée de l'Hôtel-Dieu, 2001.

Hoff, J. and Taylor, L., 'The *mimi* spirit as sculpture', *Art and Australia*, vol. 23, no. 1, 1985, pp. 73–77.

Jacob, S. and Leroy, C., *Le Temps du Rêve, art aborigène Contemporain*, exhibition catalogue, Slovénie: Cankarjev Dom, Ljubljana, 2003.

Meeuwsen, Franca, *Aboriginal kunst*, Zwolle, the Netherlands: Waanders Uitgevers, 2000.

Metamorphosis: contemporary Australian Aboriginal photography and sculpture, Palazzo Papadopoli, Venezia, 14 giugno – 13 luglio 1997 (47th Biennale di Venezia, Palazzo Papadopoli), Melbourne: Gallery Gabrielle Pizzi, 1997.

GULUMBU YUNUPINGU

Banks, Ron, 'Champions of Indigenous art', *The West Australian*, 4 September 2004, p. 11

Croft, Brenda L., 'Musée du quai Branly, Paris: Indigenous art commission from Australia', *Artonview*, no. 41, Autumn 2005, pp. 44–46.

Henly, Susan Gough, 'Indigenous art on the Seine', *Sun Herald*, 19 November, 2006, p. 28.

Hutcherson, Gillian, *Gong-wapitja: Women and art from Yirrkala, Northeast Arnhem Land*, exhibition catalogue, Canberra: Aboriginal Studies Press, 1998.

O'Riordan, Maurice, 'Sky train: The 21st Telstra National Aboriginal and Torres Strait Islander art award (NATSIAA) in Darwin', *Art Monthly Australia*, no. 174, October 2004, pp. 20–23.

CONTRIBUTORS

Simona Barkus is a member of the Kala Lagaw Ya and Meriam Mer people of Moa Island in the west and Murray Island in the east of the Torres Strait islands. Originally from Thursday Island, she now resides in Canberra, and is Trainee Assistant Curator of Aboriginal and Torres Strait Islander Art at the National Gallery of Australia.

Tina Baum is a Larrakia/Wadama woman of the Northern Territory. She is Curator of Aboriginal and Torres Strait Islander Art at the National Gallery of Australia and has worked as a curator since 1991 in Brisbane, Darwin and Canberra.

Leilani Bin-Juda is of Torres Strait Islander descent. She is the Executive Officer of the Aboriginal and Torres Strait Islander Program at the Department of Foreign Affairs and Trade, Canberra. She has previously worked with the Torres Strait Regional Authority and as a curator at the National Museum of Australia. She is currently undertaking a Masters in Cultural Heritage.

Andrew Blake is a sculptor and arts worker. With Will Stubbs he co-managed Buku-Larrnggay Mulka art centre, Yirrkala, Northern Territory, for most of the 1990s. More recently he managed Marrawuddi Gallery in Kakadu National Park, where he mounted Lofty Bardayal Nadjamerrek's first solo exhibition at Annandale Galleries. He is now back with the Yolngu at Buku-Larrnggay.

Clotilde Bullen is Associate Curator of Indigenous Art at the Art Gallery of Western Australia. She has a mixed heritage – her father is French-English, and her mother is Yamatji-Nyoongar. She sees her role as one of advocacy for Indigenous artists, as a role model for young aspiring Indigenous arts workers, and as a representative voice for Indigenous protocols and cultural sensitivities.

George Chaloupka was the Field Anthropologist and Curator of Rock Art with the Museum and Art Gallery of the Northern Territory from 1973 to 1996. As Emeritus Curator, he continues to study north Australian rock art traditions, land ownership and sites of significance. His extensive research is reflected in *From palaeoart to casual paintings* (1994) and *Journey in time* (1993).

Brenda L. Croft is a member of the Gurindji and Mudpurra peoples from the Northern Territory. She is curator of the inaugural National Indigenous Art Triennial and is Senior Curator of Aboriginal and Torres Strait Islander Art at the National Gallery of Australia, Canberra. She has been involved in the Indigenous and Australian visual arts/cultural industry since the early 1980s, as an artist, writer, arts administrator and consultant. She was a founding member of Boomalli Aboriginal Artists Co-operative Ltd.

Franchesca Cubillo is a member of the Larrakia, Bardi, Wadaman and Yanuwa Nations. She is Senior Curator, Aboriginal Art and Material Culture at the Museum and Art Gallery of the Northern Territory, Darwin. She has previously held senior positions with Tandanya, National Aboriginal Cultural Institute and the South Australian Museum, Adelaide and the National Museum of Australia, Canberra.

Rolf de Heer is a writer, director and producer of generally low-budget feature films, to varying degrees of critical, audience and commercial success. *Ten canoes*, de Heer's eleventh film, won the Special Jury Prize for Un Certain Regard at the 2006 Cannes Film Festival and six AFI Awards including Best Film.

Carol Dowling is twin sister to visual artist Julie Dowling and has contributed many written insights into her sister's work and career. She is a writer and part-time lecturer with a Masters in Indigenous Research and Development from Curtin University where she is currently studying her doctorate in Social Sciences concerning the stories of five generations of women in her family.

Murray Garde is an anthropologist and linguist who has been living and working in Western Arnhem Land for the past twenty years. Formerly the cultural research officer for Maningrida Arts and Culture and Curator of the Maningrida Djómi Museum, he is now an ARC Postdoctoral Linkage Fellow in the School of Languages and Linguistics, Melbourne University.

Kelly Gellatly is Curator of Contemporary Art (Australian and International) at the National Gallery of Victoria. She has held curatorial positions at Heide Museum of Modern Art, Melbourne and the National Gallery of Australia, where she curated the first museum survey of Indigenous photography, *Re-take: contemporary Aboriginal and Torres Strait Islander photography*.

Stephen Gilchrist is a member of the Ingarda/Yamatji people from the north-west of Western Australia. He is Curator of Indigenous Art at the National Gallery of Victoria.

Angela Hill is the Art Coordinator at Tiwi Design Aboriginal Corporation on Bathurst Island. She and her husband, Tim Hill (Manager of Tiwi Design), had a contemporary art gallery in Sydney for ten years before moving to Bathurst Island. She is undertaking a Masters in Applied Linguistics focusing on Aboriginal languages.

Patrick Hutchings is a philosopher and aesthetician whose last job before retirement was teaching Philosophy of Art at the University of Melbourne. Currently he is an occasional contributor of art criticism to *The Age* newspaper. He has a considerable interest in Indigenous art.

Susan Jenkins is a freelance art consultant based in Adelaide, offering services as a curator, editor, lecturer, valuer and writer. She was a curator of Aboriginal and Torres Strait Islander Art at the National Gallery of Australia and arts administrator with Bula'bula Arts Aboriginal Corporation, Ramingining.

Her Master's degree research focused on the National Gallery of Australia's *Aboriginal memorial*.

Apolline Kohen is the Arts Director at Maningrida Arts and Culture. She is in charge of the daily operations of the arts centre and of its exhibition program, putting together an average of twenty-five commercial exhibitions per year to promote the work of Maningrida artists.

Gary Lee is a member of the Larrakia/Wadaman people of the Northern Territory. He was born in Darwin where he currently resides. He has worked in the Indigenous arts and cultural industry since the mid 1970s as a designer, writer, curator, anthropologist and artist, and is currently completing doctoral studies at Charles Darwin University.

Bruce McLean is a member of the Johnson family of the Wirri/Birri-Gubba people of central Queensland. He is Associate Curator of Indigenous Australian Art, Queensland Art Gallery, where he began as a trainee on the exhibition *Story place: Indigenous art of Cape York and the rainforest*. He is a singer, dancer and didjeridoo player for a Brisbane-based Aboriginal dance group.

Ian McLean is an Associate Professor at the University of Western Australia, and is on the Advisory Council of *Third Text*. He has published extensively on Australian art and particularly on the intersections of Indigenous and settler art. His books include *The art of Gordon Bennett* (with a chapter by Gordon Bennett) and *White Aborigines: identity politics in Australian art*.

Graeme Marshall is co-owner, with Ros Marshall, of Marshall Arts Aboriginal Fine Art Gallery; an Adelaide gallery specialising in community-based Indigenous art from the Northern Territory, Western Australia, South Australia and Queensland. Graeme has worked in the Aboriginal arts and cultural industry since the

early 1970s. Both Graeme and Ros are passionate supporters of Indigenous art and Aboriginal-controlled art centres.

Timothy Morrell is an independent curator and writer in Brisbane and was previously a curator at the Art Gallery of South Australia and the Queensland Art Gallery. His freelance work has included exhibitions in Australia, Asia and Europe, as well as public art projects in Brisbane.

Ian Munro is the CEO of the Bawinanga Aboriginal Corporation, the parent organisation of Maningrida Arts and Culture. Ian has been working with Aboriginal people since the mid 1980s, and is passionate about Aboriginal art. He is an avid collector of bark paintings, predominantly Eastern Kuninjku works.

Keith Munro, a Kamilaroi man from north-west New South Wales and south-west Queensland is Curator Aboriginal and Torres Strait Islander Programs at the Museum of Contemporary Art, Sydney. He has worked on a number of major exhibitions including *Paddy Bedford* and *bangu yilbara: works from the MCA Collection* as well as developing engaging public programs and workshop programs.

Maurice O'Riordan is a freelance arts writer who lives in Darwin. He has worked as a curator and researcher of Aboriginal arts since the late 1980s.

Hetti Perkins is a member of the Eastern Arrernte and Kalkadoon Aboriginal communities. She is the Senior Curator of Aboriginal and Torres Strait Islander Art at the Art Gallery of New South Wales, Sydney.

Cara Pinchbeck is a member of the Kamilaroi people, and she is Curatorial Assistant of Aboriginal and Torres Strait Islander art at the Art Gallery of New South Wales.

Matthew Poll is of Loyalty Islander Descent and grew up in Byron Bay, New South Wales. He

is Artistic Director of Boomalli Aboriginal Artists Co-operative. Poll has worked at Wollongong City Gallery, the Museum of Contemporary Art, Sydney, and with local government in Western Sydney in curatorial, visitor services and project positions. He has a Bachelor of Arts in Communication.

Avril Quaill, an artist and curator, was a founding member of the Boomalli Aboriginal Artists Co-operative Ltd. She is of the Noonuccal people with clan associations to the Goenpul and Nuigi people in south-east Queensland. She is Principal Project Officer at the Queensland Indigenous Arts Marketing and Export Agency (QIAMEA) in the Department of State Development and Trade, Queensland Government.

Marianne Riphagen is currently conducting her PhD research on the subject of contemporary Indigenous Australian photography. Her research is carried out for the Radboud University Nijmegen, the Netherlands, in affiliation with the Centre for Aboriginal Economic Policy Research (CAEPR) at the Australian National University and has a strong focus on the intercultural and on photographs as socially salient objects.

Judith Ryan is the Senior Curator of Indigenous Art at the National Gallery of Victoria, Melbourne.

Belinda Scott has tertiary qualifications in anthropology, Australian history and art history and curatorship. She has been a Visiting Research Fellow at the Australian Institute of Aboriginal and Torres Strait Islander Studies and worked with Yolngu artists of Ramingining since 1989. Currently the Curator/Registrar of Bula'bula Arts Aboriginal Corporation, she was an Associate Producer on the multi-award winning film *Ten canoes*.

Russell Storer has worked as a curator at the Museum of Contemporary Art, Sydney since 2001.There he has organised a number of exhibitions, including *Interesting times: focus on*

contemporary Australian art and solo exhibitions of work by Paddy Bedford, Juan Davila, Rodney Glick and Mathew Jones and Simon Starling. He has written for and edited publications in Australia and overseas.

Professor Peter Sutton is an anthropologist and linguist at the University of Adelaide and South Australian Museum, who has worked with Aboriginal people since 1969. His books include *Dreamings: the art of Aboriginal Australia* (ed. 1988). He is currently funded by the Australian Research Council to write books on the history of the Wik people, Cape York Peninsula.

Paul Sweeney was born in 1966 in Sydney. Through the 1980s and until the mid 1990s he worked as a photographer's assistant, studio manager and freelance photographer in Sydney and Alice Springs. With Papunya Tula Artists, he has worked as field officer and assistant manager and is now the General Manager.

Dr Luke Taylor has worked with Kuninjku artists since 1980. For ten years he worked as a senior curator at the National Museum of Australia. He is currently Deputy Principal – Research at the Australian Institute of Aboriginal and Torres Strait Islander Studies. His research is published in *Seeing the inside* (1996) and recent catalogues including *Crossing country* (2004) and *<<Rarrk>>* (2005).

Chantelle Woods is a member of the Worimi people from New South Wales. She is Assistant Curator of Aboriginal and Torres Strait Islander Art at the National Gallery of Australia. Previously she worked at the Queensland Art Gallery as project officer for Indigenous Australian Art, and the Lockhart River Art Centre in Far North Queensland.

ACKNOWLEDGMENTS

In 1998 I was fortunate to be presented with the opportunity of guest curating the 2000 Adelaide Biennial of Australian Art, which culminated in *Beyond the pale: contemporary Indigenous art*, held at the Art Gallery of South Australia, whose then Director was Ron Radford, the present Director of the National Gallery of Australia. The experience was incredibly formative in my professional development as an Indigenous curator working with public institutions as, until that time, I had mainly worked with community art centres and contemporary art spaces, and mostly in a freelance capacity.

I was very grateful for the considerable support and mentoring that I received during *Beyond the pale* and ever since then I had held a desire to create a similar prospect for other Australian Indigenous curators – whether freelance, with public institutions, or contemporary art spaces and art centres – as such opportunites are few and far between.

Developing the inaugural *National Indigenous Art Triennial: Culture Warriors* has been a wonderful experience and very much a collaborative effort. I would like to gratefully acknowledge the support of the many individuals and institutions without whose assistance this project could not have been realised. Without the encouragement of the National Gallery of Australia's Chairman, Rupert Myer, and the Director, Ron Radford, it would have remained little more than a dream.

The funding bodies and sponsoring organisations: The Australia Council, particularly Karilyn Brown, Billy Crawford, Lydia Miller and Anna Waldmann; BHP Biliton; Queensland Government/Queensland Indigenous Marketing Export Agency (QIMEA), especially Helena Gulash and Avril Quaill; Arts NT, particularly Stephanie Hawkins; Arts Vic, especially Elizabeth Liddle; and the Department of Foreign Affairs and Trade, especially Leilani Bin-Juda, Anthony Taylor, Lachlan Strahan and Kathryn Thomas.

The contributing authors to the publication: Thank you for meeting a very tight deadline with grace and aplomb, and for your essays, which provide superb personal and professional insights into the artists', their communities and their art/culture. A special thanks to Kev Carmody, Bill Cullen/One Louder Productions, Mel Forbes and Paul Kelly for their inspiration and support. A big hug to Kev for being the voice of right and reason – our contemporary songman.

Organisational support: My eternal gratitude to all who have contributed from various sections throughout the National Gallery of Australia, particularly the staff of Aboriginal and Torres Strait Islander Art: Tina Baum, Chantelle Woods, Simona Barkus and Kelli Cole. I do not wish to be remiss leaving anyone out but I would also like to mention Mary-Lou Nugent, Project Manager; Erica Seccombe and Kirsty Morrison, Publications; Vicki Marsh and Helen Hyland from the Research Library; Brenton McGeachie and Steve Nebauer of the Imaging Services Section; all in Conservation, Registration and Installations – please know that I am very grateful to all who contributed beyond the call of duty.

Artists' representatives, Art/Cultural Centres, regional organisations, assisting galleries and lenders: Aboriginal and Pacific Art, Sydney, NSW; Australian Institute of Aboriginal and Torres Strait Islander Studies, Canberra, ACT; Alcaston Gallery, Melbourne, VIC; Mrs Betty Arney; Art Gallery of South Australia, Adelaide, SA; Andrew Baker Art Dealer, Brisbane, QLD; Annandale Galleries, Sydney, NSW; Artplace, Melbourne, VIC; Aurukun Arts, Aurukun, QLD; Australian Art Print Network, Sydney, NSW; Ms Sandy Barnard, Printer, Sydney, NSW; Ms Annie Bartlett and Mr Joseph Fekete; Bellas Milani Gallery, Brisbane, QLD; Bidyadanga community, WA; Mr Andrew Blake, Yirrkala, North-East Arnhem Land, NT; Mr Norman Bloom, Boomalli Aboriginal Artists Co-operative Pty Ltd, Sydney, NSW; Buku-Larrnggay Mulka Art Centre, Yirrkala, North-East Arnhem Land, NT; Bula'bula Arts Aboriginal Corporation, Ramingining, NT; Mrs Lyn Conybeare; Mr Peter Cooke, Kabulwarnamyo, Western Arnhem Land, NT; Régine Cuzin; Dick Bett Gallery, Hobart, TAS; Gallery Gabrielle Pizzi, Melbourne, VIC; Goddard de Fiddes Gallery, Perth, WA; Grahame Galleries + Editions, Brisbane, QLD; GrantPirrie, Sydney, NSW; Griffith Artworks & DELL Gallery, Queensland College of Art; Brisbane, QLD; Mr Patrick Hutchings; Indigenart, The Mossenson Galleries, Fremantle, WA, and Carlton, VIC; Injalak Arts and Crafts Association, Gunbalanya, NT; Mr Jonathan Jones, Sydney, NSW; Koorie Heritage Trust, Melbourne, VIC; Ms Jo Lagerberg; Maningrida Arts and Culture, Maningrida, NT; Marshall Arts Aboriginal Fine Art Gallery, Adelaide, SA; Mr Ron and Mrs Patricia May, Mori Gallery, Sydney, NSW; Mr Rupert Myer AO; Nellie Castan Gallery, Melbourne, VIC; Mr Peter Nelson; Ms Kaye O'Donnell, Papunya Tula Artists Pty Ltd, Alice Springs, NT; Dixon Patten; Mr Philip Price, Queensland Art Gallery, Brisbane, QLD; Ms Emily Rohr and Mr Michael Hutchinson, Roslyn Oxley9Gallery, Sydney, NSW; Mr John and Mrs Marian Schaffer; Mr Bernard and Mrs Anna Shafer, Short Street Gallery, Broome, WA; Ms Lorna Shuttlewood, Stills Gallery, Sydney, NSW; Mr Kerry Stokes/Australian Capital Equity, Perth, WA; TarraWarra Museum of Art, Yarra Valley, VIC; The Big River Collection, TAS; The Collectors, Melbourne, VIC; Mr Theo Tremblay, Billy Missi, Alick Tipoti, David Bosun and Cairns TAFE, and KickART, Cairns, QLD; Tiwi Design, Nguiu, NT; Tjungu Palya Arts, Nyapari, NT; Tolarno Galleries, Melbourne, VIC; Mr Michael and Mrs Eleonora Triguboff; Urban Art Projects, Brisbane, QLD; Justice Ann Vanstone; Bob Weis; Wesfarmers Collection of Australian Art, Perth, WA; Mr Richard and Mrs Catherine Williamson; and William Mora Galleries, Melbourne, VIC.

Design and editing: Many thanks to the innovative crew, particularly Brett Wiencke, at Art Direction, Canberra, ACT; and editors Deborah Clark, Canberra, ACT; Susan Jenkins, Adelaide, SA; and Paige Amor and Jeanie Watson, Canberra.

Photographic credits: Many thanks to Australian Art Print Network; Sofii Belling, Melbourne, VIC; Andrew Blake, Yirrkala, NT; Michael J. N. Bowles; Carol Christophersen, NT; Bell Charter, NSW; Megan Cullen, QLD; Jodie Cunningham, ACT; Amanda Dent, SA; Natasha Harth, Brisbane, QLD; Stuart Hay, ACT; Tim Hill, Nguiu, NT; Michael Hutchinson, WA; Apolline and Marc Kohen, NT; Ben Kopilow, ACT; Eric Meredith, ACT; Tony Nathan, Perth, WA; Dixon Patten, Melbourne, VIC; Molly Pease, WA; Wayne Quilliam, Melbourne, VIC; Rodney Start, Melbourne, VIC; Belinda Scott, Bula'bula Arts, Ramingining, NT; Nick Tapper, WA; and Steven Wilanydjangu, Raminginging, NT. Special thanks to Sonia Payes, Melbourne, VIC, for allowing the reproduction of your revealing portraits of Richard Bell, Gordon Hookey and John Mawurndjul.

Finally, and most importantly, I wish to pay tribute to the artists. Without their vision, innovation, generosity of spirit, wisdom and humanity this exhibition, *Culture Warriors*, would not exist. I continue to learn from you. Thank you.

Brenda L. Croft